D1544137

a Place Called Home

a Place Called Home

The People and Landscape
of Clinton County, Ohio

Photography

by

Ty Greenlees

Robert Flischel

Ronald G. Levi

Thomas E. Witte

ORANGE FRAZER PRESS
Wilmington, Ohio

ISBN: 1-933197-03-X

Copyright © 2006 Clinton County Foundation

Photography copyright © 2006 Orange Frazer Press, Inc., and Tyler R. Greenlees, Robert A. Flischel, Ronald G. Levi, and Thomas E. Witte.

No part of this publication may be reproduced or transmitted in any form or by any means, electronic or mechanical, including any information storage and retrieval system, without written permission from the publisher, except by reviewers who may wish to quote briefly.

Additional copies of *A Place Called Home, The People and Landscape of Clinton County, Ohio,* may be ordered directly from:

Orange Frazer Press
P.O. Box 214
Wilmington, Ohio 45177

Telephone 1-800-852-9332 for price and shipping information
Web site: *www.orangefrazer.com*

Published by Orange Frazer Press, Inc., for the Clinton County Foundation
Wilmington, Ohio 45177

Library of Congress Cataloging-in-Publication Data

A place called home : the people and landscape of Clinton County, Ohio / photography
 by Ty Greenlees ... [et al.].
 p. cm.
 ISBN 1-933197-03-X
 1. Clinton County (Ohio)--Pictorial works. 2. Landscape--Ohio--Clinton
 County--Pictorial works. 3. Clinton County (Ohio)--Social life and customs--Pictorial
 works. 4. Clinton County (Ohio)--Biography--Pictorial works. I. Greenless, Ty, 1966-

 F497.C55P58 2006
 977.1'76500222--dc22

 2006046400

John Baskin, art direction
Jeff Fulwiler, cover and design
Marcy Hawley & the Orange Frazer staff, text and orchestration of photography
Richard Coleman, research
Leslie Frake, project assistant
Chad DeBoard, color specialist
Tim Fauley, technical support
Lori Williams, Laura Curliss, Carolyn Matthews, and Virgene Peterson, additional research

Printed in China

Clinton County Foundation Board Members
President—Terry Habermehl
Vice president—Randy Riley
Secretary—Leilani Popp
Treasurer—Joann Chamberlin
Janet Dixon, Foundation administrator
Sarah Barker, financial administrator
Larry Barker, emeritus board member
Lennis Perkins, former Foundation board member
Harry Brumbaugh, Shirley Haines, Laura Martin, Eileen Ostermeier, Doug Naylor, Joni Streber, and Judy Tingle.
Book Committee: Joann Chamberlin, chair; Leilani Popp, Lennis Perkins, and Lori Williams.

The photography for *A Place Called Home* was funded through the generous donations of an Anonymous Donor and the following people:
Elroy Bourgraf
Harry and Judy Brumbaugh
Marvin and Joann Chamberlin
Tim and Katie Crowley
Steven and Becky Haines
Tim and Brooke James
Robert Raizk
Phil and Vicki Snow
E. Eugene and Christine Snyder
Sam Stratman
Roy Joe and Ruth Stuckey

National Bank and Trust
Jonathan Baker, DHL
Wilmington News Journal
Books 'n' More
Sara Conti, Susan Ertel, Theresa Rembert, and Katie Crowley
Mary Earles of Blanchester
Joe Saville of Sabina
Bill Cluxton of New Vienna
Pat Fenner and his 1932 Model B Deluxe Roadster
Randy Sarvis, Judy Doyle, and Terry Rupert,
 all of Wilmington College
Wilmington FD, particularly Assistant Chief Mark Wiswell
Linda Rinehart, teacher/athletic photographer
 at Wilmington High School
Maria Parker, Putnam Elementary School

To everyone who graciously cooperated in the photographs for this book, as well as special thanks to those who posed for or otherwise worked on photographs that for one reason or another failed to make it into the book.

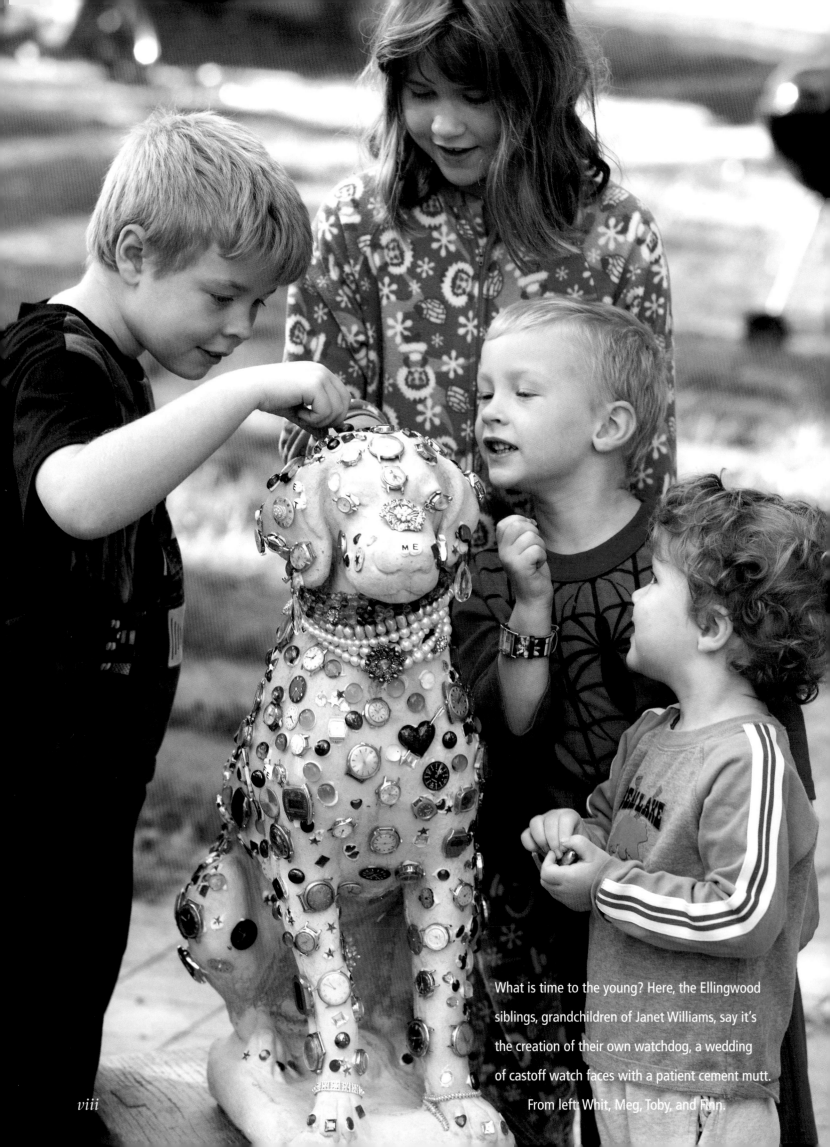

What is time to the young? Here, the Ellingwood siblings, grandchildren of Janet Williams, say it's the creation of their own watchdog, a wedding of castoff watch faces with a patient cement mutt. From left: Whit, Meg, Toby, and Finn.

Photographers

Robert Flischel
Ty Greenlees
Ron G. Levi
Thomas E. Witte

Sarah Clark
Alan Haines
Todd Joyce
Jay Paris
Dan Patterson
Roman Sapecki
Randy Sarvis
Thomas Schiff
John Schwartzel
Joe Simon
Chris Smith
Jerry Socha
Ken Steinhoff
Nelson Thompson

the Clinton County Visitors Bureau contest winners
First—Linda Rinehart
Second—Joe Saville
Third—John Porter

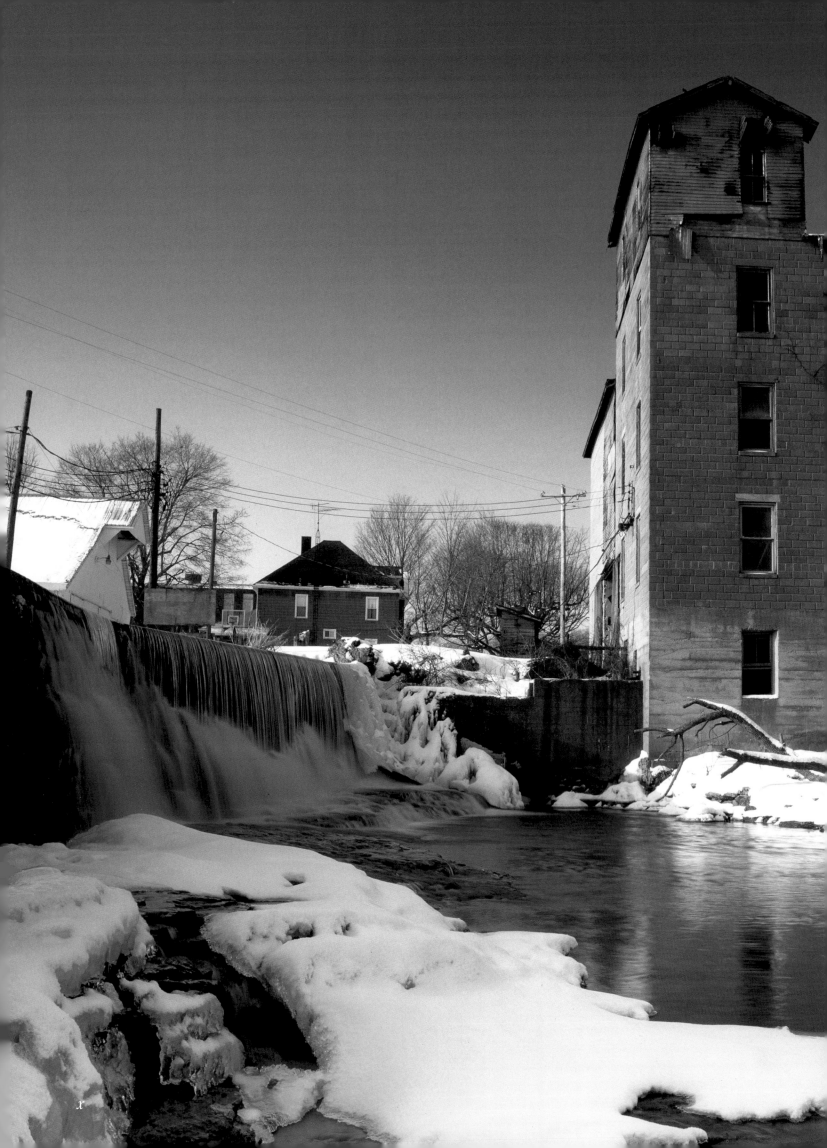

NO PARKING
TOW AWAY ZONE

When Curtis Bickel's lady

Holstein arrives in town from

New Vienna for the County Fair,

she has an eye on the local

regulations. Is that Cow Away?

Or Tow Away? Is there a Butterfat Inspector?

A girl from the country gets nervous in strange places.

\mathcal{W} hen the Clinton County Foundation went to hometown Orange Frazer Press to discuss a coffeetable photography book on the county, the overwhelming question quickly arose: *who* gets photographed, and *what*, and *why*?

They arrived at an arresting solution: Have the photographers decide. After all, the photographers would be doing the heavy lifting.

Besides, the list of invited photographers included more than a dozen of Ohio's most noteworthy photographers. They included noted Cincinnati portrait photographer Robert Flischel; the landscape and fine art photographer Ronald Levi; *Sports Illustrated* contributor Thomas Witte; Thomas Schiff, whose work includes the two-foot-wide prints made with his 360-degree camera for his bicentennial book, *Panoramic Ohio*; as well as local photojournalist Ty Greenlees, lead photographer for the *Dayton Daily News*—and a licensed pilot responsible for the book's aerial photography.

The Foundation generated wish lists. Some committee members even began carrying cameras themselves. The committee was driven by its ideas—a roadside park, an important neighborhood event, an institution. The photographers were driven by images: how could these things be photographed? That is, how could they be photographed *universally*? How could they be photographed so that they told a story outside the people concerned?

Sometimes, they said "No."

Sometimes, the weather refused to cooperate. (One farm family lamented the early and parched state of its corn crop. "You can't photograph it looking like *this*," they lamented. And, of course, we didn't.)

Committee members—sometimes accompanied by the photographers themselves—wandered into businesses, offices, and knocked on countless doors, asking to look.

What were they looking *for*?
Why, *light*, said the photographers.
And *faces*.

And backgrounds.
And expanse of land and sky.

Anything *interesting*, they said, which they—and their pictures—would define.

The naturalist Ron Levi, a specialist in limited edition fine art prints, slid into the yard of a surprised farmer, explained that he was chasing a rainbow, and secured a hasty permission to shoot the farmer's pasture (and the rainbow).

Bill Cluxton came out on a frigid winter afternoon to open up the old New Vienna gym so that a dozen of the most

Rod wore the same hat and sat in the same rocker, which he had kept in the basement, as though he thought Sapecki might return.

Dorothy Kirk, the *grande dame* of Peterson Place, came out just before her 97th birthday to be photographed with all the residents, then again two weeks later when five dozen members of the county's several book clubs posed in front of the library, dressed to the nines and carrying their favorite books. (Dan Nixon fussed that it seemed a bit anachronistic. "They should all be carrying laptops," he said.)

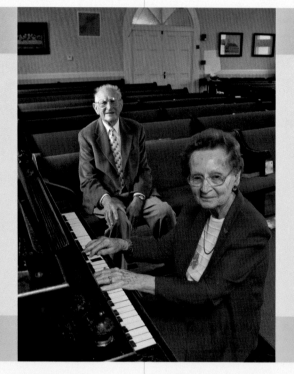

They just might be the county's favorite couple. It's partly because Walter Nichols was for years the superintendent of schools and partly because—in their 90s—they still perform musically (Grace marks middle C with a piece of tape so she can find it) and partly because they're still irreversibly a couple. On the other hands, why not? It's only been 68 years. At right, that's their extended family—Cape May. From left: Helen and Ralph Rannels, Helen Davis, Grace Stewart, Ann Evans, Walter and Grace, Kay McMillan, Jane Dunlap, Ruth McDonald, the Reverend Mary Cochran, Rosalie Smith, Thelma Settlemyre, Esther and Williard Karns, Lucile Beckett, Martha and Donald Bernard, Glen Custis, Irvin and Hilda Brandehoff.

famous county basketball players could be photographed, including Ralph Turner, who regaled everyone with a story of when he dribbled down the very same court upon which they were standing, paused to shoot on the far sideline—and someone standing on the stage behind the goal kicked him in the head.

The Columbus photographer Roman Sapecki recalled doing a magazine portrait of Rod Moler at the Capricorn Inn. In the portrait, Rod was tilted impossibly far back in an old rocker, wearing a cowboy hat. Visiting Rod again—after twenty years—Sapecki redid his original portrait, this time in color.

A Clinton County flight crew from World War II rolled out at daybreak for a rendezvous at Wright-Patterson, where they were photographed by Dan Patterson, one of the best military aviation photographers in the country—with their original bomber.

Patterson found it highly unusual that two of the local boys—Tom Browning and Homer Lundy—could still wear their flight jackets, and during the shoot Mr. Lundy admitted that he only became a pilot to impress a girl—who soon afterward ditched him for another branch of the service. Mr. Lundy, of course, found himself headed for the Pacific.

The crew at Station 2 kindly pushed the antique pumper outside for the photographer, and elsewhere, Chris Horsley led Thomas Witte through the steam tunnel under the courthouse to the old subterranean coal boiler where Witte posed him and painted him with light. There's a portrait of Reesville postmaster Marilyn Cooper, as well as one of her predecessor, Gladys Linn, a wonderful character who kept the post office in the front room of her house (it sometimes smelled of gingerbread) and, upon occasion, refused to put up mail for someone who had talked back to her.

The technical problems found in the new digital world—and having to produce a photograph as large as 12"x18"—were astounding, worked on constantly by the photographers; Orange Frazer's resident production manager, Tim Fauley; and OFP's color specialist, Chad DeBoard.

The Ohio weather was, well, Ohio weather, which necessitated canceled schedules, inconvenienced people, and six dozen definitions of the phrase "partly cloudy."

Among the countless problems was one constant, which alleviated the countless problems: the unflagging kindness and unending generosity of the people in the county.

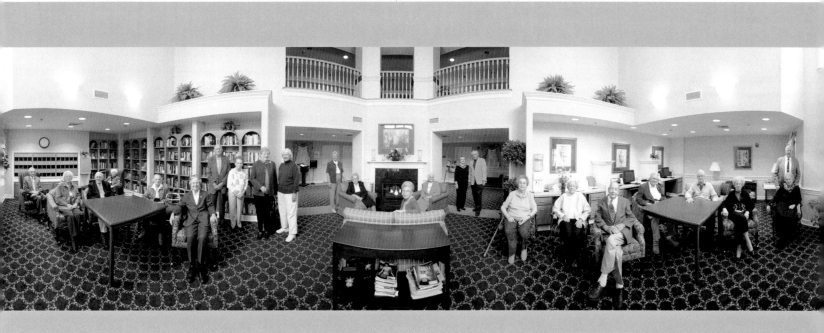

The photographers did a first day at school, the first baby born in the county, and a first haircut, as well as the last service station owned by a woman, the last Cider Bowl game, and the last photograph of community benefactor Elizabeth Williams, taken on the slide at the park a week before she died unexpectedly of a heart attack.

The photographers, driving in from elsewhere, learned— among other things—that Clinton Countians drive ten miles an hour slower than people elsewhere; that "in the wee hours" in Port William means "anytime after 9:30 p.m."; and that John Philip Sousa marches played in the fair show ring might make your pig strut.

That's where the title of the book came from—
A Place Called Home; the People and Landscape of Clinton County.

—The editors

a Place Called Home

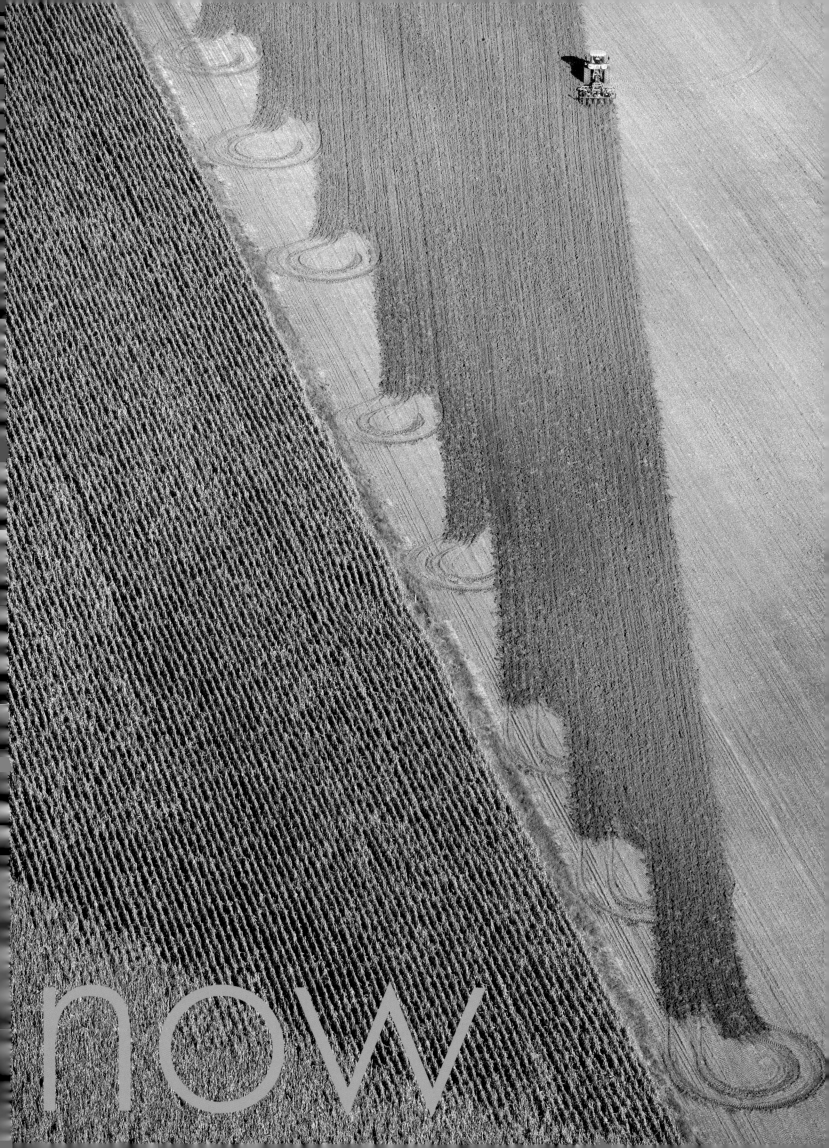

now

Introducing the agricultural life of the county, photographer Ty Greenlees

gives the viewer two iconic pictures that convey nearly two centuries

of life here: below, a man and his horses; at left, a man and his machinery.

The aerial picture is near Lees Creek, while closer to earth Mike McCormick

plows his small acreage on Sprague Road with Barney, Erma, and Leon.

Mike, co-pastor of Chester Friends Meeting (along with wife, Nancy), has

four working horses, this partnership being both a practical arrangement

for a small holding as well as a tribute to his Iowa boyhood when his

father farmed with horses. Indeed, one of his fondest childhood memories

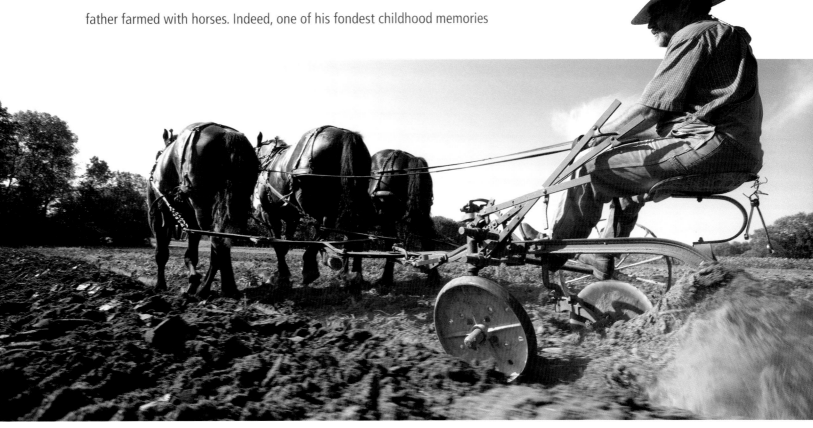

is of following his father out before dawn, standing transfixed before

the picture of the horses placidly eating in their stalls as his father talked

to them. In time, Mike bought his father's equipment and acquired horses

of his own, working with them to grow organic potatoes and corn. Says

Nancy, "My husband puzzles me because he is an extrovert, then he

finds he must break away. So when he is tired of the foolishness of man,

he turns to his horses, which connect him to common sense and to God."

The horse, says Mike, is a powerful symbol of freedom, openness, loyalty,

gentleness—"and the simplicity inherent in the Quaker faith."

THEN

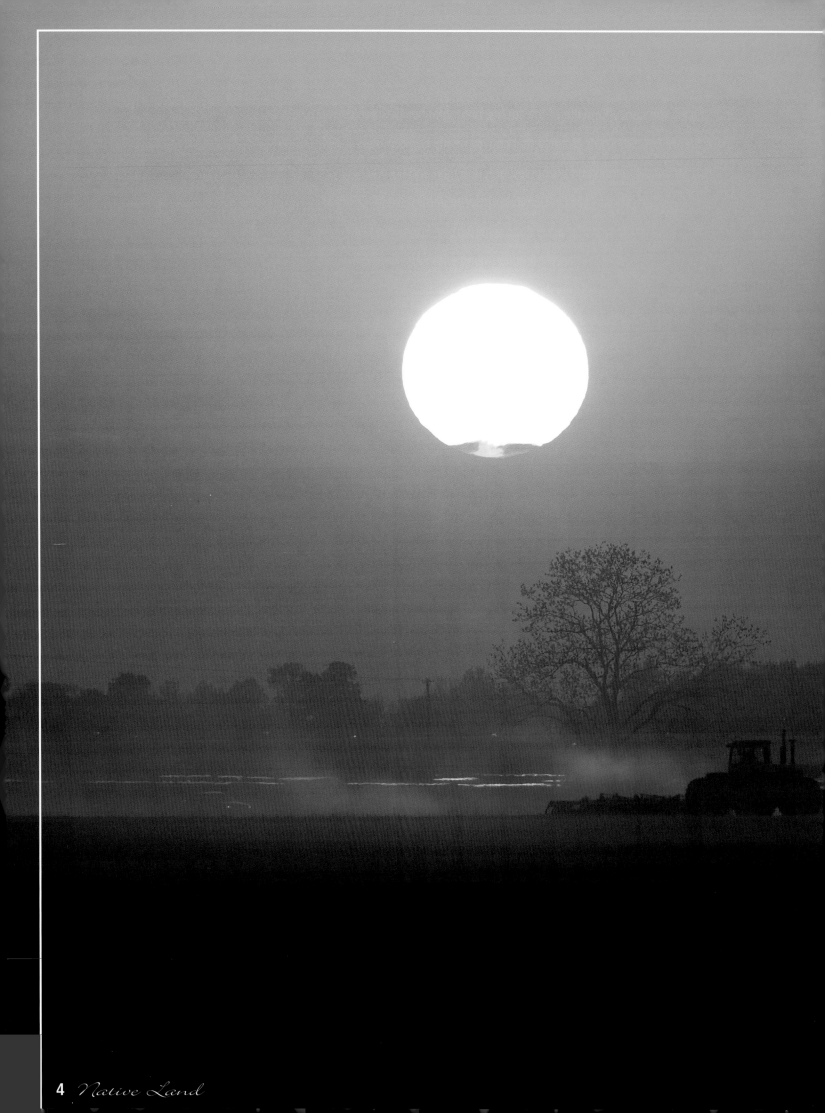

This tableau is found along Reardon Road, between US68 and SR134, a quintessential springtime scene repeated endlessly—from the farmer's point of view, anyway—across a county that still farms nearly 225,000 agricultural acres.

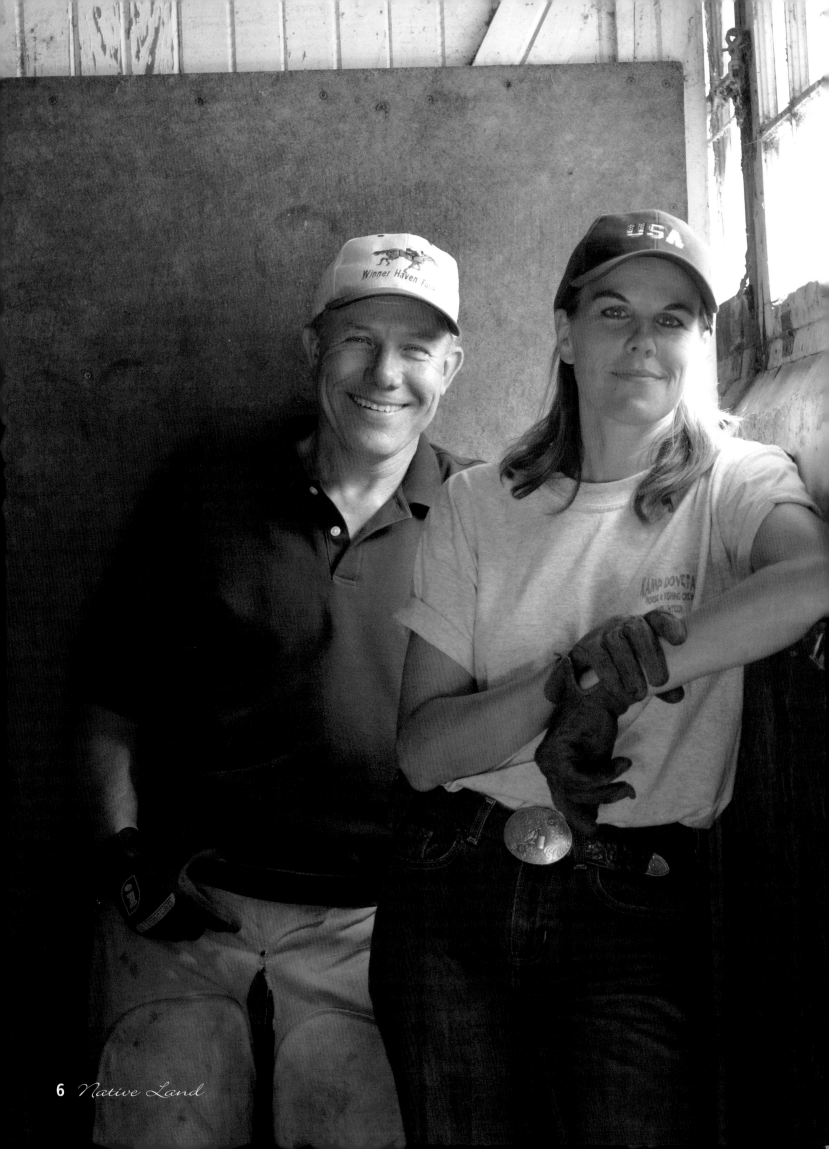

You'll find Bobby and Colleen *McMichael* on their Cuba Road farm, attending to horse business.

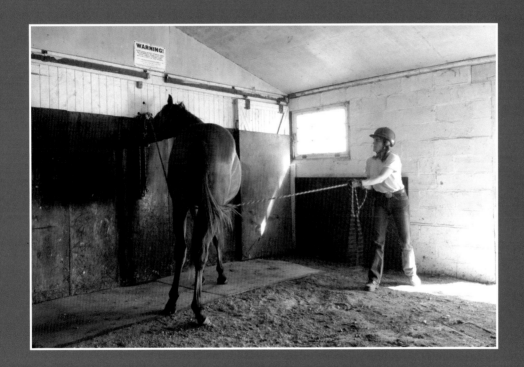

They raise thoroughbreds, train, break, board, give *Lessons*—and Bobby is both a farrier and an equine dentist.

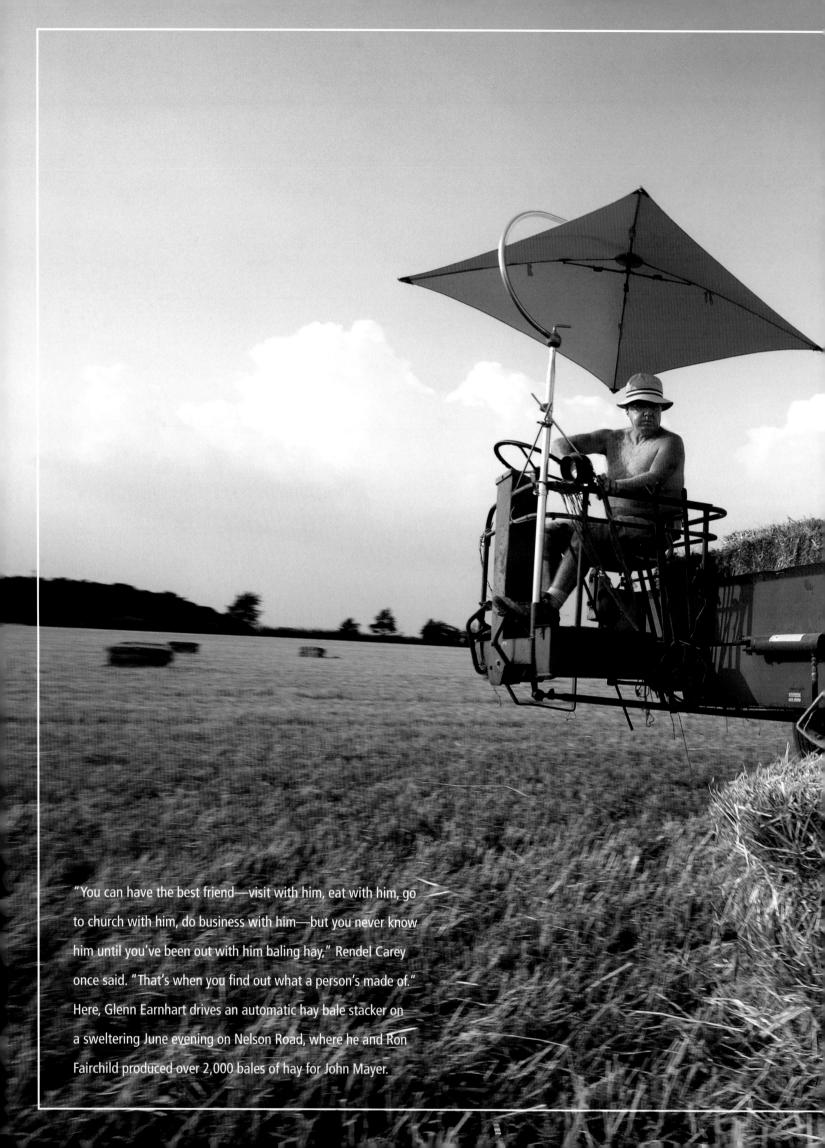

"You can have the best friend—visit with him, eat with him, go to church with him, do business with him—but you never know him until you've been out with him baling hay," Rendel Carey once said. "That's when you find out what a person's made of." Here, Glenn Earnhart drives an automatic hay bale stacker on a sweltering June evening on Nelson Road, where he and Ron Fairchild produced over 2,000 bales of hay for John Mayer.

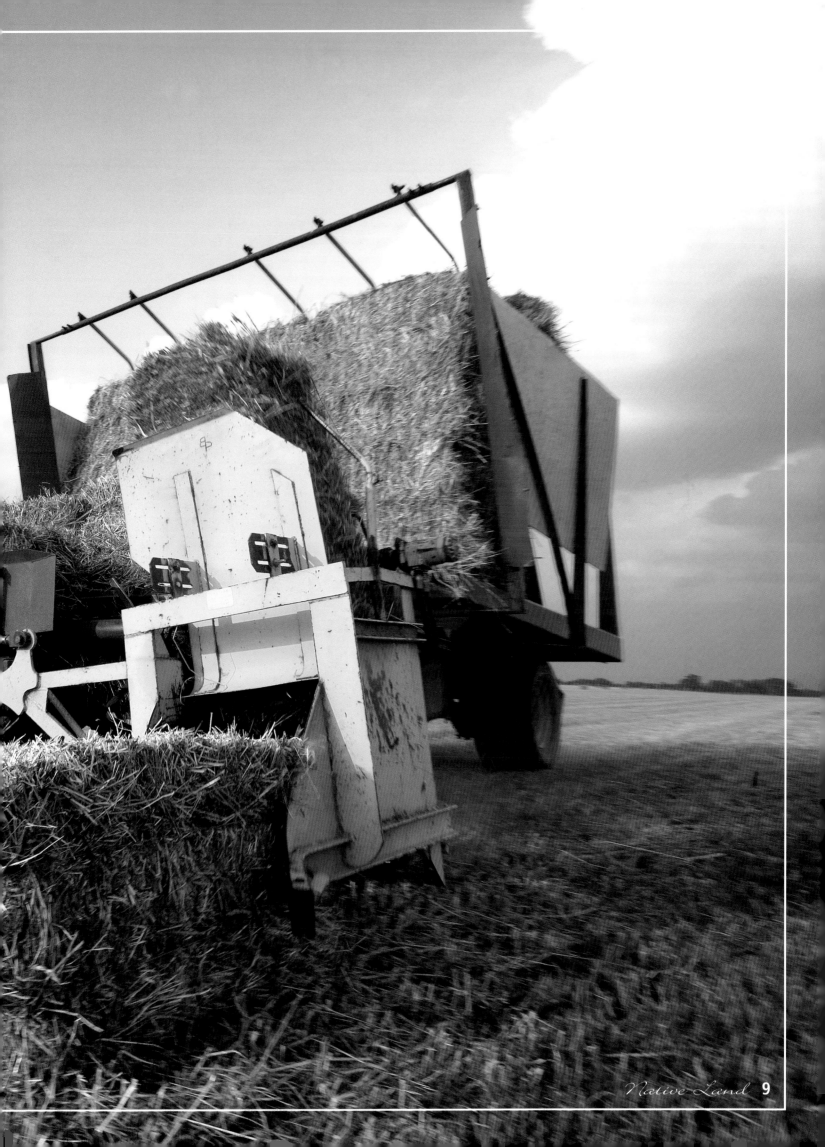

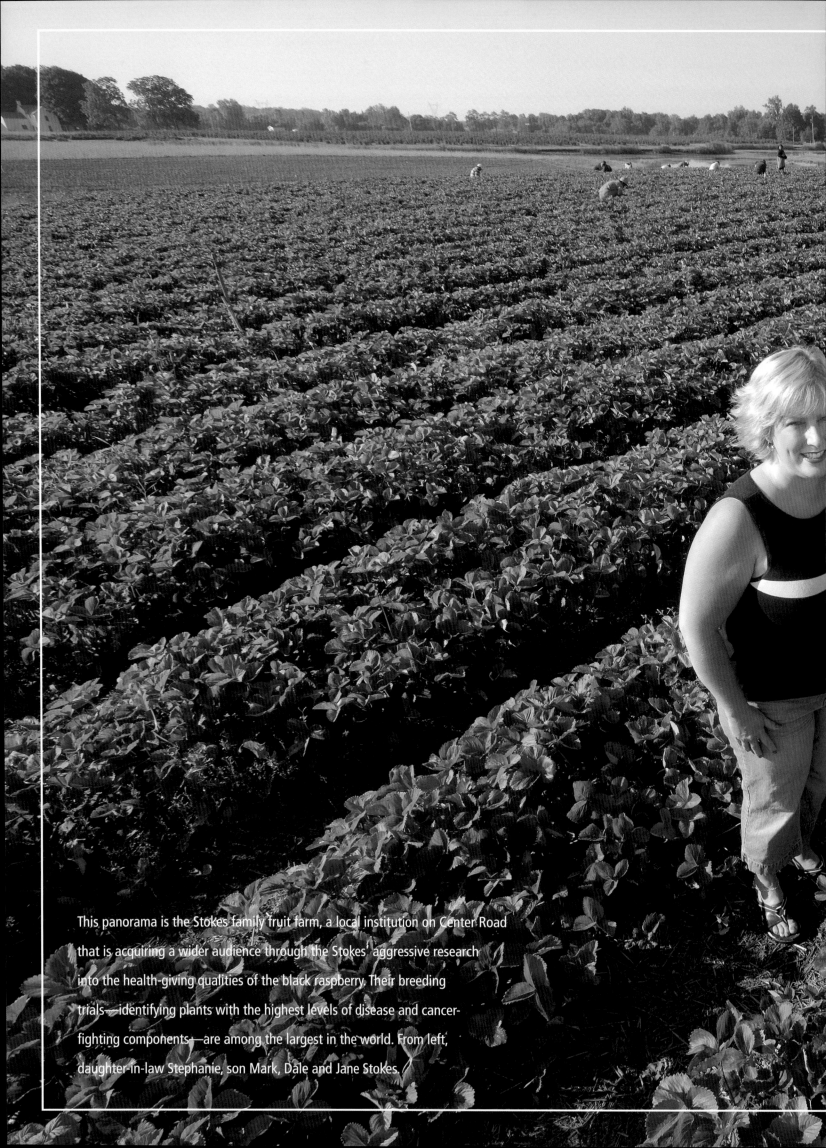

This panorama is the Stokes family fruit farm, a local institution on Center Road that is acquiring a wider audience through the Stokes' aggressive research into the health-giving qualities of the black raspberry. Their breeding trials—identifying plants with the highest levels of disease and cancer-fighting components—are among the largest in the world. From left, daughter-in-law Stephanie, son Mark, Dale and Jane Stokes.

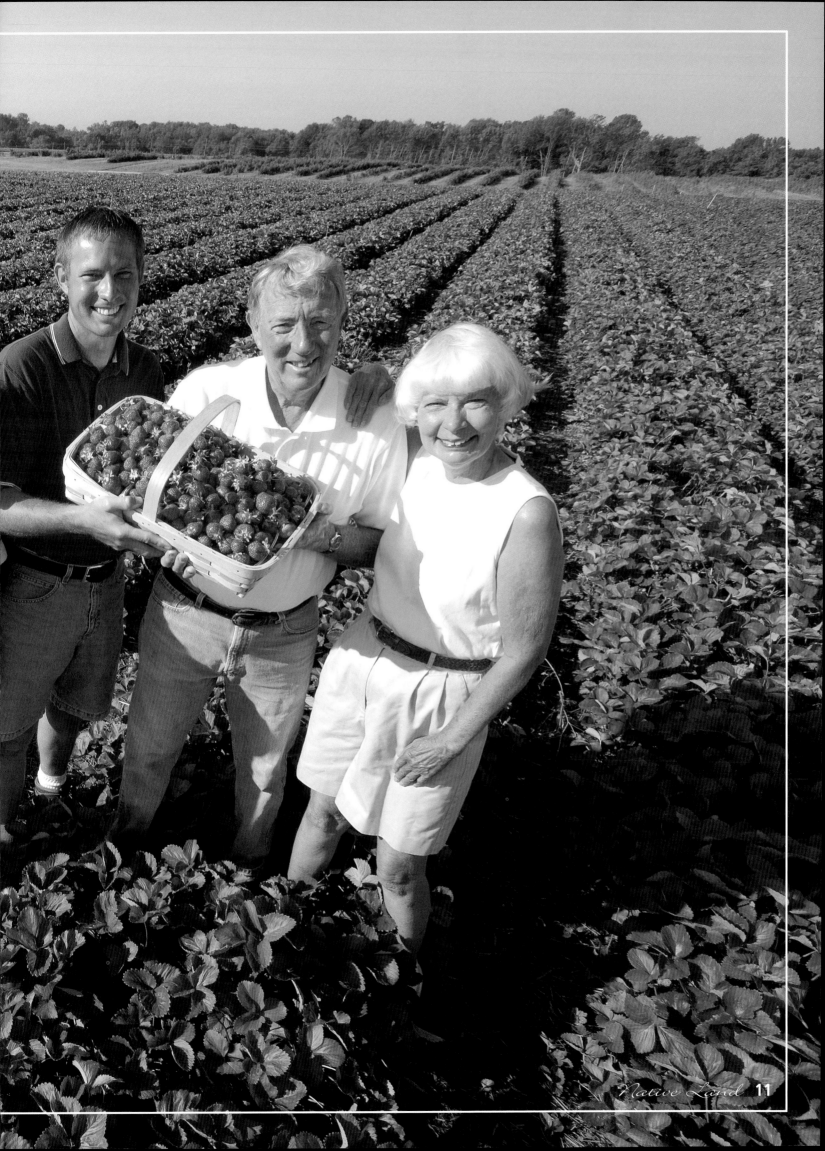

DO i HEAR

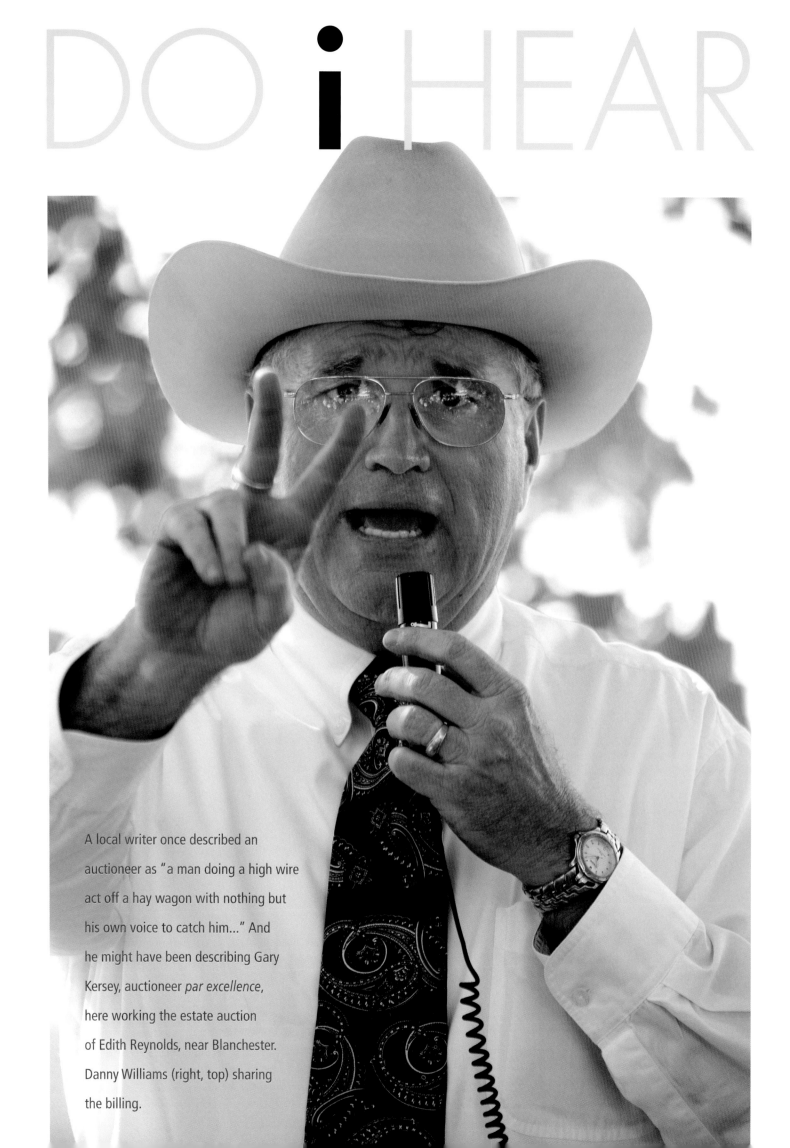

A local writer once described an auctioneer as "a man doing a high wire act off a hay wagon with nothing but his own voice to catch him..." And he might have been describing Gary Kersey, auctioneer *par excellence*, here working the estate auction of Edith Reynolds, near Blanchester. Danny Williams (right, top) sharing the billing.

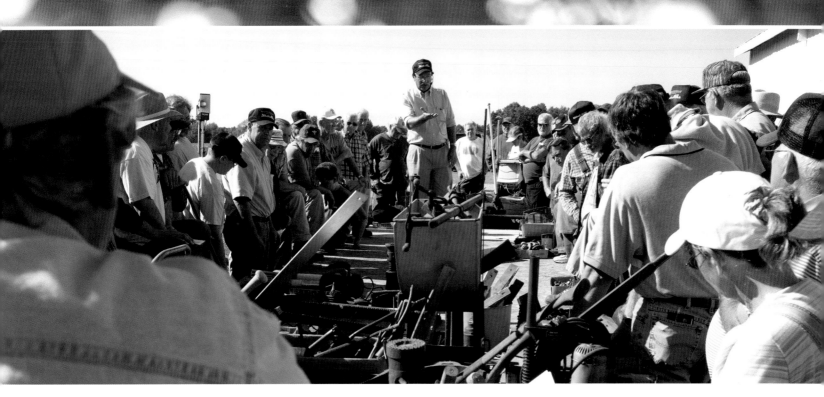

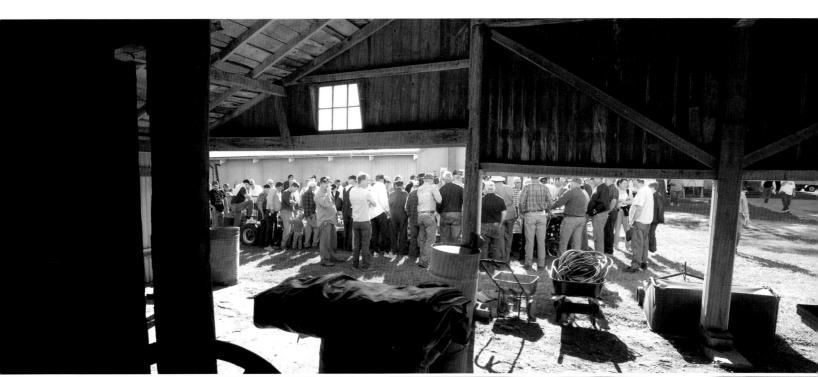

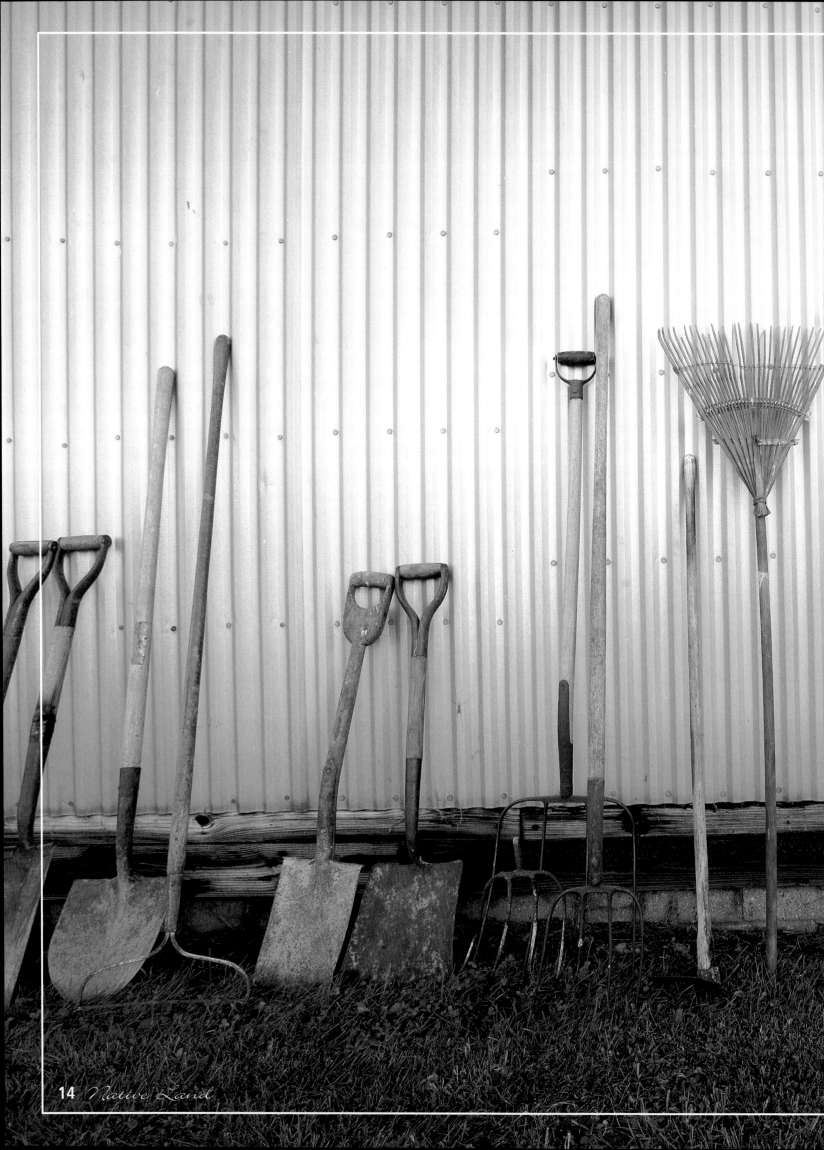

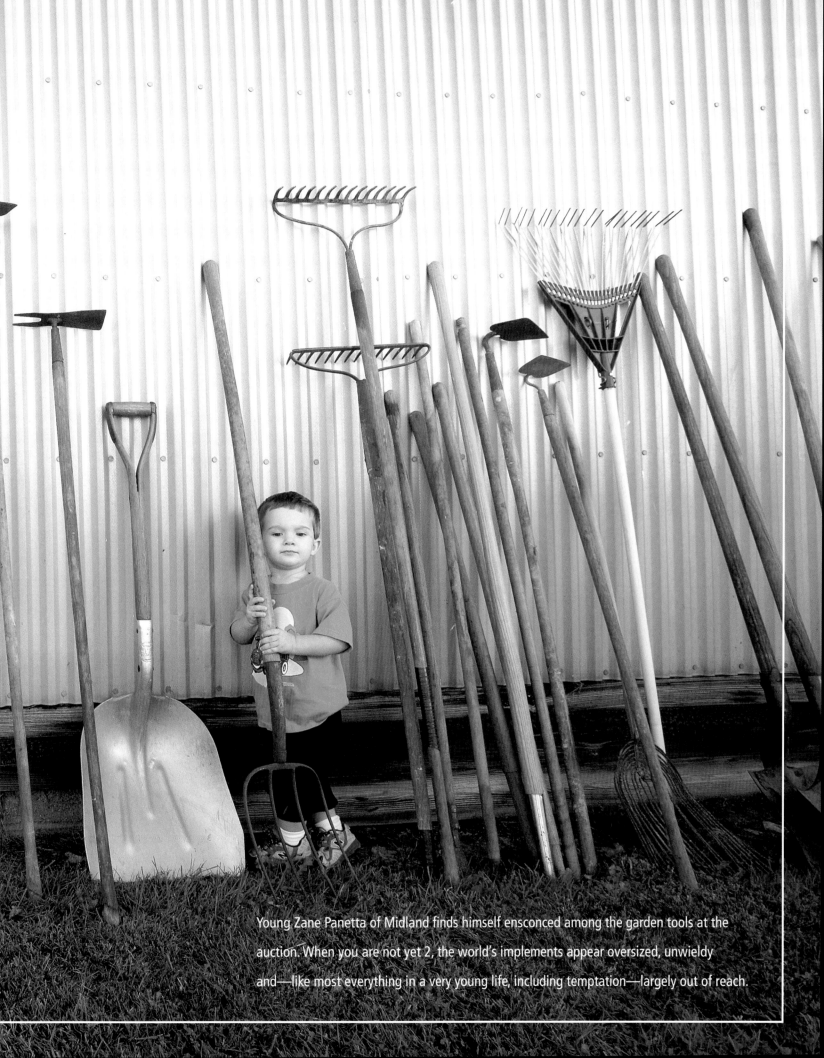

Young Zane Panetta of Midland finds himself ensconced among the garden tools at the auction. When you are not yet 2, the world's implements appear oversized, unwieldy and—like most everything in a very young life, including temptation—largely out of reach.

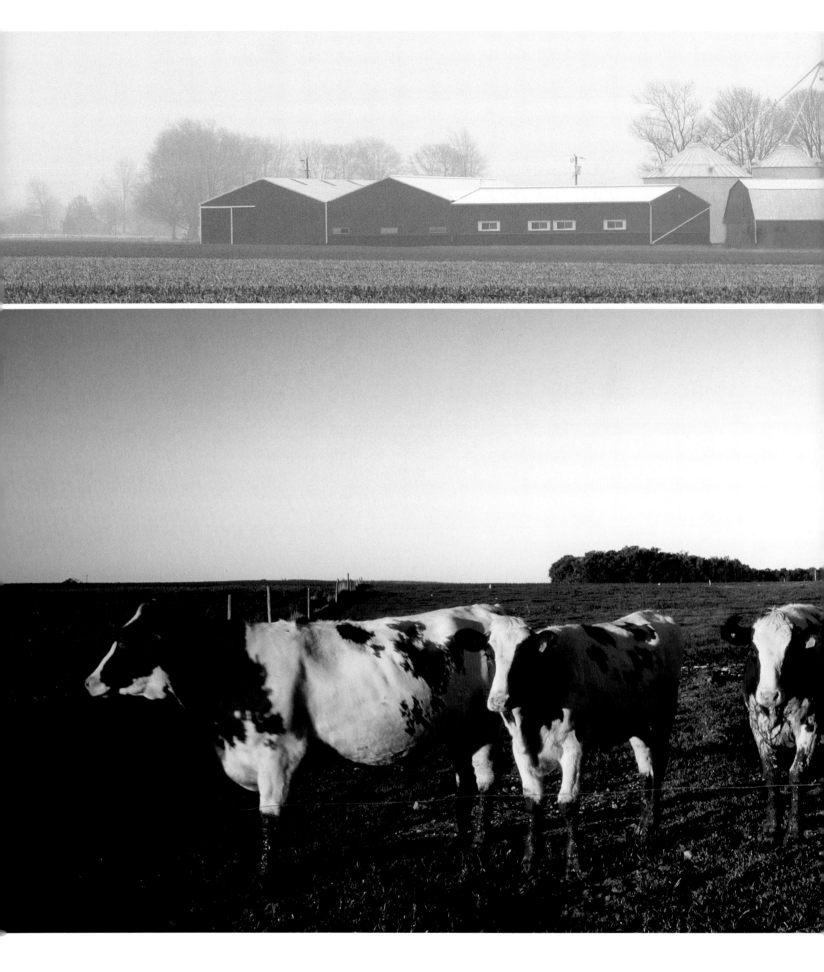

what are you lookin' at!

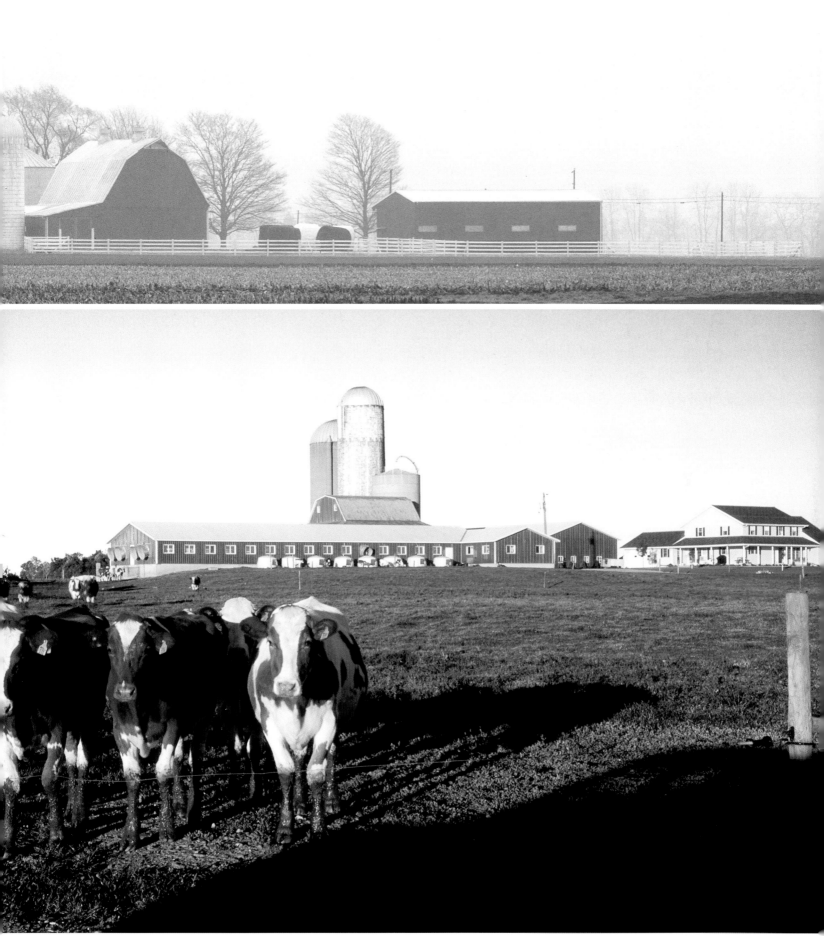

Here's more of the county's rural topography—John and Joy Settlemyre's farm on SR350 near Cowan Lake, and the Stoltzfus dairy on Morris Road, near Sabina. They're two of the county's more picturesque rural operations.

not all barns are red.

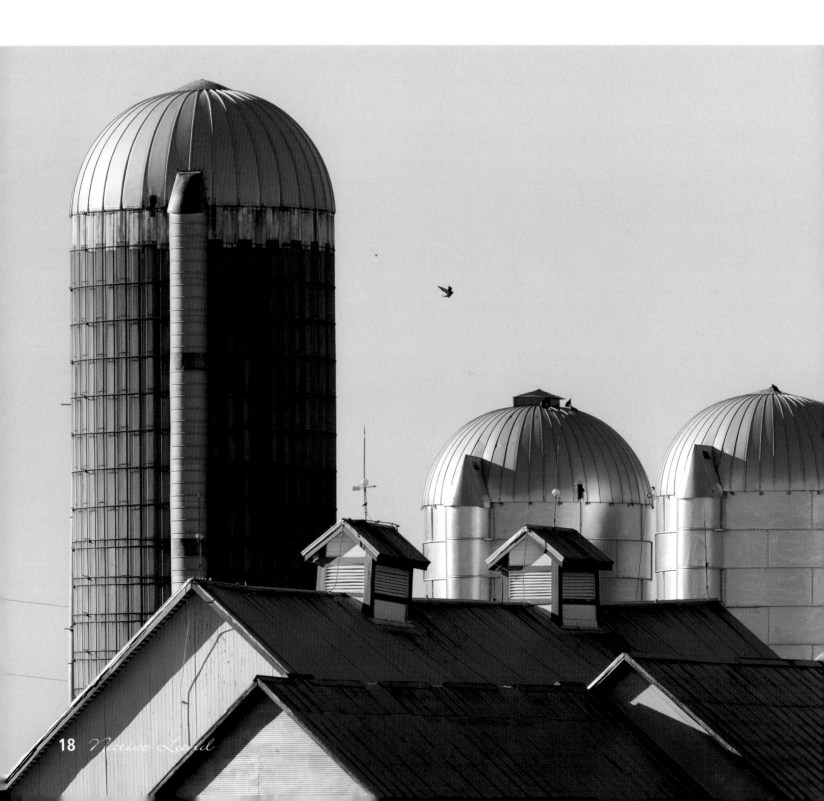

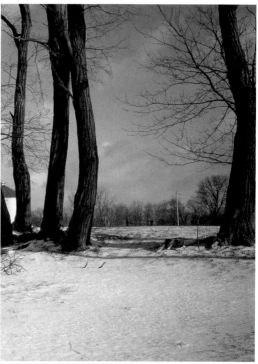

In the county, the old barns still hold on. When Andy Wilson ran the old First National Bank, he would not approve a farm loan until he'd checked the applicant's barn. If the house was in better repair than the barn, Andy turned down the loan. Once, things worked that way.

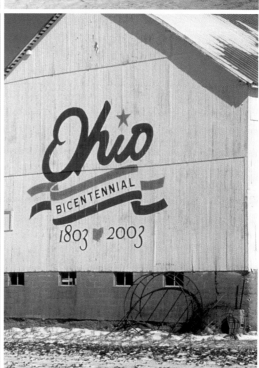

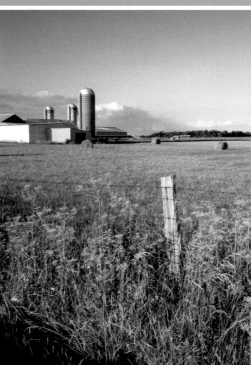

Picturesque places: Left, the farm of David and Andrea Harner on SR729 near the intersection of Antioch Road; top, the Burdett Hunter farm, west of Martinsville; right, the bicentennial barn on New Oglesbee Road, now owned by Dick and Judy Bracht; and at bottom, the Baldino farm on SR380, south of SR73.

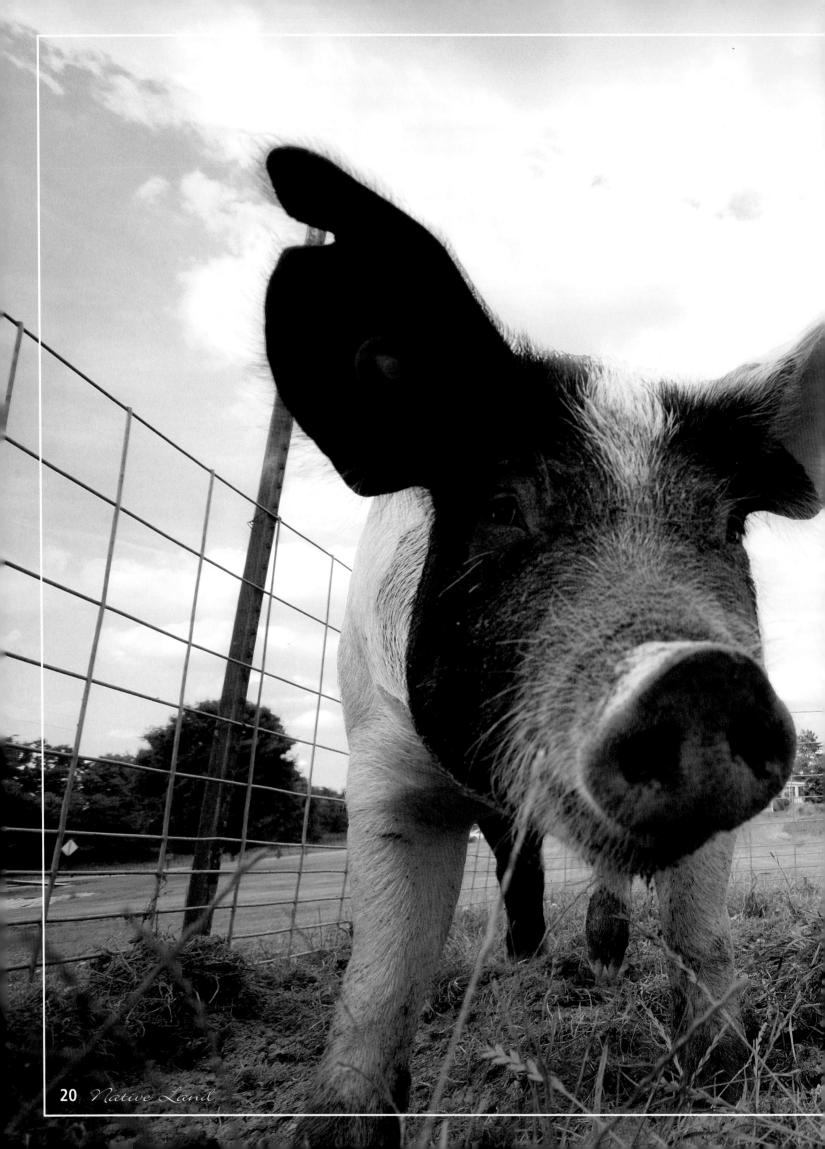

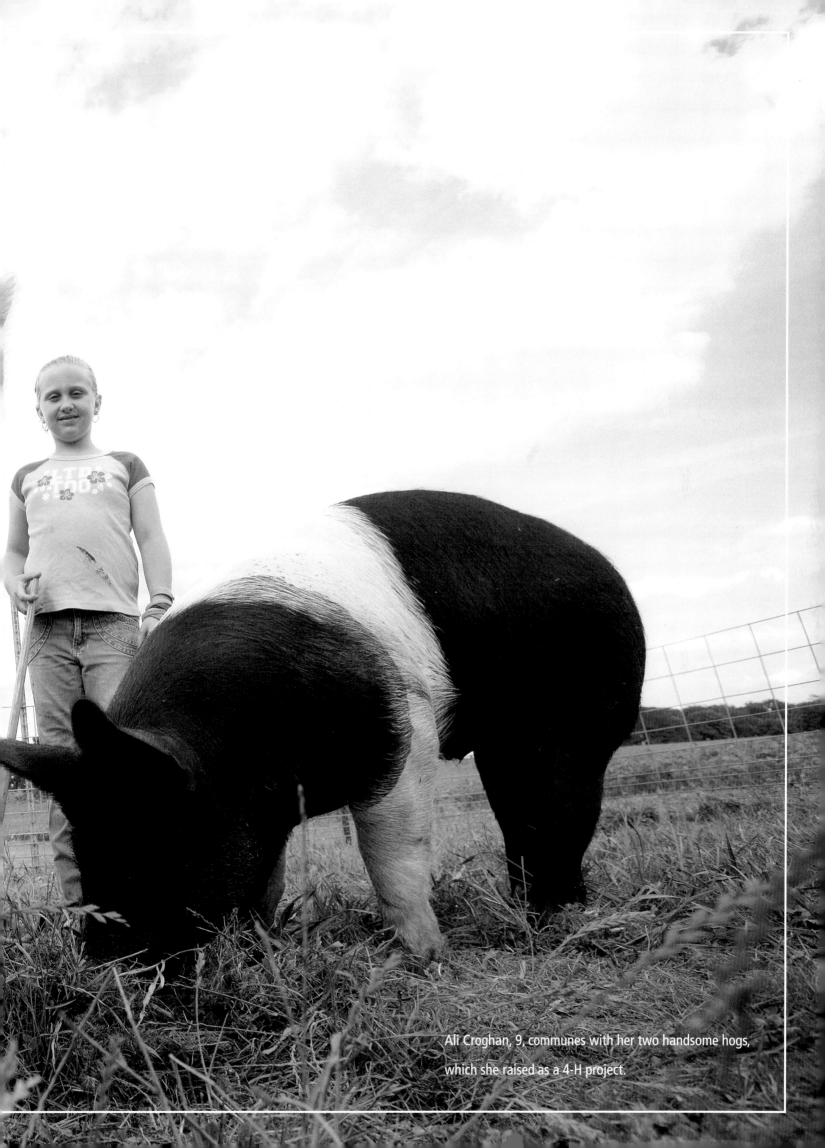

Ali Croghan, 9, communes with her two handsome hogs, which she raised as a 4-H project.

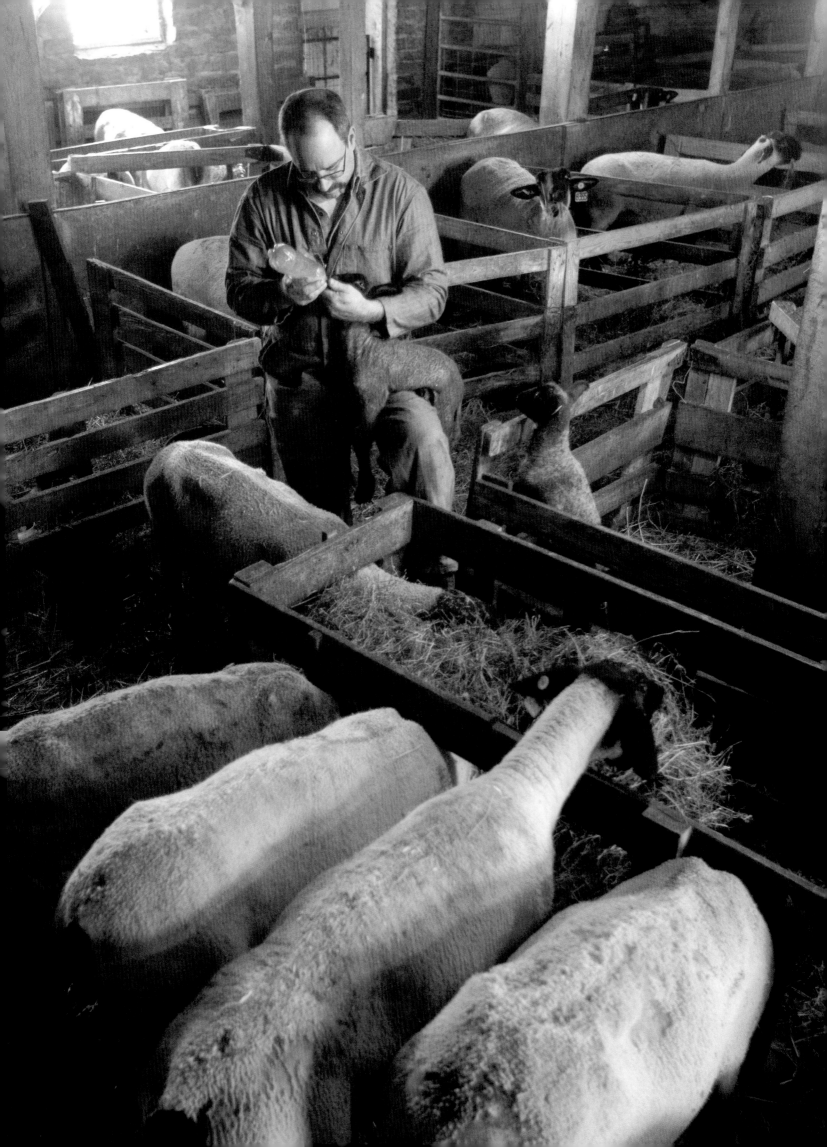

Here's the story. Mothers certainly know it, and so do sheep farmers. Human babies and baby lambs alike are born when they are ready, not when it's convenient. So when Roger Achor was called for jury duty during February lambing time, the operation of son Bruce was well underway—some 275 lambs had already been produced and another 125 or so were on the way. No Roger? An appalling prospect.

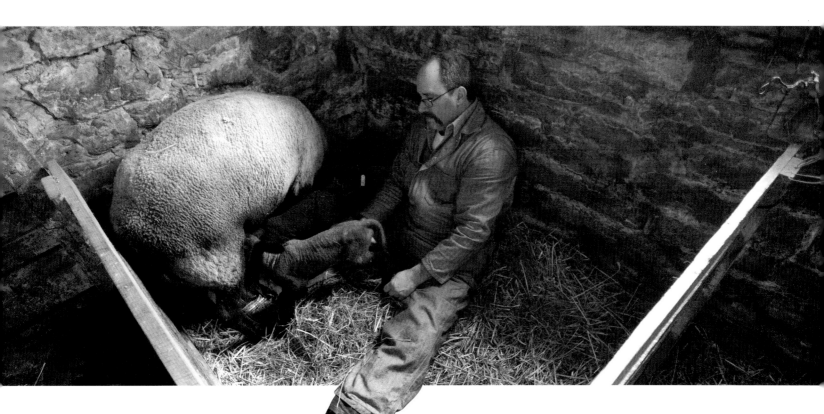

But sometimes, in a place called home, folks understand your situation. So the local court acceded to the Higher Court, and Roger was excused to help Bruce. Now picture how weary Bruce (photographed here after a night in the Achor maternity ward) would have looked if Roger *hadn't* been excused.

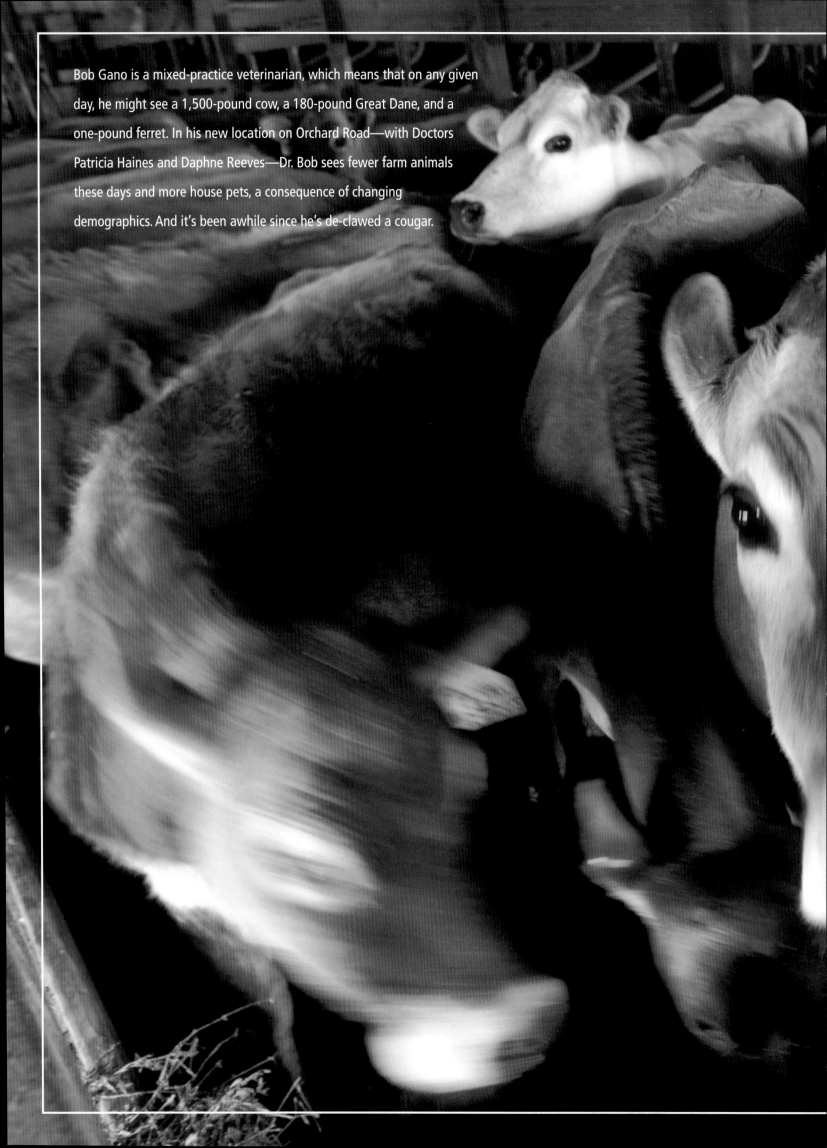

Bob Gano is a mixed-practice veterinarian, which means that on any given day, he might see a 1,500-pound cow, a 180-pound Great Dane, and a one-pound ferret. In his new location on Orchard Road—with Doctors Patricia Haines and Daphne Reeves—Dr. Bob sees fewer farm animals these days and more house pets, a consequence of changing demographics. And it's been awhile since he's de-clawed a cougar.

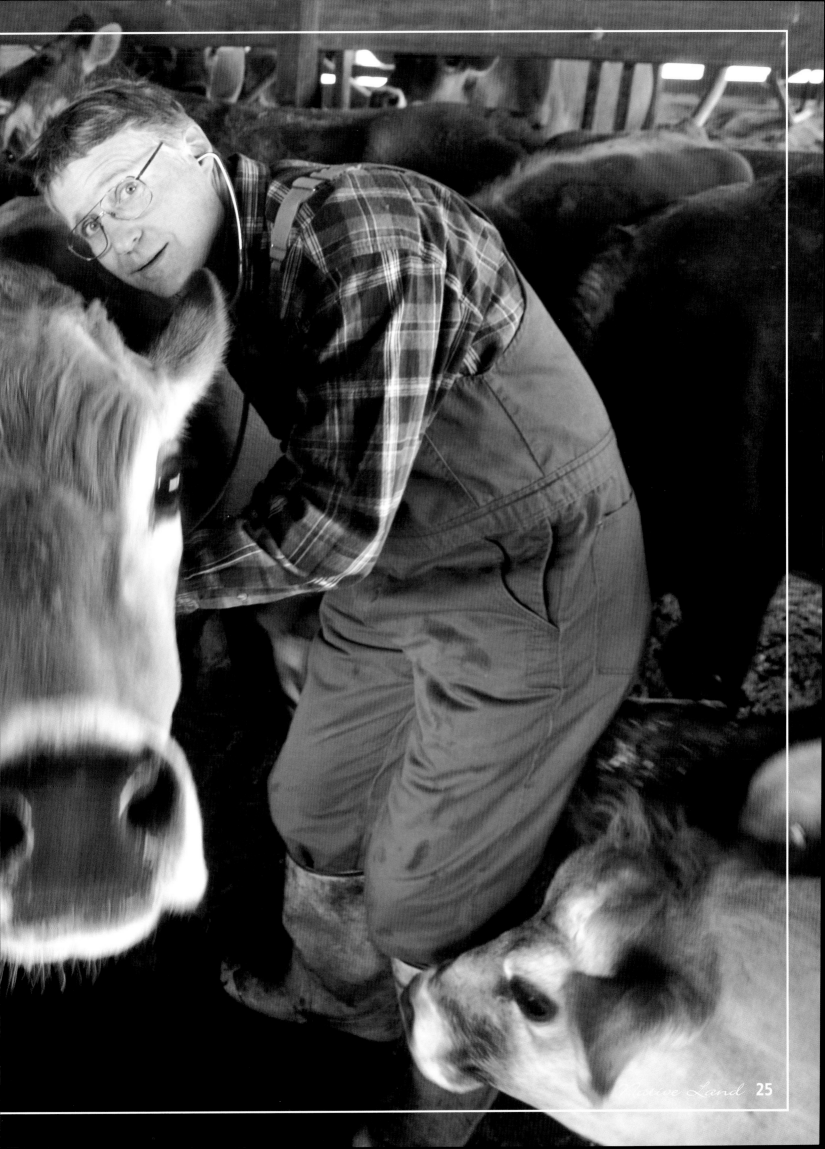

don't forget to clean behind the EARS

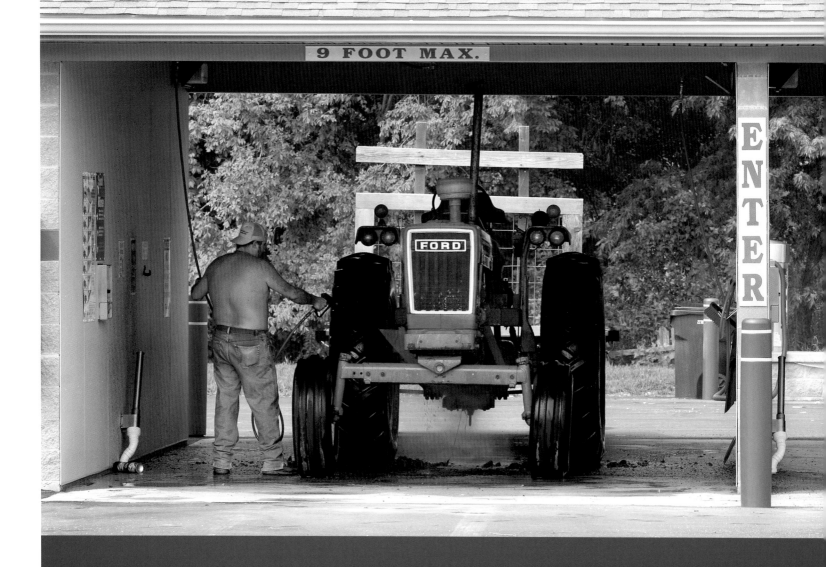

9 FOOT MAX.

FORD

ENTER

Big doings in Clarksville along about July when the car wash fills up—that's Heath McKinley (left) and Perry Powell getting their machinery ready for the Fourth of July Parade. Lots of July-the-Fourths in Clarksville, all the way back to 1837, when the place was incorporated. First Clarksvillian was William Smalley.

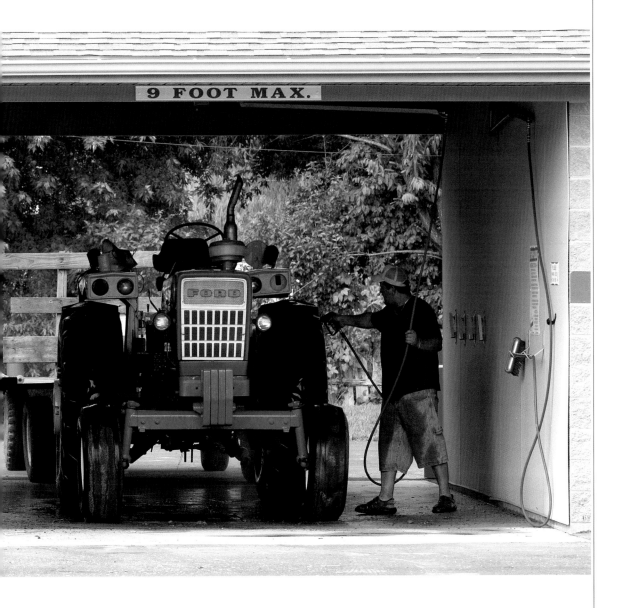

He showed up in 1797 after escaping from some Indians, who marked his ears. Smalley was a take-charge kind of fellow; when a lawyer withheld the deed to his house, he put on his Indian clothes and threatened the lawyer with a tomahawk. He came home with his deed, too.

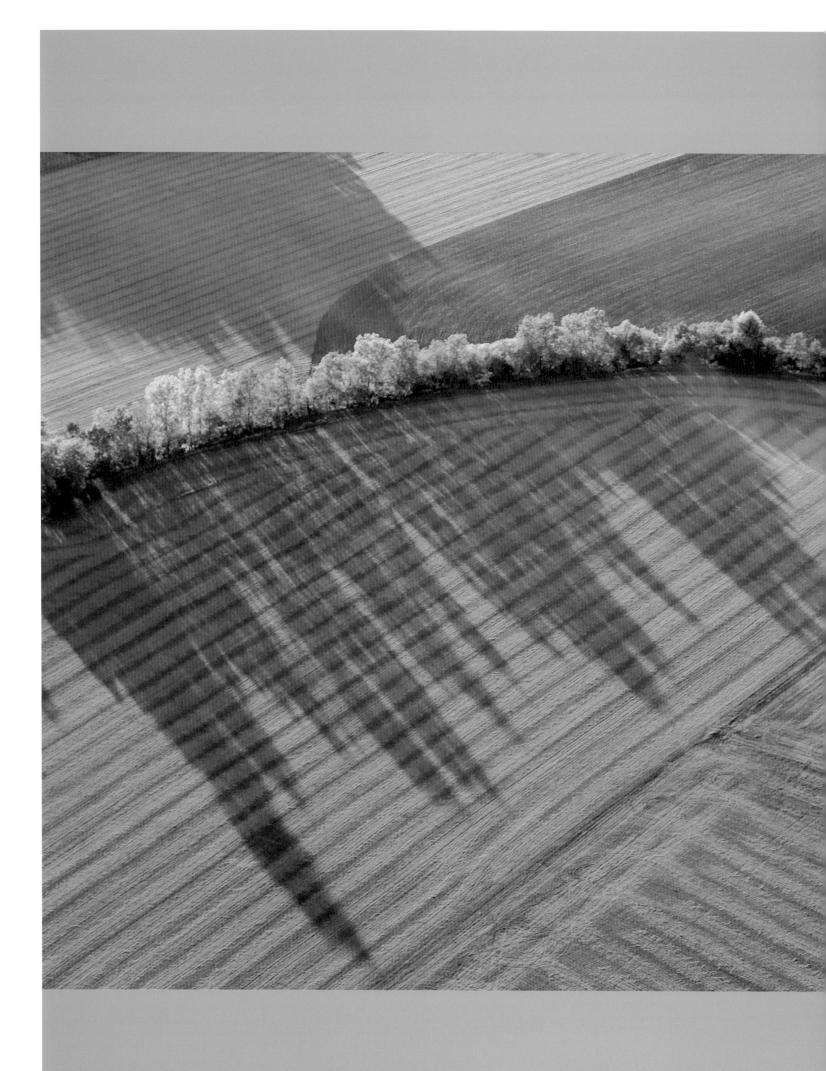

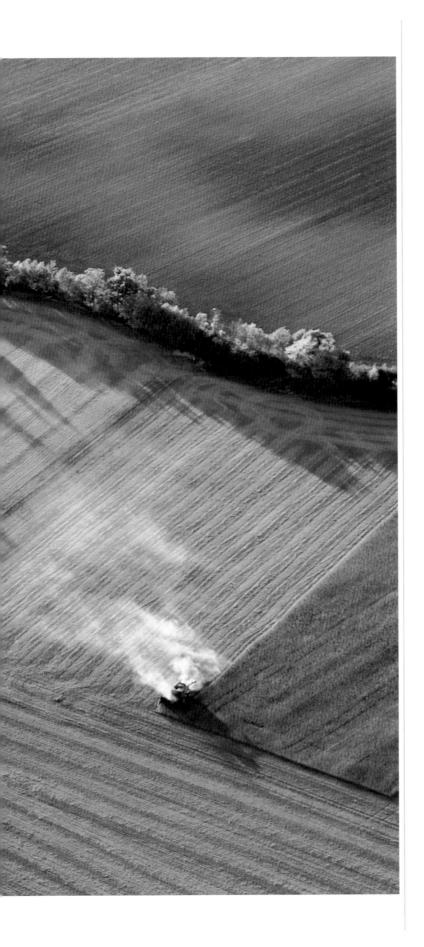

It starts with, say, Charles Borton (below) planting soybeans on a muggy late spring evening along Nelson Road. It concludes with something such as the scene at left, a combine snuffling its way across similar fields (the ones here being somewhere around Stone and Melvin Roads). The bird's eye view of the process is instructive, for it

shows the symmetry of even the managed landscape. The farmer lives close to the ground, though, where things are messier: the various failures of everything from his equipment to his lunch. From the view on high, one sees only the flawless progress of man and machine. It's a good view, one he *needs*.

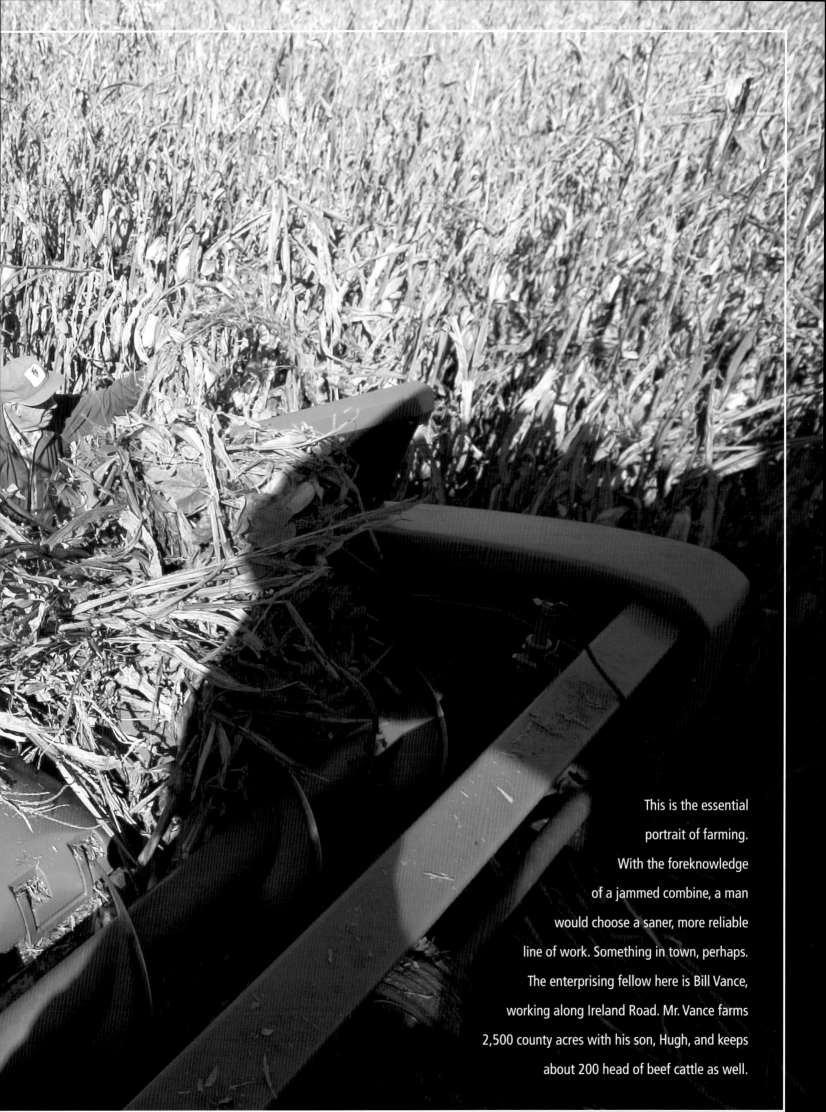

This is the essential
portrait of farming.
With the foreknowledge
of a jammed combine, a man
would choose a saner, more reliable
line of work. Something in town, perhaps.
The enterprising fellow here is Bill Vance,
working along Ireland Road. Mr. Vance farms
2,500 county acres with his son, Hugh, and keeps
about 200 head of beef cattle as well.

Ocean of Corn

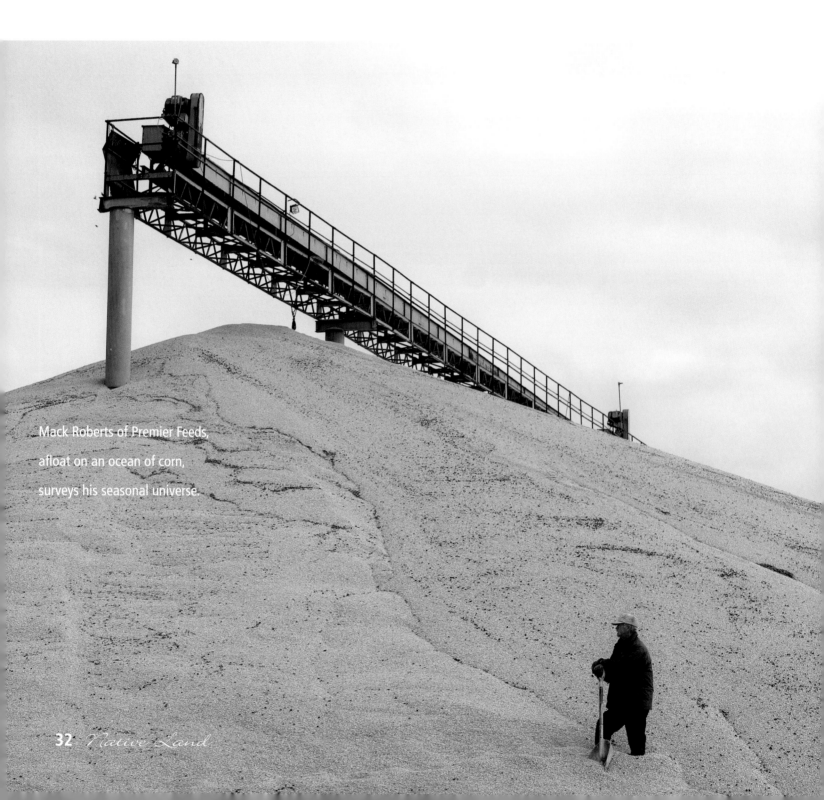

Mack Roberts of Premier Feeds, afloat on an ocean of corn, surveys his seasonal universe.

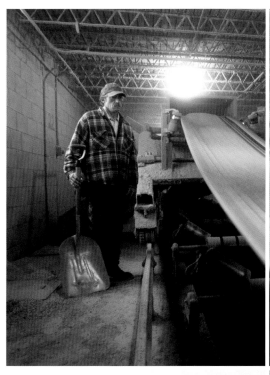

The colors of the season seem to be elsewhere when you work at the local elevators (Landmark, at left, or Clarksville, below). Nothing remains but the subdued yellows of the grain itself. Even the skies grow duller, as if the atmosphere were augmented by some residue of crops drifting heavenward.

In 2004, the storage area at Melvin was nearly two football fields in length. The pile of grain was probably 70 feet at its apex—maybe the highest hill in Clinton County. It represented about 1.8 million bushels, the biggest concentration of corn in Clinton County. And several counties around, as well.

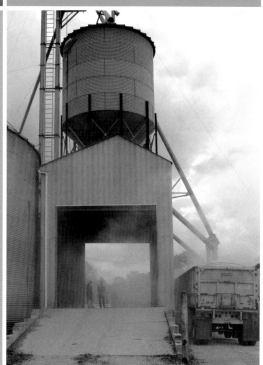

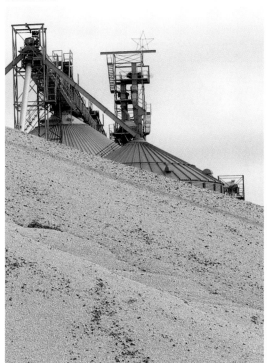

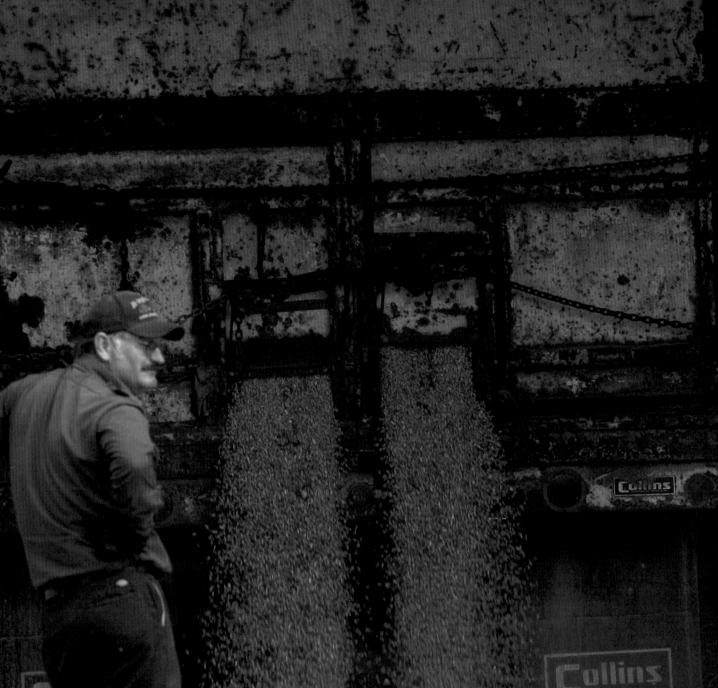

Donald Watson takes a seasonal breather on an overcast *Autumn* afternoon at the Sabina Farmers Exchange.

Craig Davis is having himself a pensive late fall *Moment* at Jim Parker's Clarksville AG Service.

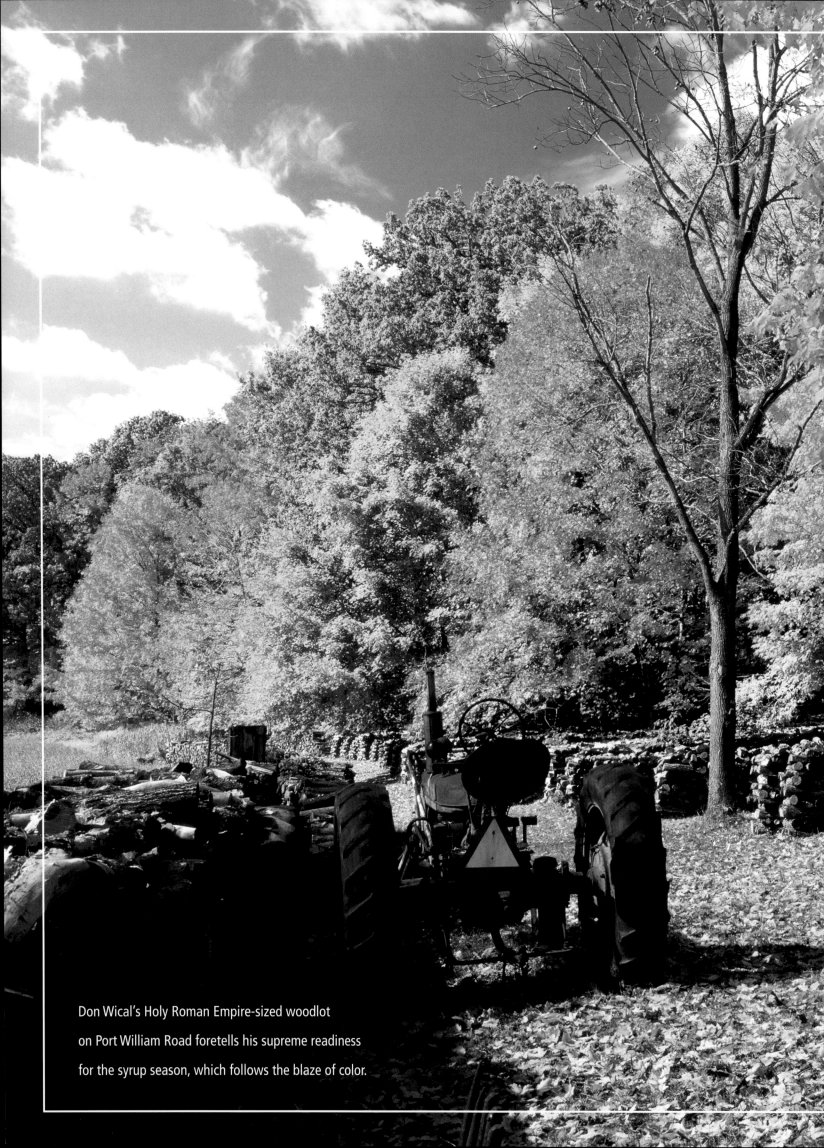

Don Wical's Holy Roman Empire-sized woodlot
on Port William Road foretells his supreme readiness
for the syrup season, which follows the blaze of color.

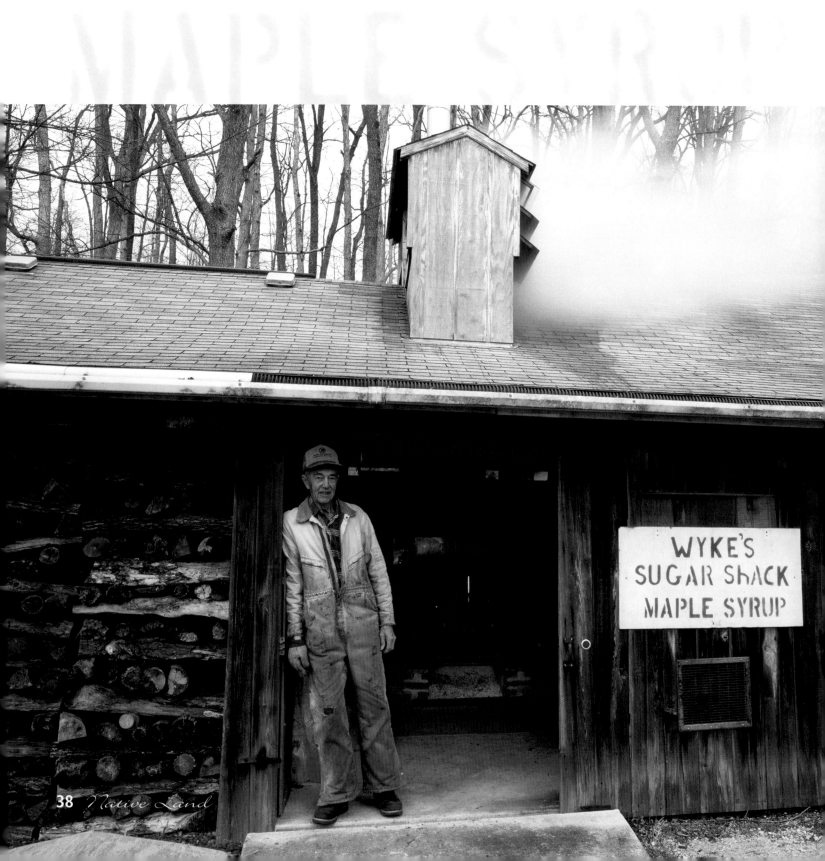

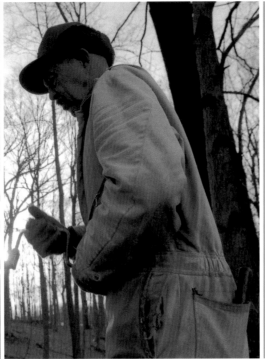

It seems a grand romance to the city folks, who drive out in the breaking up of winter, looking for real maple syrup. But ask the few remaining artisans, like the Wicals, what it's like when the water's been boiling for two days and a night, with no relief in sight.

Look closely in the remaining maple groves around the county and you might still be able to find a few clinging remnants of sugar shacks like that of Mr. Wical. Once, nearly every farm had one. Today, a functioning sugar house is about as rare as a Democrat in the county courthouse.

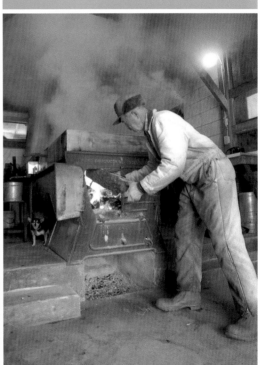

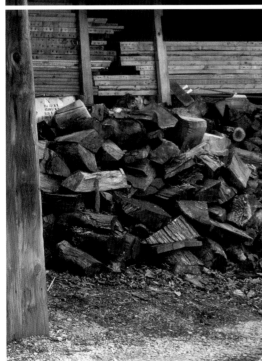

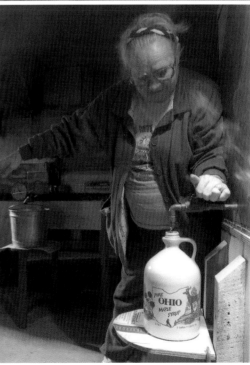

T H E H U M A N

"The heat was another presence in those summers," wrote our resident essayist. "It was like a taciturn relative we accommodated. We moved over a bit, and down one at the table, and that was pretty much that..." So here is summer in the county (from left): The park caterpillar was built by Bill Shafer, Cris Potter's grandfather, when he worked at Champion Bridge. That's Cris and Yolanda, with Kayla Hall, age 6. Then, a display of the best way to spend August, when the humidity causes the mosquitoes to stick together. That's Cowan Lake Beach. At 700 acres, Cowan is quite a pool. (Clockwise from lower left: Amber Brewer, Erin Hoff, Jeffrey Wiesman, and Brittany Hoff.) That's the scenery at a Lumberton campout with the offspring of photographer Ty Greenlees and wife—Claire and Avery. And behind it all July 4th in the park, a tradition featuring pyrotechnics and a cast of thousands.

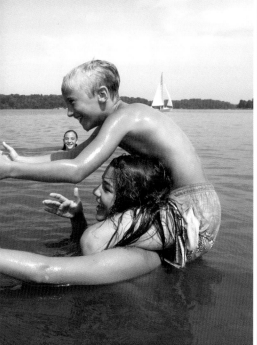

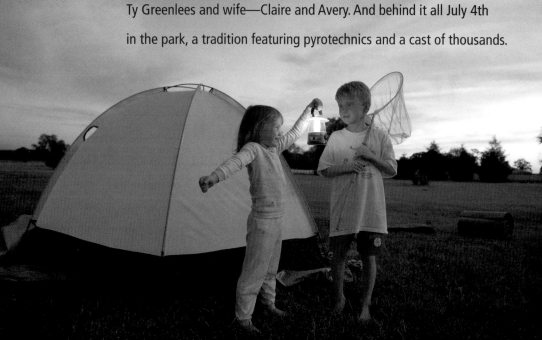

C O N D I T I O N

Downhill

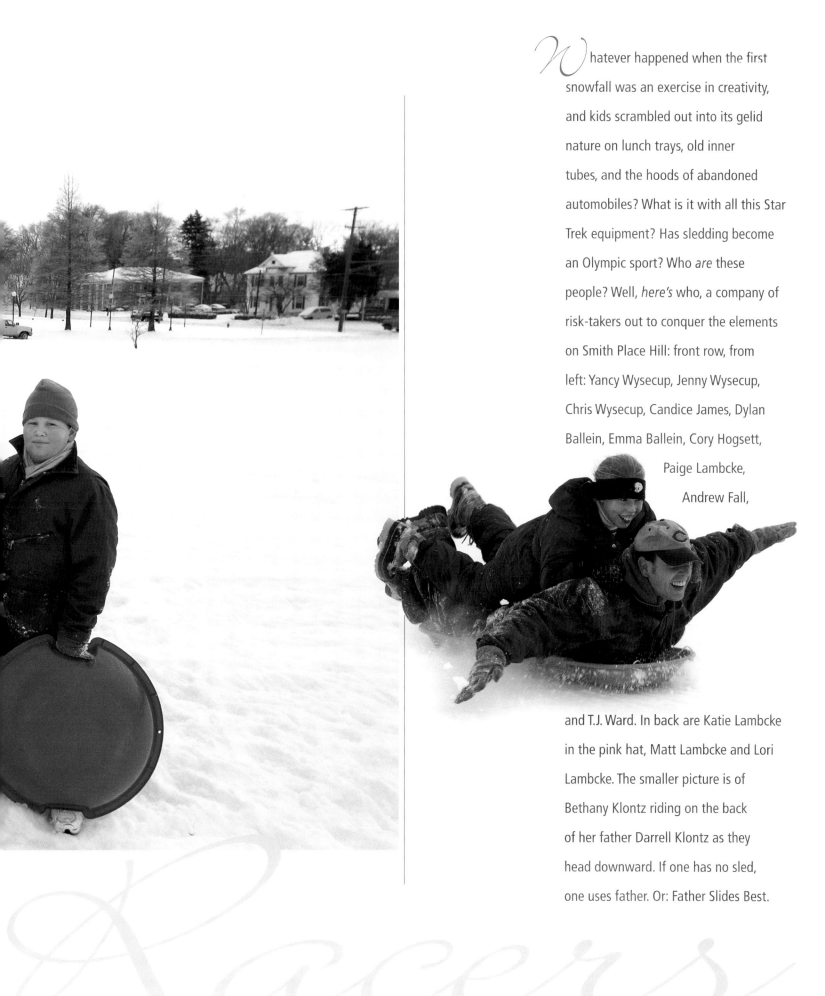

Whatever happened when the first snowfall was an exercise in creativity, and kids scrambled out into its gelid nature on lunch trays, old inner tubes, and the hoods of abandoned automobiles? What is it with all this Star Trek equipment? Has sledding become an Olympic sport? Who *are* these people? Well, *here's* who, a company of risk-takers out to conquer the elements on Smith Place Hill: front row, from left: Yancy Wysecup, Jenny Wysecup, Chris Wysecup, Candice James, Dylan Ballein, Emma Ballein, Cory Hogsett, Paige Lambcke, Andrew Fall, and T.J. Ward. In back are Katie Lambcke in the pink hat, Matt Lambcke and Lori Lambcke. The smaller picture is of Bethany Klontz riding on the back of her father Darrell Klontz as they head downward. If one has no sled, one uses father. Or: Father Slides Best.

Racers

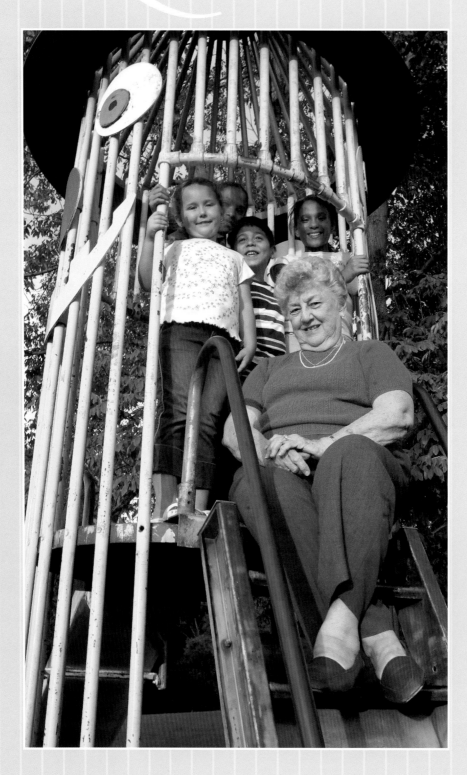

For decades, Elizabeth Williams was our most generous citizen and one of the best-loved locals. Her charities ranged from the college to the National Theatre of the Deaf, which she brought here at great expense to play before tiny audiences. The rest of us didn't know what we were missing. Now we all miss *her*. With her are, from left, Sydney Shumaker, Elexis Murdock, young boy from Chicago, and Ciara Murdock.

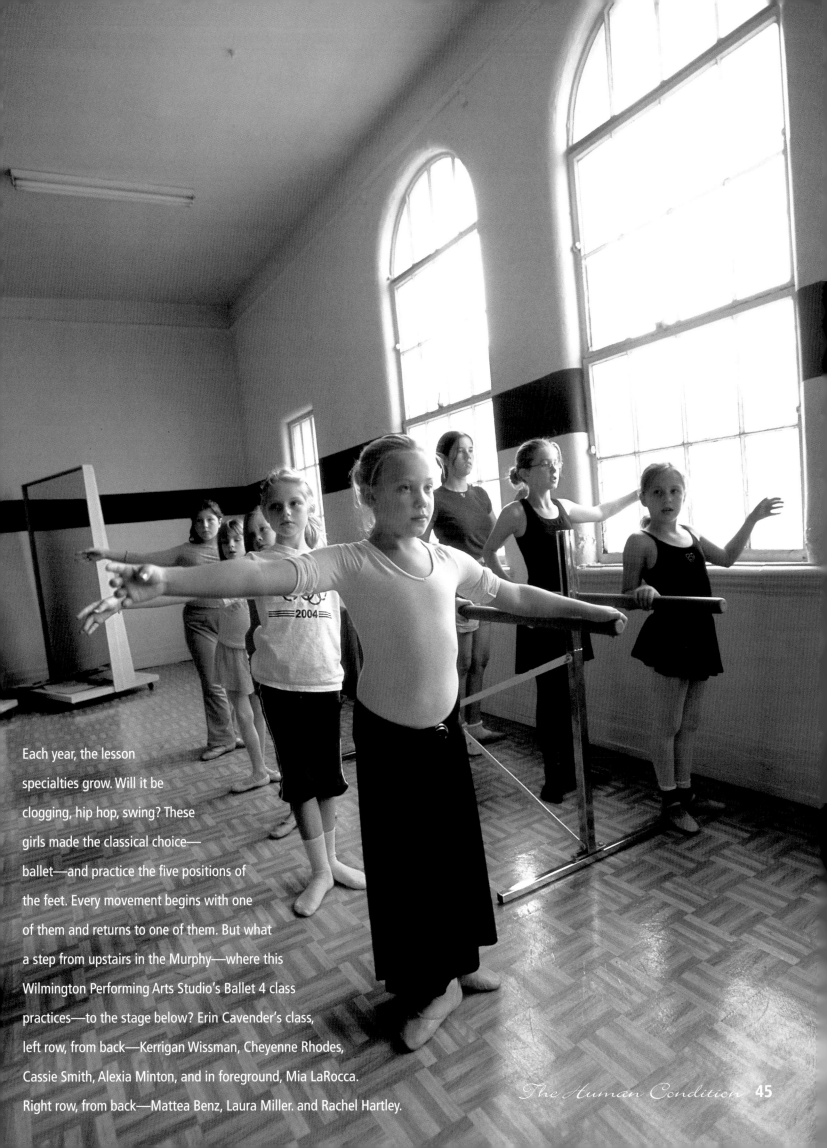

Each year, the lesson specialties grow. Will it be clogging, hip hop, swing? These girls made the classical choice—ballet—and practice the five positions of the feet. Every movement begins with one of them and returns to one of them. But what a step from upstairs in the Murphy—where this Wilmington Performing Arts Studio's Ballet 4 class practices—to the stage below? Erin Cavender's class, left row, from back—Kerrigan Wissman, Cheyenne Rhodes, Cassie Smith, Alexia Minton, and in foreground, Mia LaRocca. Right row, from back—Mattea Benz, Laura Miller. and Rachel Hartley.

Lady Like

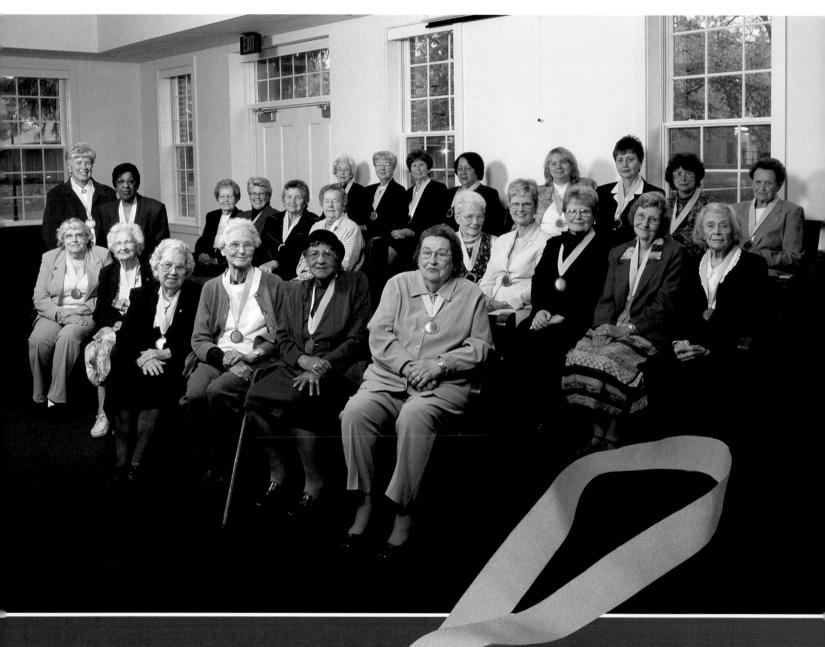

OUTSTANDING

Behind every good county is a collection of unsung heroines whose altruism, strength, wit, and brains generally go unnoticed. Not anymore. Each year since 2000, five or six are honored with flowers, medallions, and a laundry list of their accomplishments, from the volunteer who created our city bike trails to a doctor who delivered our local population now using them. *(See page 254.)*

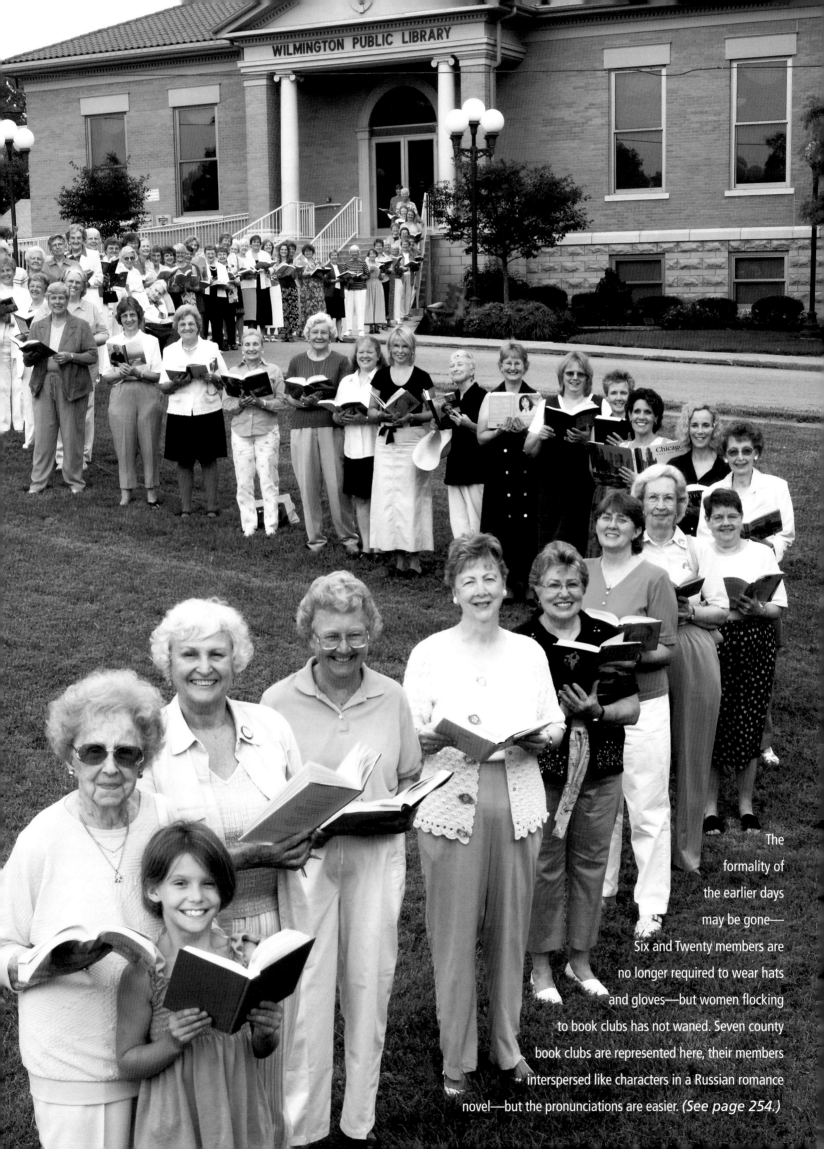

WILMINGTON PUBLIC LIBRARY

The formality of the earlier days may be gone—Six and Twenty members are no longer required to wear hats and gloves—but women flocking to book clubs has not waned. Seven county book clubs are represented here, their members interspersed like characters in a Russian romance novel—but the pronunciations are easier. *(See page 254.)*

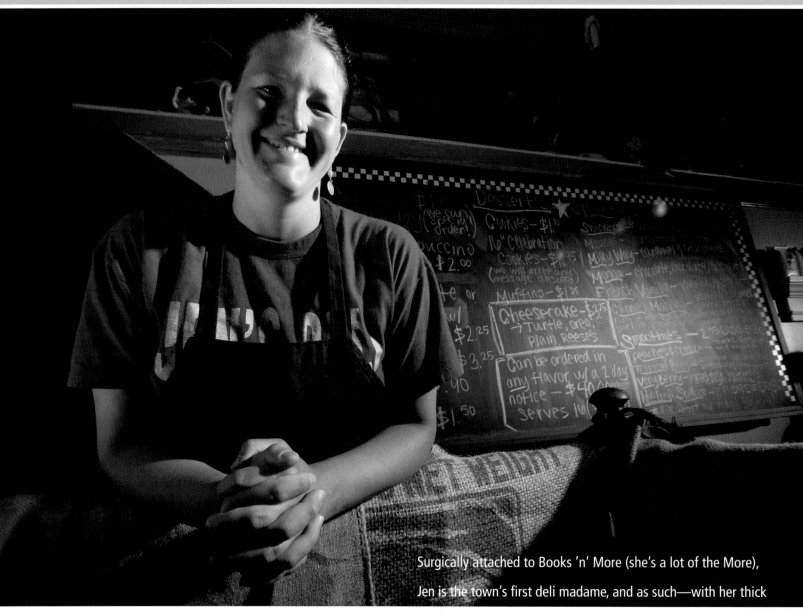

Surgically attached to Books 'n' More (she's a lot of the More), Jen is the town's first deli madame, and as such—with her thick sandwiches, coffee bar, and strange tee-shirts—she's now a local institution. She's also believed to preside over the only known American deli where one can purchase a skateboard.

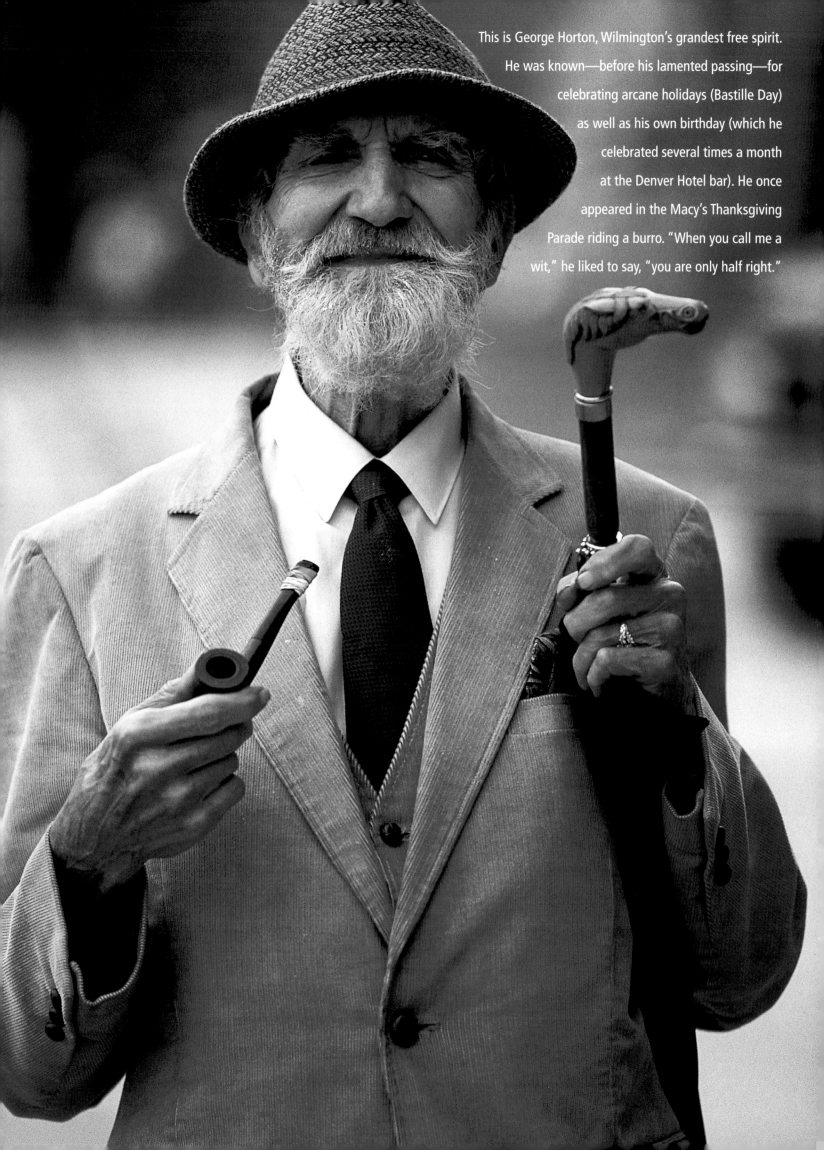

This is George Horton, Wilmington's grandest free spirit. He was known—before his lamented passing—for celebrating arcane holidays (Bastille Day) as well as his own birthday (which he celebrated several times a month at the Denver Hotel bar). He once appeared in the Macy's Thanksgiving Parade riding a burro. "When you call me a wit," he liked to say, "you are only half right."

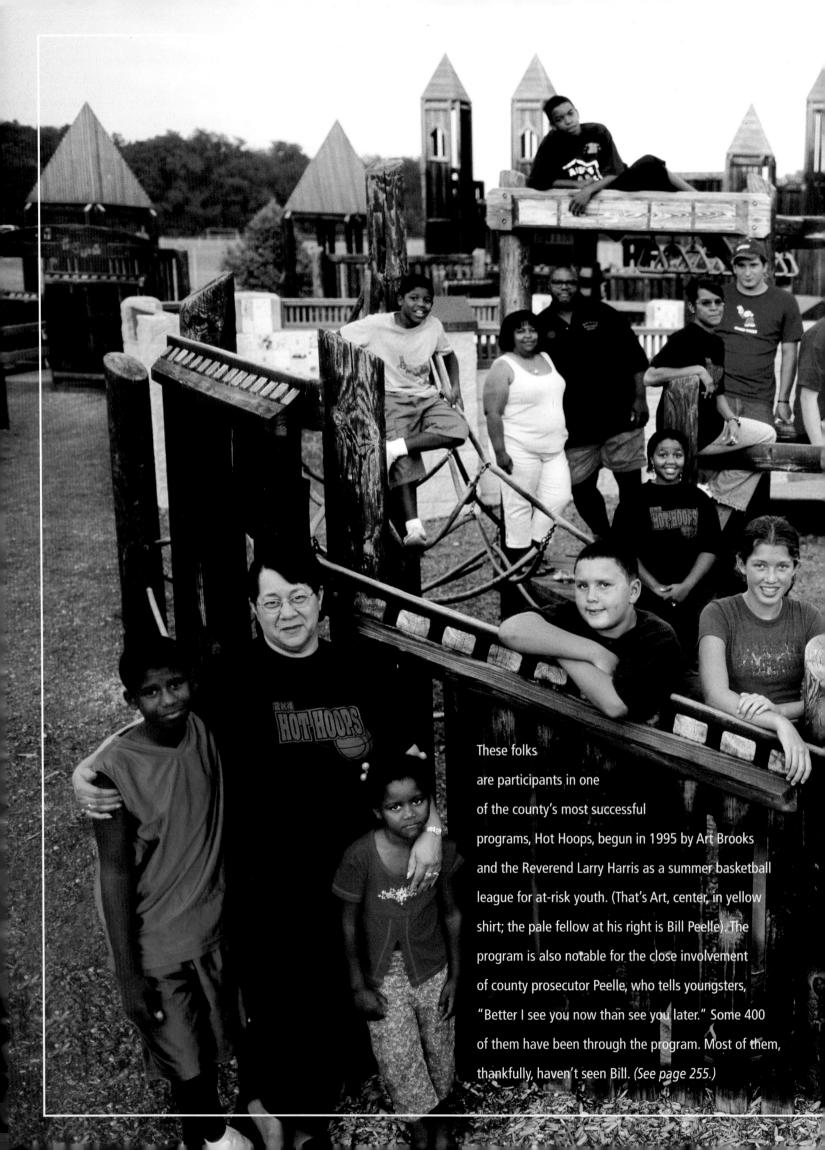

These folks are participants in one of the county's most successful programs, Hot Hoops, begun in 1995 by Art Brooks and the Reverend Larry Harris as a summer basketball league for at-risk youth. (That's Art, center, in yellow shirt; the pale fellow at his right is Bill Peelle). The program is also notable for the close involvement of county prosecutor Peelle, who tells youngsters, "Better I see you now than see you later." Some 400 of them have been through the program. Most of them, thankfully, haven't seen Bill. (See page 255.)

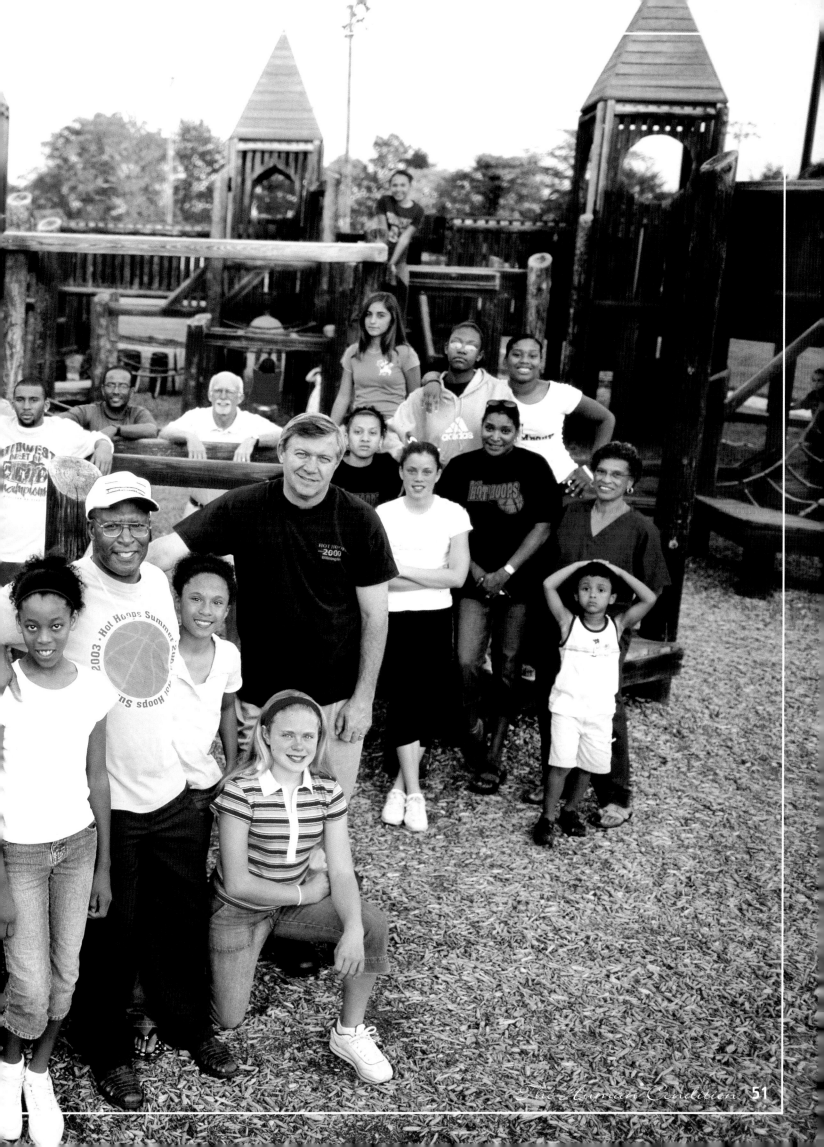

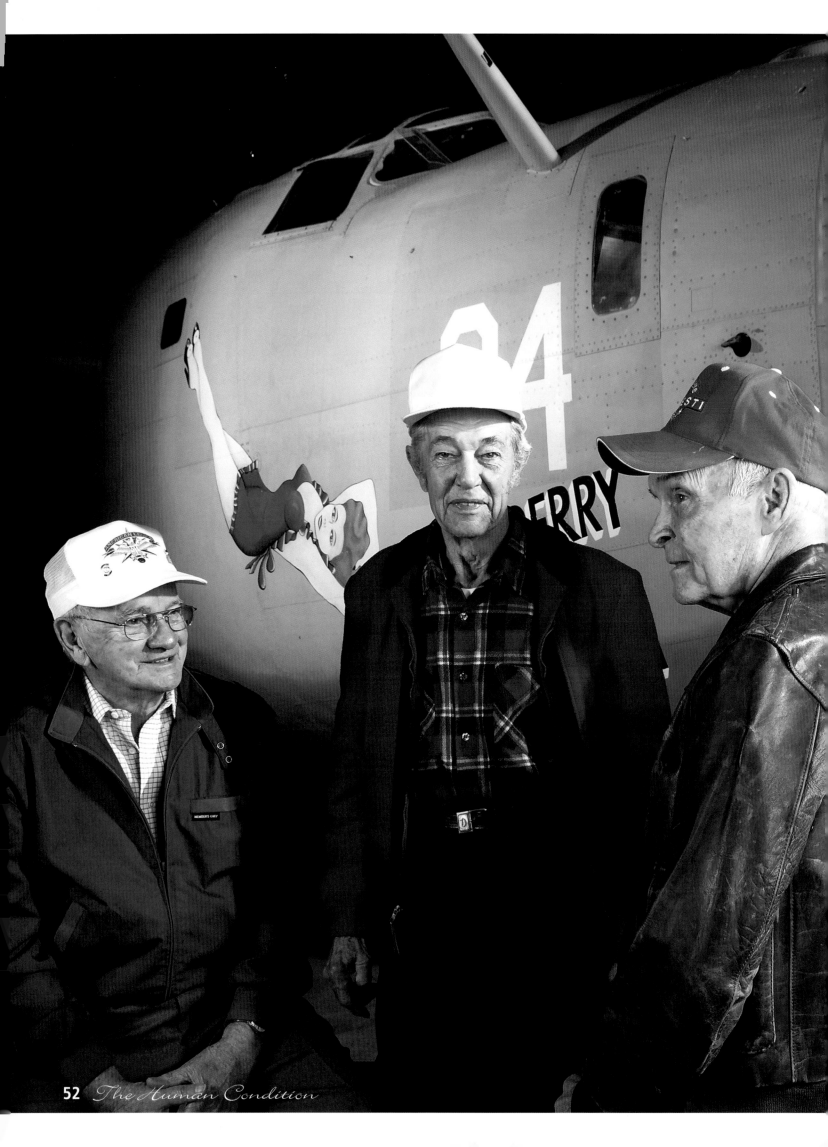

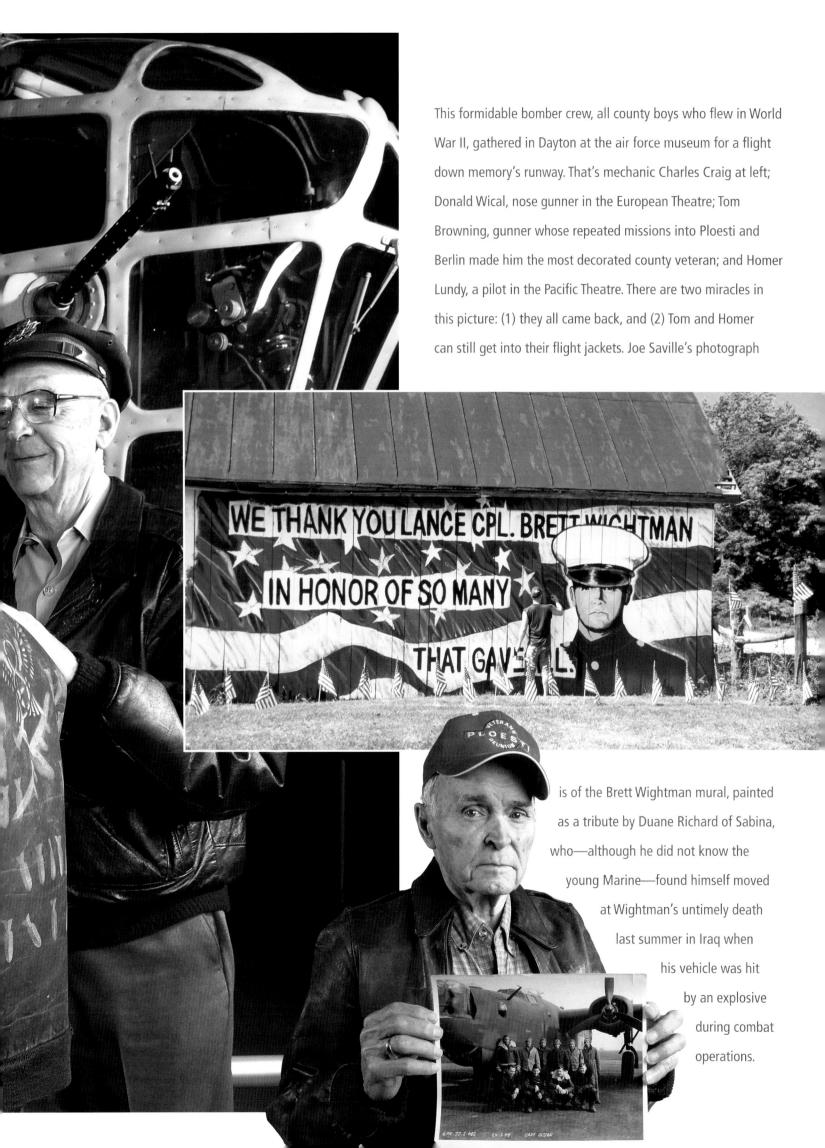

This formidable bomber crew, all county boys who flew in World War II, gathered in Dayton at the air force museum for a flight down memory's runway. That's mechanic Charles Craig at left; Donald Wical, nose gunner in the European Theatre; Tom Browning, gunner whose repeated missions into Ploesti and Berlin made him the most decorated county veteran; and Homer Lundy, a pilot in the Pacific Theatre. There are two miracles in this picture: (1) they all came back, and (2) Tom and Homer can still get into their flight jackets. Joe Saville's photograph

WE THANK YOU LANCE CPL. BRETT WIGHTMAN
IN HONOR OF SO MANY
THAT GAVE ALL.

is of the Brett Wightman mural, painted as a tribute by Duane Richard of Sabina, who—although he did not know the young Marine—found himself moved at Wightman's untimely death last summer in Iraq when his vehicle was hit by an explosive during combat operations.

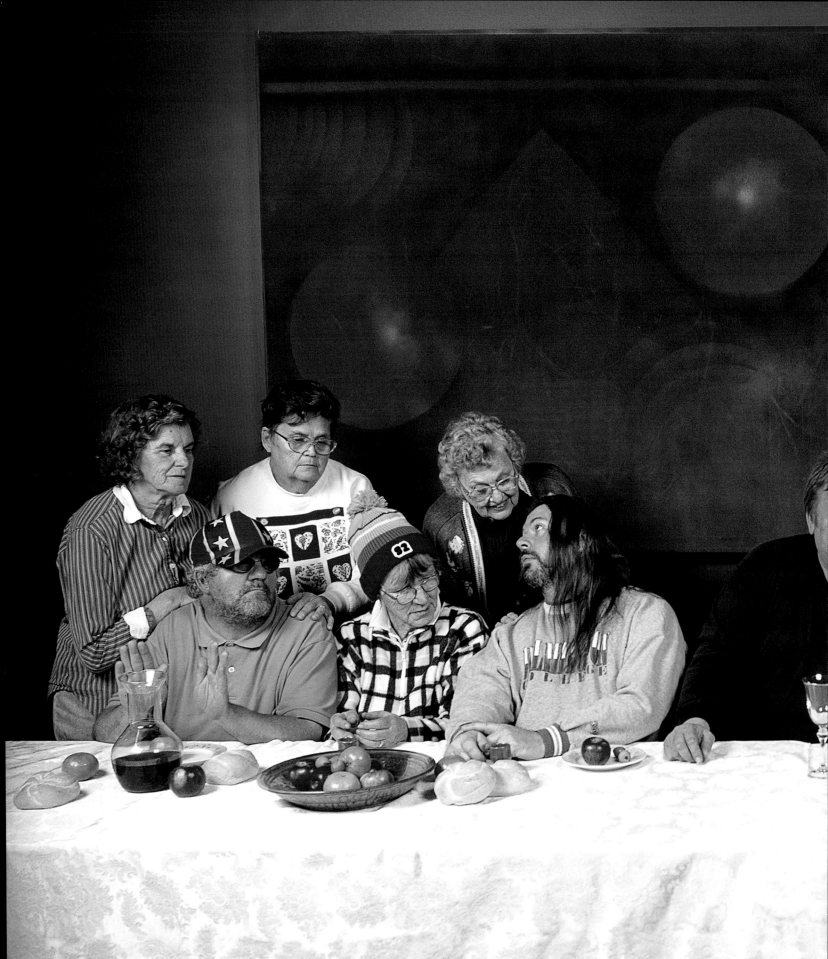

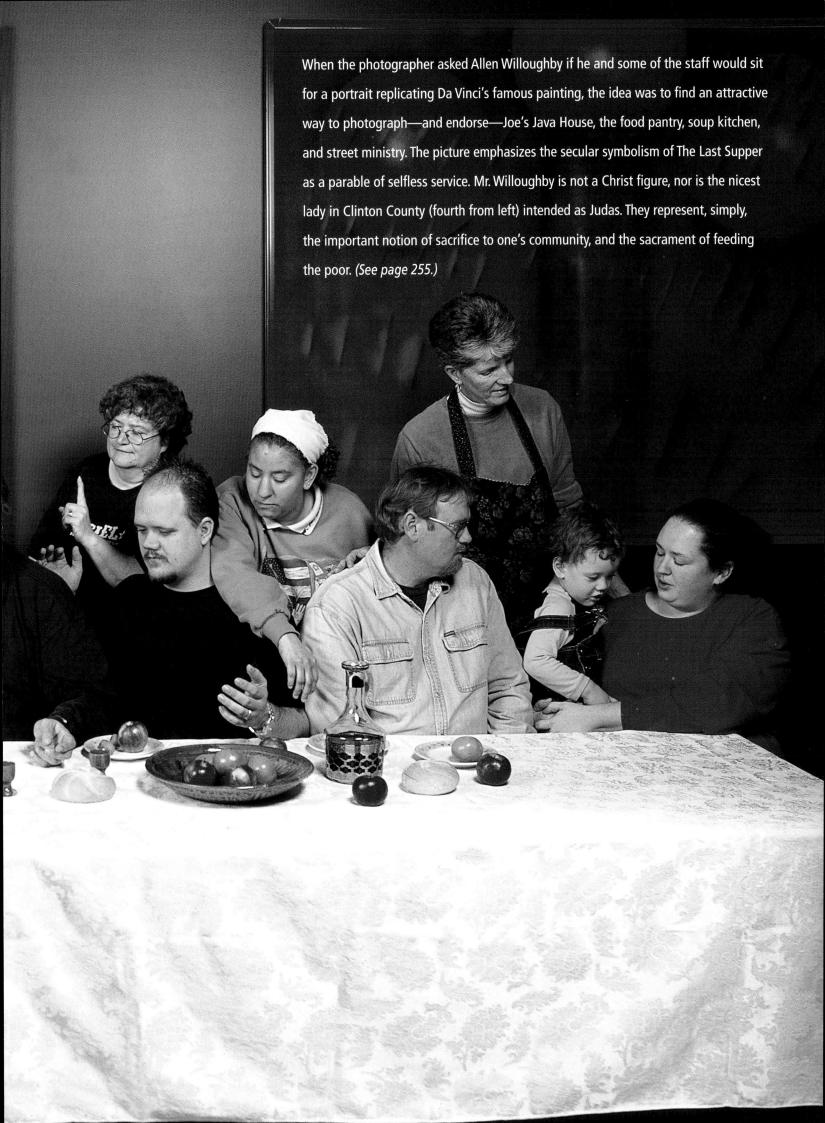

When the photographer asked Allen Willoughby if he and some of the staff would sit for a portrait replicating Da Vinci's famous painting, the idea was to find an attractive way to photograph—and endorse—Joe's Java House, the food pantry, soup kitchen, and street ministry. The picture emphasizes the secular symbolism of The Last Supper as a parable of selfless service. Mr. Willoughby is not a Christ figure, nor is the nicest lady in Clinton County (fourth from left) intended as Judas. They represent, simply, the important notion of sacrifice to one's community, and the sacrament of feeding the poor. (See page 255.)

The World's a Stage

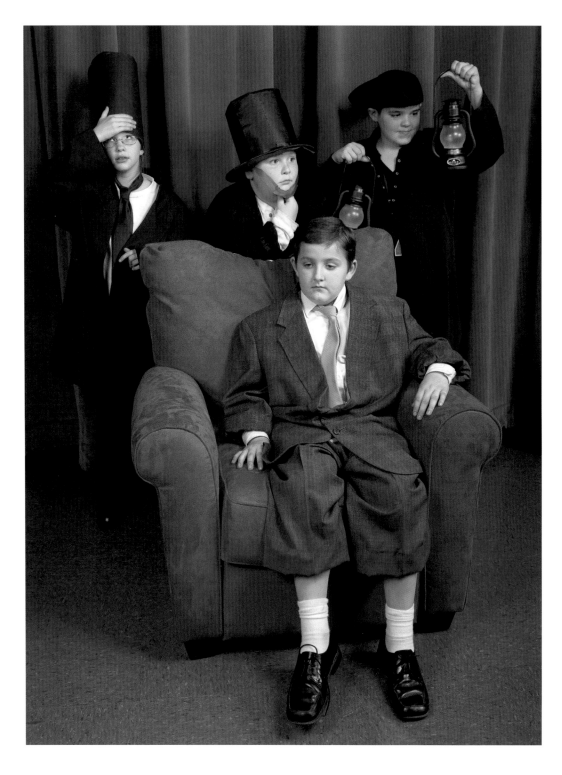

The Putnam Elementary Wax Museum, in which students become historical figures,

has been an annual feature at Putnam for most of a decade.

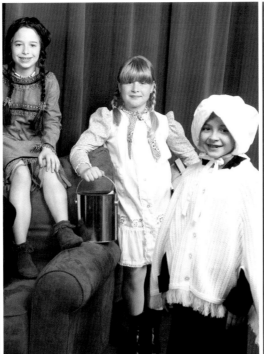

At left—Jordan Greene (Annie Oakley), Abigail Gundler (Hawaiian Princess), Kaleb McDaniel (Thomas Edison), Cherokee Spiering (Pocahontas), Mackenzie Curless (Laura Ingalls Wilder), and Morgan Swinderman (Harriet Beecher Stowe). Below—Courtney Shaw (Anne Frank), Kyle Speakman (Johnny Appleseed), Alana Florea (Annie Oakley), and in foreground, Kayla Smith (Laura Ingalls Wilder).

At far left—Alex Prichard (Abe Lincoln as freighted with the responsibilities of saving the Union), Craig Young (a pensive Abe Lincoln), Jake Smith (Paul Revere), and, seated, Trevor Fields (John F. Kennedy). Below are Gus Mitchem (Ben Franklin), Adam Furlow (Johnny Appleseed), and Samantha Parker (Pocahontas).

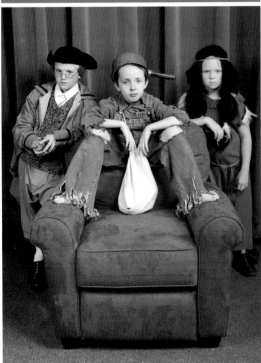

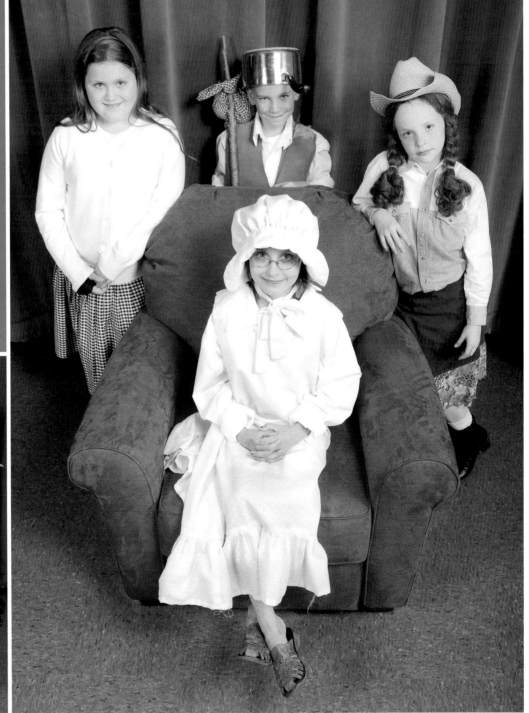

Peterson Place was our first "planned community"—designed in the 1920s with a
landscaped common space. It quickly became the town's prestigious address, which it has
remained. The matriarch in the chair is the late Dorothy Kirk (the foundation for her house
was dug with a team of mules), the guiding spirit of the town library. *(See page 255.)*

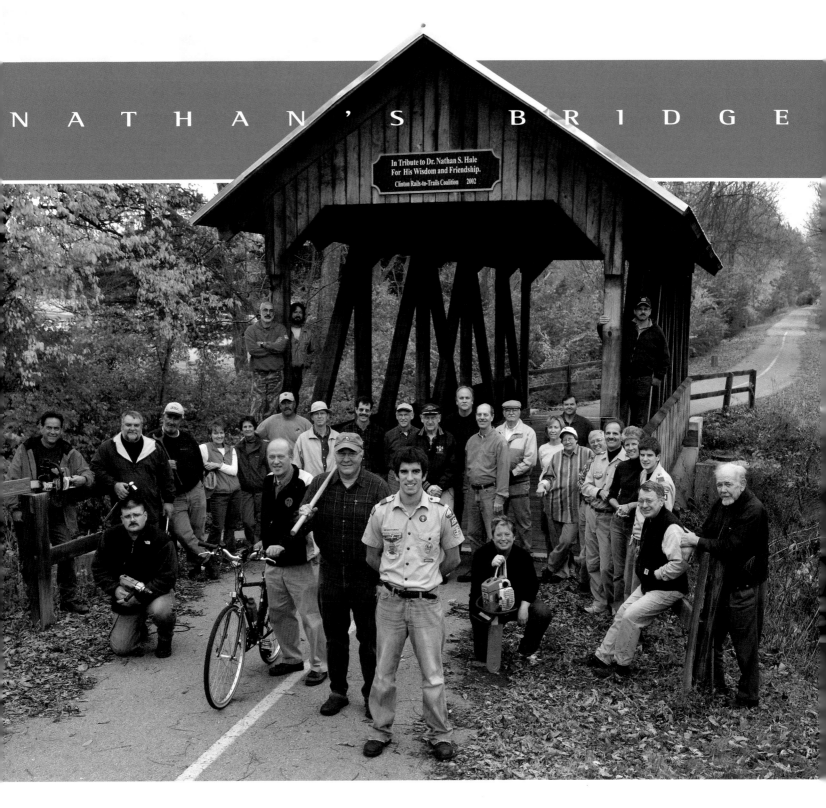

In Tribute to Dr. Nathan S. Hale
For His Wisdom and Friendship.
Clinton Rails-to-Trails Coalition 2002

Jonah Hein's (foreground) heavyweight Eagle Scout project was this bridge, a tribute to Dr. Nathan Hale,

built with the help of most everyone in Wilmington who could drive a straight nail (and several who

couldn't). Dr. Hale—doctor, naturalist, public servant, and character—was also famous for once sneaking

an ailing coon dog into the radiology lab and giving it an upper GI. *(See page 255.)*

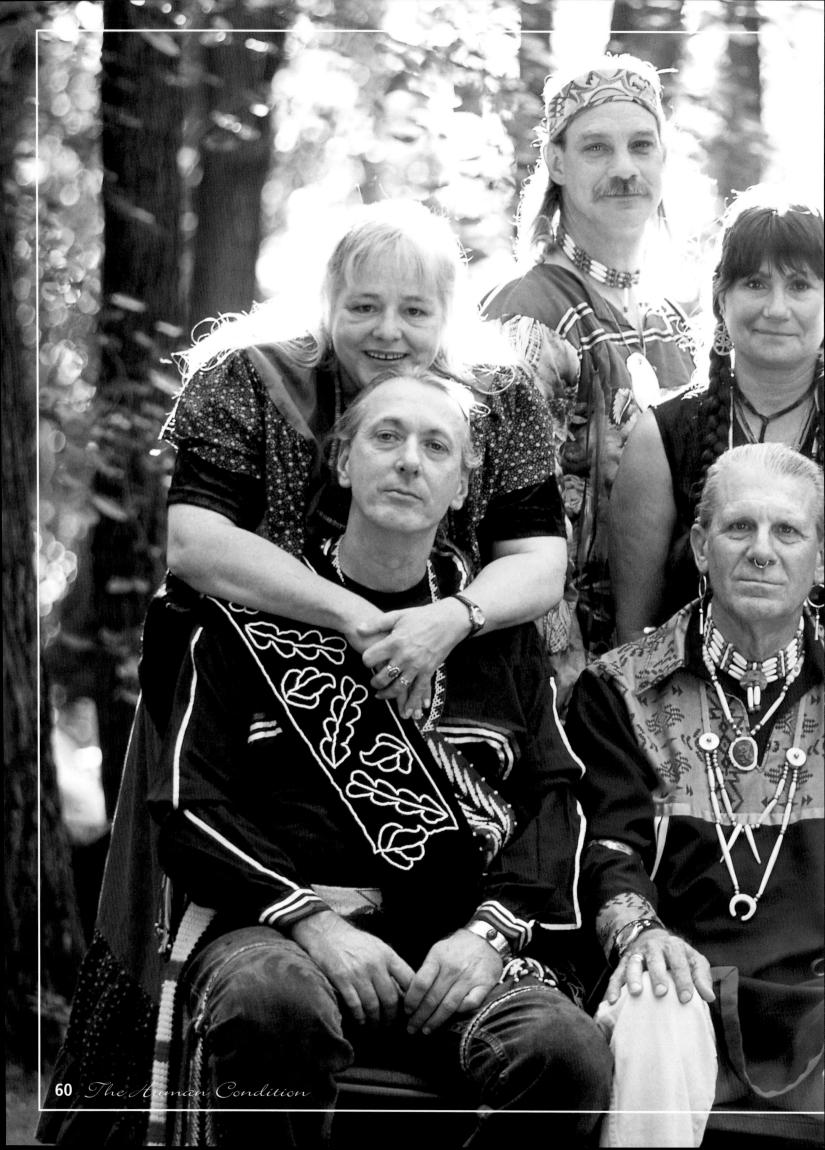

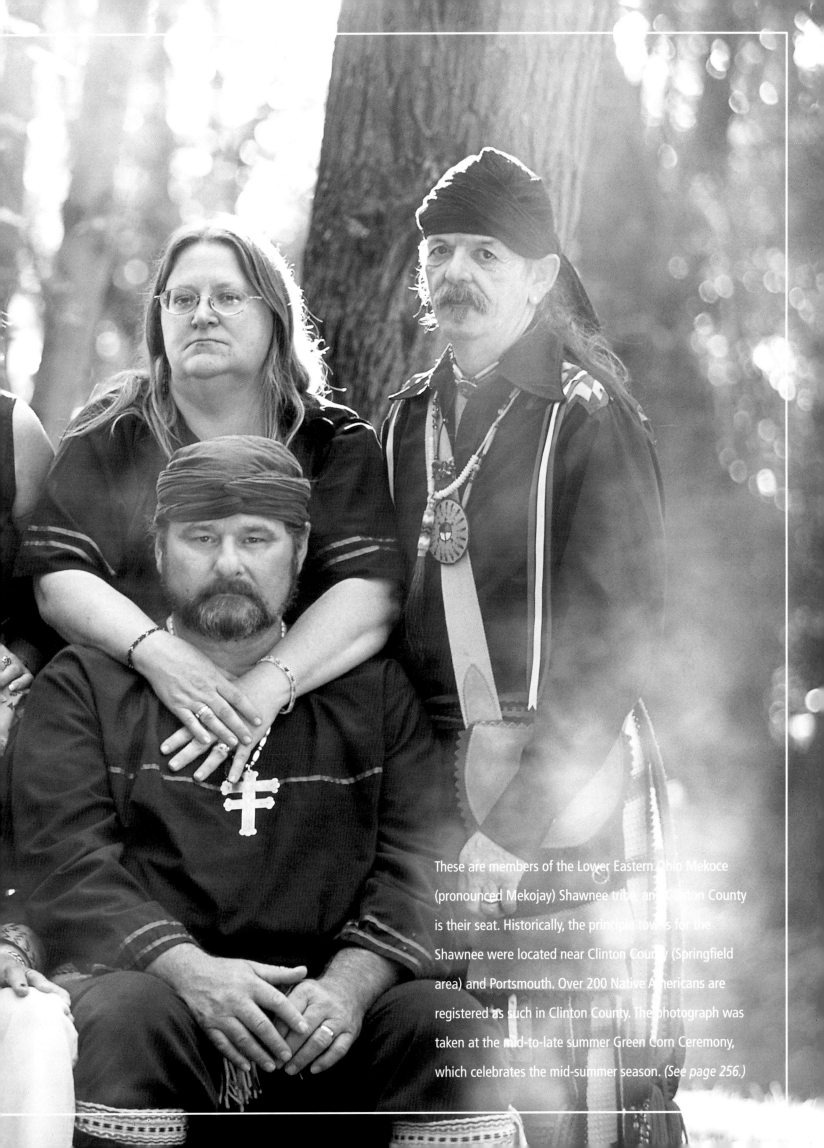

These are members of the Lower Eastern Ohio Mekoce (pronounced Mekojay) Shawnee tribe, and Clinton County is their seat. Historically, the principle towns for the Shawnee were located near Clinton County (Springfield area) and Portsmouth. Over 200 Native Americans are registered as such in Clinton County. The photograph was taken at the mid-to-late summer Green Corn Ceremony, which celebrates the mid-summer season. *(See page 256.)*

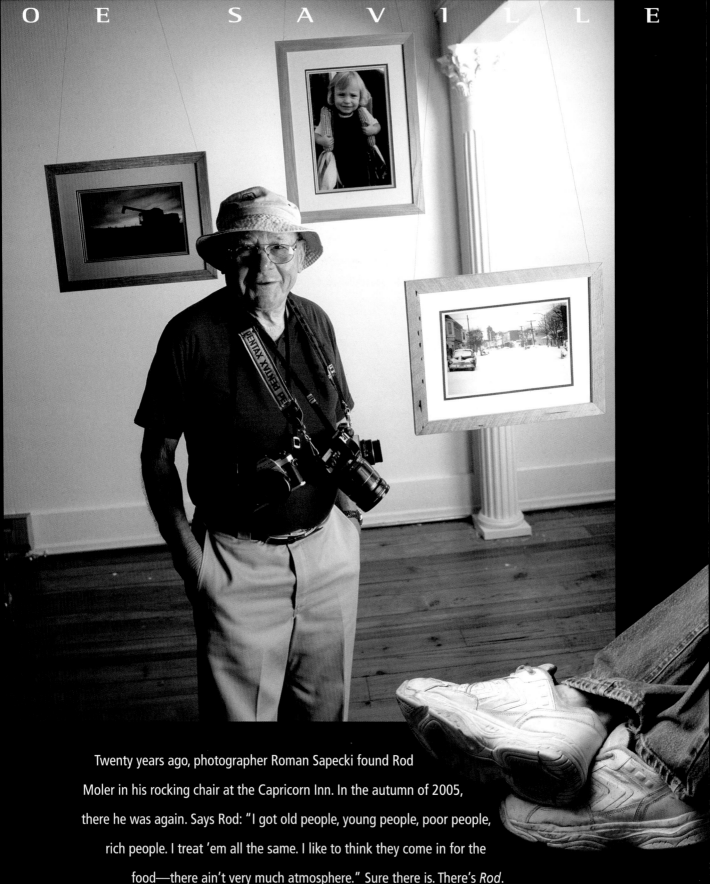

Twenty years ago, photographer Roman Sapecki found Rod
Moler in his rocking chair at the Capricorn Inn. In the autumn of 2005,
there he was again. Says Rod: "I got old people, young people, poor people,
rich people. I treat 'em all the same. I like to think they come in for the
food—there ain't very much atmosphere." Sure there is. There's *Rod*.

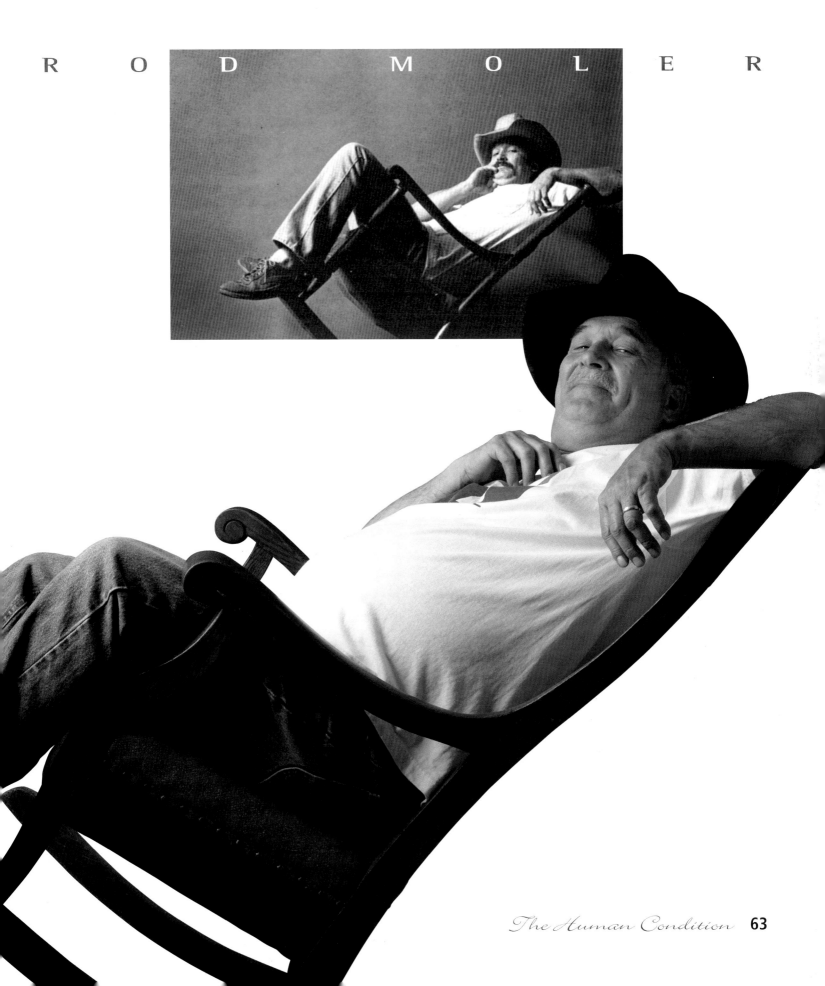

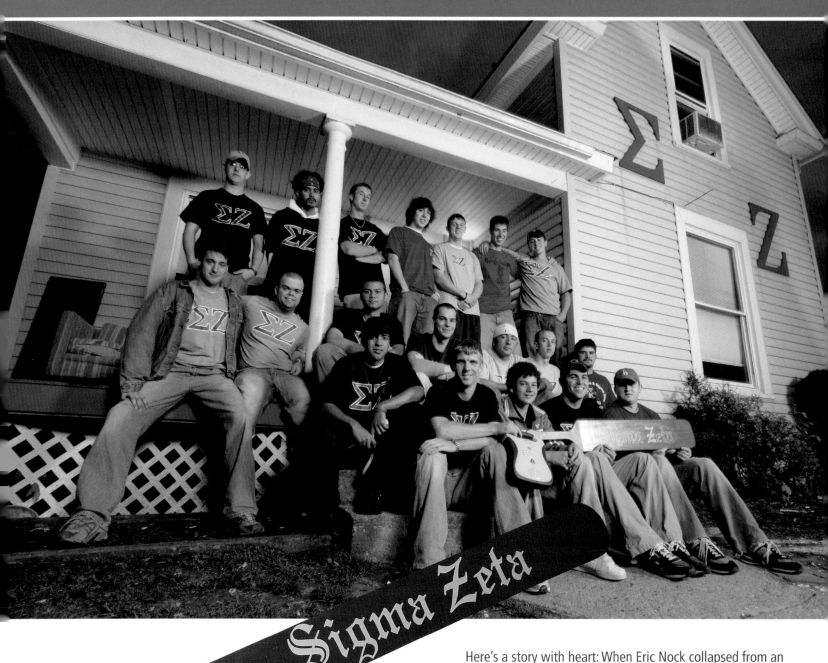

Here's a story with heart: When Eric Nock collapsed from an undiagnosed cardiac disease during a 2004 summer soccer camp, Sigma Zeta member Kyle Anderson administered CPR until the EMT unit arrived, carrying a portable defibrillator. That's Kyle holding one of two defibrillators his fraternity donated to the college after raising $4,000. He's seated next to a restored Eric Nock. *(See page 256.)*

HAT GIRLS

These Red Hat ladies—the Cape May Red Hatters and the Happy Hatters of Wilmington—occupy the porch of the Sara Rose Gallagher House in Sabina, their splendid nonchalance a testimony to Red Hat society, a wonderful organization dedicated to no projects, no rules, and no bylaws (thereby making it the only totally successful group in the county). *(See page 256.)*

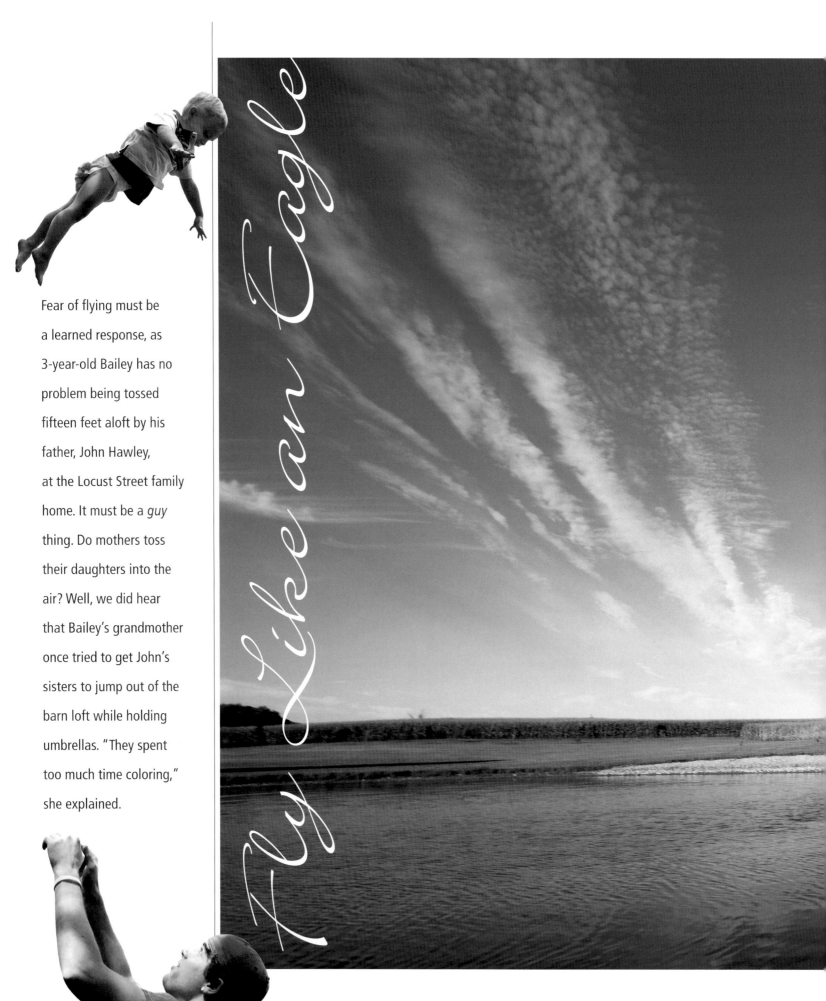

Fly Like an Eagle

Fear of flying must be a learned response, as 3-year-old Bailey has no problem being tossed fifteen feet aloft by his father, John Hawley, at the Locust Street family home. It must be a *guy* thing. Do mothers toss their daughters into the air? Well, we did hear that Bailey's grandmother once tried to get John's sisters to jump out of the barn loft while holding umbrellas. "They spent too much time coloring," she explained.

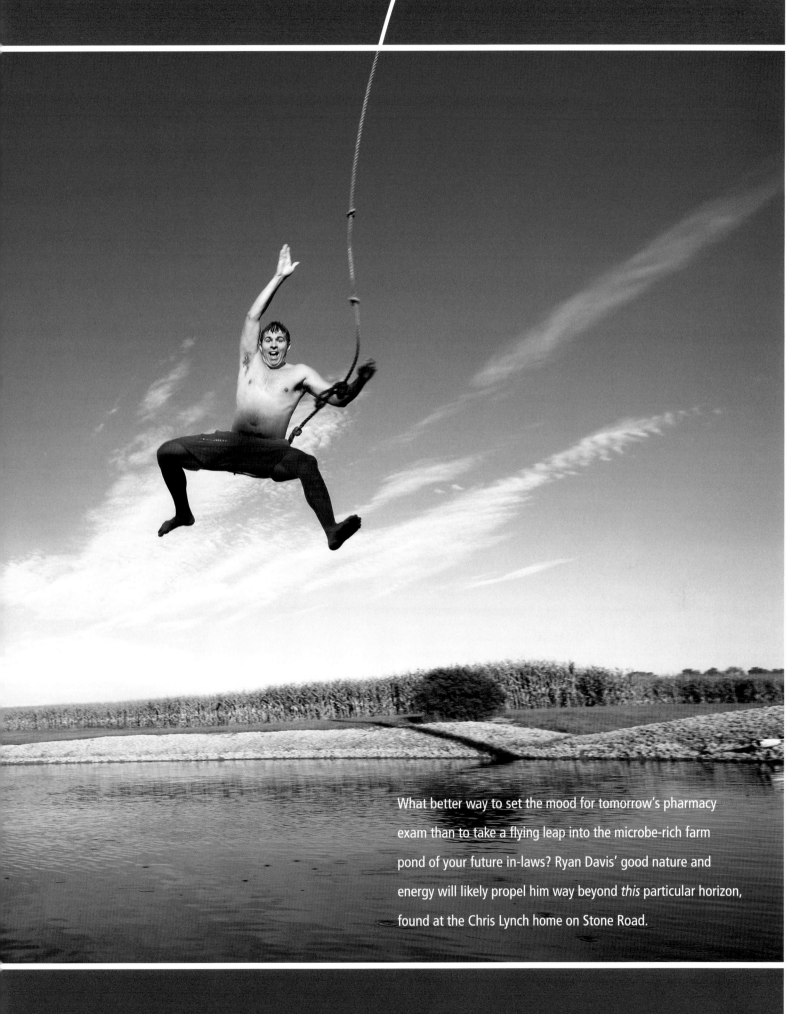

What better way to set the mood for tomorrow's pharmacy exam than to take a flying leap into the microbe-rich farm pond of your future in-laws? Ryan Davis' good nature and energy will likely propel him way beyond *this* particular horizon, found at the Chris Lynch home on Stone Road.

*J*oe Nuxhall says that if everyone who told him they saw him pitch his first major league game back in 1944 actually did, there would have been 30,000 people there instead of 3,500. But he smiles and says, "Really? That's great." Now 1,000 people can say they saw him throw a pitch to *Joe* author Greg Hoard on Main Street in September of 2005

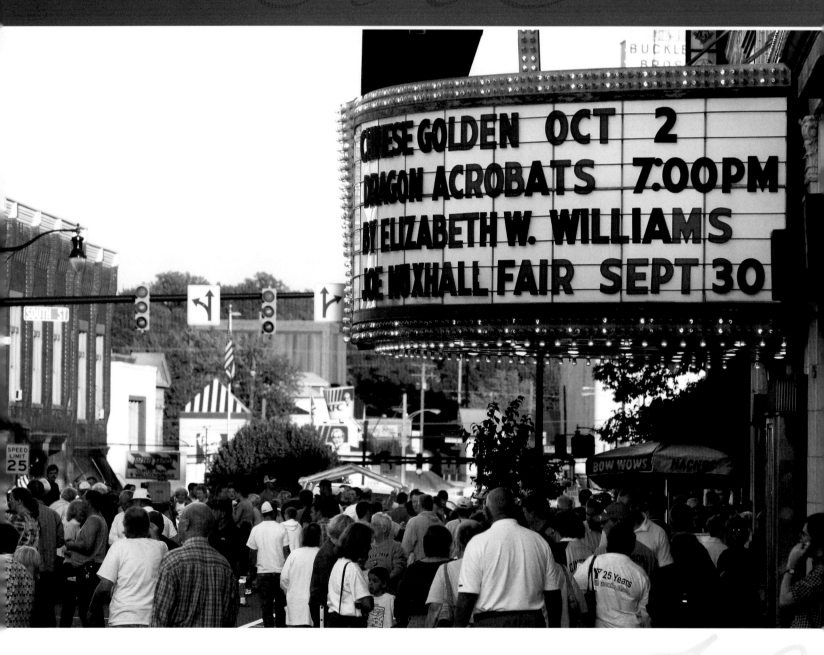

and had him autograph their book. With their gift for promotional flair, Dan and Marla Stewart at Books 'n' More created a street fair that rivaled the best big city signing, and the mayor declared it "Joe Nuxhall Day." Sixty years from now, 10,000 Clinton Countians can say, "I was there."

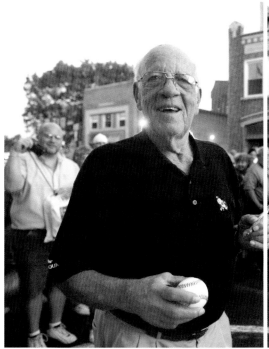

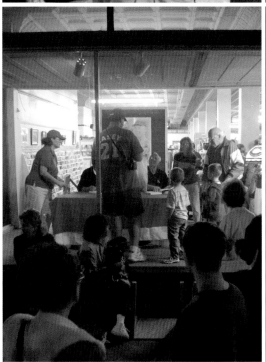

When Orange Frazer Press brought Joe Nuxhall and Greg Hoard to Wilmington for a book signing, a crowd was predicted but no one thought that nearly a thousand people wanted autographs. Joe said it was almost as difficult as facing Stan Musial that day back in 1944. Then he left to put ice on his signing arm.

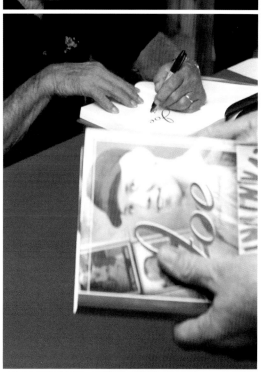

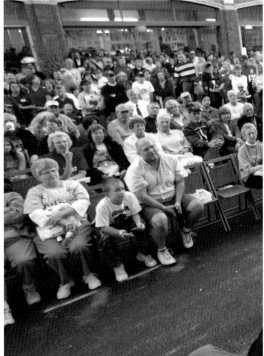

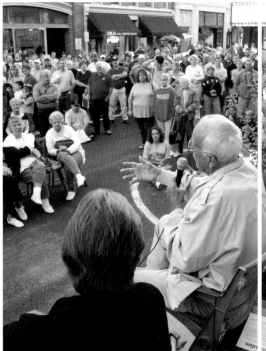

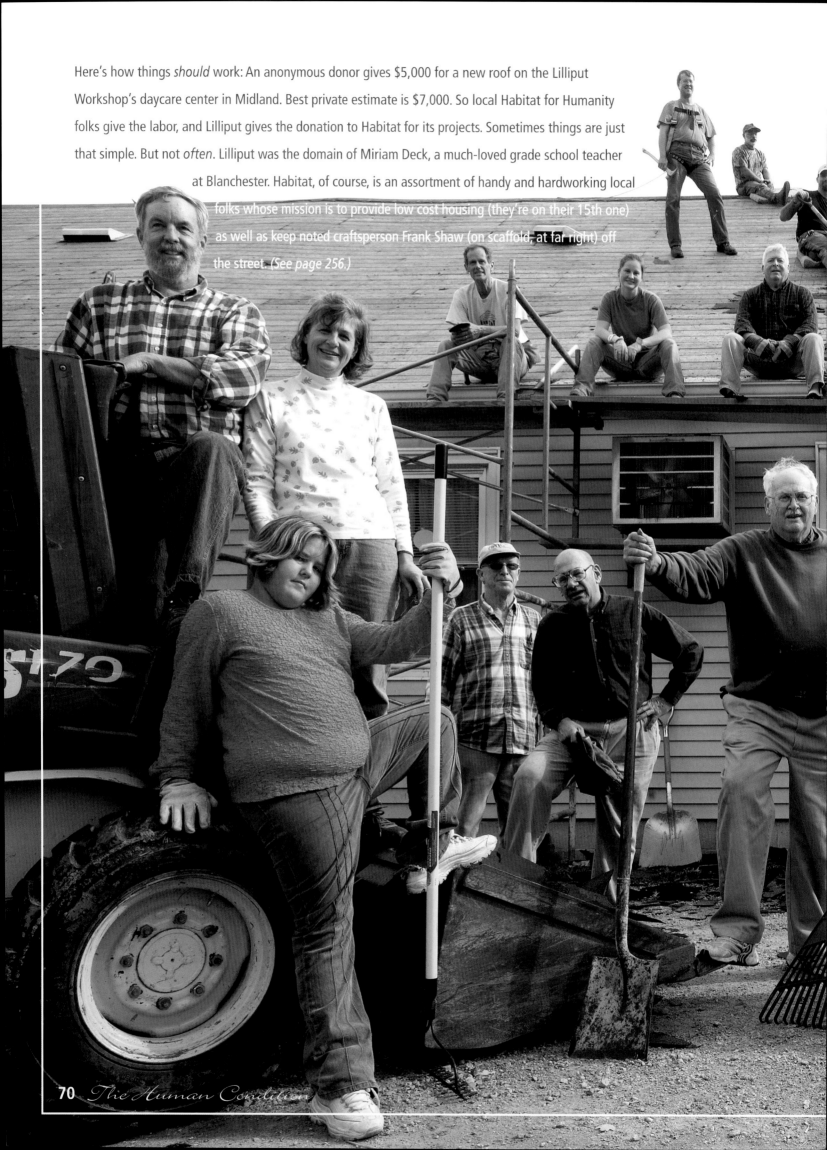

Here's how things *should* work: An anonymous donor gives $5,000 for a new roof on the Lilliput Workshop's daycare center in Midland. Best private estimate is $7,000. So local Habitat for Humanity folks give the labor, and Lilliput gives the donation to Habitat for its projects. Sometimes things are just that simple. But not *often*. Lilliput was the domain of Miriam Deck, a much-loved grade school teacher at Blanchester. Habitat, of course, is an assortment of handy and hardworking local folks whose mission is to provide low cost housing (they're on their 15th one) as well as keep noted craftsperson Frank Shaw (on scaffold, at far right) off the street. *(See page 256.)*

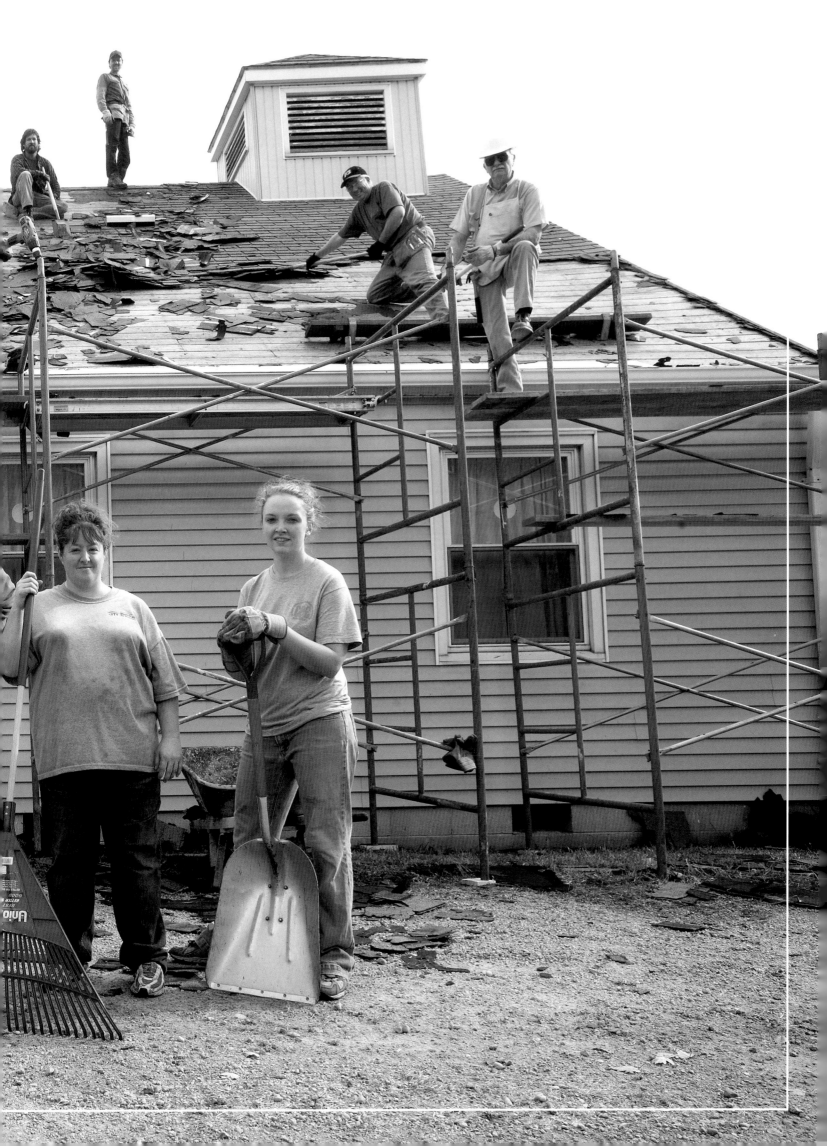

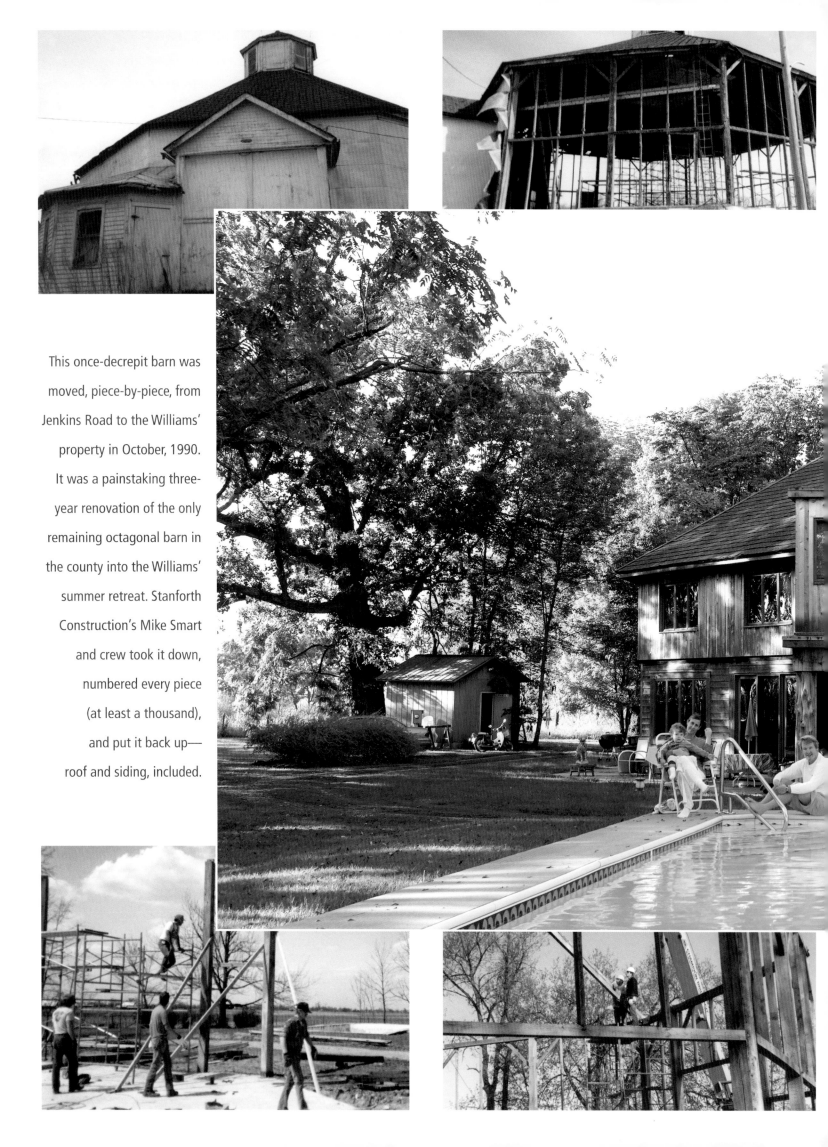

This once-decrepit barn was moved, piece-by-piece, from Jenkins Road to the Williams' property in October, 1990. It was a painstaking three-year renovation of the only remaining octagonal barn in the county into the Williams' summer retreat. Stanforth Construction's Mike Smart and crew took it down, numbered every piece (at least a thousand), and put it back up—roof and siding, included.

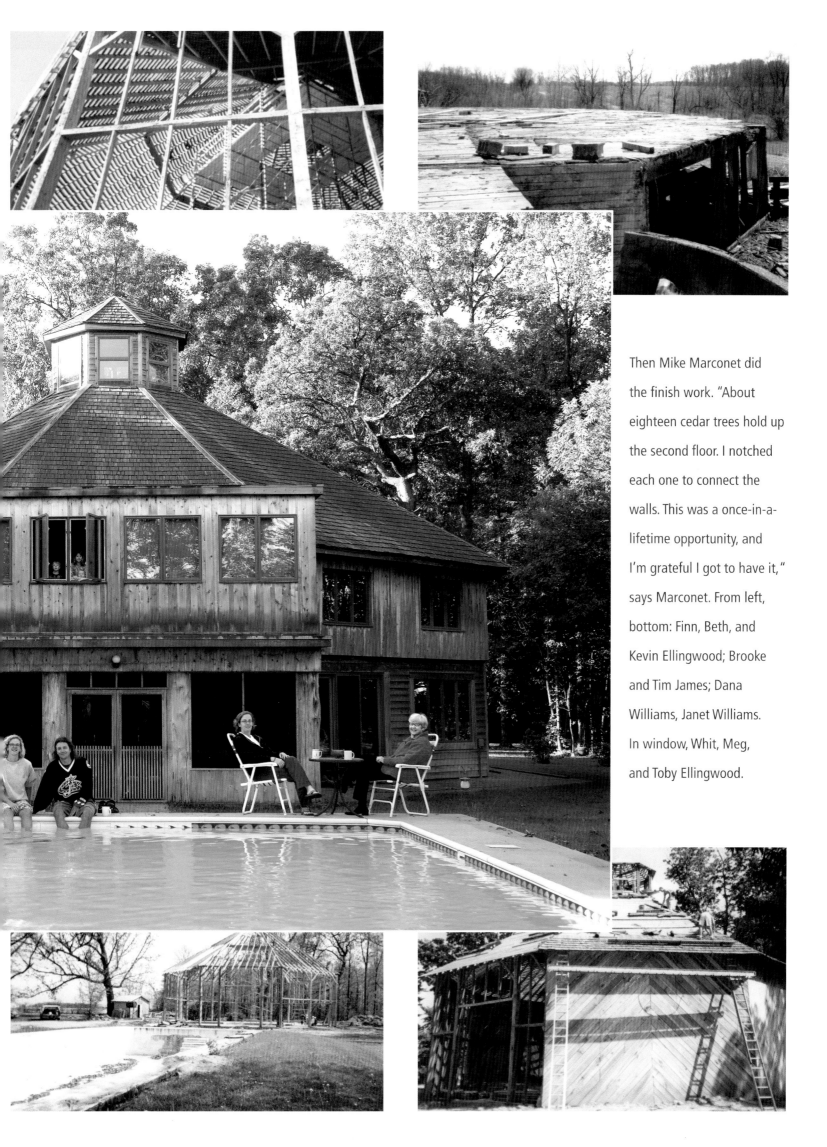

Then Mike Marconet did the finish work. "About eighteen cedar trees hold up the second floor. I notched each one to connect the walls. This was a once-in-a-lifetime opportunity, and I'm grateful I got to have it," says Marconet. From left, bottom: Finn, Beth, and Kevin Ellingwood; Brooke and Tim James; Dana Williams, Janet Williams. In window, Whit, Meg, and Toby Ellingwood.

These are the Master Gardeners, the people who prove that it *is* easy being green. In return for intensive horticultural training (and the right to be masterful) the gardeners repay the extension service with volunteer work—such things as their hothouse container "grow labs" in the local schools, work on the fairgrounds, and a hotline that tells you what to do when your pansy patch dries out. Check out their newsletter, too:

G R E E N T H U M B

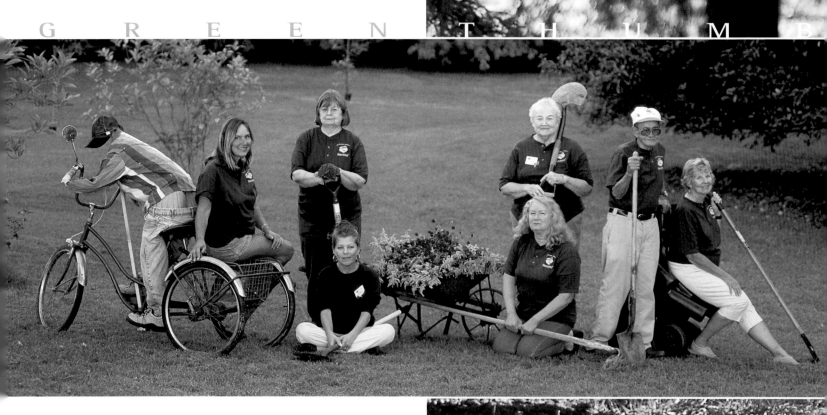

the Clinton County CommPost. It's too mulch. At right is Mr. Pumpkin Butt, in Wilmington College's Hazard Arboretum. P.B is the masterful scarecrow in Jackie Schneder's garden, an invention of Mr. Schneder. Representing the Masters: Karen Magella, Linda Johnson (sitting on ground) Janet Esmail (standing behind Linda), Mary Helen Mack (kneeling) Eileen Ostermeier (standing behind Helen), Kenneth Gray (standing with shovel) and Judy Stopkotle.

Nice

Pumpkins

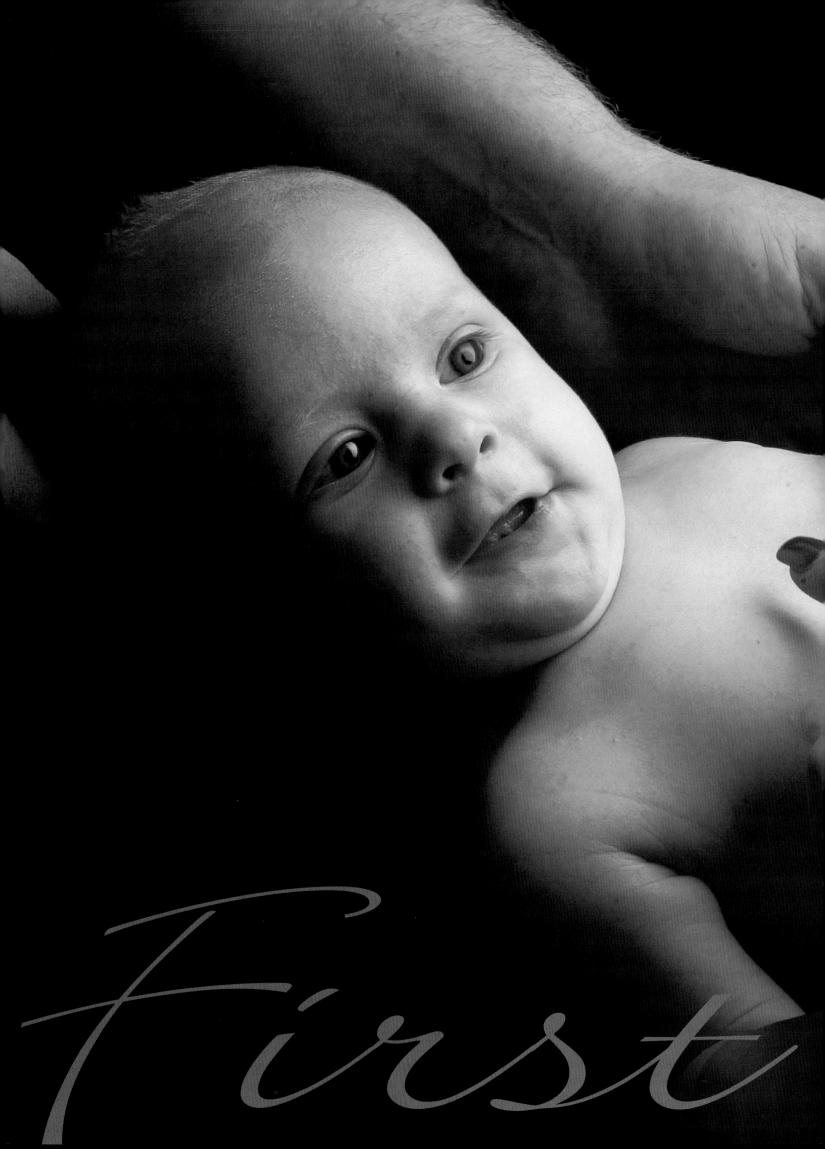

First

Briar Lee Gray (left) entered Clinton County (and the world) by setting the weight-to-beat standard of 11 pounds, 5 ounces—only 80 minutes into the new year of 2005. CMH honors the first baby of the year with gifts and kudos, but the real honor went to his mom and dad, Casey and Nathan Gray of Midland. Other mothers in Clinton County just heard the news and thought, "Yegads, 11 pounds." In serene counterpose is Opal Gilliam of Friendly Center, who turned 103 in March.

Fine W I N E

Ms. Gilliam likes country western music, lottery tickets, and socializing. She attributes her longevity to a diet of fried food—particularly potatoes—as well as beer and pizza (preferably with peppers and onions). Her granddaughter, Vanessa, says the secret is Opal's work ethic. "She doesn't think there's enough sweat involved in life anymore," says Vanessa of her grandmother. Listen up, Briar Lee.

Born

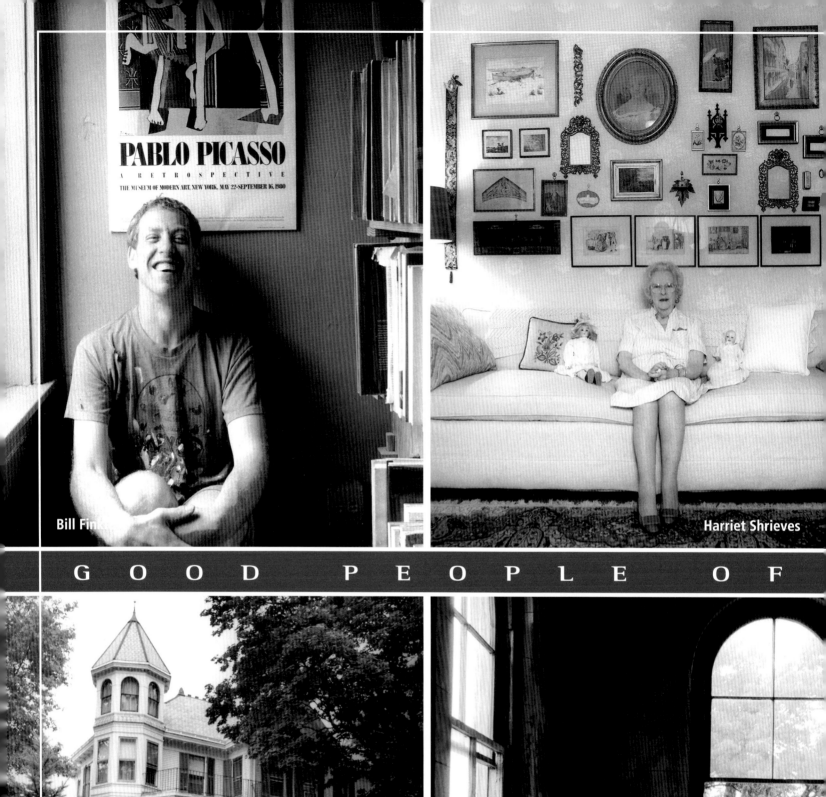

Bill Fink

Harriet Shrieves

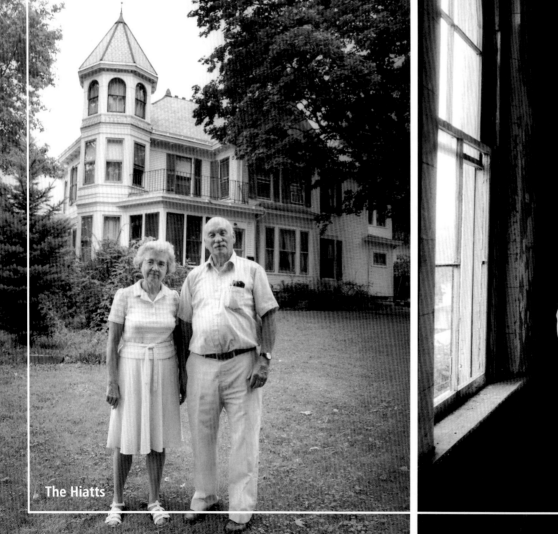

The Hiatts

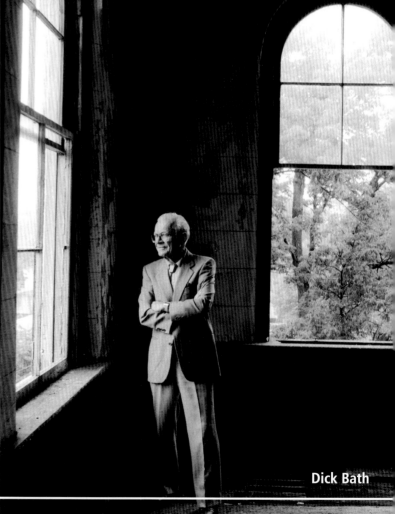

Dick Bath

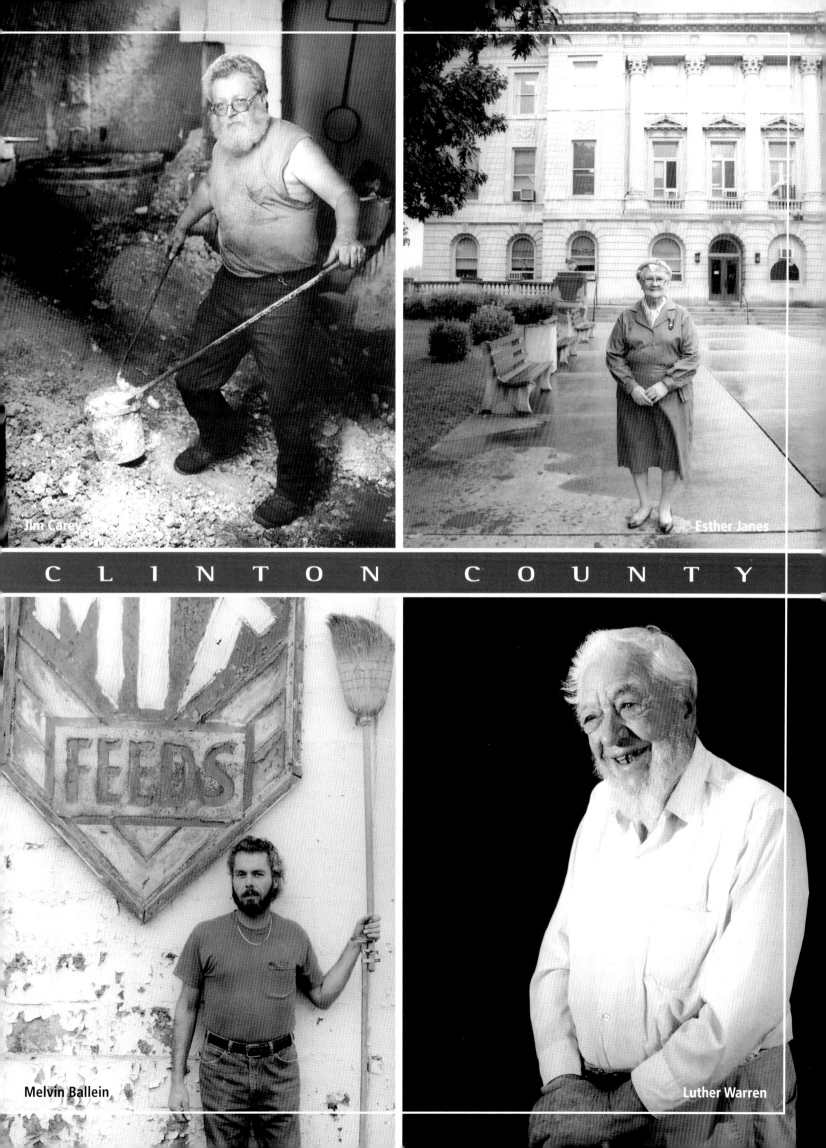

Jim Carey

Esther Janes

CLINTON COUNTY

Melvin Ballein

Luther Warren

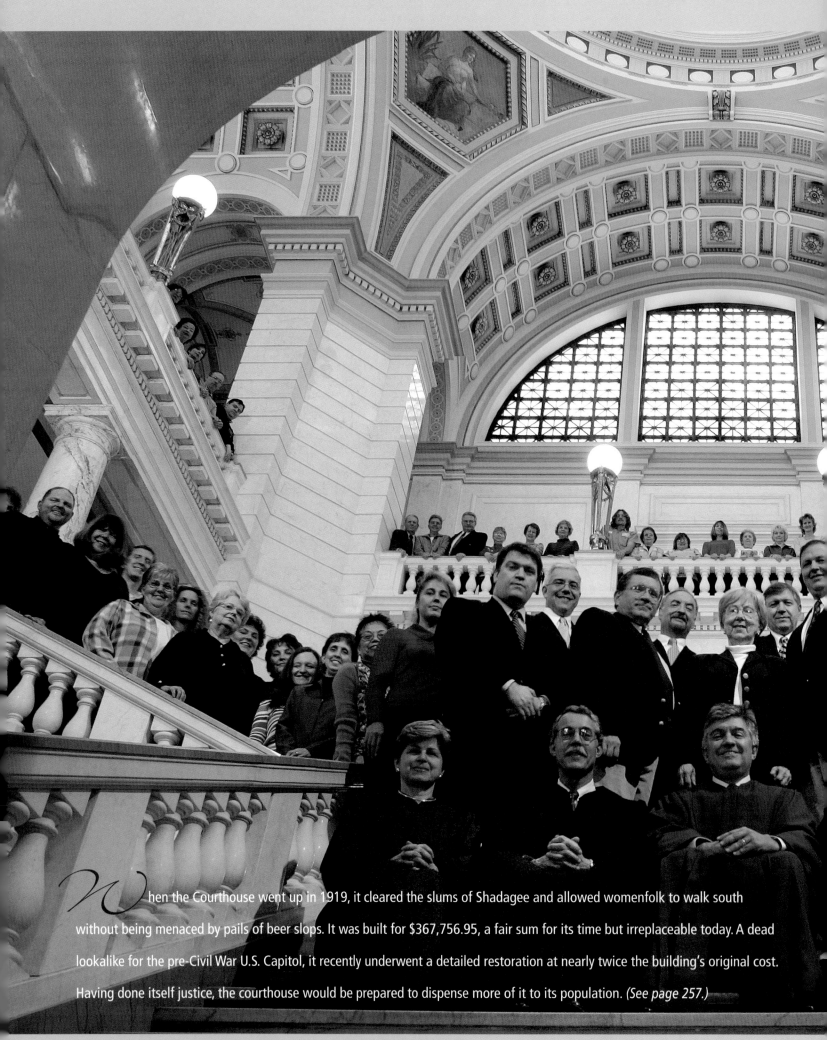

When the Courthouse went up in 1919, it cleared the slums of Shadagee and allowed womenfolk to walk south without being menaced by pails of beer slops. It was built for $367,756.95, a fair sum for its time but irreplaceable today. A dead lookalike for the pre-Civil War U.S. Capitol, it recently underwent a detailed restoration at nearly twice the building's original cost. Having done itself justice, the courthouse would be prepared to dispense more of it to its population. *(See page 257.)*

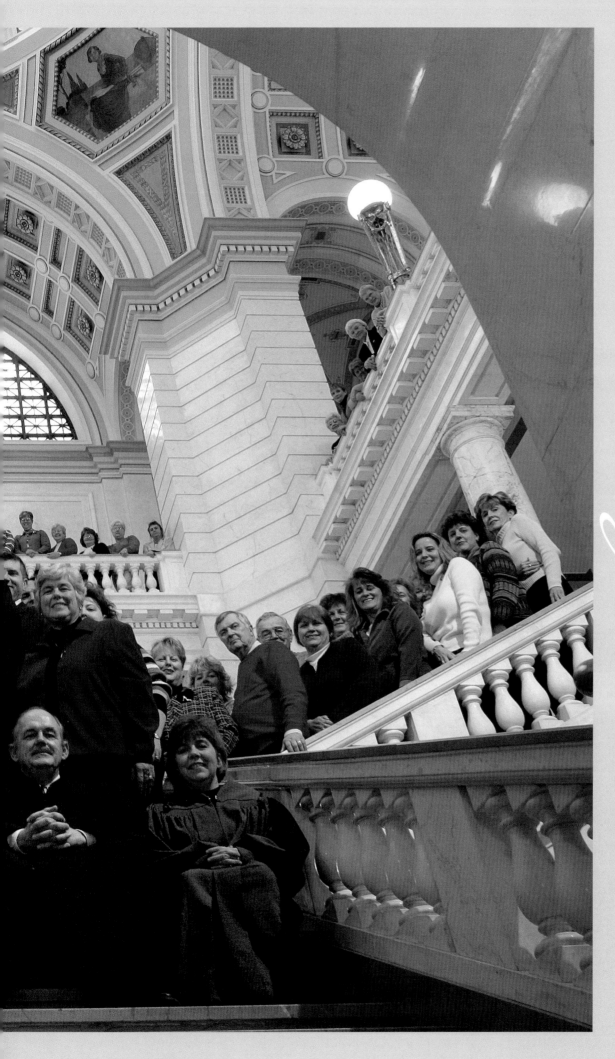

The Body Politic

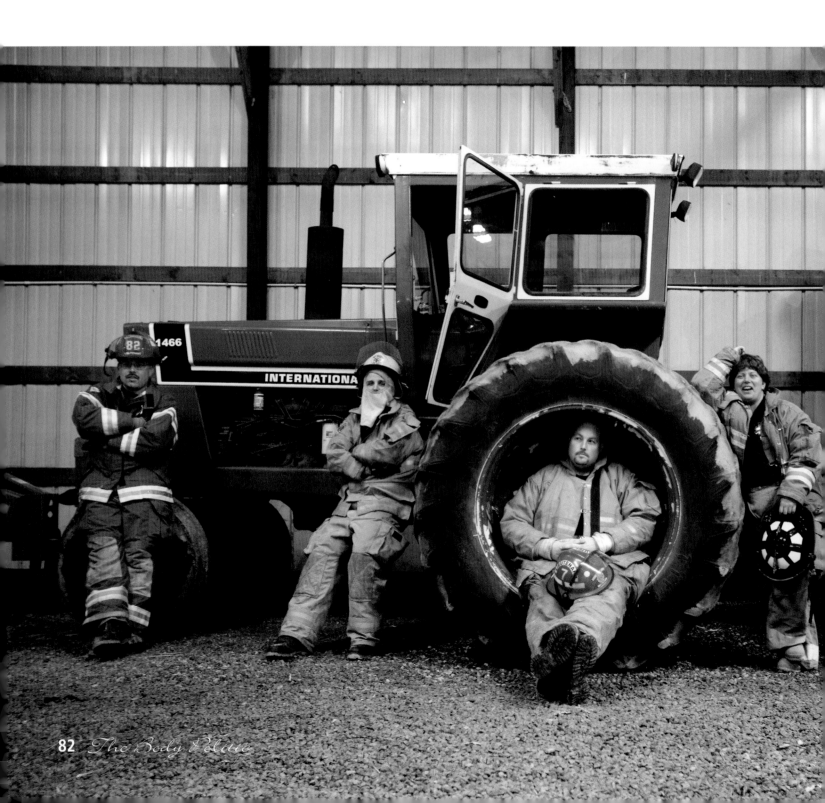

The county mayors, from left: Thomas White, Blanchester; Scott L. Lander, Martinsville; Joyce Schaeffer, Midland; David R. Raizk, Wilmington; Chris Towner, New Vienna; Charles Hargrave, Sabina; and Sherry Bellew, Clarksville. Orchestration by Mayor Raizk, a professional of long-standing repute on both public and theatrical stages.

(Left) At Mike Mason's barn near Port William, participants in the Southern Ohio Fire and EMS School wait for the next farm emergency scenario. (Below) Sheriff Ralph Fizer Jr. and his men occupy the old jail, where (right), a guest marks the slow passage of his days. *(See page 258.)*

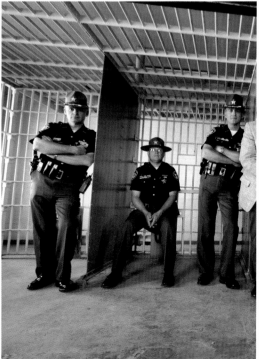

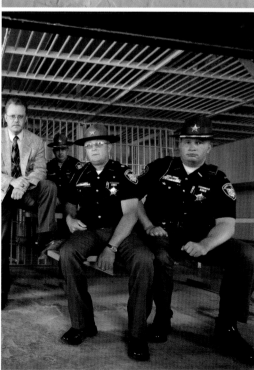

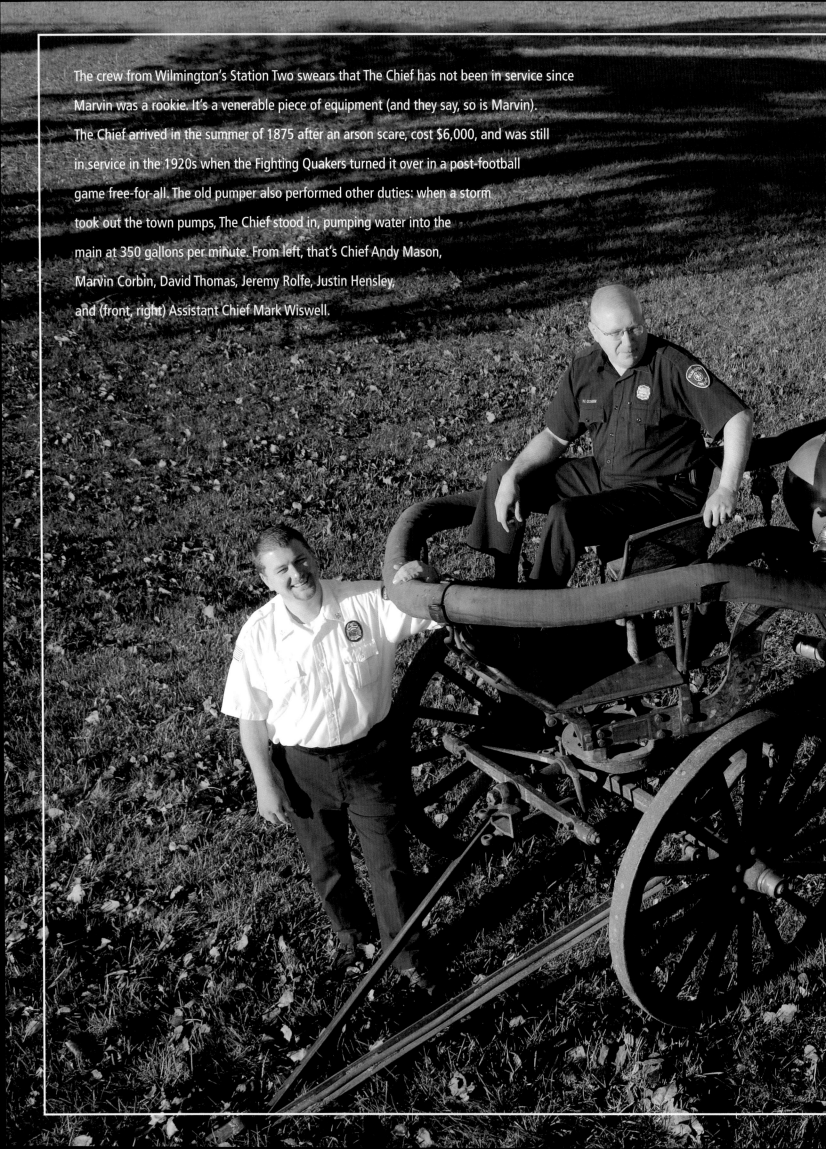

The crew from Wilmington's Station Two swears that The Chief has not been in service since
Marvin was a rookie. It's a venerable piece of equipment (and they say, so is Marvin).
The Chief arrived in the summer of 1875 after an arson scare, cost $6,000, and was still
in service in the 1920s when the Fighting Quakers turned it over in a post-football
game free-for-all. The old pumper also performed other duties: when a storm
took out the town pumps, The Chief stood in, pumping water into the
main at 350 gallons per minute. From left, that's Chief Andy Mason,
Marvin Corbin, David Thomas, Jeremy Rolfe, Justin Hensley,
and (front, right) Assistant Chief Mark Wiswell.

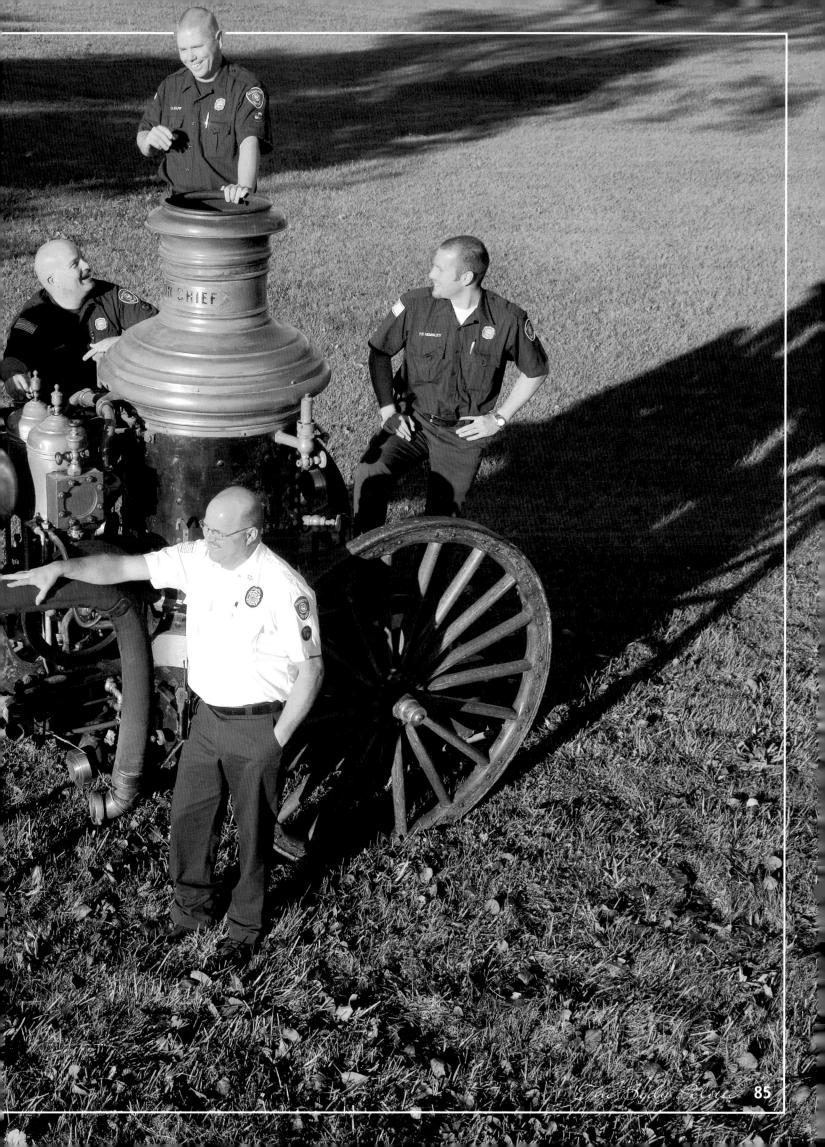

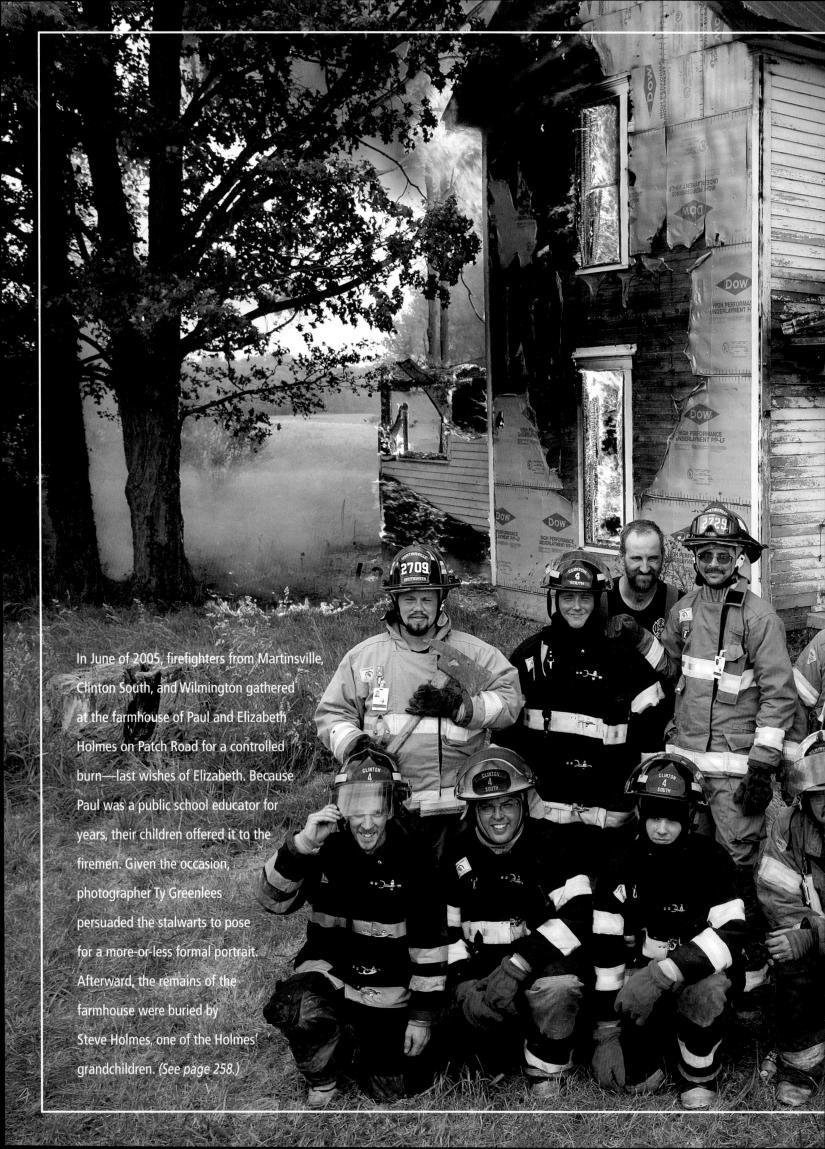

In June of 2005, firefighters from Martinsville, Clinton South, and Wilmington gathered at the farmhouse of Paul and Elizabeth Holmes on Patch Road for a controlled burn—last wishes of Elizabeth. Because Paul was a public school educator for years, their children offered it to the firemen. Given the occasion, photographer Ty Greenlees persuaded the stalwarts to pose for a more-or-less formal portrait. Afterward, the remains of the farmhouse were buried by Steve Holmes, one of the Holmes' grandchildren. (See page 258.)

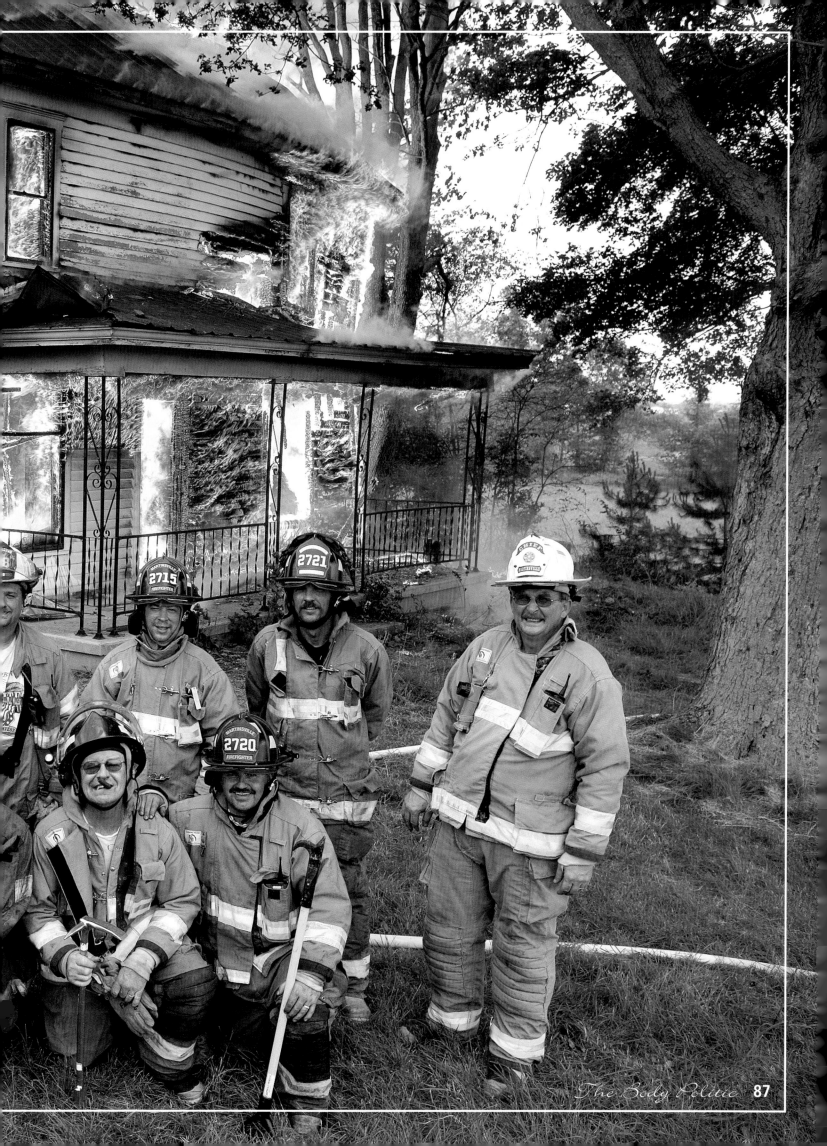

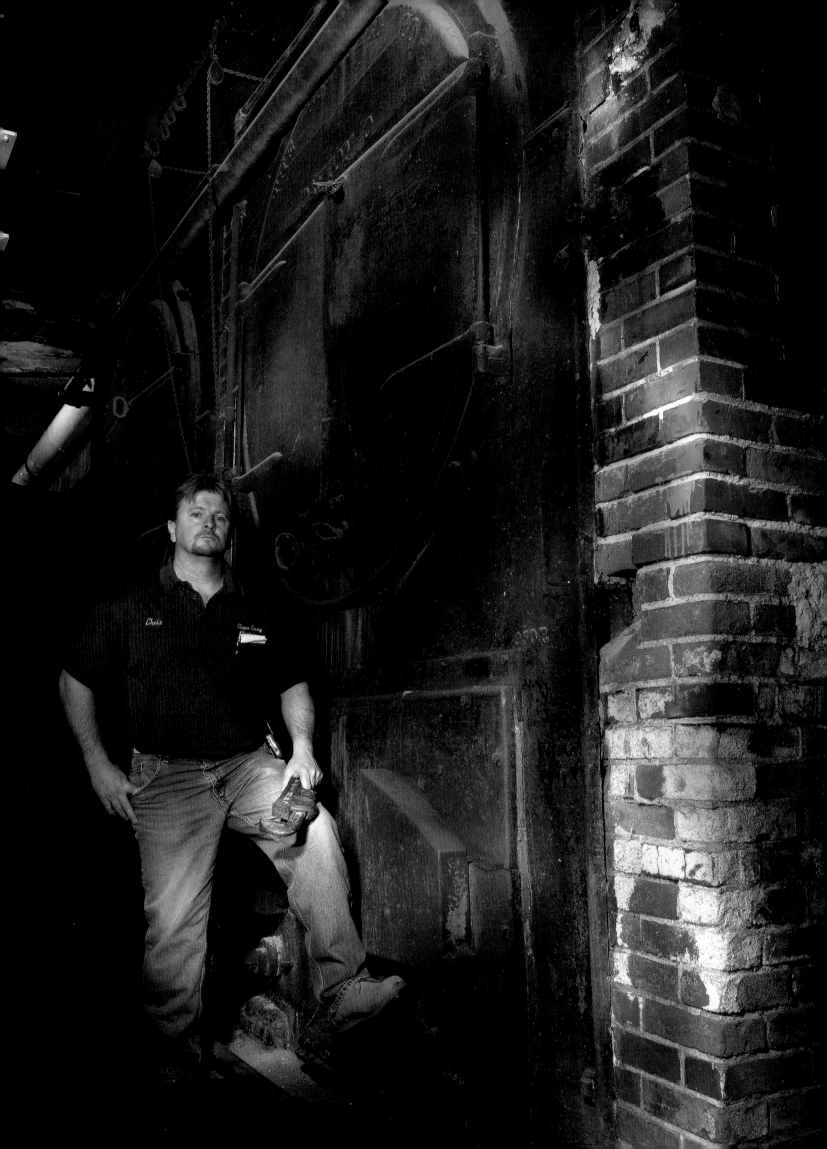

\mathcal{L}ongstanding members of Chris Horsley's county maintenance crew (posing in the steam tunnel in the courthouse basement) recall when maintenance was not much more than taking care of the courthouse, including sprinkling salt on the parking lot—by hand—and running up to the third floor with trash cans when it rained. Before the latest renovation, visitors were sometimes sprinkled with falling plaster but the plaster having been restored by the commissioners'

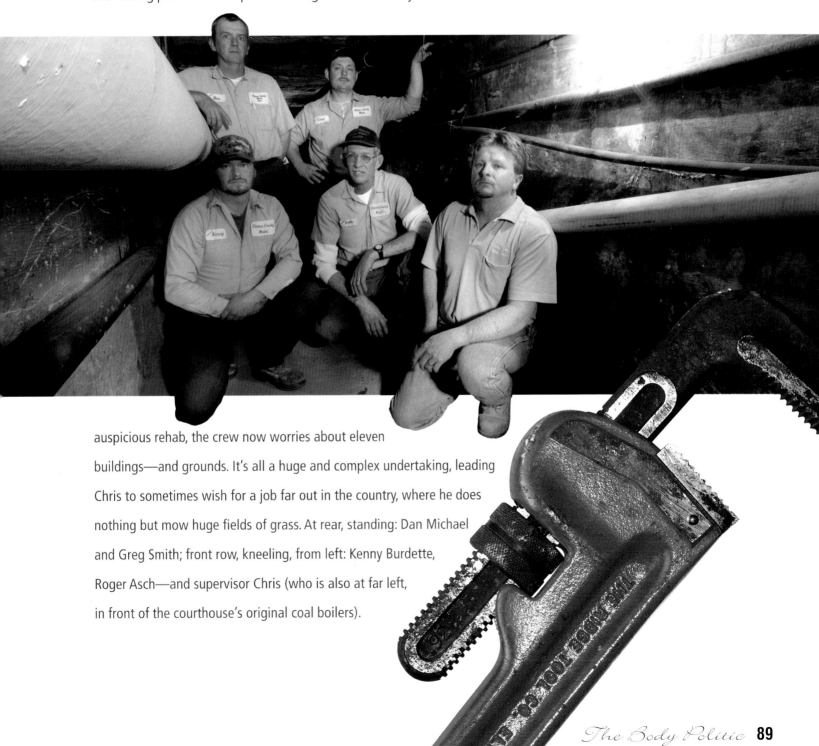

auspicious rehab, the crew now worries about eleven buildings—and grounds. It's all a huge and complex undertaking, leading Chris to sometimes wish for a job far out in the country, where he does nothing but mow huge fields of grass. At rear, standing: Dan Michael and Greg Smith; front row, kneeling, from left: Kenny Burdette, Roger Asch—and supervisor Chris (who is also at far left, in front of the courthouse's original coal boilers).

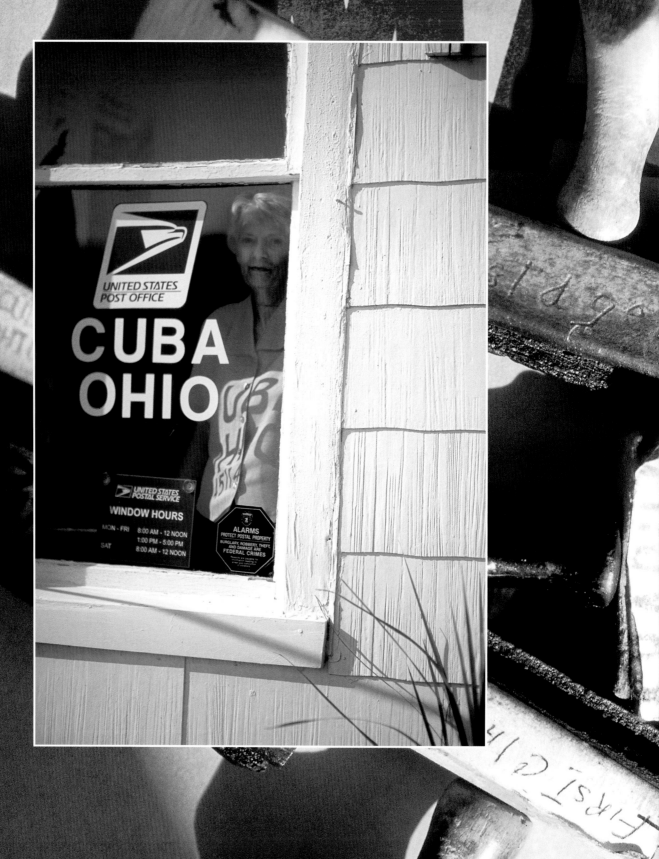

They're reminders of who we once were, back before such things as "global priority" and "guaranteed overnight express." They're wonderful quirky little buildings out in places like Reesville, Lees Creek, Midland, and Martinsville, most of them run by women, the only concession to modern times being their timely

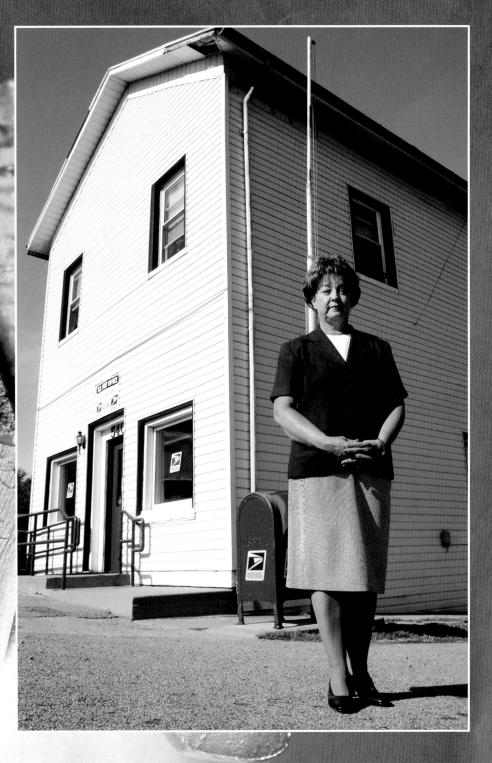

service and the fact these dauntless ladies are referred to as "post*masters*." For that, indeed, is what they are. Masters of the post. It's a splendid amalgam— these savvy women replete with the aura of history. That's Kay Walker (left) and Marilyn Cooper in front of her Reesville office.

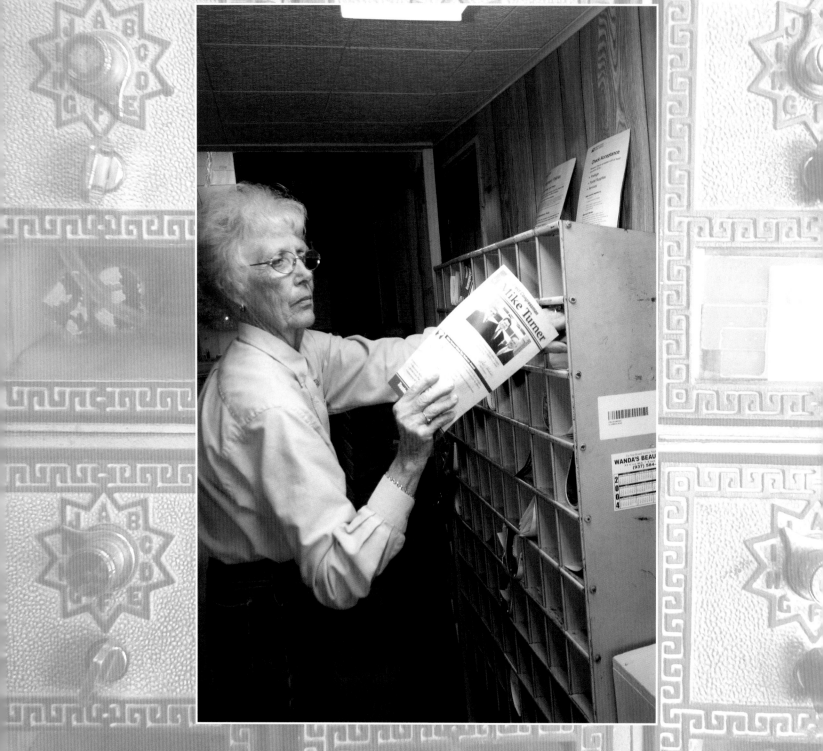

Shirley Louderback presides over her compact domain, which
consists of forty postal boxes, as well as the hamlet of Lees Creek
itself and environs. It may be small but the world is large,
and the world—news, bills, catalogs—still arrives here,
much in the same way it always has.

Martinsville

Space is reserved at the Martinsville Post Office for mail trucks—and, of course, for the community bulletin board.

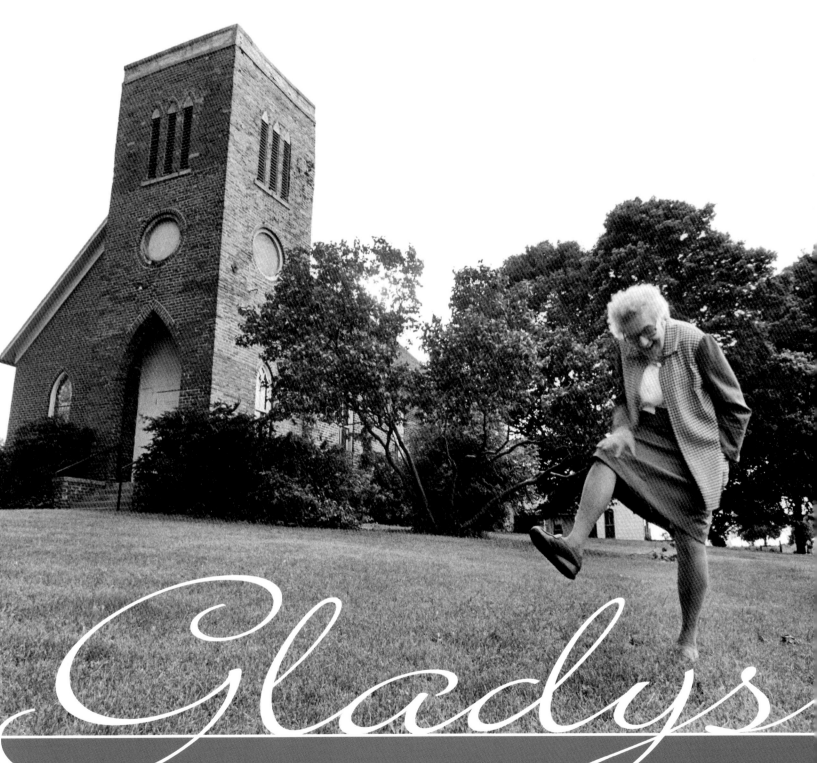

Gladys

When Gladys Linn was the postmaster of Reesville, the 56 postal boxes were in the front room of her house, and it was likely the only post office in America filled frequently with the smell of gingerbread. She hand-delivered mail to sick patrons, and even an occasional plug of chewing tobacco to Fred Weller, who lived alone in the old Reesville grocery.

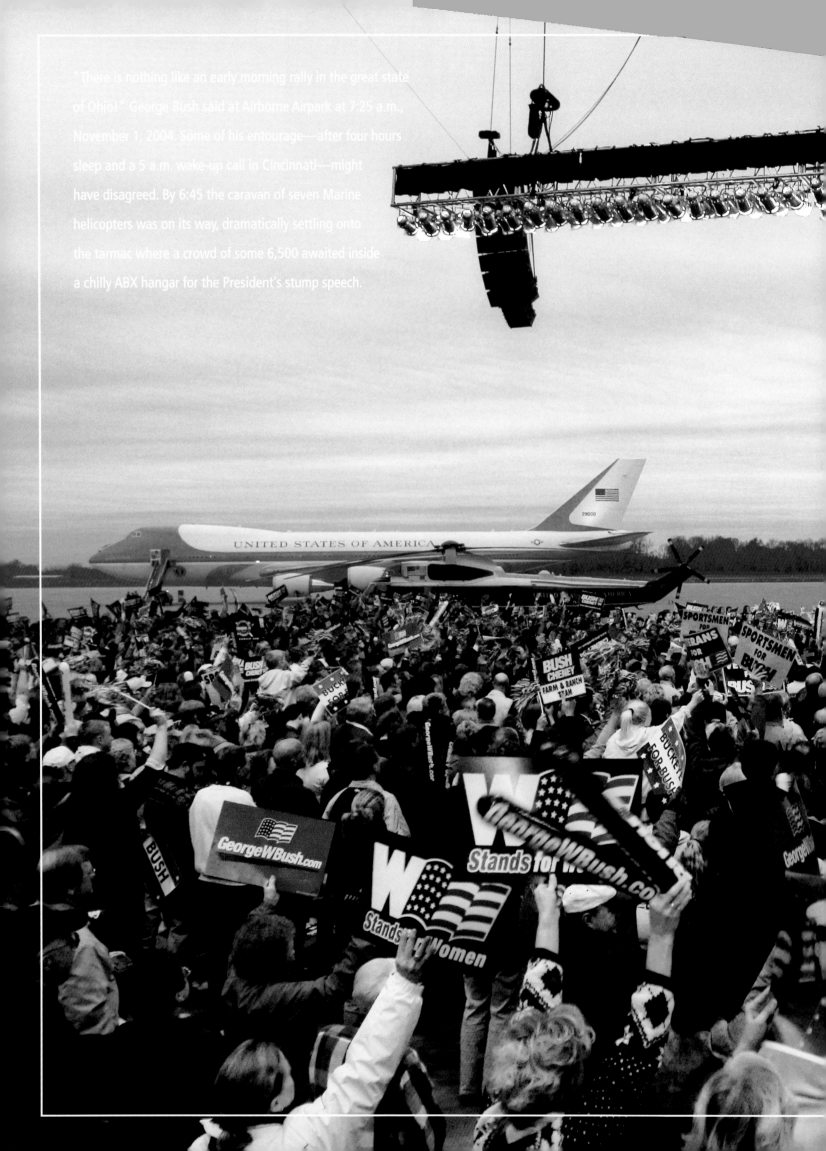

"There is nothing like an early morning rally in the great state of Ohio!" George Bush said at Airborne Airpark at 7:25 a.m., November 1, 2004. Some of his entourage—after four hours sleep and a 5 a.m. wake-up call in Cincinnati—might have disagreed. By 6:45 the caravan of seven Marine helicopters was on its way, dramatically settling onto the tarmac where a crowd of some 6,500 awaited inside a chilly ABX hangar for the President's stump speech.

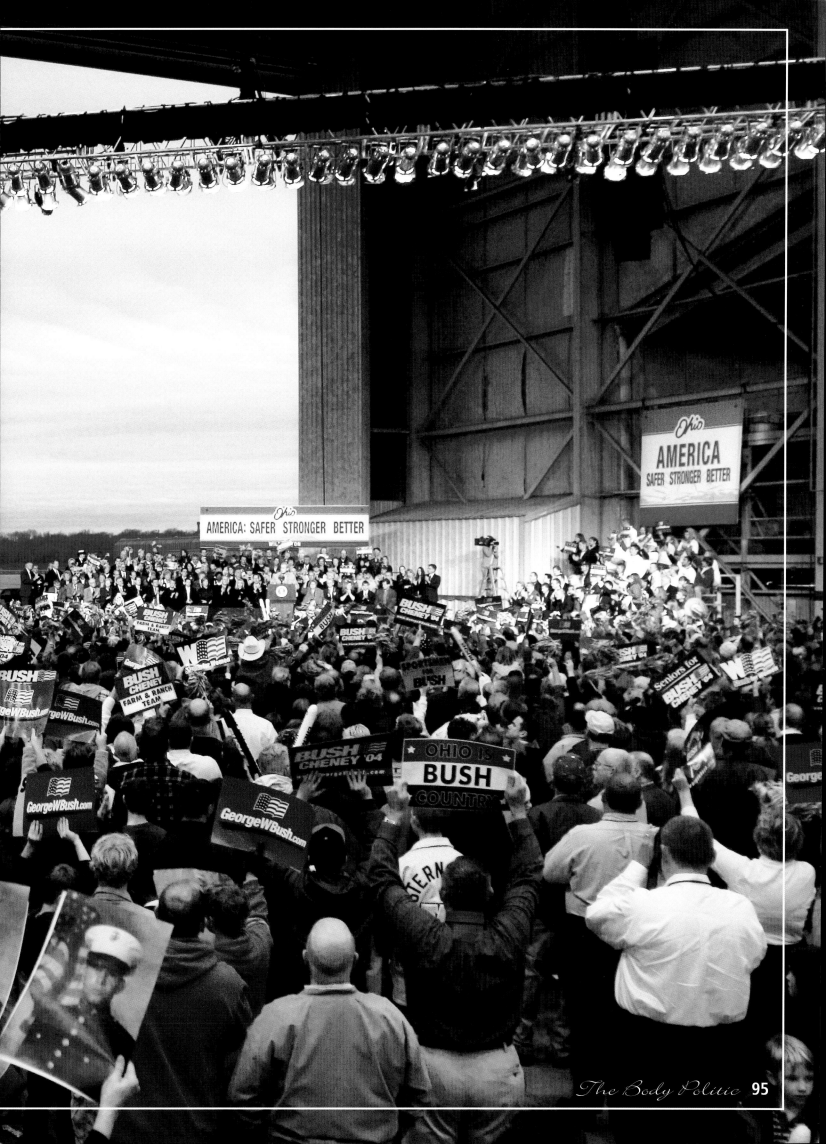

PRESIDENTIAL ELECTION

Left..........or..........Right?

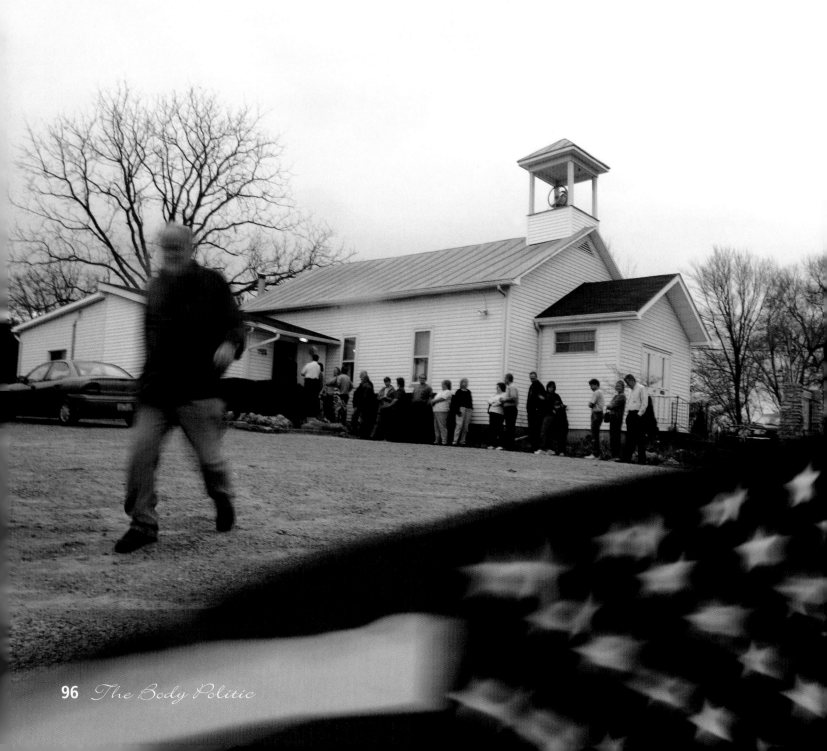

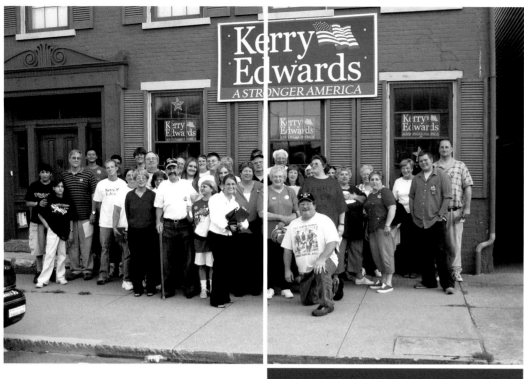

When election day 2004 rolled around, *USA Today* called Clinton County "a key component of the 'out there' regions." We had suddenly become, God forbid, a "micropolitan area." But the vote in rural America's "big towns" (George Bush got 70 percent of the county vote) tilted the election.

At left, early morning voters head to the polling place at Cuba Monthly Meeting. At top, the county's ethnic minority—the Democrats—pose in front of their local headquarters. At right, Donna Clevenger watches at the courthouse as the returns come up. And so does (at bottom) Harry Brumbaugh.

The crowd, by one estimate containing something like half the population of Wilmington, included Max Allen, a local farmer who woke up at 4 a.m. because, he said, "I never saw a President before." Wrote an English reporter about the President's arrival, "The sound system played the

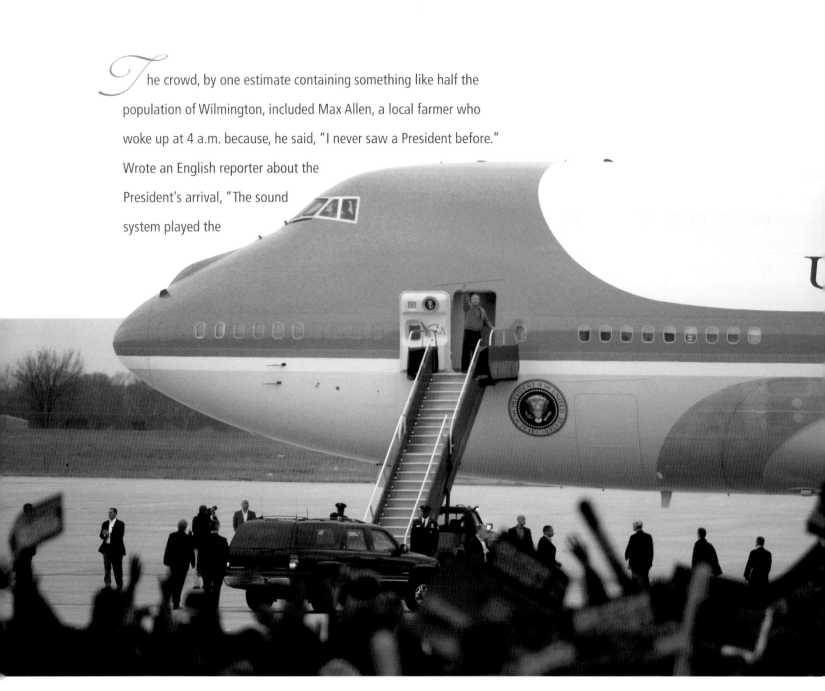

grandiose theme tune to *Air Force One*, a thriller starring Harrison Ford as a tough, embattled president. The crowd found itself part of a movie and erupted with delight." Washington reporters disagreed. They said the theme was from *Top Gun*. No matter, for after a hail of political promises and retold jokes, the President waved briskly, climbed aboard, and was off for Pittsburgh—and victory.

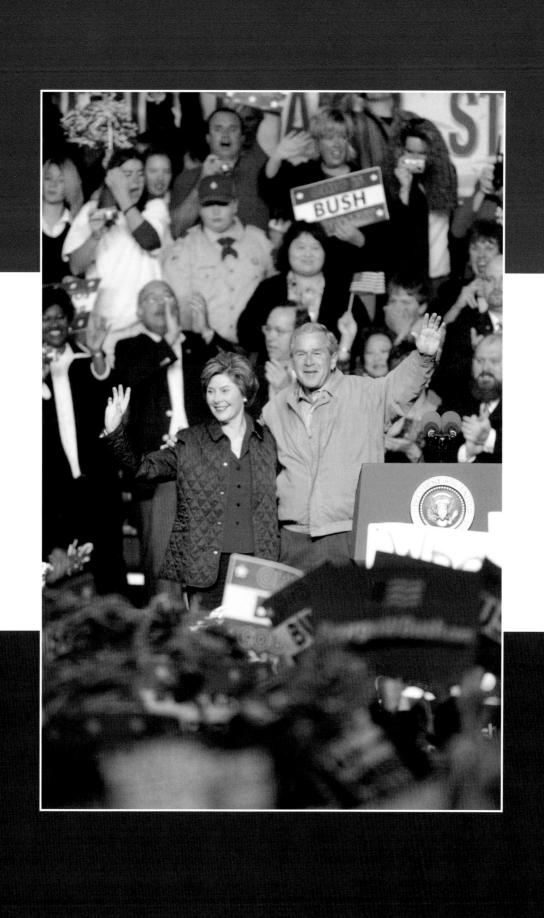

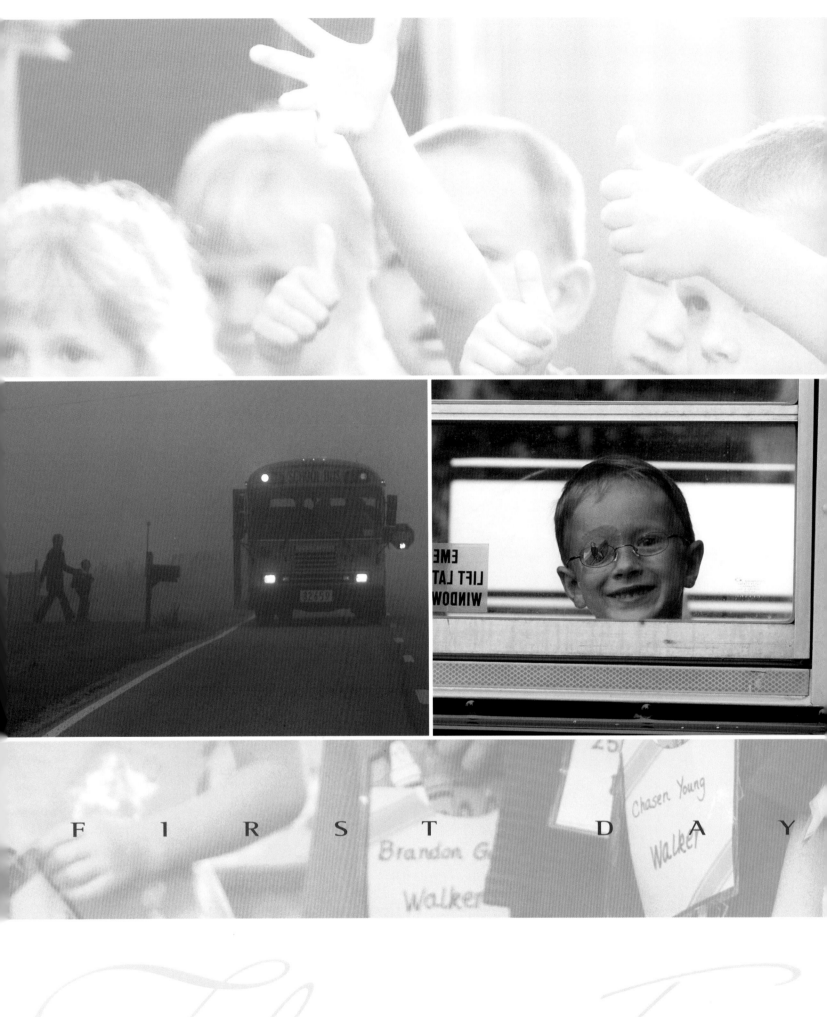

F I R S T D A Y

Of the grand personal events that define us, the First Day at School stands worthy of capitalization. The day launches us into the pursuit of learning: social skills (and lack thereof), peer-group rivalry, misplaced modifiers, the lifelong antipathy to algebra and cafeteria food, and the imbedded ability to recall dates of no particular relevance. (Remember how one's first teacher fell into one of two categories: [1] a celestial creature who is the idealized picture of wisdom, or [2] an old woman with her hair in a bun—she is, say, 36—who taught math to Wilbur Wright?) And so life away from home begins. From left, the bus makes a morning run near Lumberton; Avery Greenlees signals his first day is under control; Gus McCarty surrounded by attentive classmates—and teacher Kristin Sirmans—as he adjusts to his first day at Denver Place Elementary; and the First Day

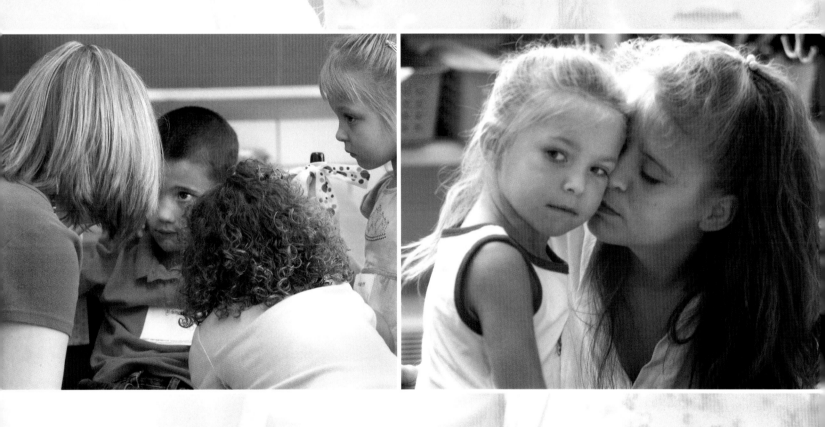

O F S C H O O L

portrait—a mother (Tammy Williams) and her brave daughter (Miranda Cole). The children in the background are Mary O'Boyle's kindergarten students at Denver: Caledonia Crawford, Jade Dalton (behind Caledonia), Brandon Garrett, Connor Reighley, Chasen Young, Calvin Fletcher, Claire Fritz, and Sydney Shumaker.

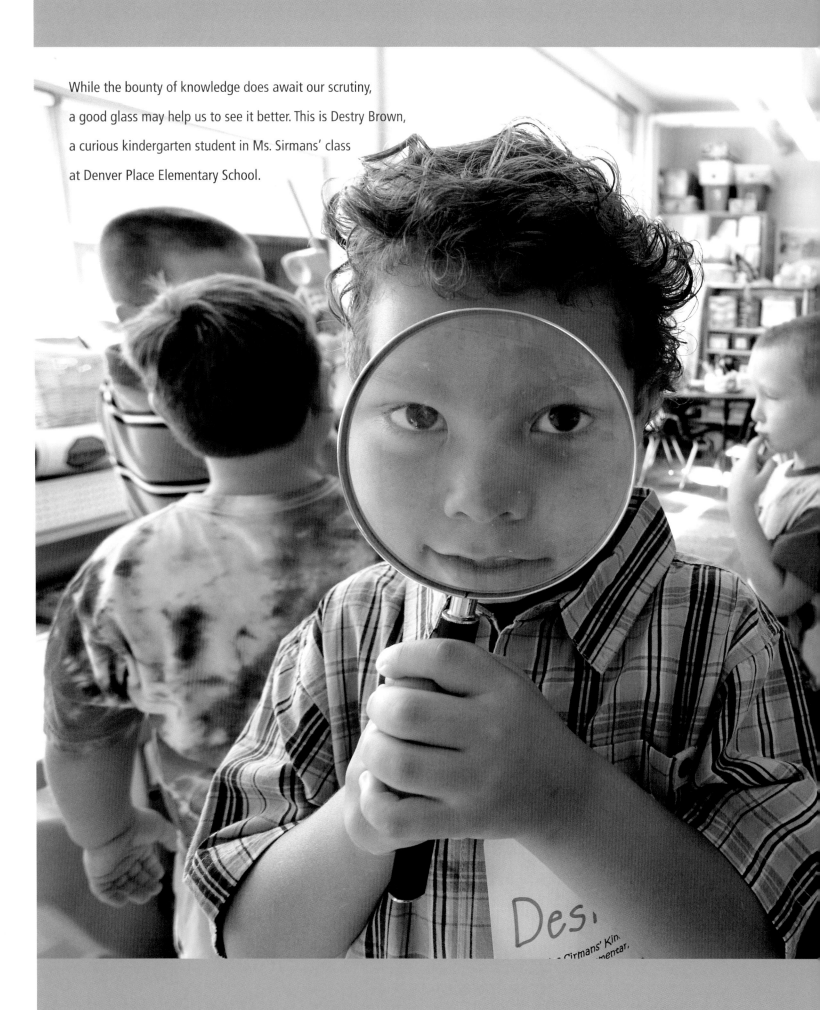

While the bounty of knowledge does await our scrutiny, a good glass may help us to see it better. This is Destry Brown, a curious kindergarten student in Ms. Sirmans' class at Denver Place Elementary School.

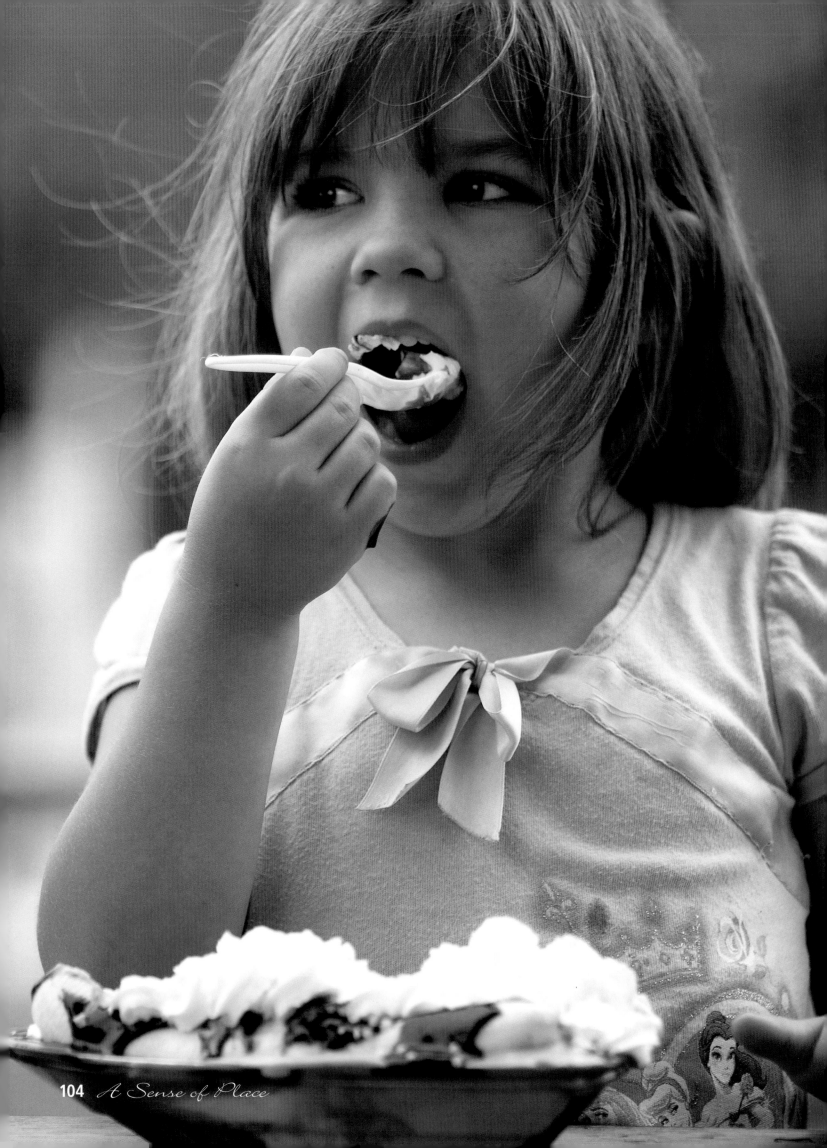

A Sense of Place

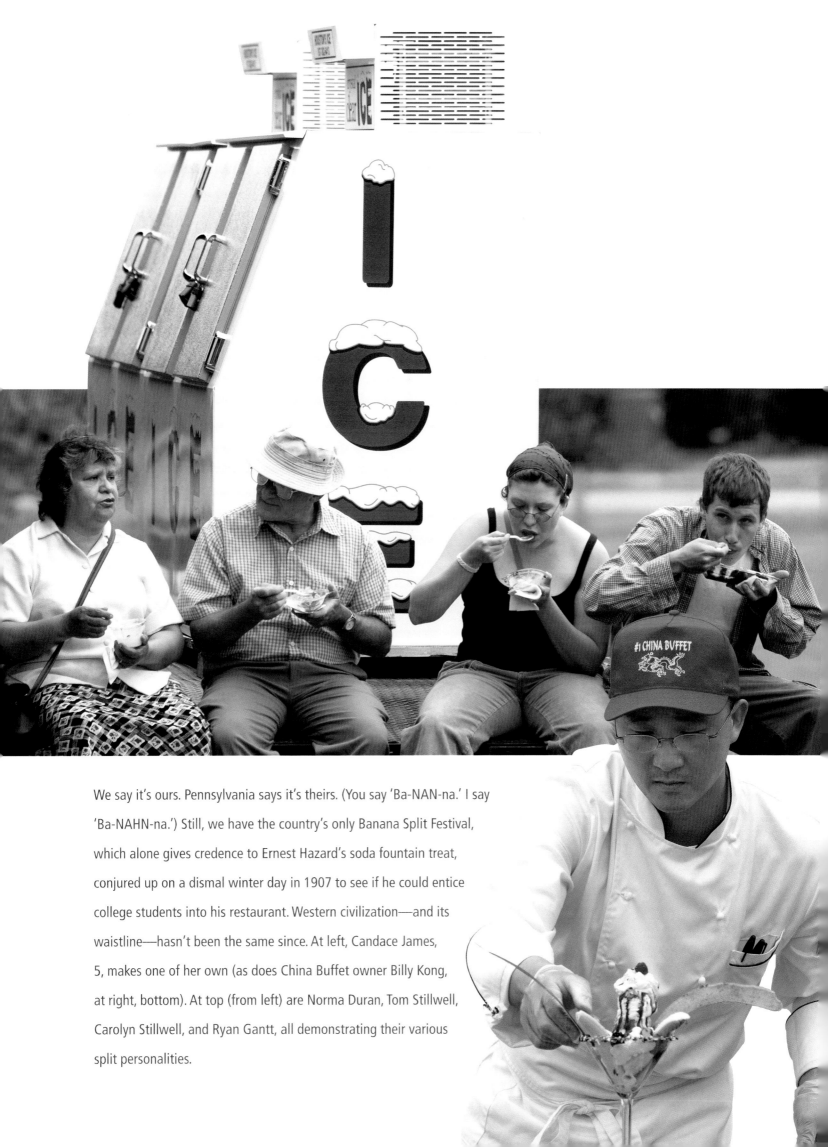

We say it's ours. Pennsylvania says it's theirs. (You say 'Ba-NAN-na.' I say 'Ba-NAHN-na.') Still, we have the country's only Banana Split Festival, which alone gives credence to Ernest Hazard's soda fountain treat, conjured up on a dismal winter day in 1907 to see if he could entice college students into his restaurant. Western civilization—and its waistline—hasn't been the same since. At left, Candace James, 5, makes one of her own (as does China Buffet owner Billy Kong, at right, bottom). At top (from left) are Norma Duran, Tom Stillwell, Carolyn Stillwell, and Ryan Gantt, all demonstrating their various split personalities.

When hometown boy-turned baseball magnate Charlie Murphy finished building his theatre in 1918, the town druggist said of its $250,000 cost, "Charlie, that's a bad investment. It won't pay two percent." Replied Charlie, "Dan, it's not an investment. It's a monument." And so it was. It was a *monument* to Murphy, his hometown, and, unwittingly, to the more than half a century when people came

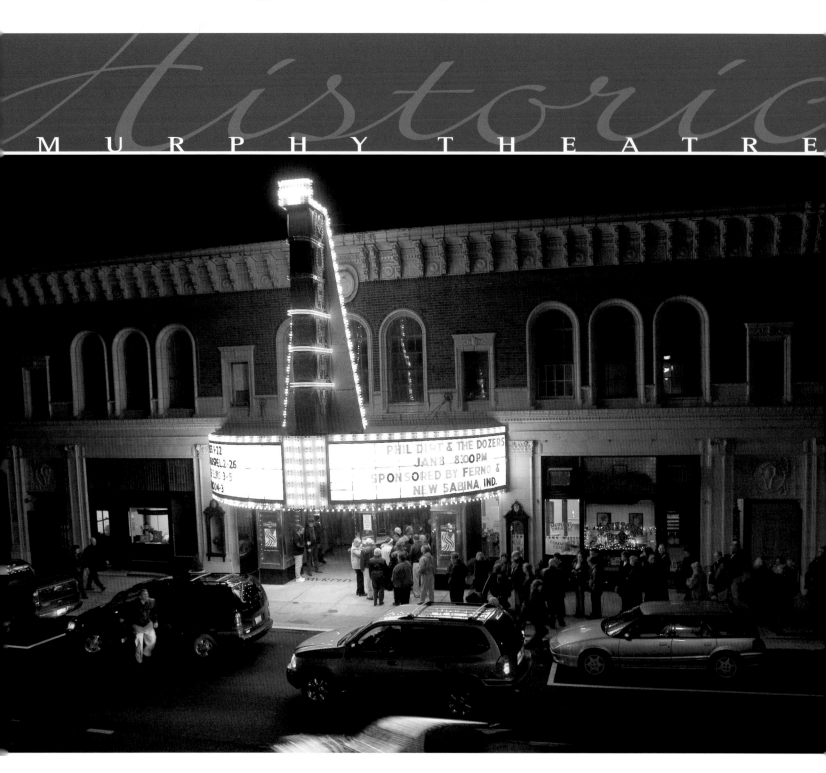

out and sought their entertainment in such monumentally grand buildings. John Philip Sousa gave a concert in the Murphy, Sarah Bernhardt's leading man came to town early then spent the afternoon fishing with Doc Hale, and *The Music Box Revue of 1938* polished its performance here before opening on Broadway. Movies, plays, lectures, high school graduations, concerts.

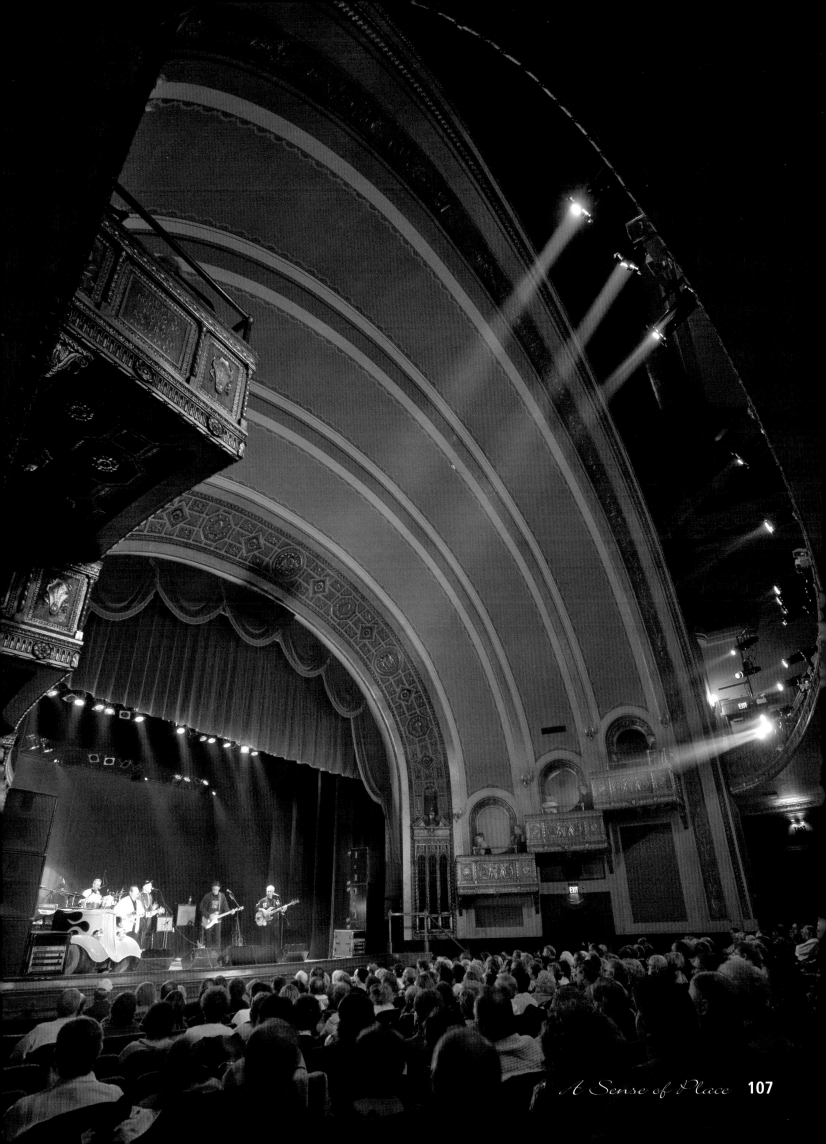

And after all these years, it's still the symbolic heart of the old downtown, renovated into a multipurpose arts center. The old lady can still draw a crowd, and she distinguishes her town with light, architecture, and nearly 90 years of memories. (The wide photographs were taken of the lobby and the interior by Thomas Schiff with his panorama camera.)

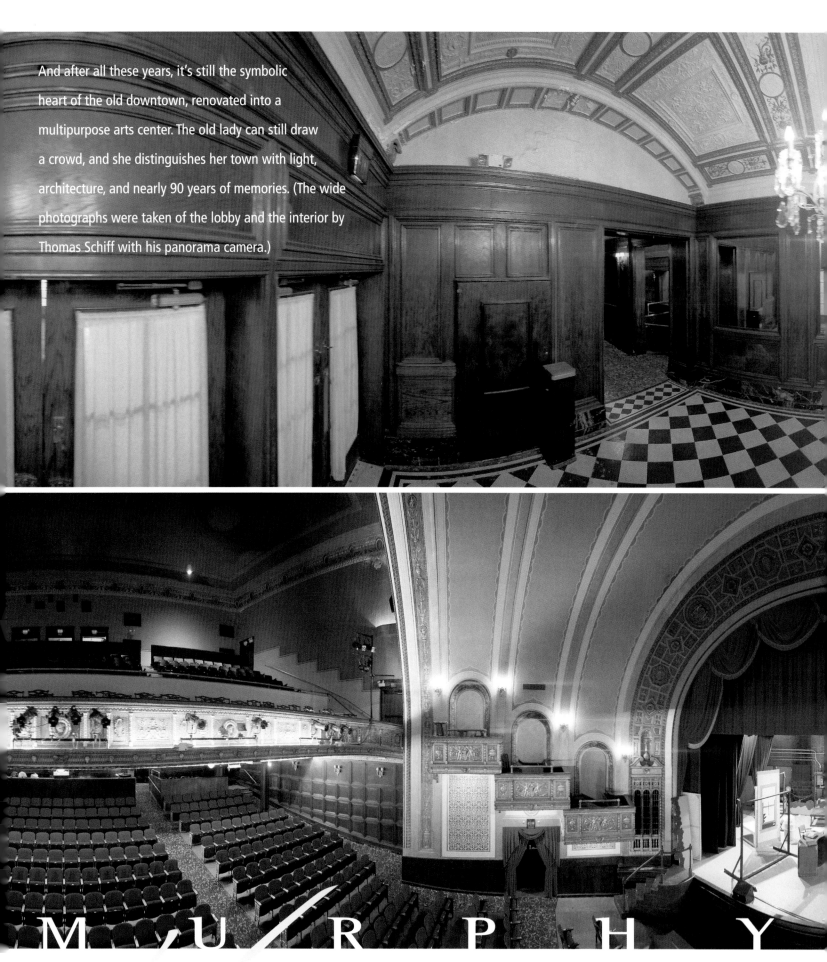

M U R P H Y

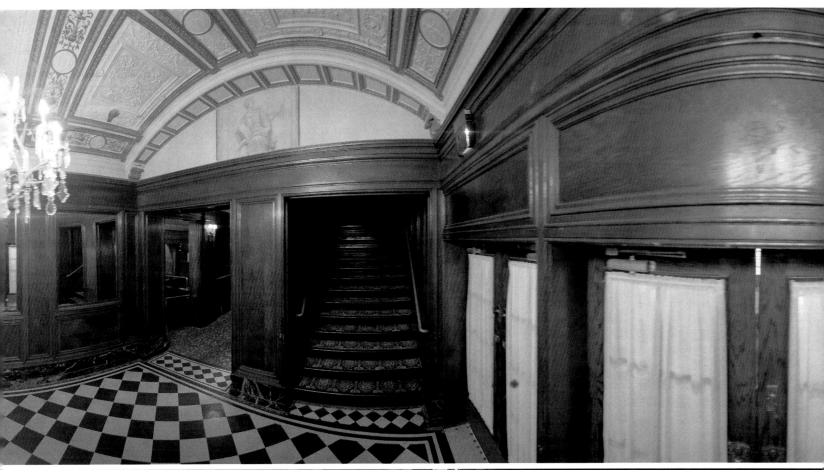

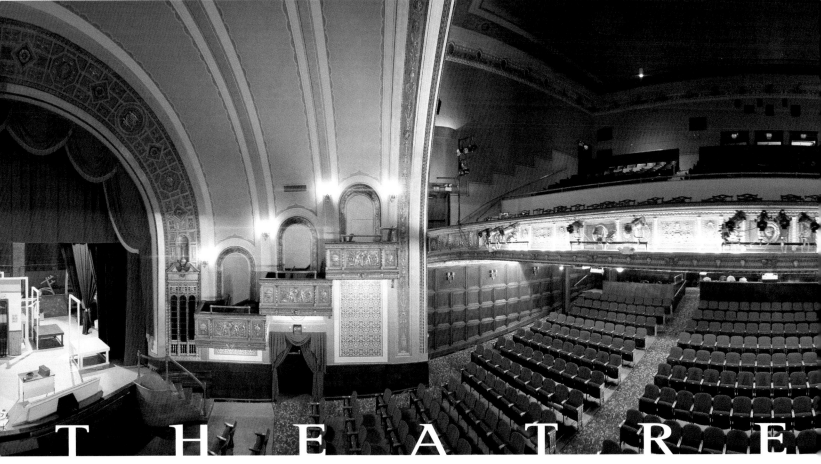

THEATRE

At right, the marquee as centerpiece for

Martha Coolidge's 1993 period film, *Lost in Yonkers*.

The locals straightened up, combed their mustaches,

and for fifteen minutes, we were all famous.

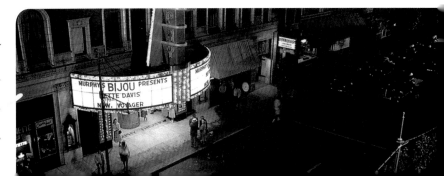

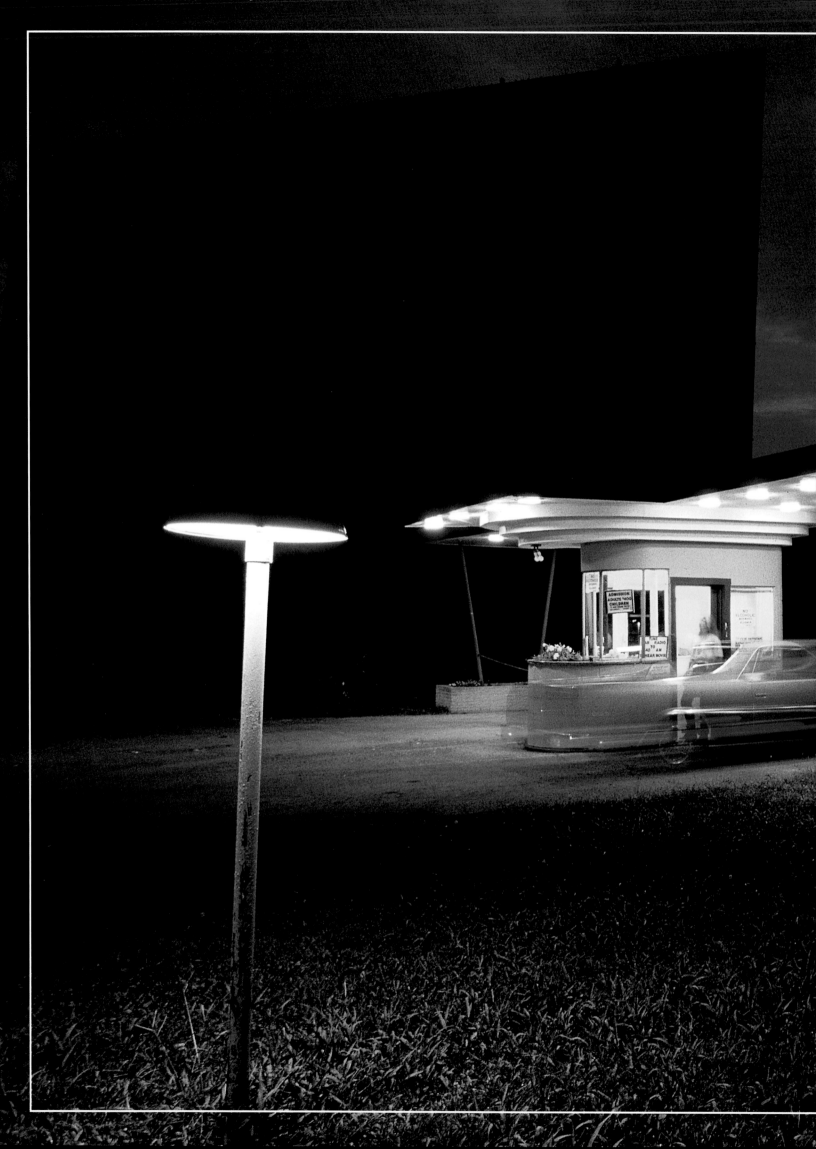

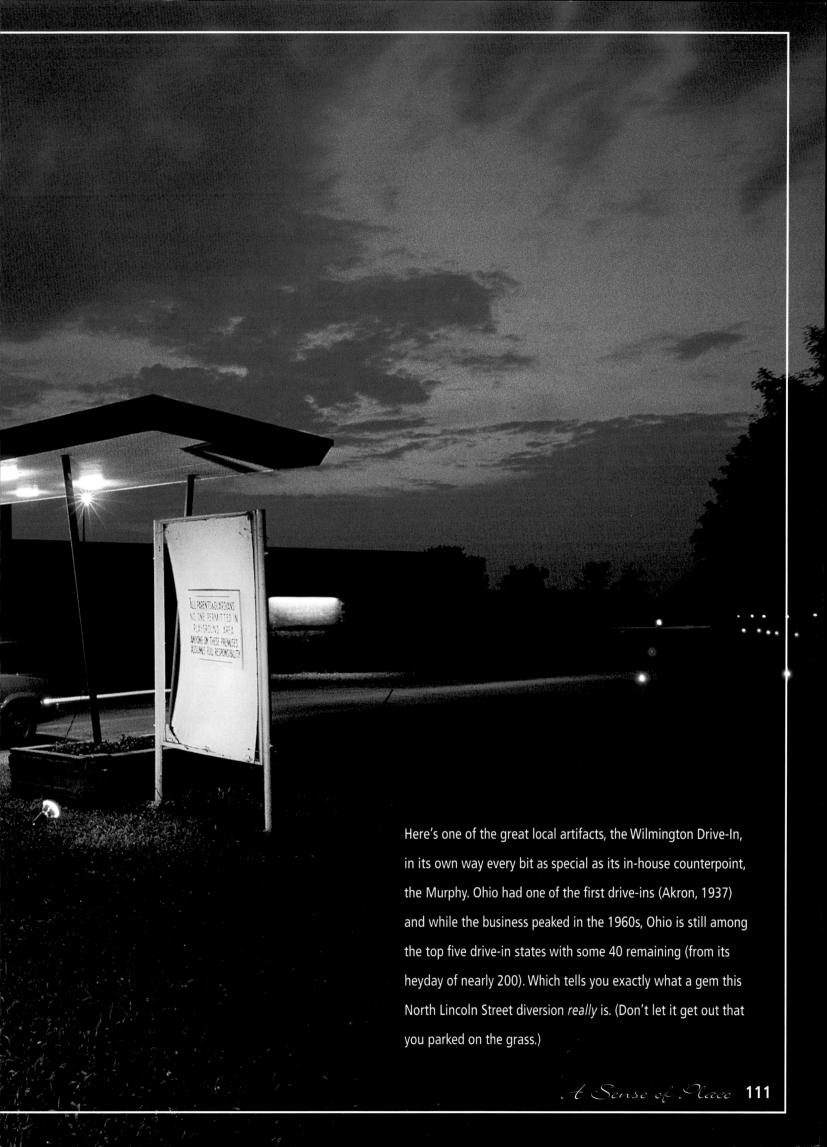

Here's one of the great local artifacts, the Wilmington Drive-In, in its own way every bit as special as its in-house counterpoint, the Murphy. Ohio had one of the first drive-ins (Akron, 1937) and while the business peaked in the 1960s, Ohio is still among the top five drive-in states with some 40 remaining (from its heyday of nearly 200). Which tells you exactly what a gem this North Lincoln Street diversion *really* is. (Don't let it get out that you parked on the grass.)

Nearly a hundred years of surgeries are represented by these three Clinton Memorial Hospital veterans: Dr. Tom Matrka, an orthopedic surgeon; and Dr. Ruth Hayes and Dr. Jack Boyd, now retired general surgeons. Dr. Hayes performed almost 15,000 surgeries in her 31 years (ten per week, not counting vacations). Hernias, appendixes, and gall bladders plague Clinton Countians, with the periodic liver resection, hole in the aorta, trauma injury to bowels and lungs—even a stab wound to the heart (he survived). CMH now has four general surgeons and three orthopedic surgeons with a workload of repair that would make a truck mechanic weak in the knees.

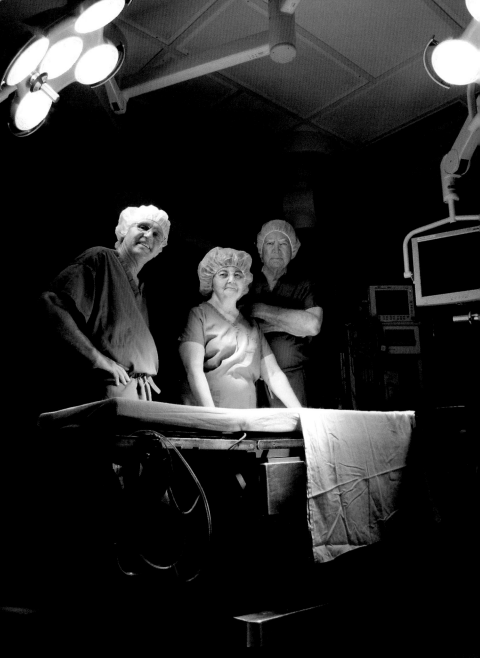

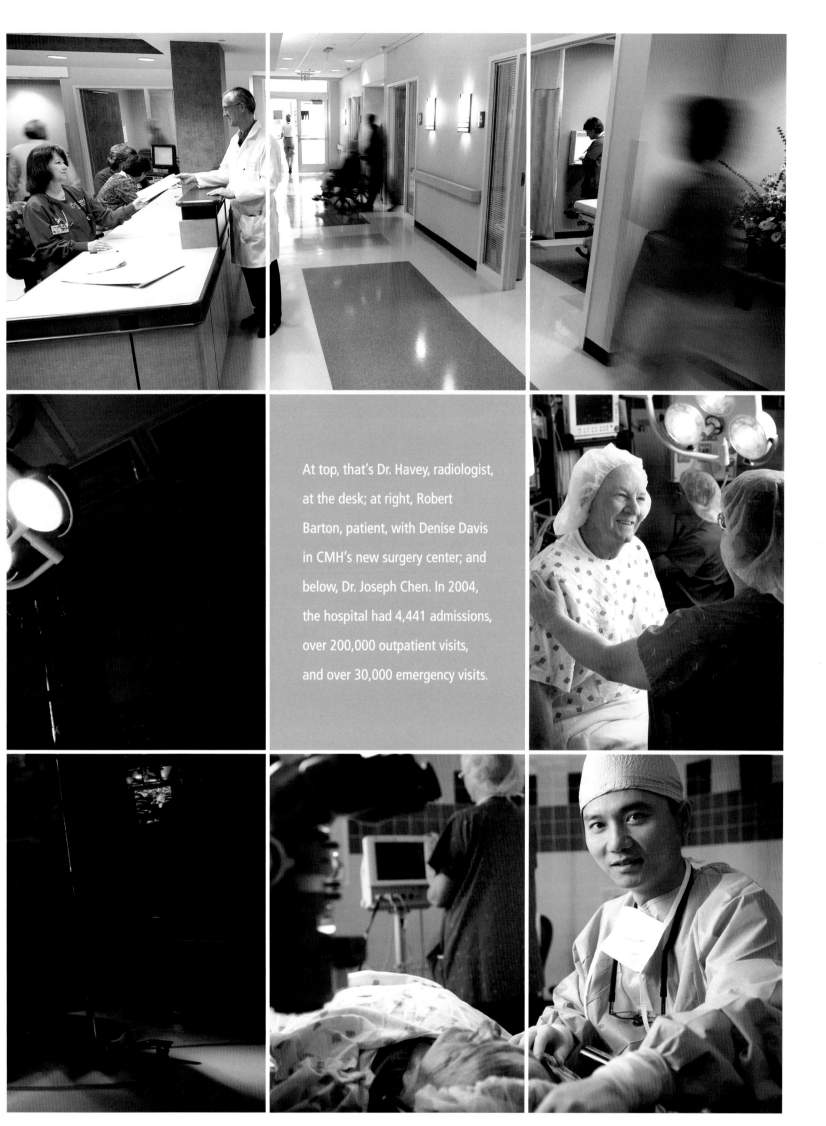

At top, that's Dr. Havey, radiologist, at the desk; at right, Robert Barton, patient, with Denise Davis in CMH's new surgery center; and below, Dr. Joseph Chen. In 2004, the hospital had 4,441 admissions, over 200,000 outpatient visits, and over 30,000 emergency visits.

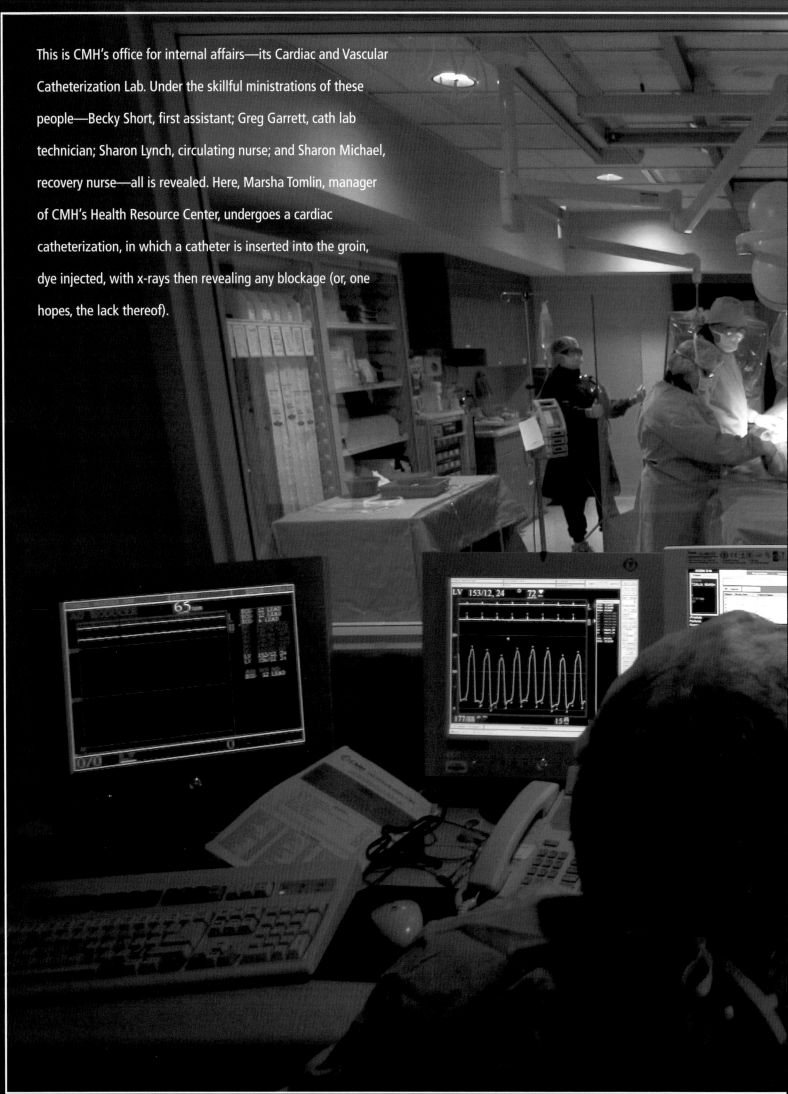

This is CMH's office for internal affairs—its Cardiac and Vascular Catheterization Lab. Under the skillful ministrations of these people—Becky Short, first assistant; Greg Garrett, cath lab technician; Sharon Lynch, circulating nurse; and Sharon Michael, recovery nurse—all is revealed. Here, Marsha Tomlin, manager of CMH's Health Resource Center, undergoes a cardiac catheterization, in which a catheter is inserted into the groin, dye injected, with x-rays then revealing any blockage (or, one hopes, the lack thereof).

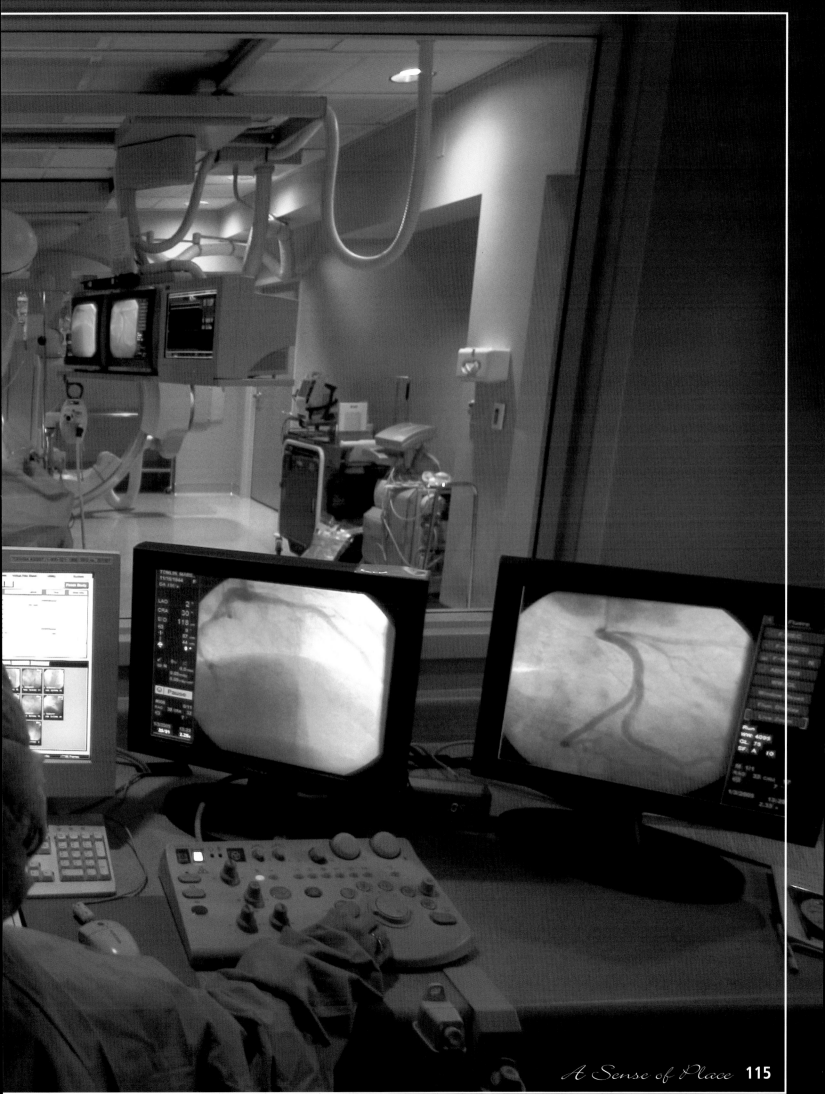

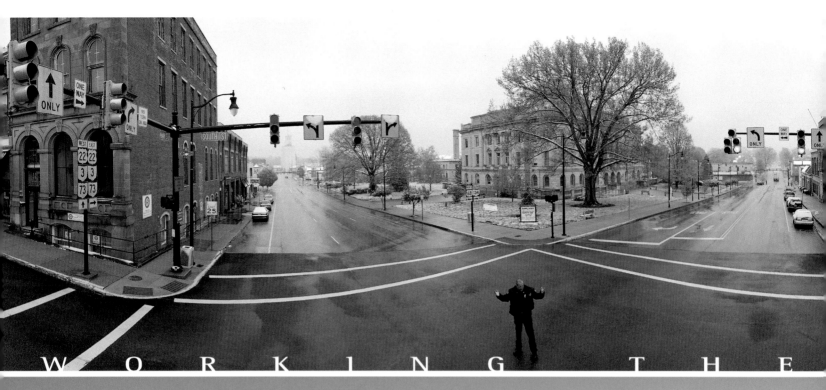

W O R K I N G T H E

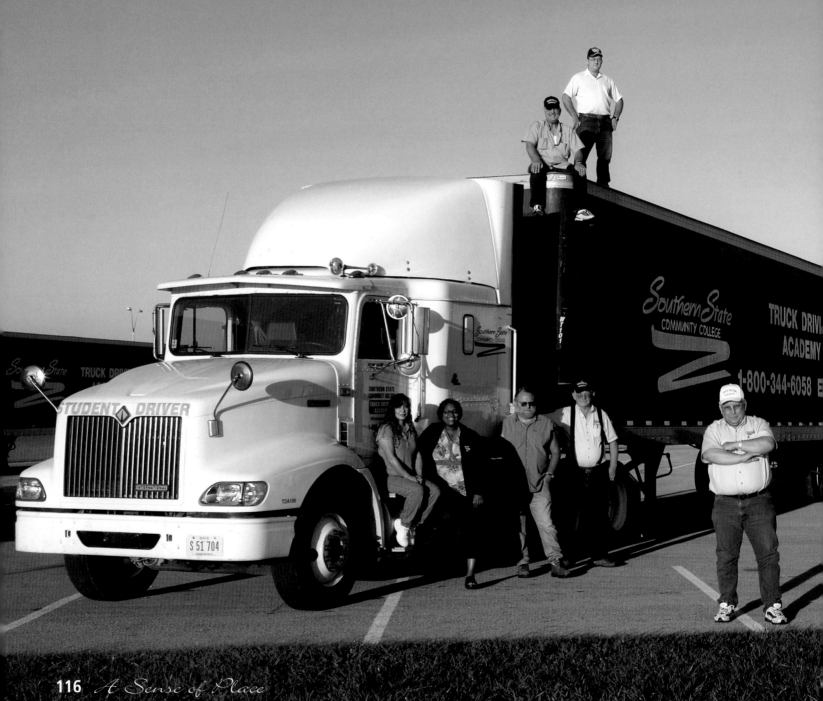

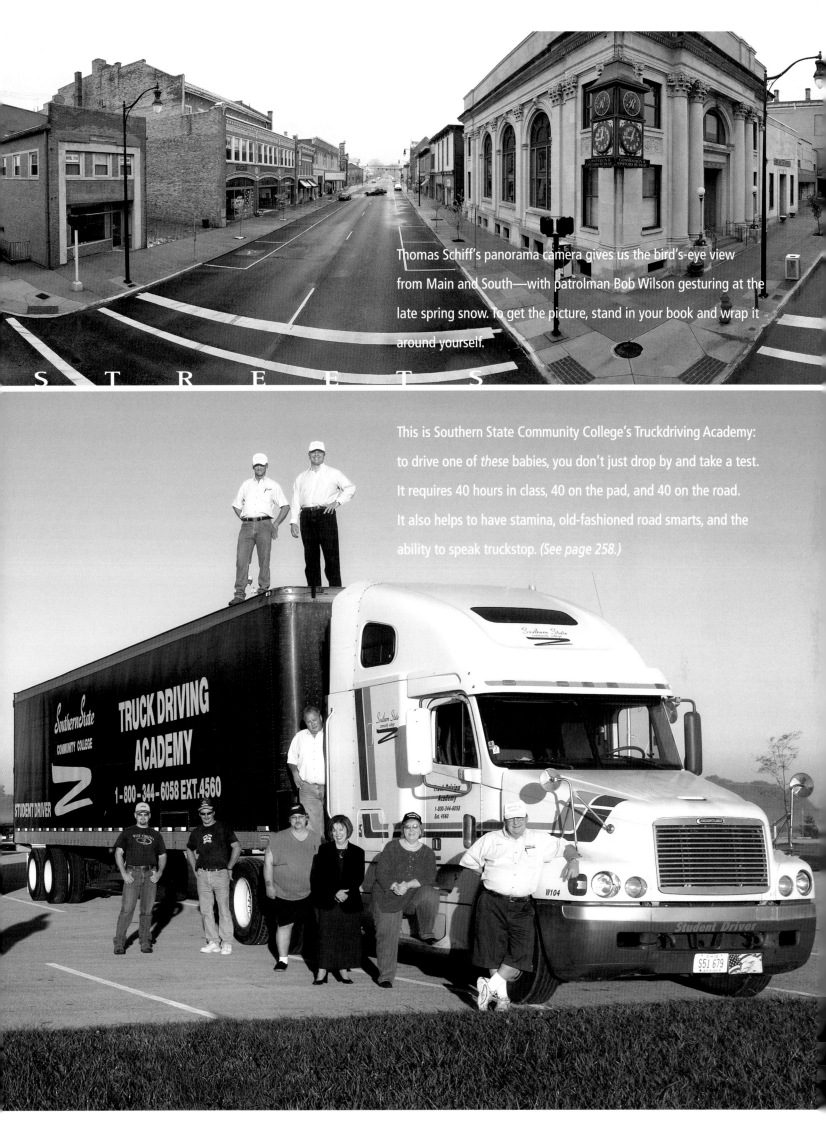

Thomas Schiff's panorama camera gives us the bird's-eye view from Main and South—with patrolman Bob Wilson gesturing at the late spring snow. To get the picture, stand in your book and wrap it around yourself.

S T R E E T S

This is Southern State Community College's Truckdriving Academy: to drive one of *these* babies, you don't just drop by and take a test. It requires 40 hours in class, 40 on the pad, and 40 on the road. It also helps to have stamina, old-fashioned road smarts, and the ability to speak truckstop. *(See page 258.)*

Two of the county's grandest institutions, both—sadly—gone. That's
Dr. Nathan Hale (below), the surgeon whose father began the first hospital
here. Behind him is the splendid old William Cleveland-designed Main School,
which fell into disrepair, it was said, because of internal budget
considerations over a $20 downspout.

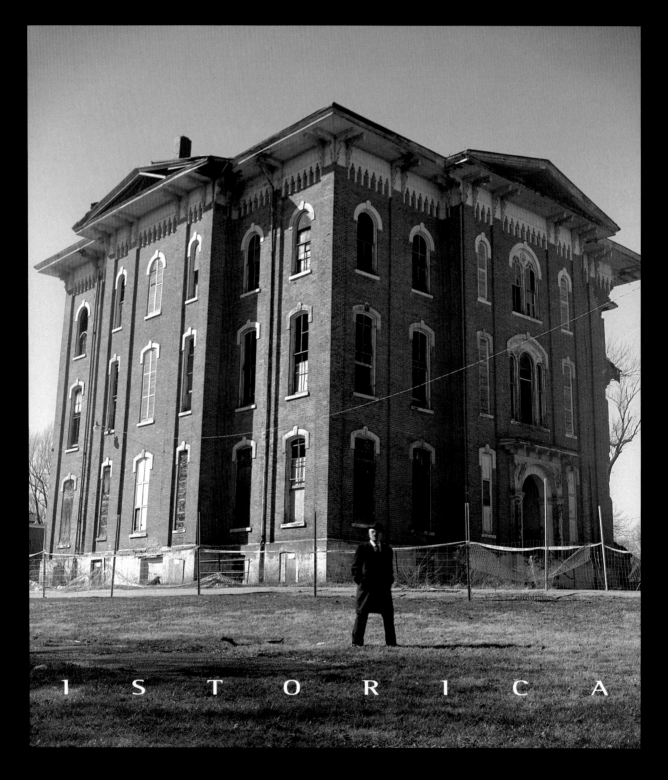

H I S T O R I C A L

Madame Kay Fisher, an exhibit herself, shows off part of the vintage clothing
collection at the Clinton County Historical Society. It's extensive and rather
extraordinary even for a large museum, representing the best of what the
Midwest wore in most of two centuries. It also includes some designer pieces.
The folks here do *occasionally* get out of town.

S O C I E T Y

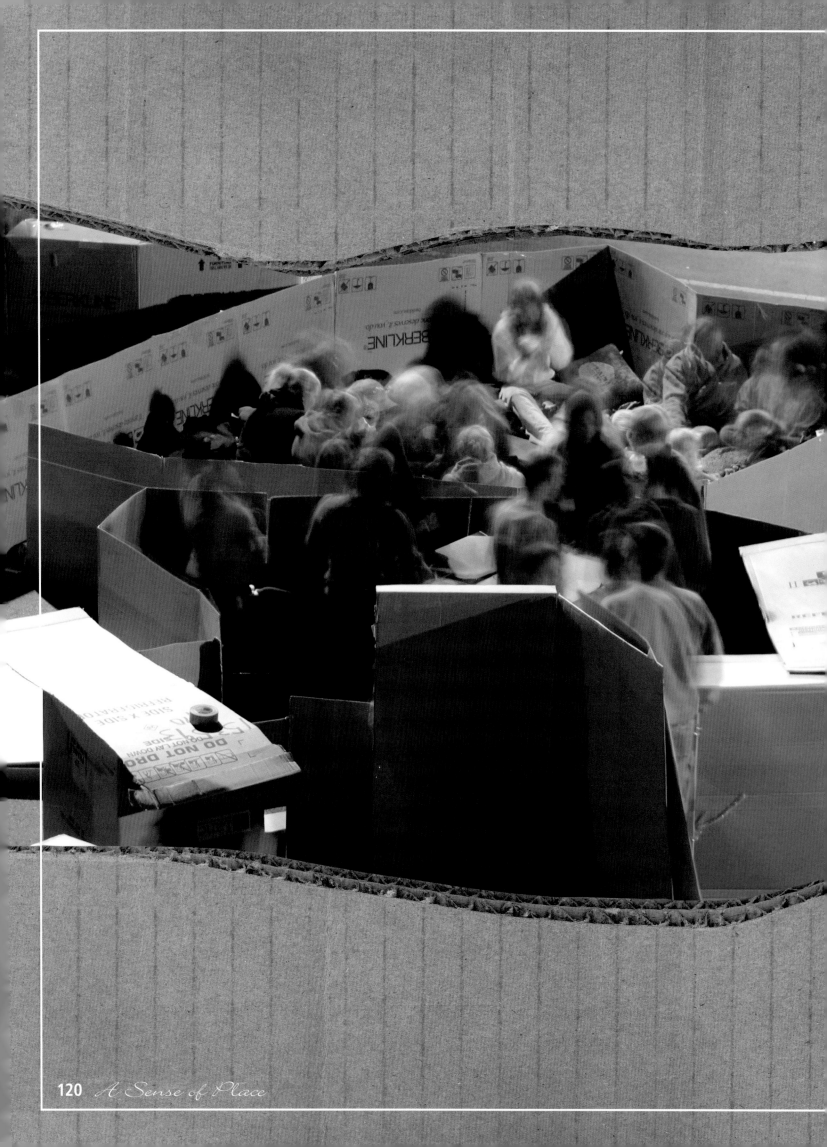

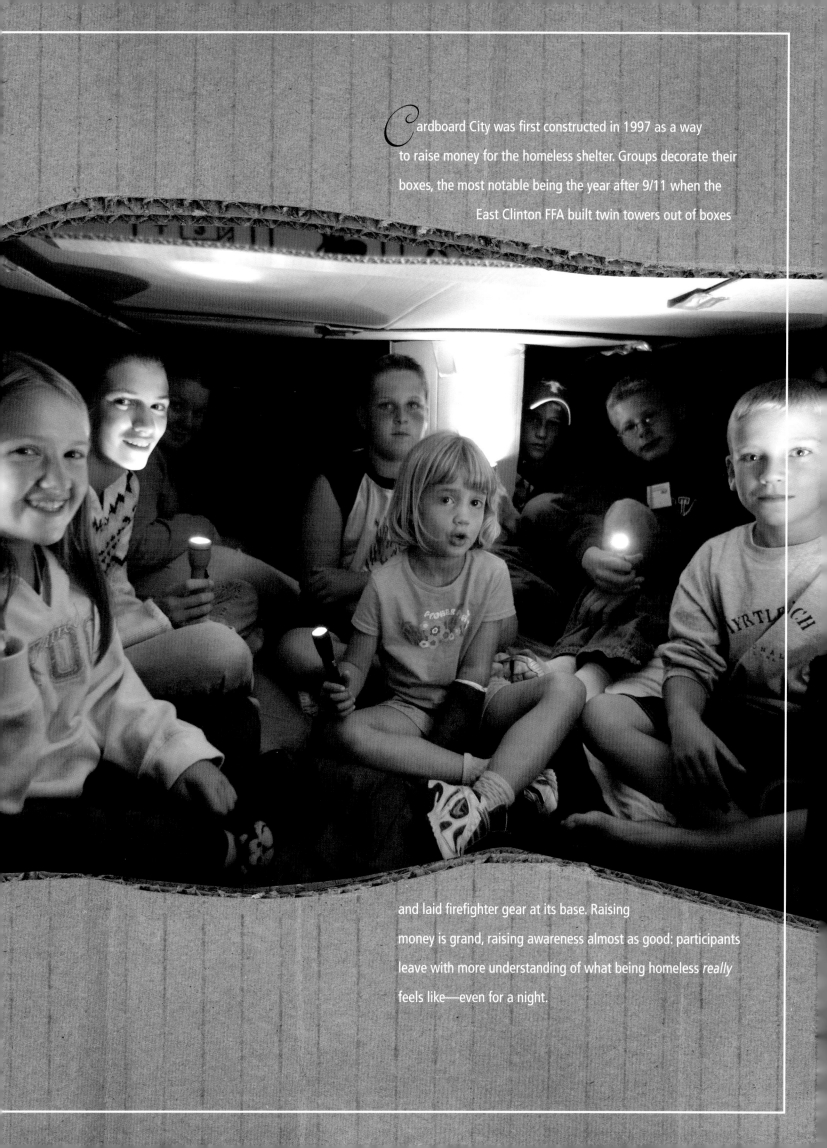

*C*ardboard City was first constructed in 1997 as a way to raise money for the homeless shelter. Groups decorate their boxes, the most notable being the year after 9/11 when the East Clinton FFA built twin towers out of boxes

and laid firefighter gear at its base. Raising money is grand, raising awareness almost as good: participants leave with more understanding of what being homeless *really* feels like—even for a night.

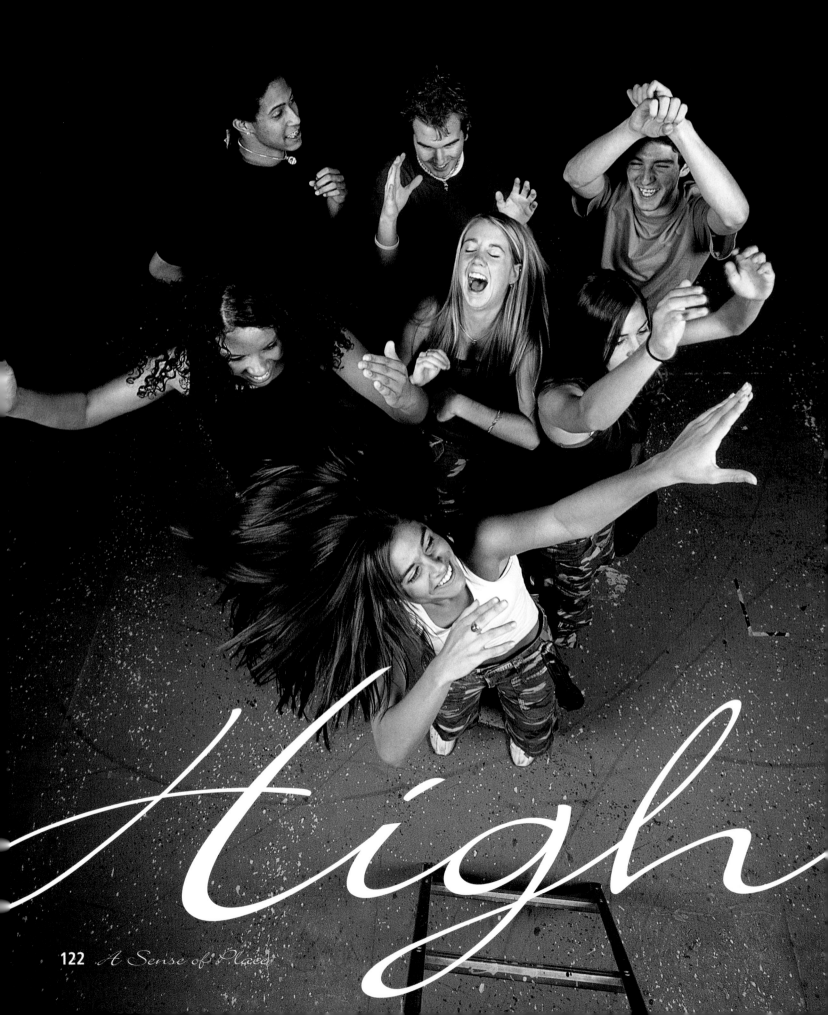

High

A Sense of Place

Two pictures as metaphor for high school life—organic chemistry (below) and personal chemistry (at left). The two facets of school life are the academic and the extracurricular. The former is the study of chemical compounds; the latter the quest to convert base elements into happy feet. Judith Johnston (below, and center), a National Board-certified teacher at Wilmington High, is seen here with students Saleena Speelman and Jacob Green. The WHS hip-hop dancers are (in rear, from left) Terence Harding, Ben VanPelt, and Petey Camacho, then (in middle) Cierra Arrington, Kelly Holmer, and Tara Atsalis. Allison Atsalis is in foreground.

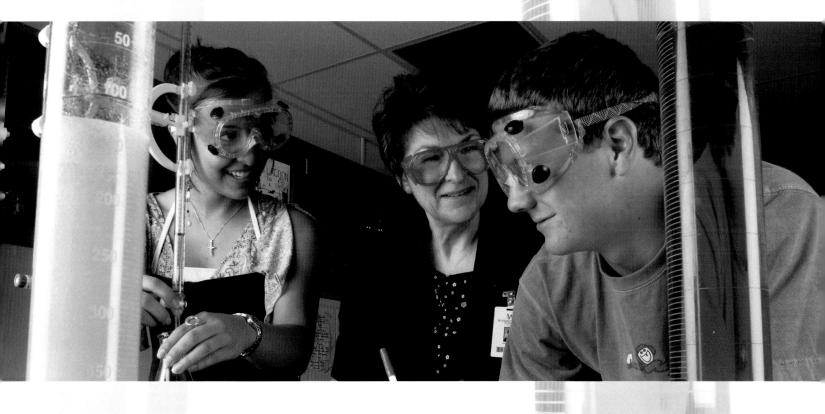

school

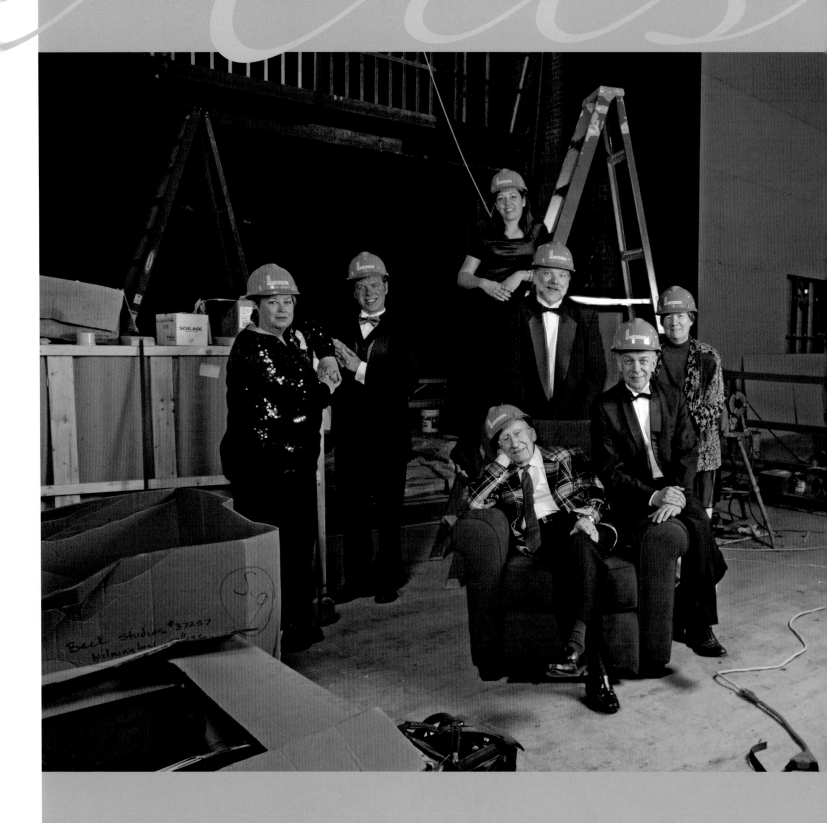

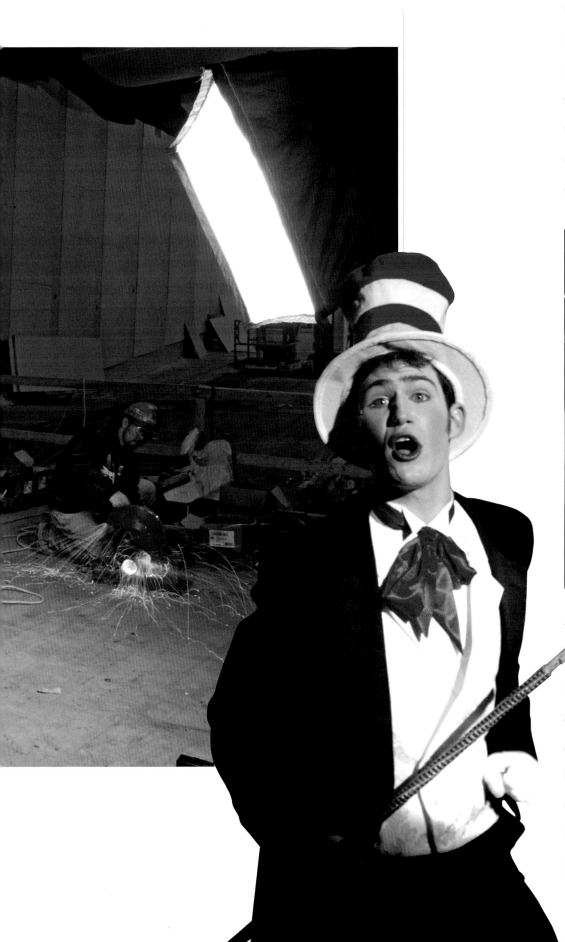

The before (at left) and after (below) of the Hugh G. Heiland Theatre of Wilmington College's new Oscar F. Boyd Cultural Arts Center. That's the dean himself, Sir Heiland (in the chair), with his loyal—and unspeakably talented—retinue who have been doing theatre here since he taught most of them how. At far left, Faye Mahaffey,

Timothy Larrick, and Tricia Heys (on ladder). J. Wynn Alexander (behind Hugh), Steven Haines (on chair arm), and Becky Haines. And the cut-up at far right is Brian Senters, who helped build the place. (See page 259 for others.) The foreground cat in the hat is Michael DiBiasio from Steven Haines' production of Seussical.

The Beautiful Campus of

COLLEGE

Wilming

This is the pastoral landscape of Wilmington College, a Quaker school of some 1,000 on-campus students. To see it today, one would never suspect that in 1871, the first president lived in a makeshift apartment on the third floor of College Hall with his family—who made up the entire faculty.

ton

At left, a serene picture of mid-campus as students walk past the library (is this, too, a metaphor?); College Hall is at right (and may also be seen in photo at left, to the right of the library); the Library (of course) at right, and at bottom, Kettering Hall.

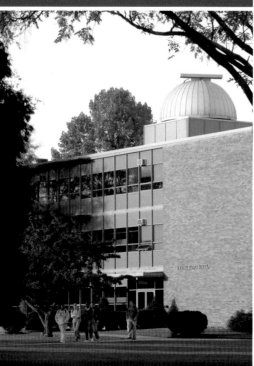

The college frat-and-sorority scene is a fundamental rite of passage in which members learn the value of important social rituals such as bed racing and water polo. The various Greeks range from Greek jocks to Greek geeks and feature at least one illustrious official still notorious for his own ritual, known locally as "the pressed ham." Pie boy is Adam Iannaggi of Gamma Phi Gamma (AKA the Gobblers) and the bed race team is made up of Gobblers and Delta Omega Theta sorority.

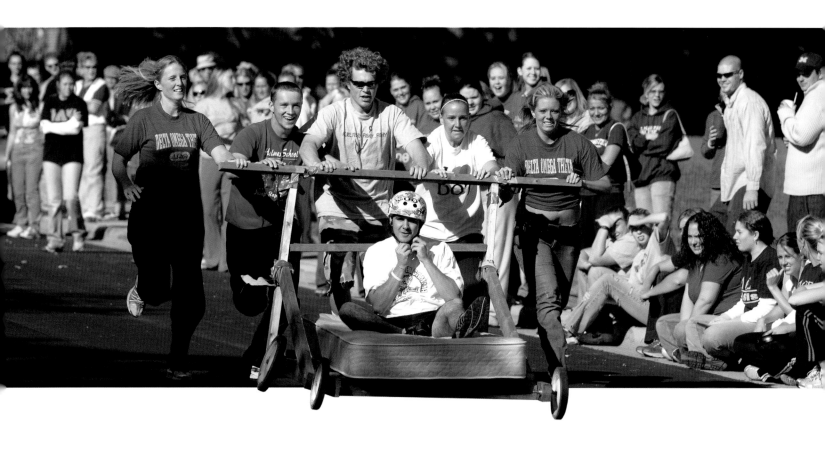

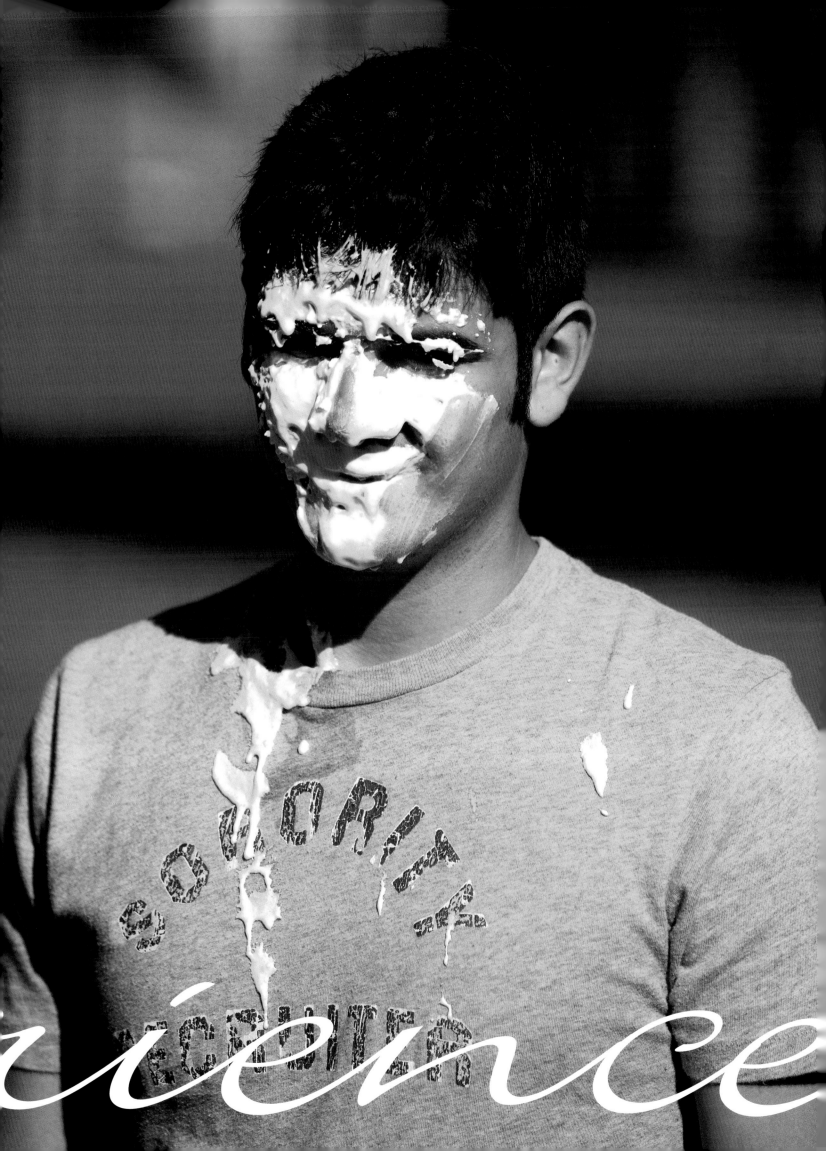

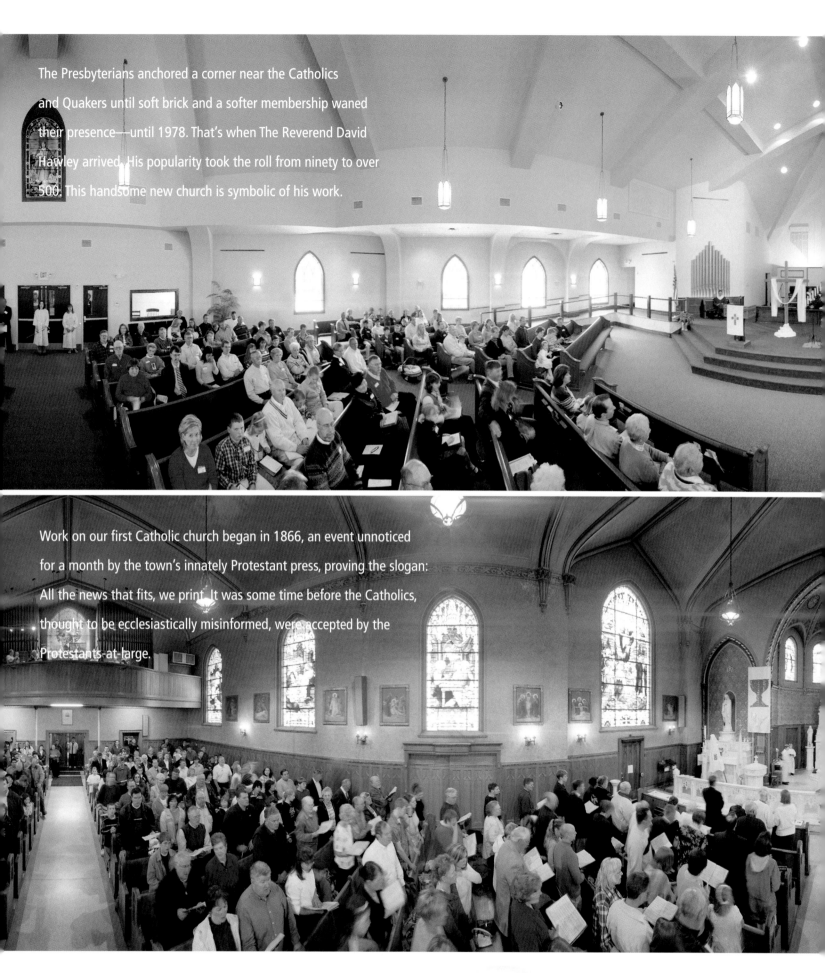

The Presbyterians anchored a corner near the Catholics and Quakers until soft brick and a softer membership waned their presence—until 1978. That's when The Reverend David Hawley arrived. His popularity took the roll from ninety to over 500. This handsome new church is symbolic of his work.

Work on our first Catholic church began in 1866, an event unnoticed for a month by the town's innately Protestant press, proving the slogan: All the news that fits, we print. It was some time before the Catholics, thought to be ecclesiastically misinformed, were accepted by the Protestants-at-large.

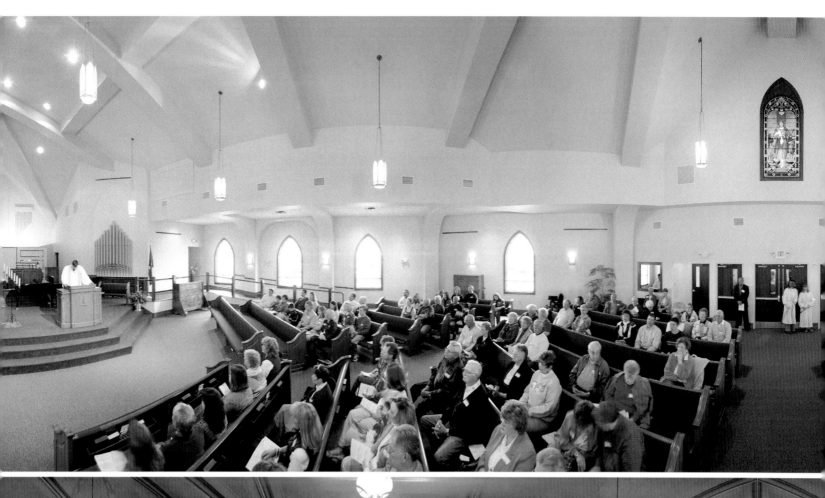

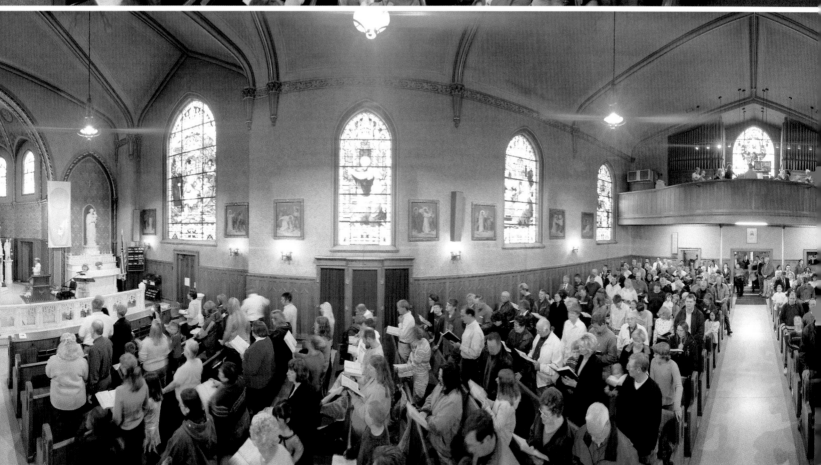

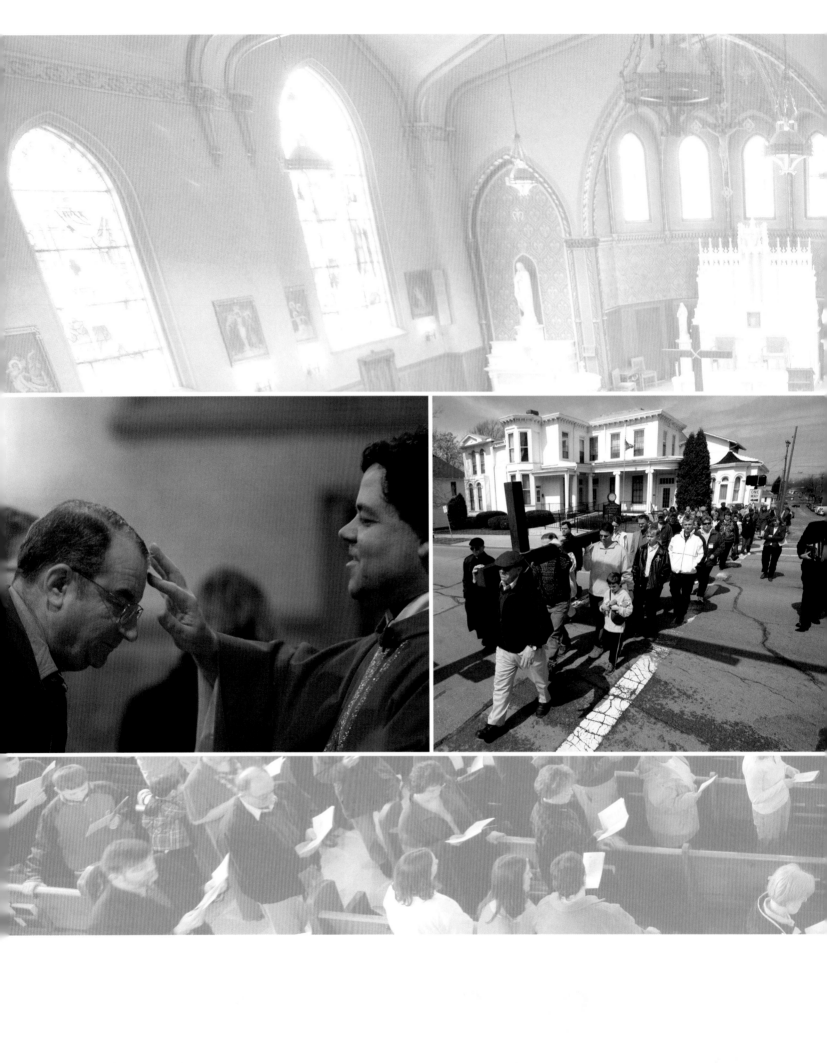

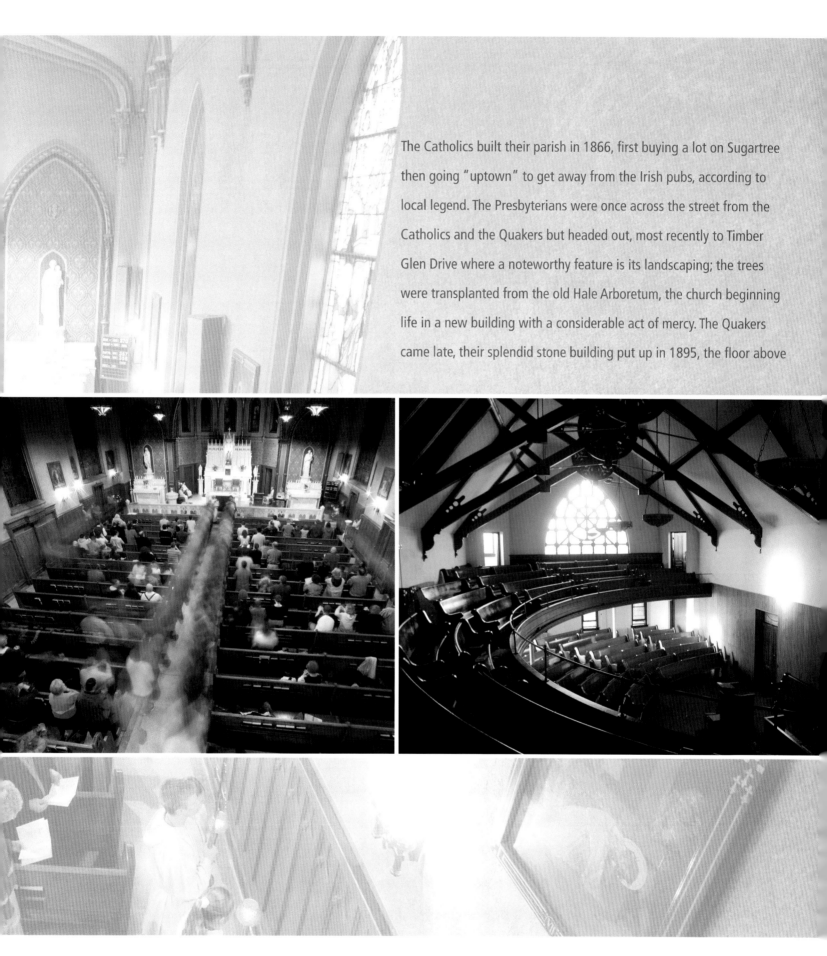

The Catholics built their parish in 1866, first buying a lot on Sugartree then going "uptown" to get away from the Irish pubs, according to local legend. The Presbyterians were once across the street from the Catholics and the Quakers but headed out, most recently to Timber Glen Drive where a noteworthy feature is its landscaping; the trees were transplanted from the old Hale Arboretum, the church beginning life in a new building with a considerable act of mercy. The Quakers came late, their splendid stone building put up in 1895, the floor above street level, it was said, so rimmed wheels of wagons on granite pavers wouldn't ruin the Sunday silence. Father James Wedig (right) places ashes on Dan Murtland (left) during Ash Wednesday at Saint Columbkille; the ecumenical Good Friday services and the walking of the cross; Saint Columbkille services; and the Friends Church sanctuary.

Twice a day, the weather balloon goes up—to 100,000 feet, measuring the upper atmosphere. It's an event coordinated around the world, which translates into 7 a.m. and 7 p.m. for the local technicians at the National Weather Service. Which is not located here because of the weather, but the geography—it's strategically placed amidst major metro areas and serves 52 counties in three states. And if you think the phrase, "If you don't like the local weather, wait five minutes," belongs only to us here in weather-whimsical Ohio, technician Don Hughes will tell you he's heard it every place he's ever been.

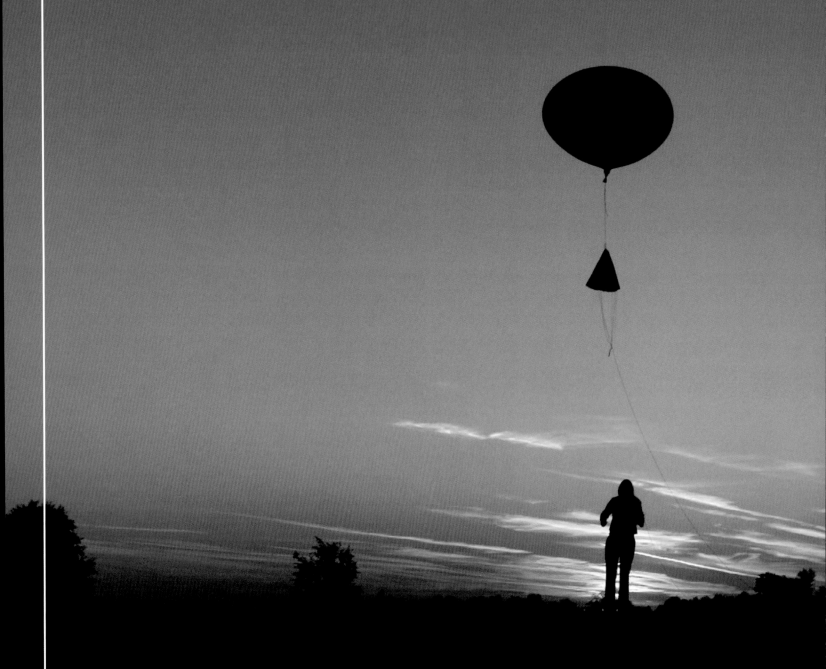

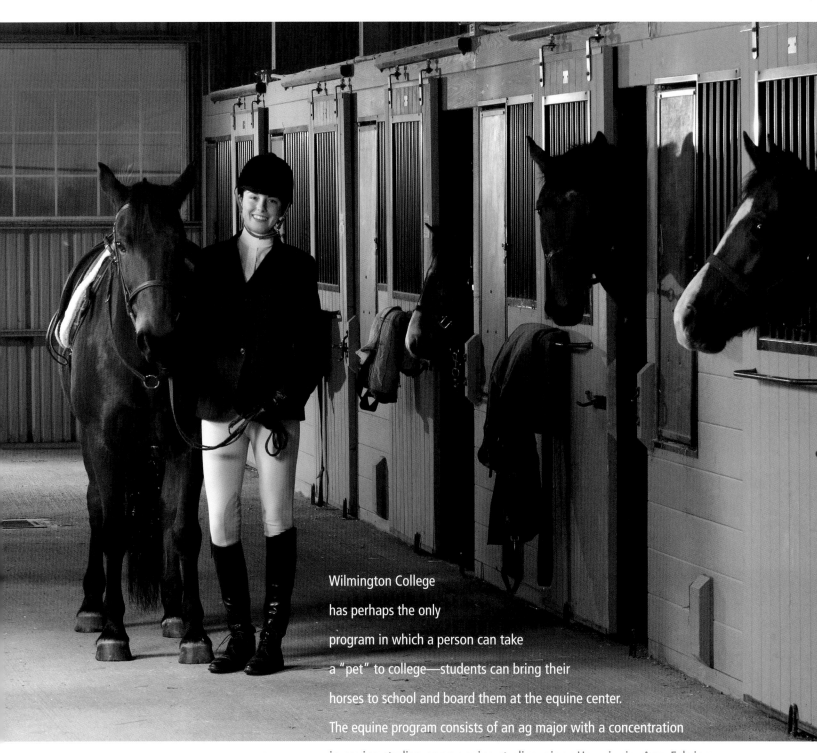

Wilmington College
has perhaps the only
program in which a person can take
a "pet" to college—students can bring their
horses to school and board them at the equine center.
The equine program consists of an ag major with a concentration
in equine studies, or an equine studies minor. Here, junior Amy Fehring
is dressed for English-style riding.

Sports of

ad anyone in county sports ever brought home a national title
before? The Quaker footballers *almost* did it when Bill Ramseyer
coached them. Anyway, now someone had—the 2004 Wilmington
College women's basketball team. They did it in dramatic fashion,
too, winning the Division III title with six losses in the season, the
most of any champion since 1983. It was the Lady Quakers' third

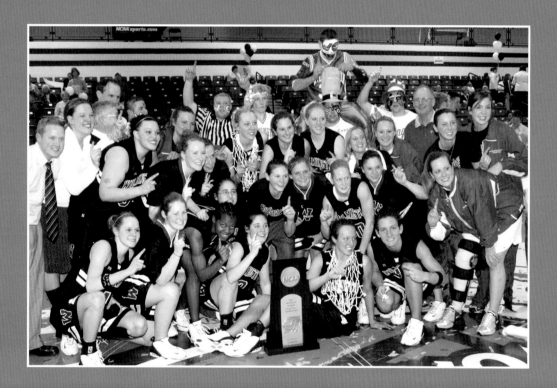

straight NCAA Tournament appearance; in 2003 they made the
Sweet Sixteen and the year before that, the Elite Eight. For the
title, they beat Bowdoin, the number one team in the nation,
59-53. Tara Rausch, meantime (back row, center, wearing the net),
had 16 points in the title game, as well as seven rebounds,
two assists, two steals, and two blocked shots. Not a bad way
to end her All-American career.

All Sorts

They come now to see the local hero, Marque Jones the younger. A few years back, it was "Q" the elder—Markie's dad, also a star receiver for the Quakers. As for the position, Q the elder admits only that the kid is faster. "After the fifth grade," he says, "it was all over. But to get him, I say, 'Let's do some 800 meters

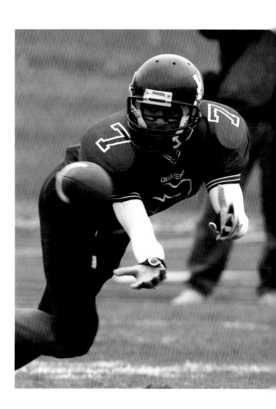

or a mile...'" Markie's speed helped him to 6th place in the long jump at the spring indoor NCAA Division III nationals—the first WC long jumper to be All-American.

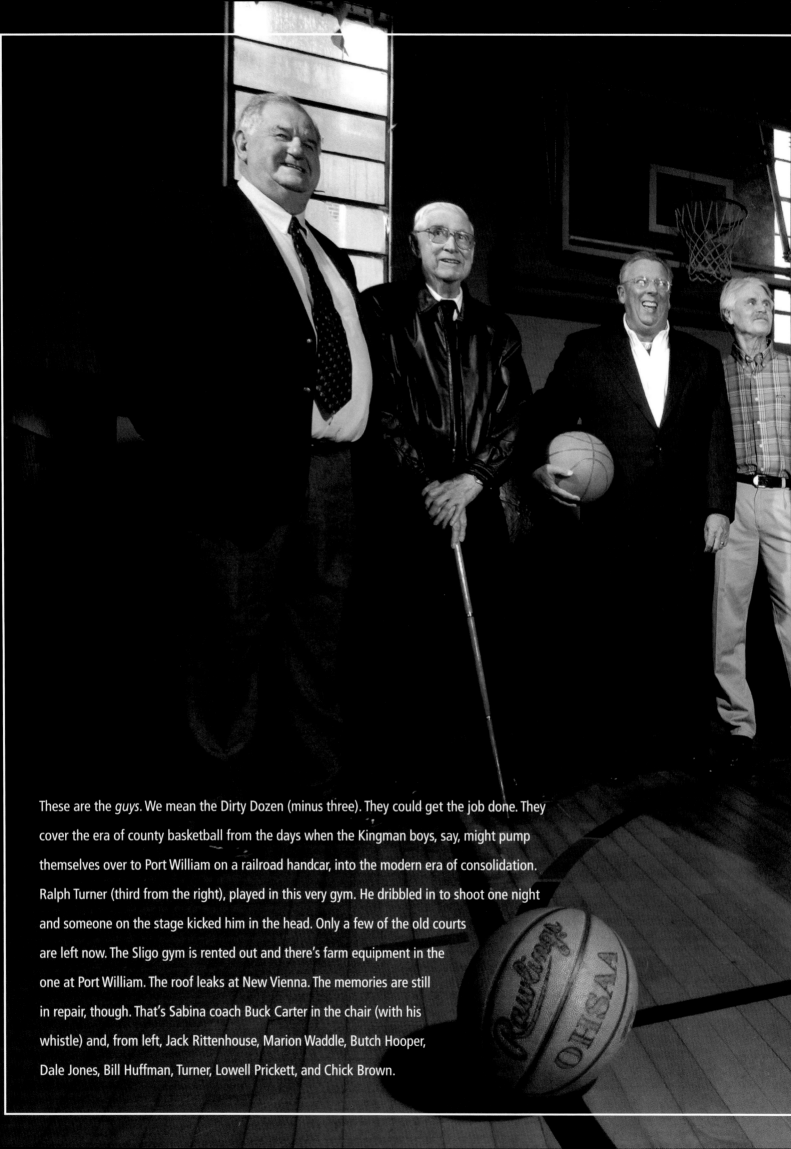

These are the *guys*. We mean the Dirty Dozen (minus three). They could get the job done. They cover the era of county basketball from the days when the Kingman boys, say, might pump themselves over to Port William on a railroad handcar, into the modern era of consolidation. Ralph Turner (third from the right), played in this very gym. He dribbled in to shoot one night and someone on the stage kicked him in the head. Only a few of the old courts are left now. The Sligo gym is rented out and there's farm equipment in the one at Port William. The roof leaks at New Vienna. The memories are still in repair, though. That's Sabina coach Buck Carter in the chair (with his whistle) and, from left, Jack Rittenhouse, Marion Waddle, Butch Hooper, Dale Jones, Bill Huffman, Turner, Lowell Prickett, and Chick Brown.

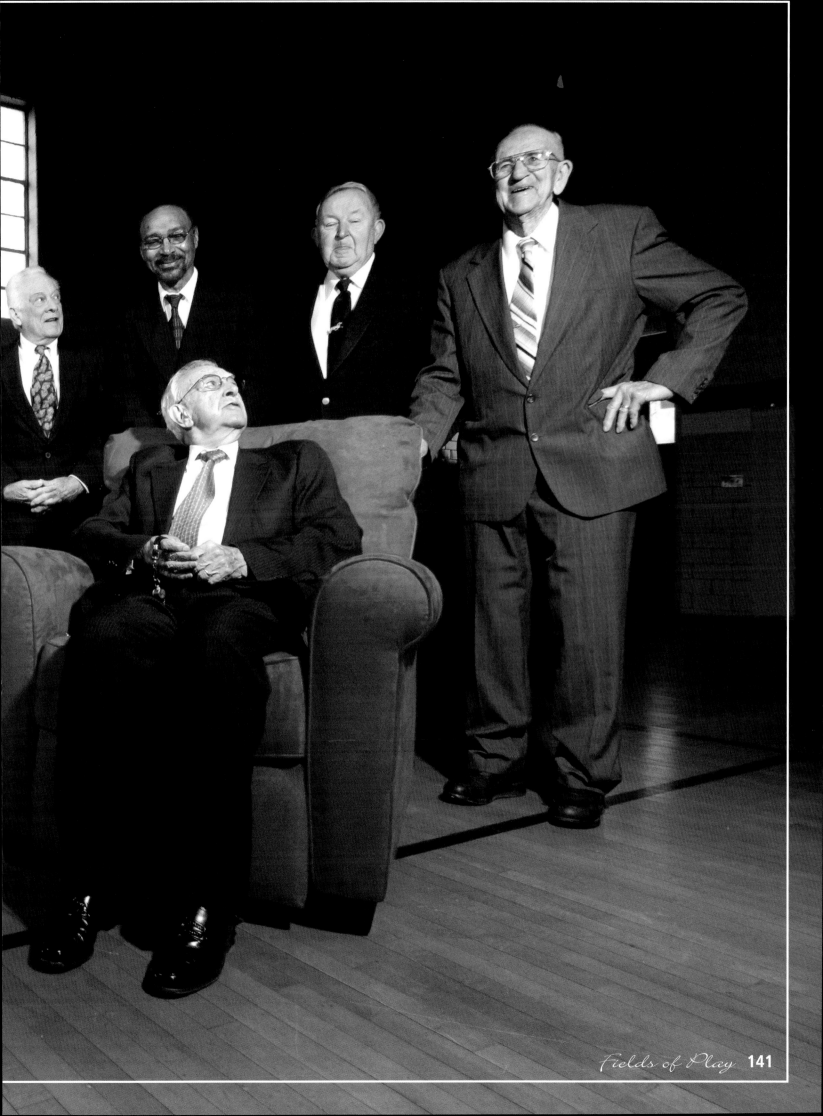

The water-lovers turn out faithfully at the YMCA, for a variety of reasons ranging from arthritis to floating meditation. They like the water above 80 degrees, but Muriel Hiatt has the best reason for attending: "I do it to impress my grandchildren," she says.

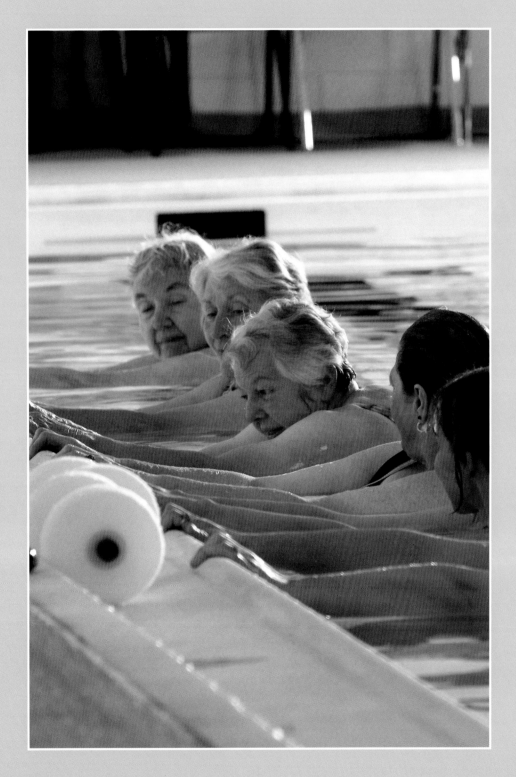

At left, that's lifeguard Dave Trowbridge discussing technique with Tina Johnson (middle) and Jeannie Christian. And the picture above is of the YMCA's early morning aquatic aerobics class, with Muriel Hiatt, Barbara Tobler, Pat Midgley, Tina Johnson, and Jeannie Christian.

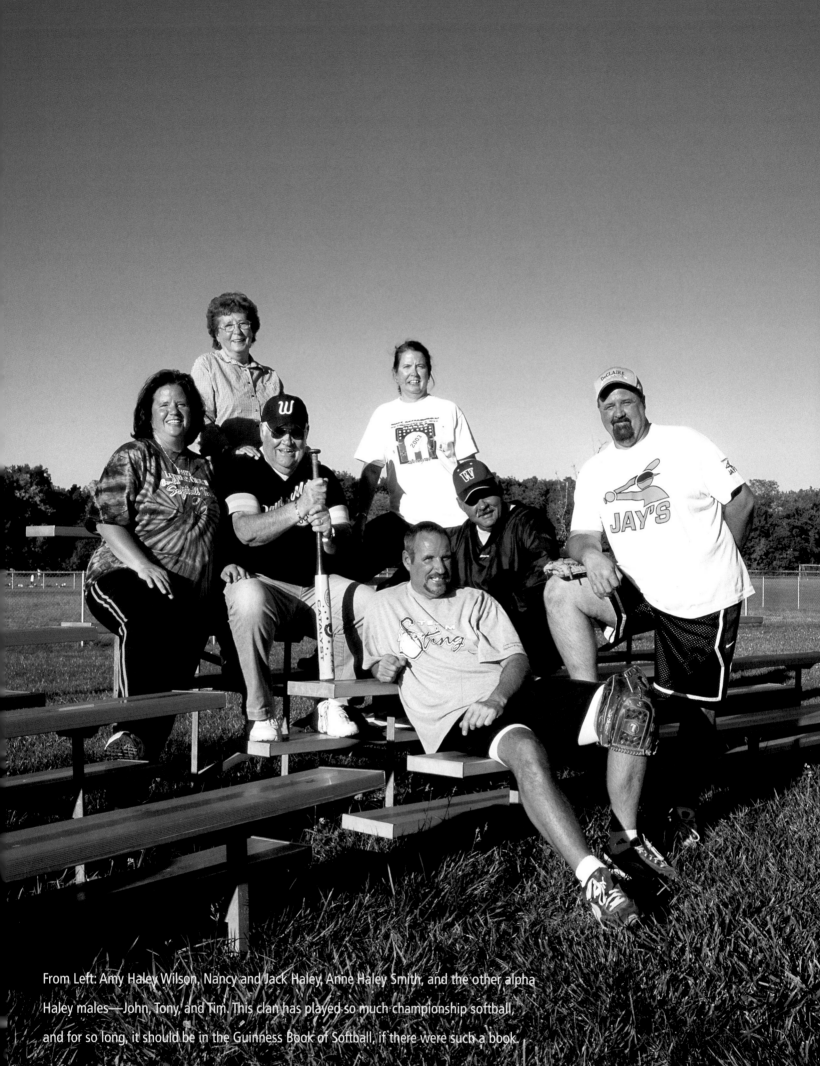

From Left: Amy Haley Wilson, Nancy and Jack Haley, Anne Haley Smith, and the other alpha Haley males—John, Tony, and Tim. This clan has played so much championship softball, and for so long, it should be in the Guinness Book of Softball, if there were such a book.

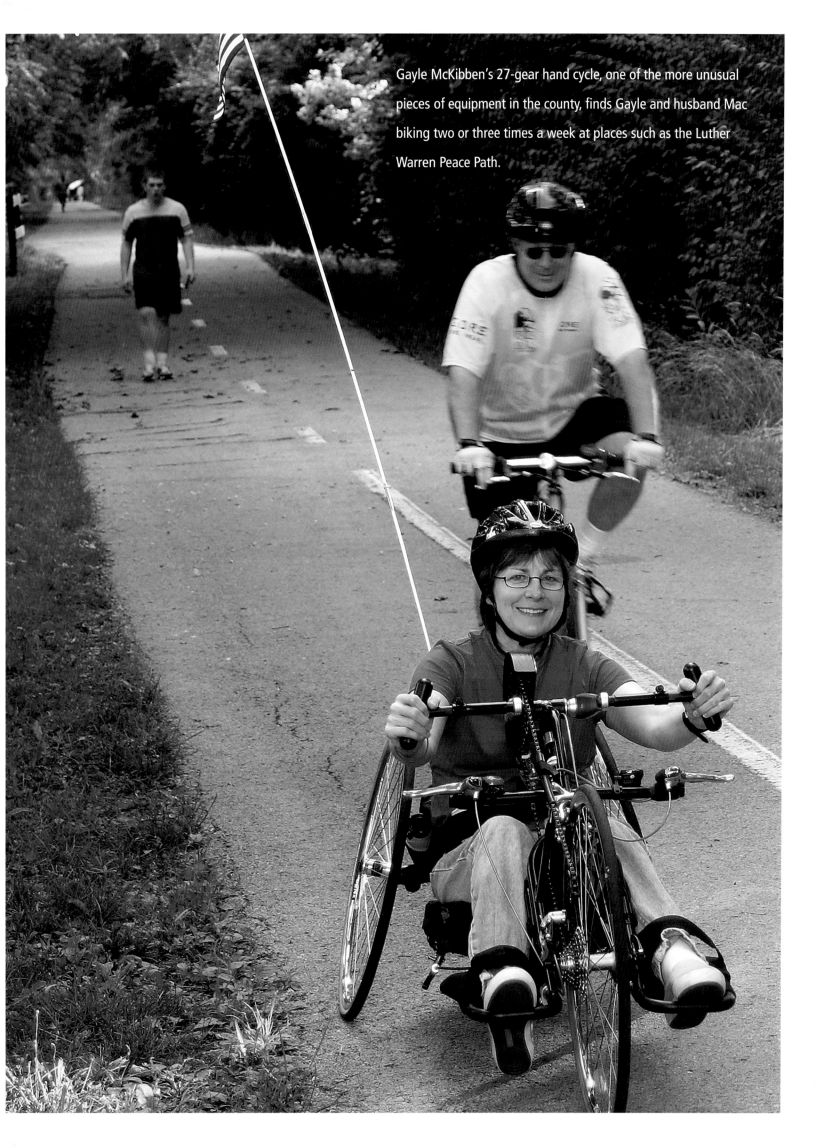

Gayle McKibben's 27-gear hand cycle, one of the more unusual pieces of equipment in the county, finds Gayle and husband Mac biking two or three times a week at places such as the Luther Warren Peace Path.

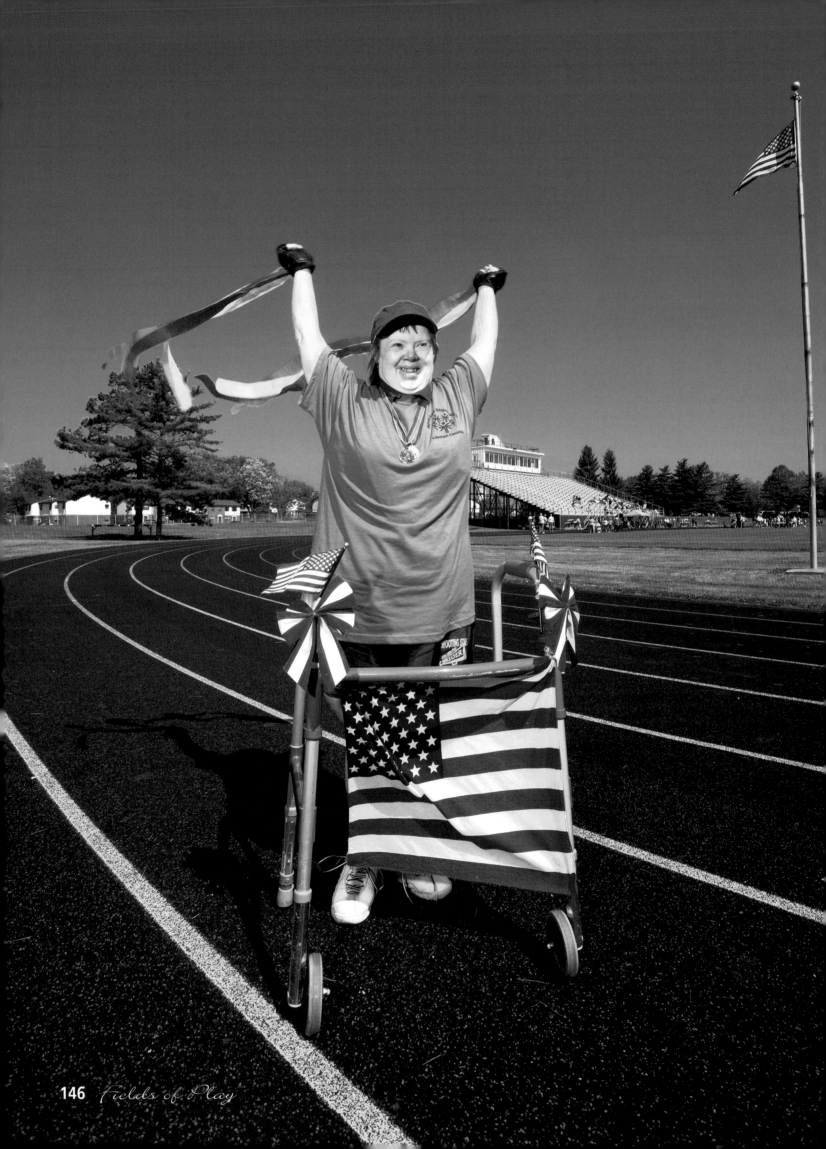

This is Sandy Fugett, celebrating her 50-yard dash victory in the Special Olympics Track and Field event, which is held annually in the county. Do not ask about her times, for Sandy is not running against time. She is running against the idea that she *can't* run. Which is why she is a winner—and she has the medals to show it. The motto for the Special Olympics is: "Let me win, but if I can't win, let me be brave in the attempt." As Rod Lane, superintendent of the county's Mental Retardation and Developmental Disabilities program,

Special

says, "Those who participate and don't finish first seem as happy as those who *do* finish first." And that, of course, is a medal in itself. Sandy, meanwhile, decorates her walker in accordance with the seasons (the flag means that it must have been Memorial Day)—and she keeps on running. Bless her.

Oly

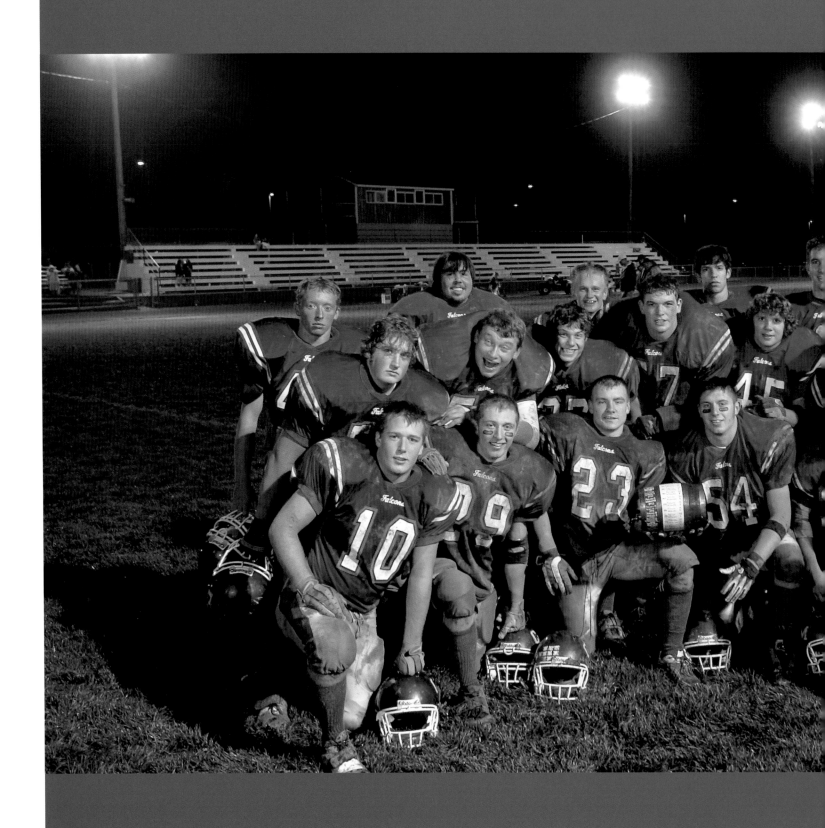

Clinton

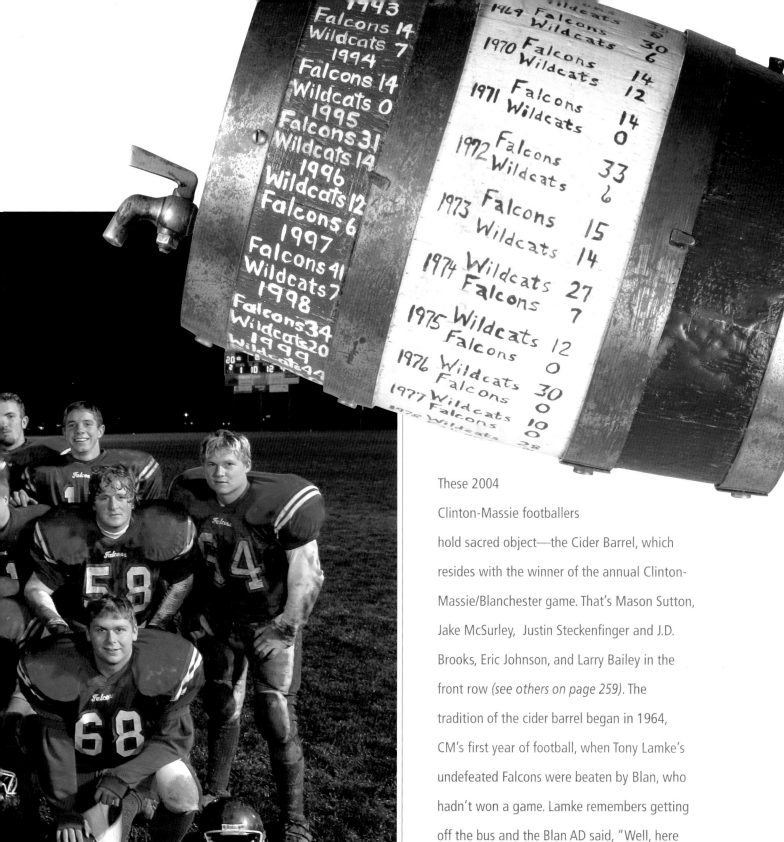

1993
Falcons 14
Wildcats 7
1994
Falcons 14
Wildcats 0
1995
Falcons 31
Wildcats 14
1996
Wildcats 12
Falcons 6
1997
Falcons 41
Wildcats 7
1998
Falcons 34
Wildcats 20
1999
Wildcats

1969 Falcons
Wildcats 30
1970 Falcons 6
Wildcats 14
12
1971 Falcons 14
Wildcats 0
1972 Falcons 33
Wildcats 6
1973 Falcons 15
Wildcats 14
1974 Wildcats 27
Falcons 7
1975 Wildcats 12
Falcons 0
1976 Wildcats 30
Falcons 0
1977 Wildcats 10
Falcons 0
Wildcats 28

These 2004 Clinton-Massie footballers hold sacred object—the Cider Barrel, which resides with the winner of the annual Clinton-Massie/Blanchester game. That's Mason Sutton, Jake McSurley, Justin Steckenfinger and J.D. Brooks, Eric Johnson, and Larry Bailey in the front row *(see others on page 259)*. The tradition of the cider barrel began in 1964, CM's first year of football, when Tony Lamke's undefeated Falcons were beaten by Blan, who hadn't won a game. Lamke remembers getting off the bus and the Blan AD said, "Well, here it is." And Lamke said, looking at the barrel, "What IS it?" Thus the tradition began.

Massie

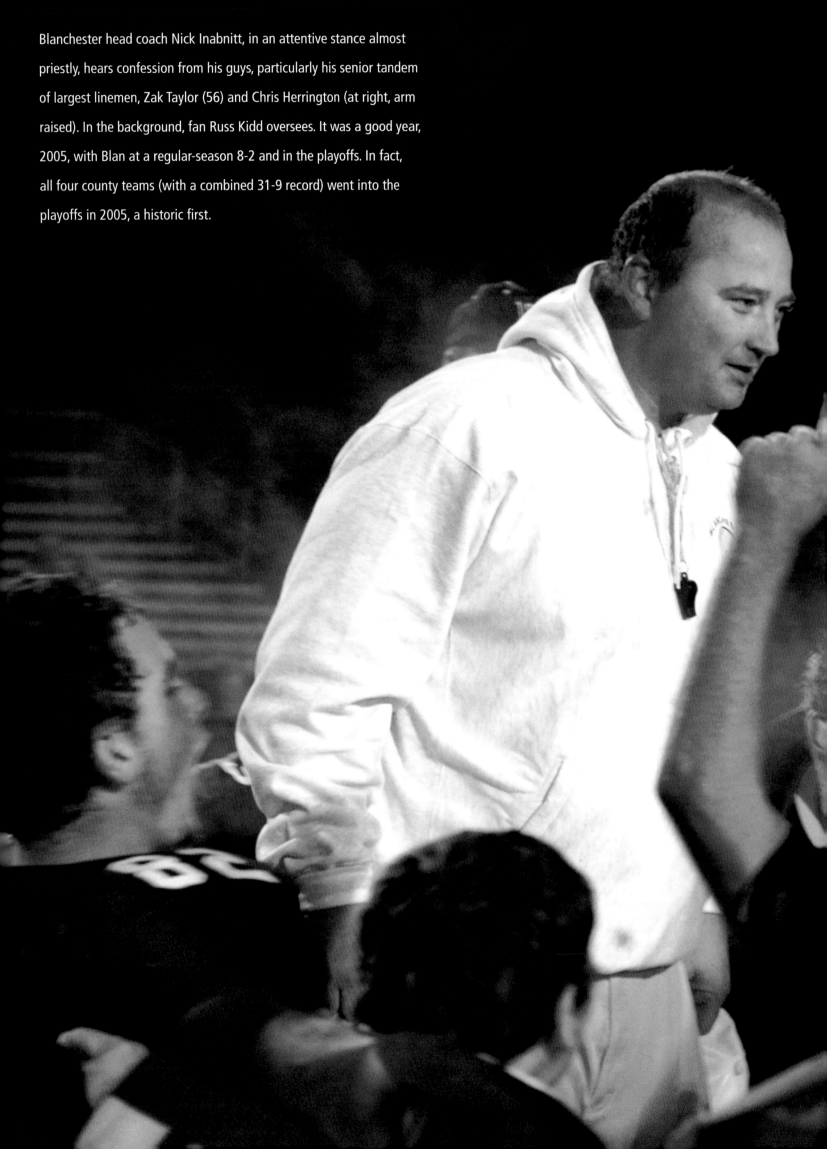

Blanchester head coach Nick Inabnitt, in an attentive stance almost priestly, hears confession from his guys, particularly his senior tandem of largest linemen, Zak Taylor (56) and Chris Herrington (at right, arm raised). In the background, fan Russ Kidd oversees. It was a good year, 2005, with Blan at a regular-season 8-2 and in the playoffs. In fact, all four county teams (with a combined 31-9 record) went into the playoffs in 2005, a historic first.

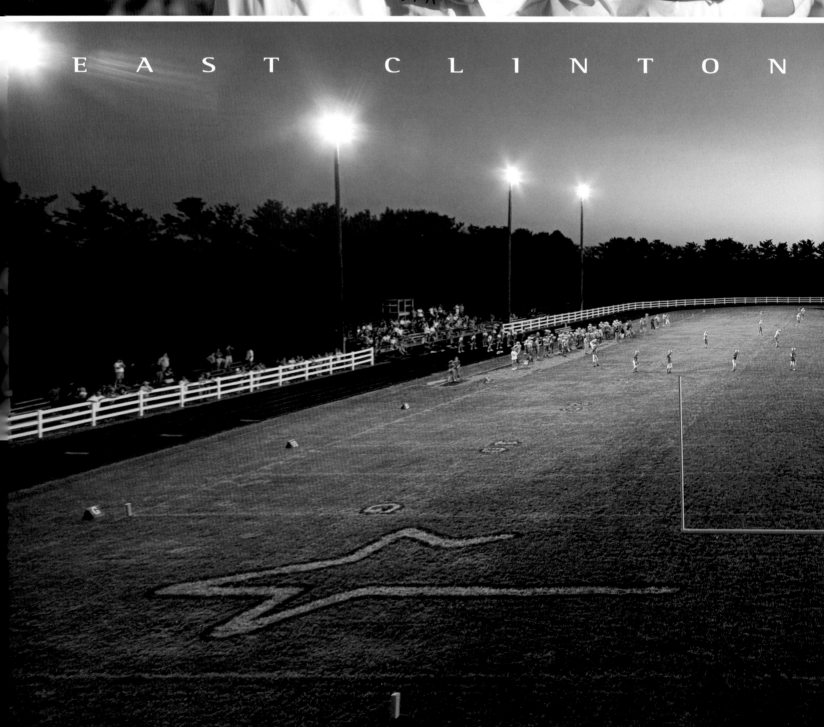

EAST CLINTON

1

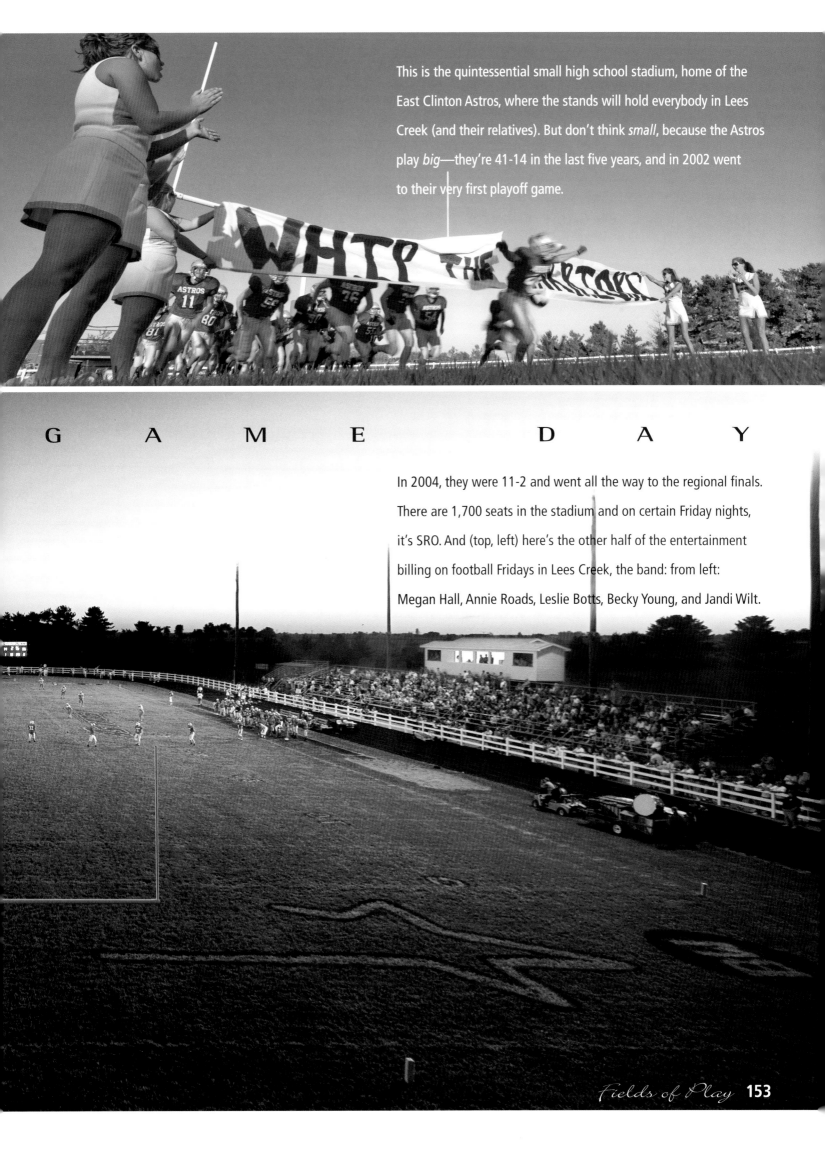

This is the quintessential small high school stadium, home of the East Clinton Astros, where the stands will hold everybody in Lees Creek (and their relatives). But don't think *small*, because the Astros play *big*—they're 41-14 in the last five years, and in 2002 went to their very first playoff game.

G A M E D A Y

In 2004, they were 11-2 and went all the way to the regional finals. There are 1,700 seats in the stadium and on certain Friday nights, it's SRO. And (top, left) here's the other half of the entertainment billing on football Fridays in Lees Creek, the band: from left: Megan Hall, Annie Roads, Leslie Botts, Becky Young, and Jandi Wilt.

Wilmington High School

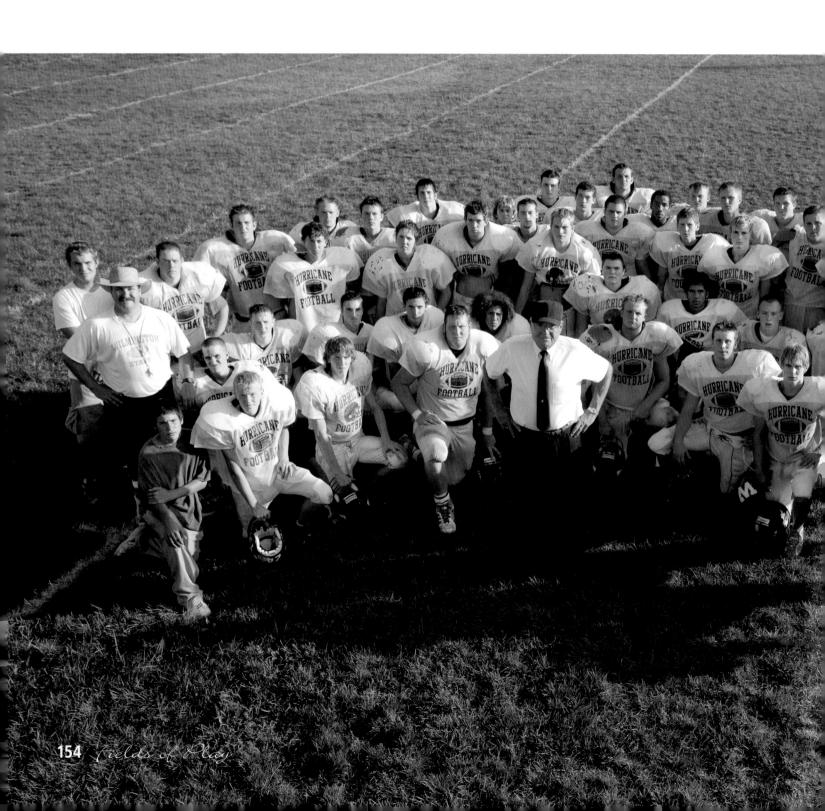

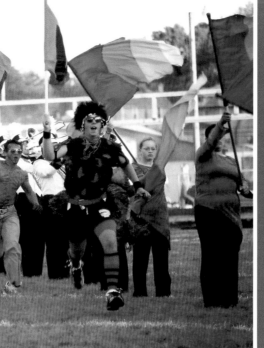

The Hurrying Hurricane was 7-3 in 2005, then there was that heartbreaking 29-22 overtime loss to villainous Miami Trace in the playoffs. Well, there *is* a next year—which is already here—and Coach Ron Vida, who brought to WHS a sense of heightened expectation, expects even more this year.

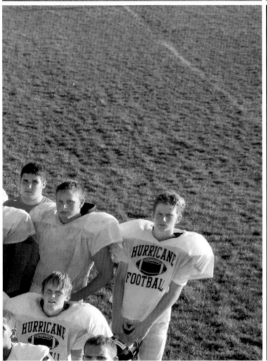

That's Coach Vida (at far left) with his 2005 edition (see page 259), and former WHS coach Oakie Waddell, out front, who shows up at practice from time to time and lays out some old-time fervor. Below is a holiday showing of the '04-'05 WHS girls basketball players. *(See page 259.)*

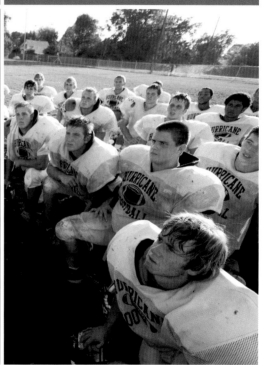

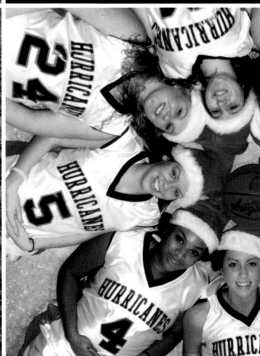

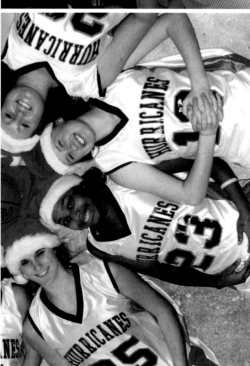

The Royal Z Lanes has held its place
as one of the county's recreational
mainstays since it opened as the Airport
Bowl back in 1952. It's also one
of our most democratic institutions,
with bowlers ranging from age 5
on up to Dick Spinks, at 91, the Z's
elder statesman.

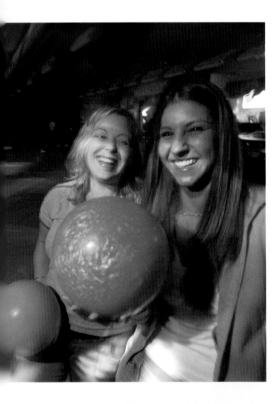

Above, it's Jenna Hill and Jessica Noggle,
out on a Friday night. At right, the
bowlers are (from left) Adam Roe,
Elizabeth Ames, Derrick Combs,
Lindsay Pollard, Courtney Hart, and
Jake Lambert. In case you wondered,
Shane Ison at the pro shop has the Z's
highest bowling average—235.

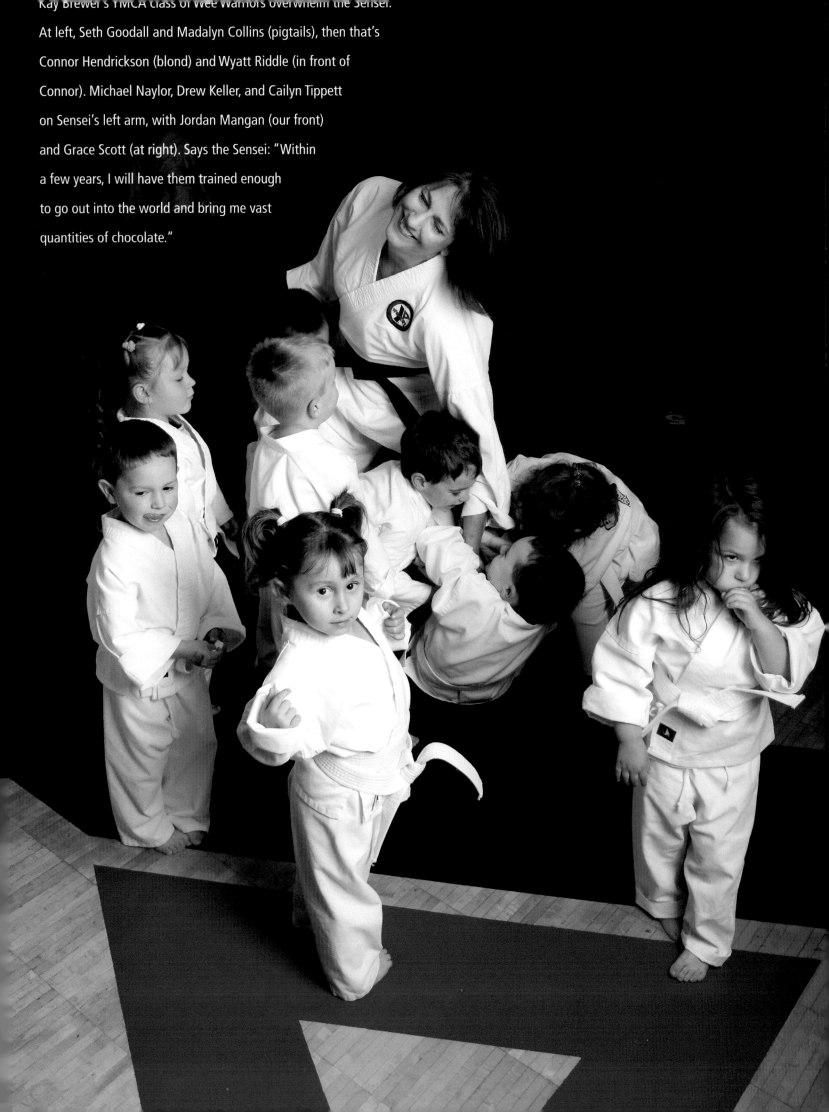

Kay Brewer's YMCA class of Wee Warriors overwhelm the Sensei.
At left, Seth Goodall and Madalyn Collins (pigtails), then that's
Connor Hendrickson (blond) and Wyatt Riddle (in front of
Connor). Michael Naylor, Drew Keller, and Cailyn Tippett
on Sensei's left arm, with Jordan Mangan (our front)
and Grace Scott (at right). Says the Sensei: "Within
a few years, I will have them trained enough
to go out into the world and bring me vast
quantities of chocolate."

Soccer came to the cornfields well over a decade ago, longer if you count the best program around—Bud Lewis' Wilmington College program. He started in 1975 and now has over 400 wins. Here, youngster Adam Wasson leads his teammates through a tunnel of parents after a SAY game.

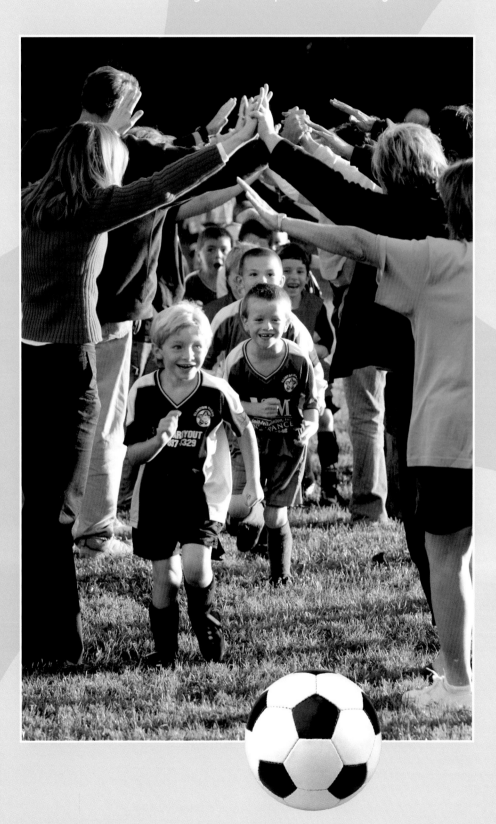

a PIECE of WORK

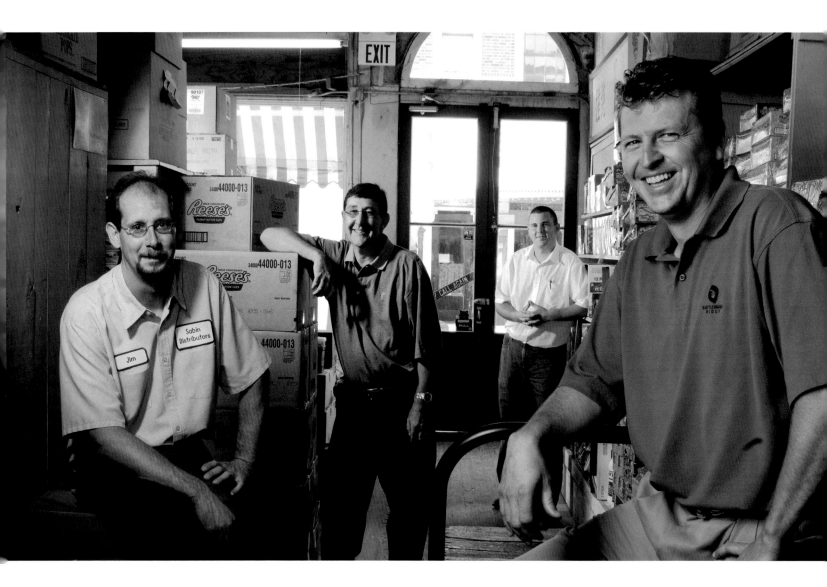

Sabin Wholesale, your downtown distributor (and house museum), has been wonderfully unchanged for just two years shy of the century mark. It dates back to Fred Sabin, who never had a cash register until Ohio's sales tax went into effect in the 1930s. Before, his cash drawer was a cigar box. Two generations down, Jim Burnett and sister Susan carry on grandfather's tradition. They do it so well and consistently that if Fred returned, he'd be right at home. From left, that's Jim Surharski, Dale Stewart, Adam Redfern, and Jim.

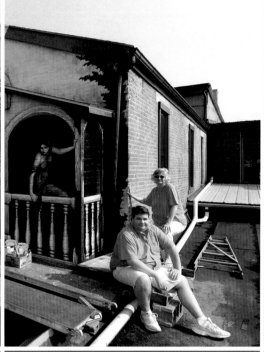

Left, the staff of Orange Frazer Press—named after the 19th century grocer (and world-traveler) of the same name—supervise their new mural, done because, well, they wanted to design something larger than a coffeetable book. Below is Delmar Ferguson, who has worked at Champion Bridge for 39 years.

Left are Mark, Molly and the Dullea family in the Denver Hotel's elevator. They're the resourceful folks who've been first to understand the place since Dick Bath was a bellhop. Below are the downtown barbers, gathered in Harold Davis' Oak Barbershop (circa 1915). From left: Teresa Rice, Don Holland, Arla Faye Carnahan, Dale Inwood, and Davis.

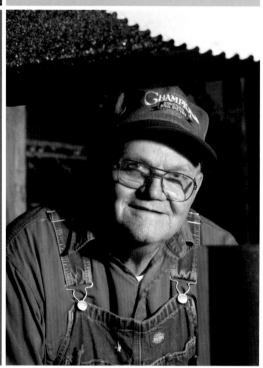

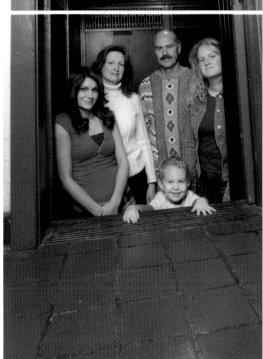

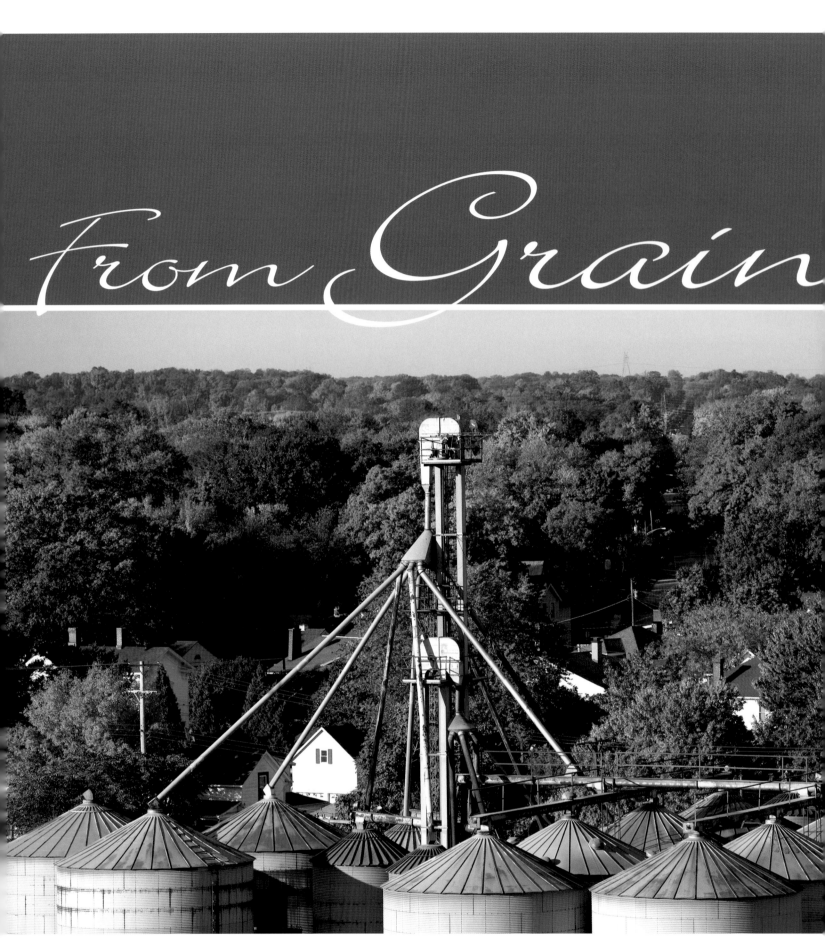

From Grain

Herewith, the county's two symbolic underpinnings: grain storage bins and stone. As long as

we've been here, corn has been, too. Corn was here before transportation, actually. And before

the railroads, the saying in the county was that the only way to get your corn to market was

feed it to the pigs and drive it there. Stone solved the transportation problem, though.

to *Stone!*

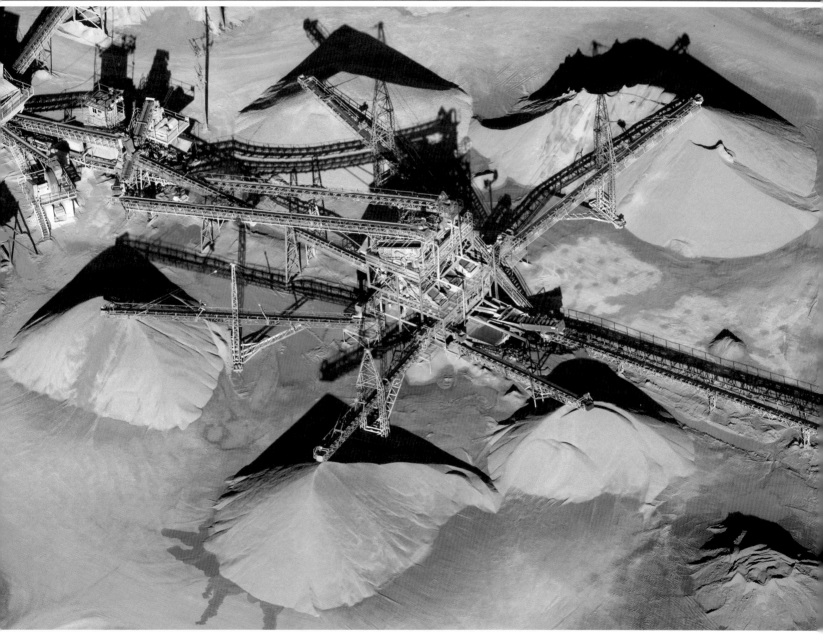

For most of a century, transportation bedeviled us. Yet the solution was, pardon the pun,

underfoot: the limestone which surfaces in the center of the county. It made our roads,

and—as a fertilizer—grew our corn. Above (and from above) is the Melvin quarry,

which produced over a million and a half tons of gravel in 2004.

*W*alt (below) and Wilmingtoons, the downtown music shop,

ranks among those out-of-the-ordinary entrepreneurial ventures such as

Barney's Bagels, begun in the 1970s by a college student who pictured

farmers coming by for a morning bagel before hitting the North Forty.

Walt, unlike Barney, has persisted. Even if the occasional matron *has*

wandered in and mistaken his tongue studs for earrings. Walt, bless 'im,

is one of us, tattoos and all.

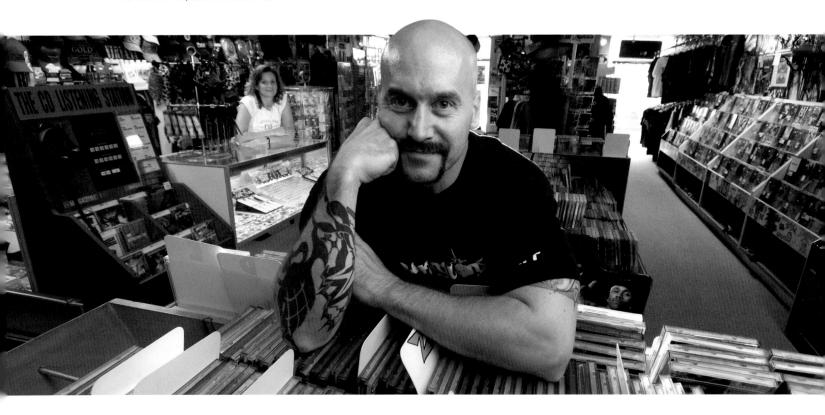

(right) The Buckley family got into the grain and feed supply business

in 1904 and stayed in it. Before corn driers, though, the major operation

was buying summer wheat. In the mid-1950s, James and Bruce began

adding bins and today, the bins can store some 300,000 bushels of grain.

They also occupy an iconic spot on the city landscape. Those tall sentinels,

in one way or another, *are* Wilmington. From left, Corey Buckley,

Steve Fricke, Bruce Buckley, and Mark Buckley.

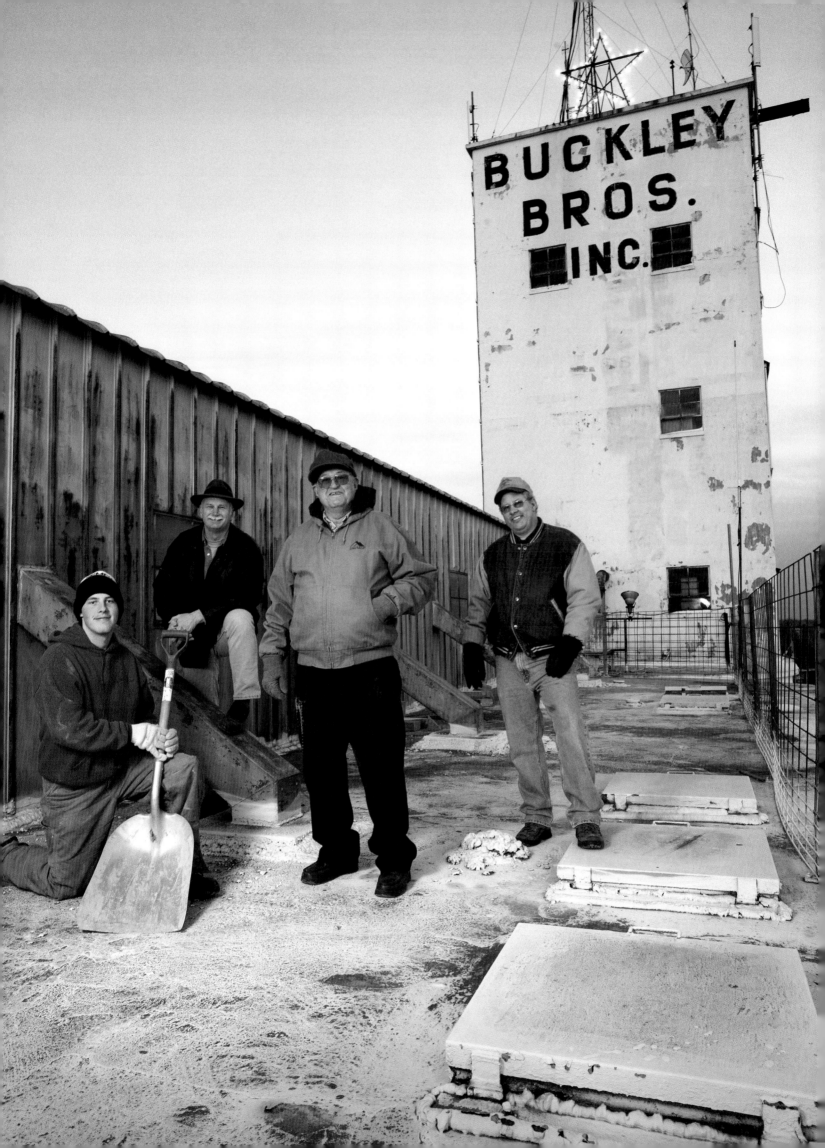

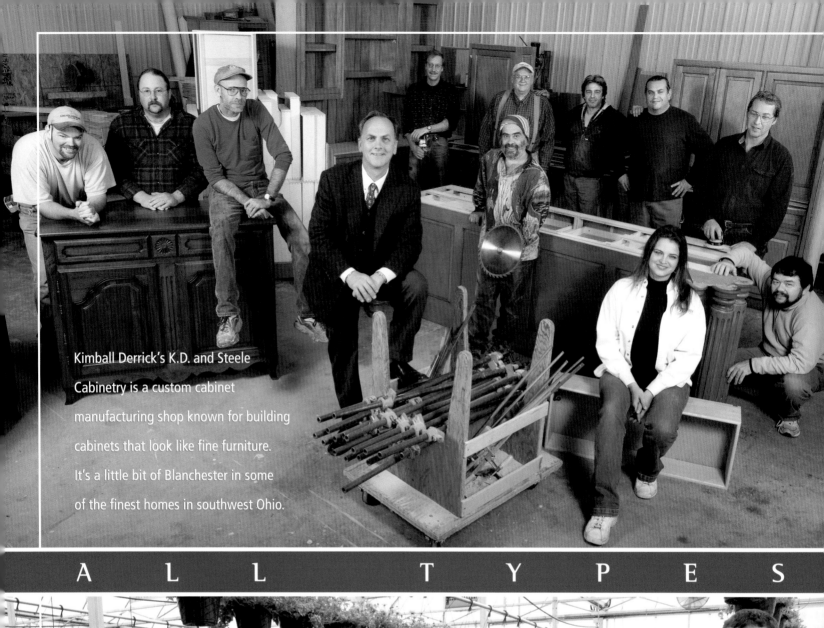

Kimball Derrick's K.D. and Steele
Cabinetry is a custom cabinet
manufacturing shop known for building
cabinets that look like fine furniture.
It's a little bit of Blanchester in some
of the finest homes in southwest Ohio.

A L L T Y P E S

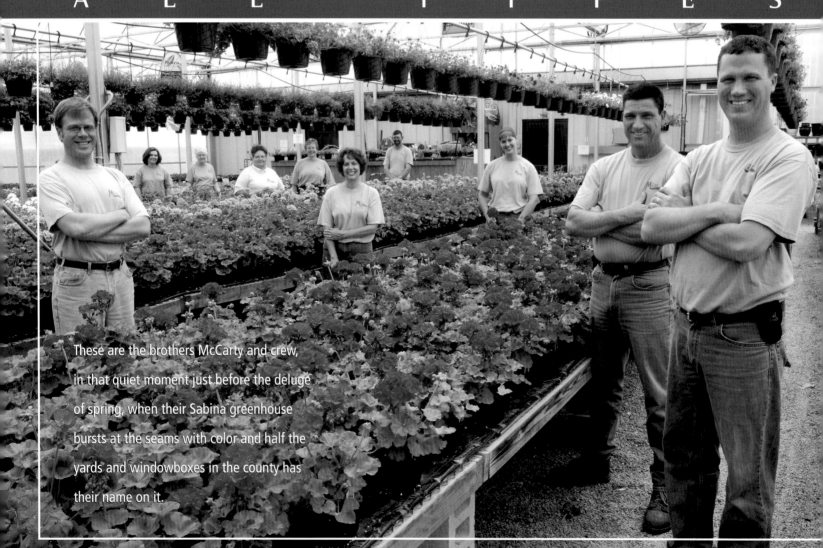

These are the brothers McCarty and crew,
in that quiet moment just before the deluge
of spring, when their Sabina greenhouse
bursts at the seams with color and half the
yards and windowboxes in the county has
their name on it.

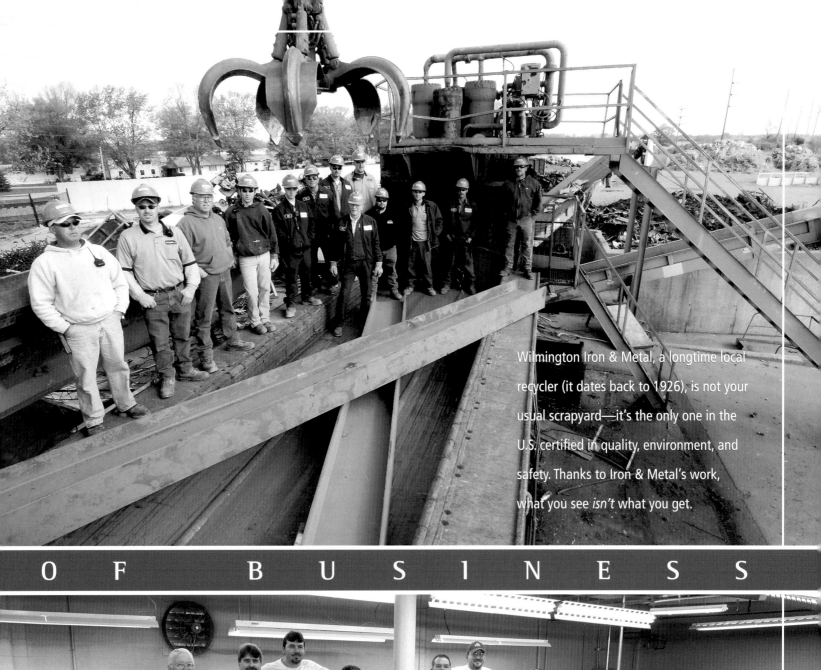

Wilmington Iron & Metal, a longtime local recycler (it dates back to 1926), is not your usual scrapyard—it's the only one in the U.S. certified in quality, environment, and safety. Thanks to Iron & Metal's work, what you see *isn't* what you get.

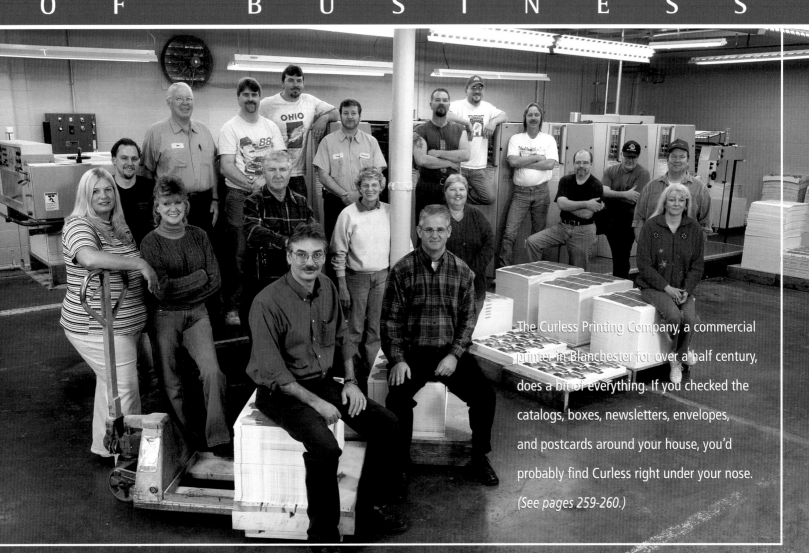

The Curless Printing Company, a commercial printer in Blanchester for over a half century, does a bit of everything. If you checked the catalogs, boxes, newsletters, envelopes, and postcards around your house, you'd probably find Curless right under your nose.

(See pages 259-260.)

Timothy Smith, the face of National Bank and Trust for most of the last twenty years, strikes a pose with his trusty 3-wood. A favorite instrument of the retiring CEO—equally at home in boardroom, courtside, or on the links—it would have been mostly unknown to Smith's illustrious predecessors, Matthew Rombach and General Denver. Like Smith, however, both were adept at the long game, which explains the extraordinary presence of the bank here since 1872.

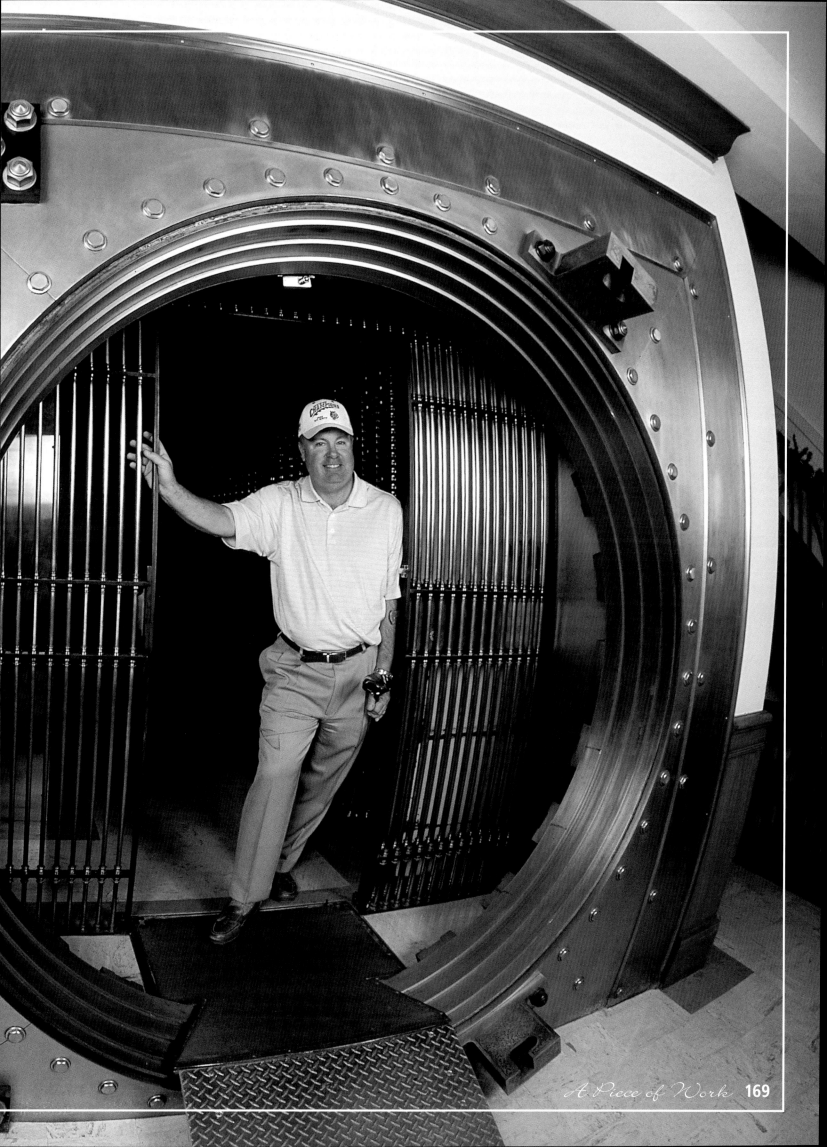

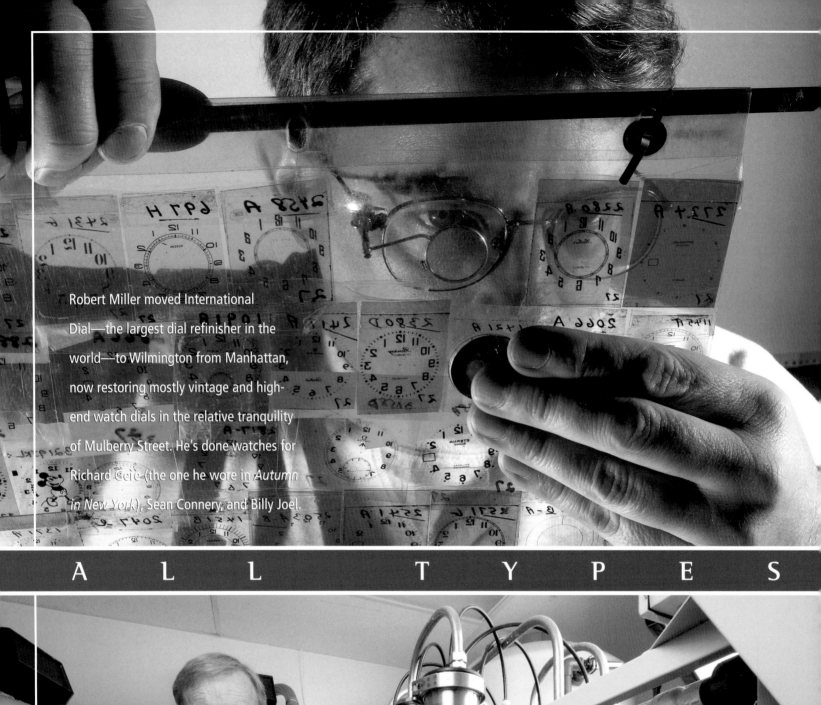

Robert Miller moved International Dial—the largest dial refinisher in the world—to Wilmington from Manhattan, now restoring mostly vintage and high-end watch dials in the relative tranquility of Mulberry Street. He's done watches for Richard Gere (the one he wore in *Autumn in New York*), Sean Connery, and Billy Joel.

A L L T Y P E S

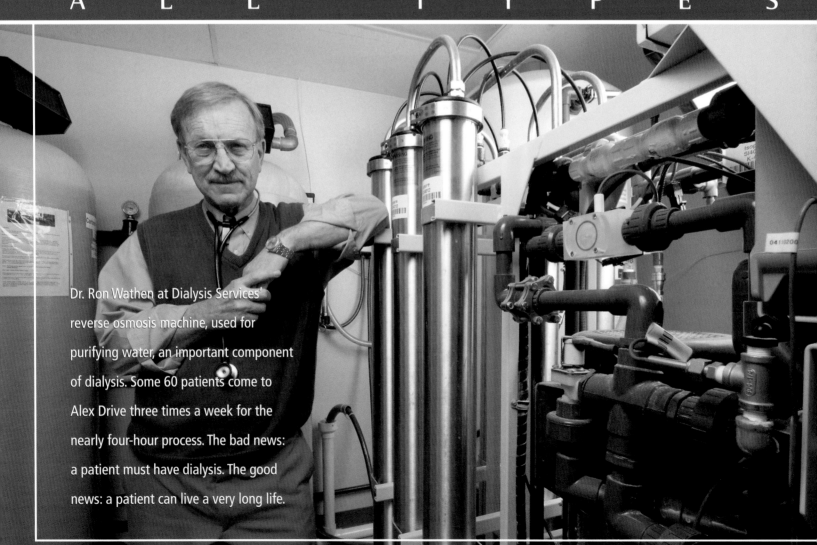

Dr. Ron Wathen at Dialysis Services' reverse osmosis machine, used for purifying water, an important component of dialysis. Some 60 patients come to Alex Drive three times a week for the nearly four-hour process. The bad news: a patient must have dialysis. The good news: a patient can live a very long life.

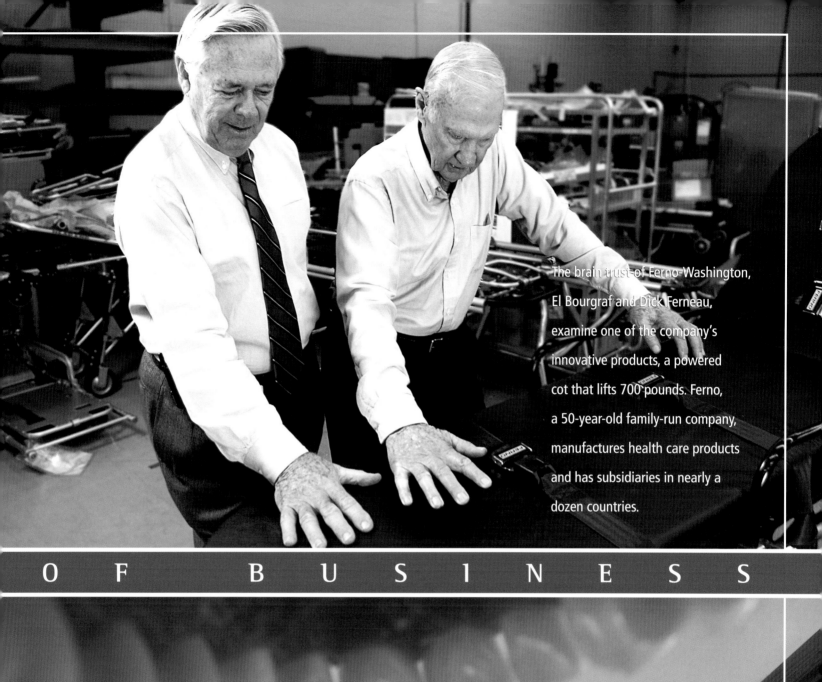

The brain trust of Ferno-Washington, El Bourgraf and Dick Ferneau, examine one of the company's innovative products, a powered cot that lifts 700 pounds. Ferno, a 50-year-old family-run company, manufactures health care products and has subsidiaries in nearly a dozen countries.

O F B U S I N E S S

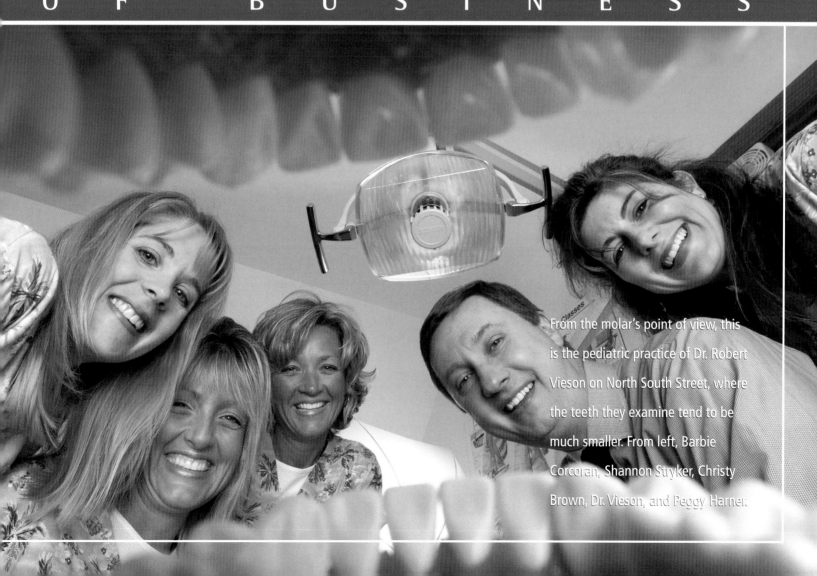

From the molar's point of view, this is the pediatric practice of Dr. Robert Vieson on North South Street, where the teeth they examine tend to be much smaller. From left, Barbie Corcoran, Shannon Stryker, Christy Brown, Dr. Vieson, and Peggy Harner.

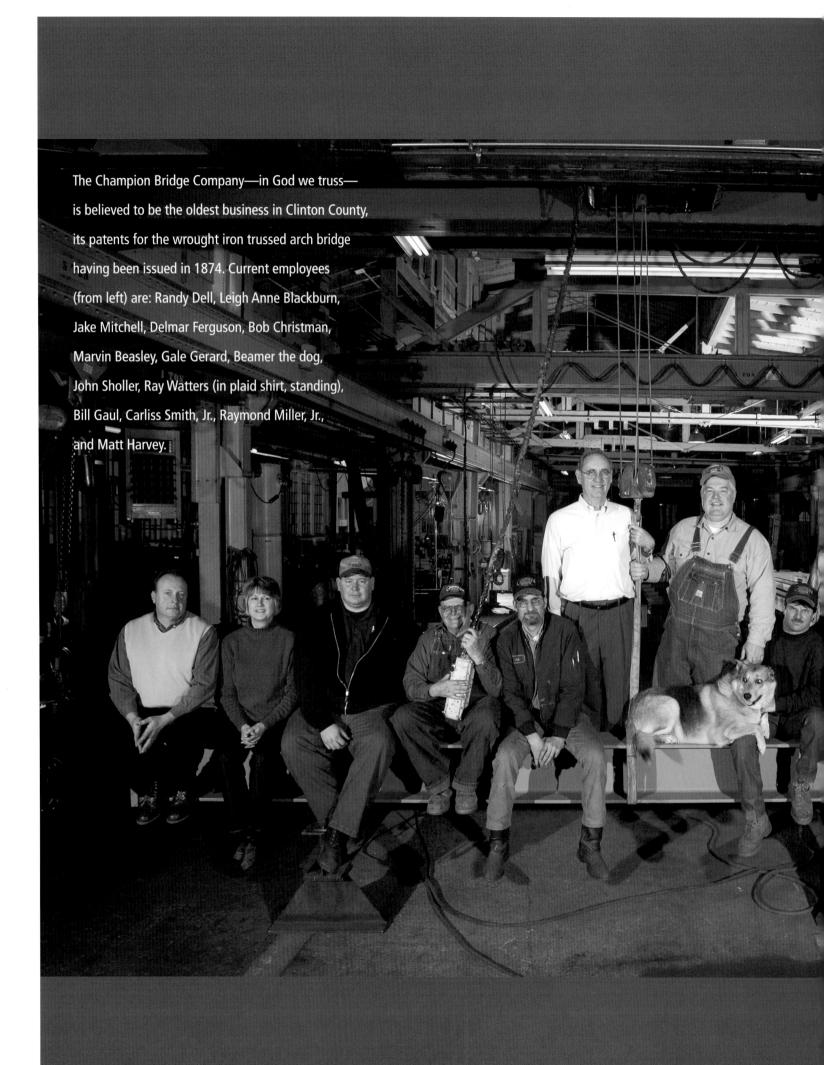

The Champion Bridge Company—in God we truss—
is believed to be the oldest business in Clinton County,
its patents for the wrought iron trussed arch bridge
having been issued in 1874. Current employees
(from left) are: Randy Dell, Leigh Anne Blackburn,
Jake Mitchell, Delmar Ferguson, Bob Christman,
Marvin Beasley, Gale Gerard, Beamer the dog,
John Sholler, Ray Watters (in plaid shirt, standing),
Bill Gaul, Carliss Smith, Jr., Raymond Miller, Jr.,
and Matt Harvey.

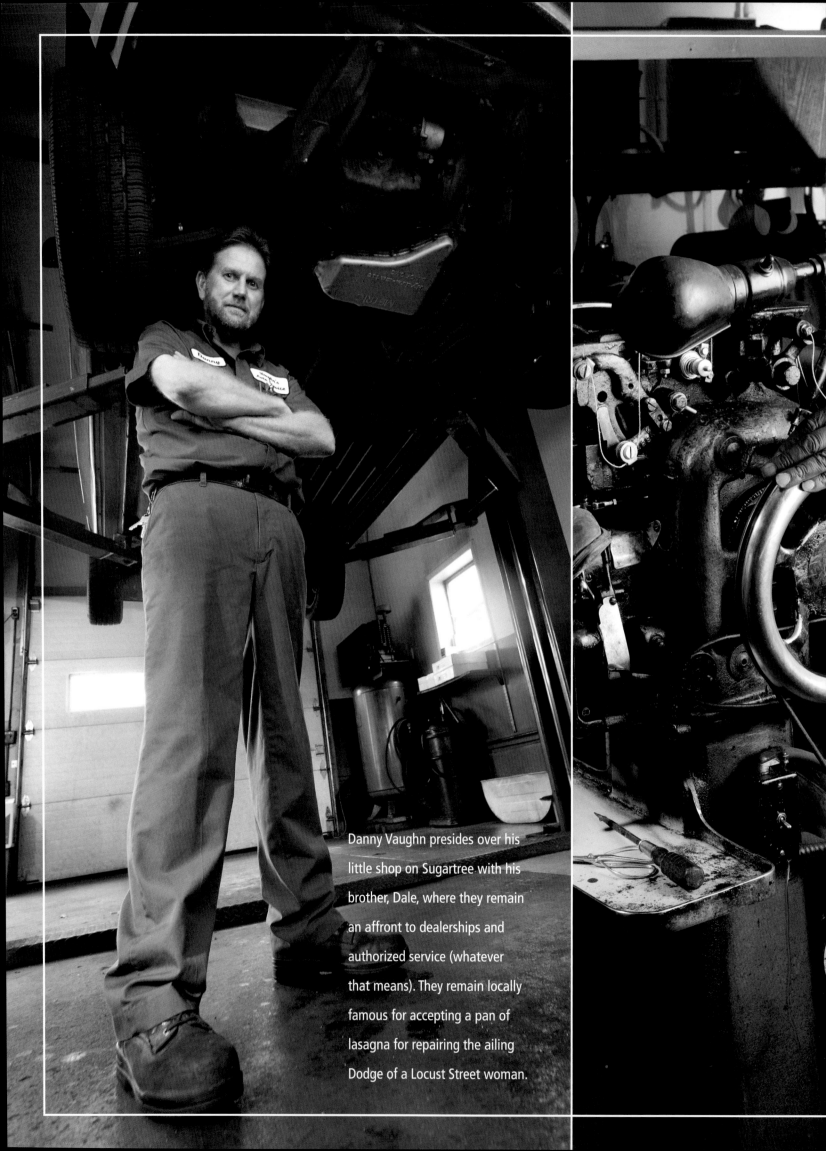

Danny Vaughn presides over his little shop on Sugartree with his brother, Dale, where they remain an affront to dealerships and authorized service (whatever that means). They remain locally famous for accepting a pan of lasagna for repairing the ailing Dodge of a Locust Street woman.

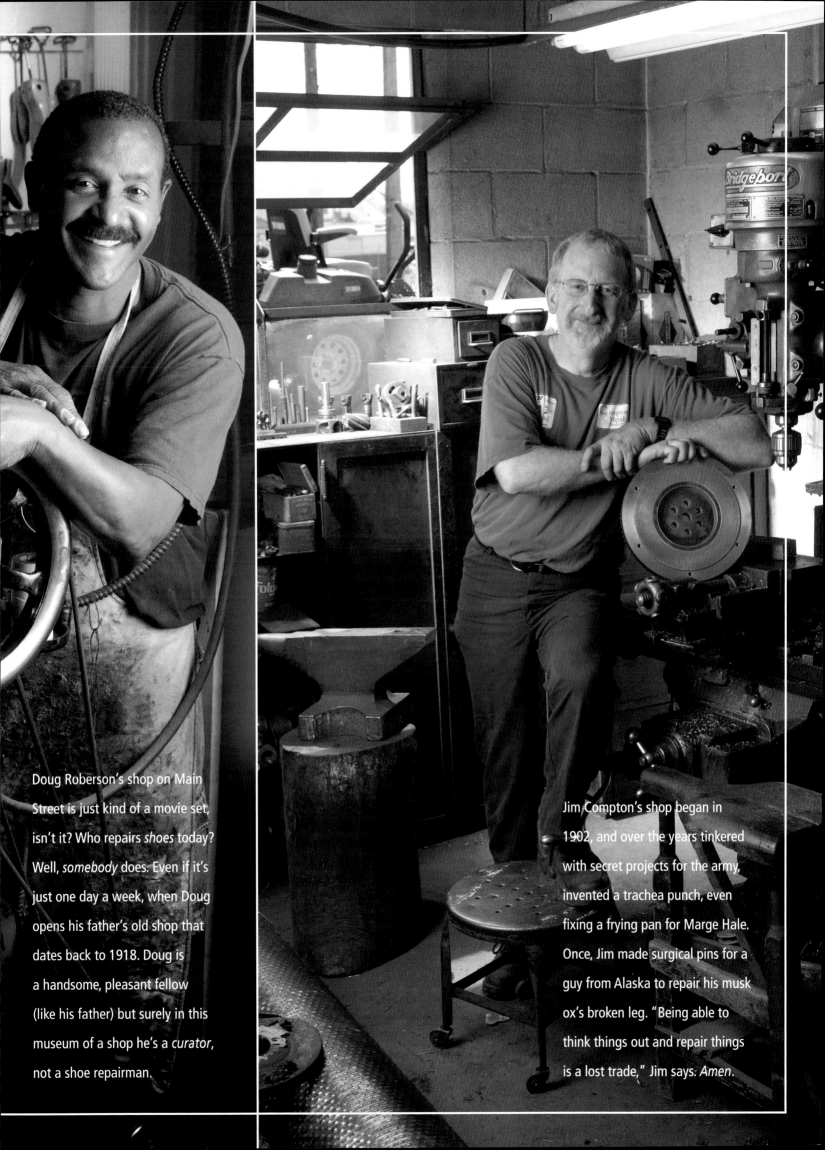

Doug Roberson's shop on Main Street is just kind of a movie set, isn't it? Who repairs *shoes* today? Well, *somebody* does. Even if it's just one day a week, when Doug opens his father's old shop that dates back to 1918. Doug is a handsome, pleasant fellow (like his father) but surely in this museum of a shop he's a *curator*, not a shoe repairman.

Jim Compton's shop began in 1902, and over the years tinkered with secret projects for the army, invented a trachea punch, even fixing a frying pan for Marge Hale. Once, Jim made surgical pins for a guy from Alaska to repair his musk ox's broken leg. "Being able to think things out and repair things is a lost trade," Jim says. *Amen.*

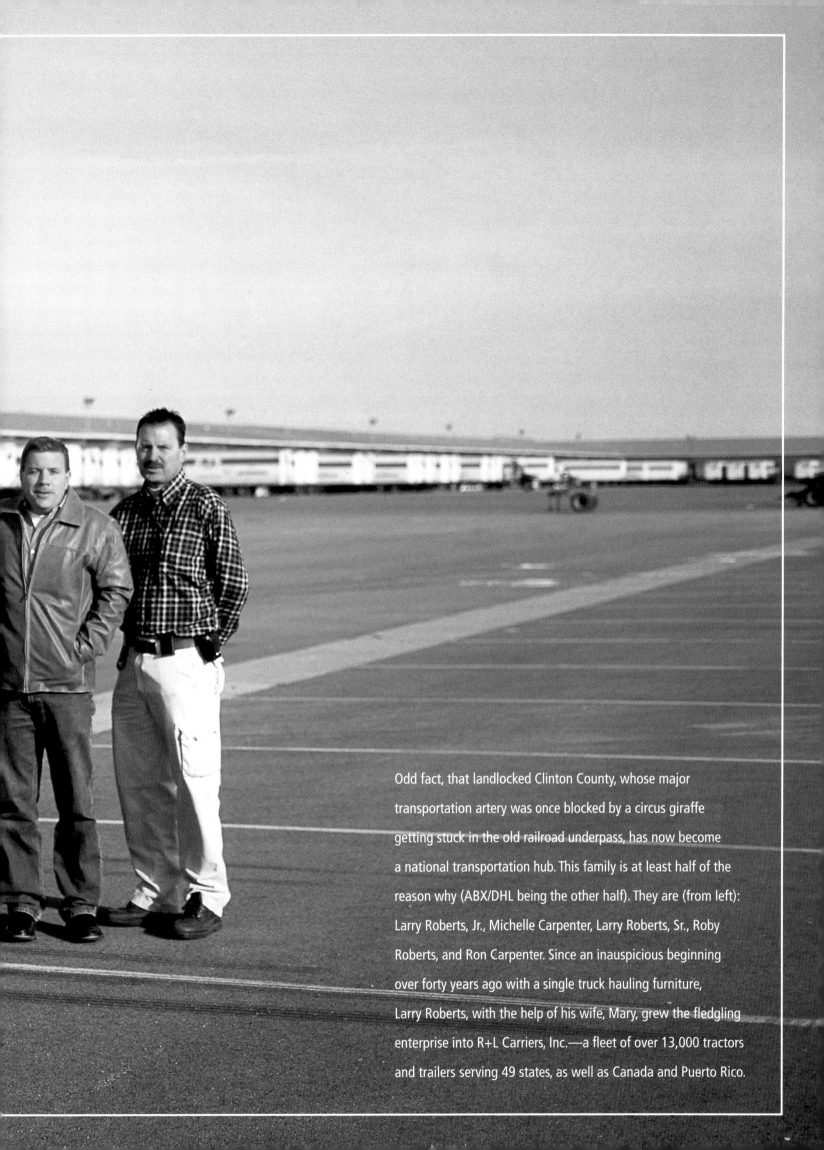

Odd fact, that landlocked Clinton County, whose major transportation artery was once blocked by a circus giraffe getting stuck in the old railroad underpass, has now become a national transportation hub. This family is at least half of the reason why (ABX/DHL being the other half). They are (from left): Larry Roberts, Jr., Michelle Carpenter, Larry Roberts, Sr., Roby Roberts, and Ron Carpenter. Since an inauspicious beginning over forty years ago with a single truck hauling furniture, Larry Roberts, with the help of his wife, Mary, grew the fledgling enterprise into R+L Carriers, Inc.—a fleet of over 13,000 tractors and trailers serving 49 states, as well as Canada and Puerto Rico.

Is there a meal on this flight?

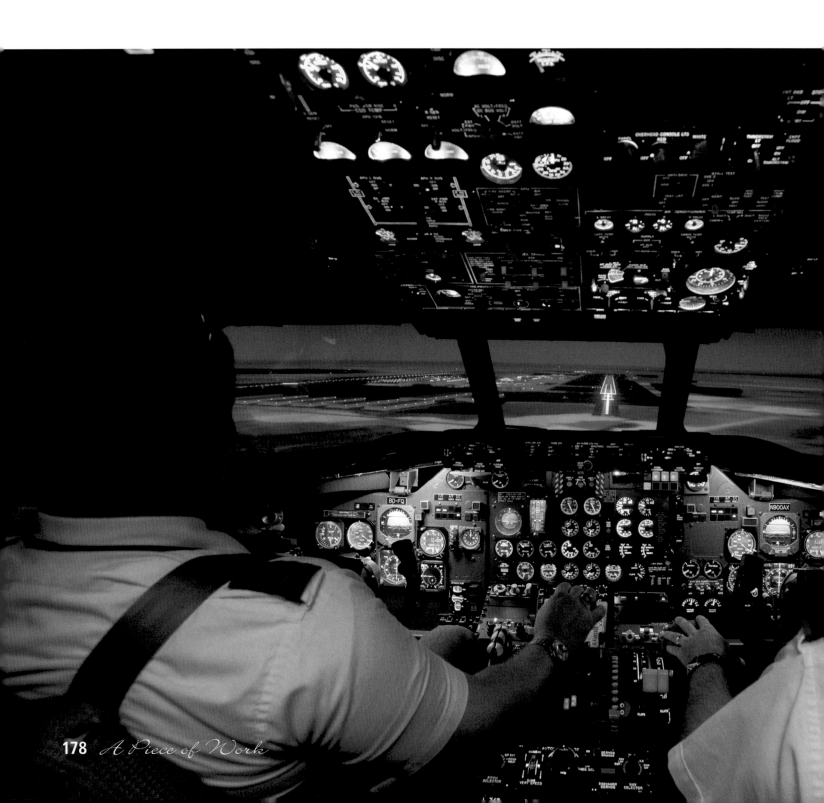

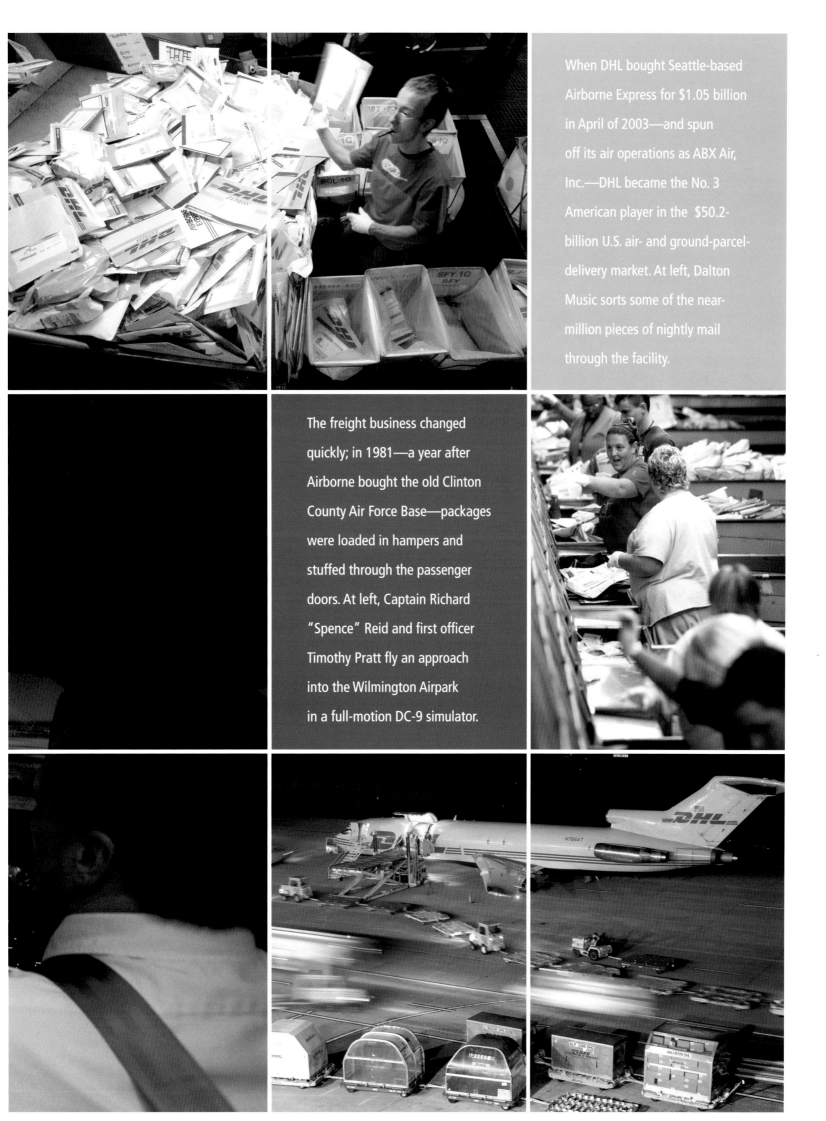

When DHL bought Seattle-based Airborne Express for $1.05 billion in April of 2003—and spun off its air operations as ABX Air, Inc.—DHL became the No. 3 American player in the $50.2-billion U.S. air- and ground-parcel-delivery market. At left, Dalton Music sorts some of the near-million pieces of nightly mail through the facility.

The freight business changed quickly; in 1981—a year after Airborne bought the old Clinton County Air Force Base—packages were loaded in hampers and stuffed through the passenger doors. At left, Captain Richard "Spence" Reid and first officer Timothy Pratt fly an approach into the Wilmington Airpark in a full-motion DC-9 simulator.

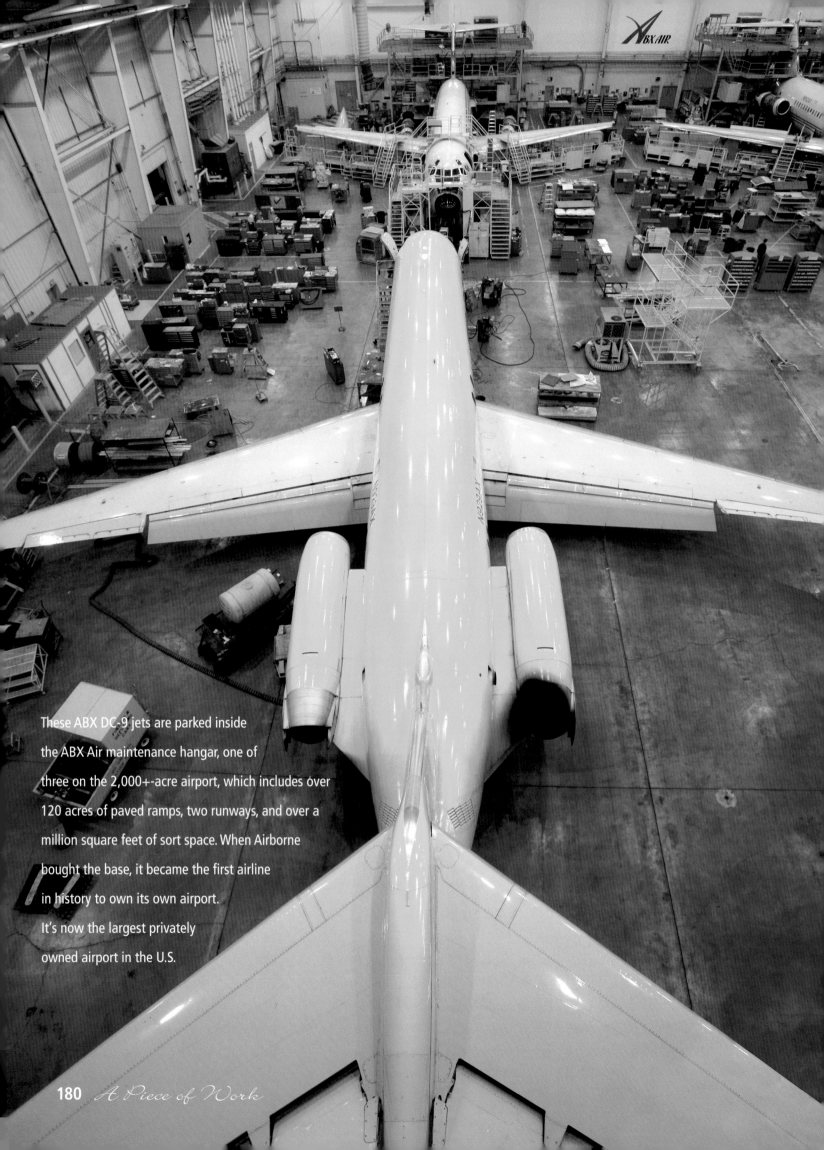

These ABX DC-9 jets are parked inside the ABX Air maintenance hangar, one of three on the 2,000+-acre airport, which includes over 120 acres of paved ramps, two runways, and over a million square feet of sort space. When Airborne bought the base, it became the first airline in history to own its own airport. It's now the largest privately owned airport in the U.S.

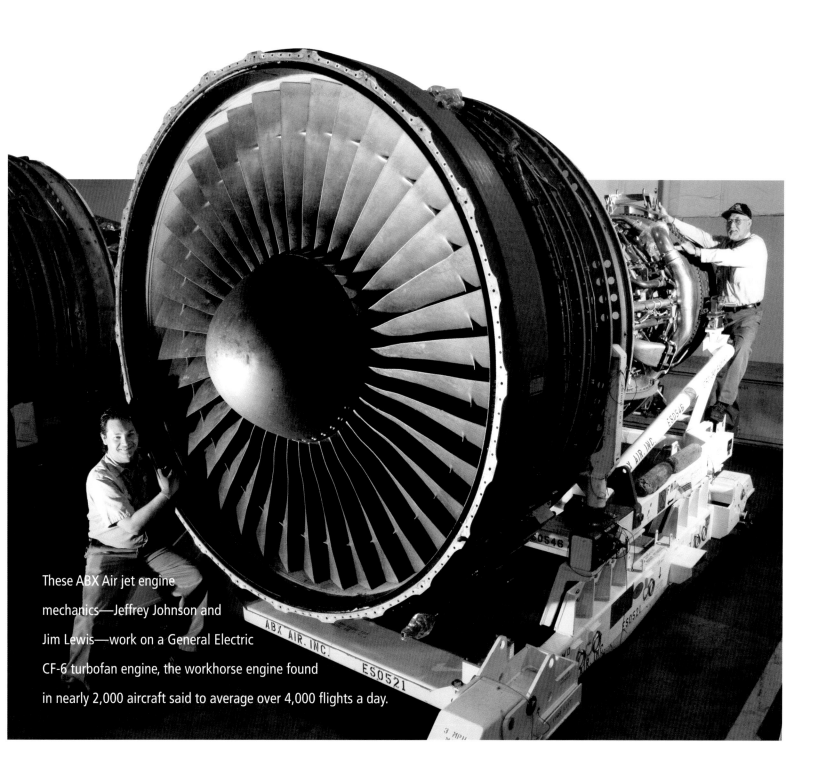

These ABX Air jet engine mechanics—Jeffrey Johnson and Jim Lewis—work on a General Electric CF-6 turbofan engine, the workhorse engine found in nearly 2,000 aircraft said to average over 4,000 flights a day.

town

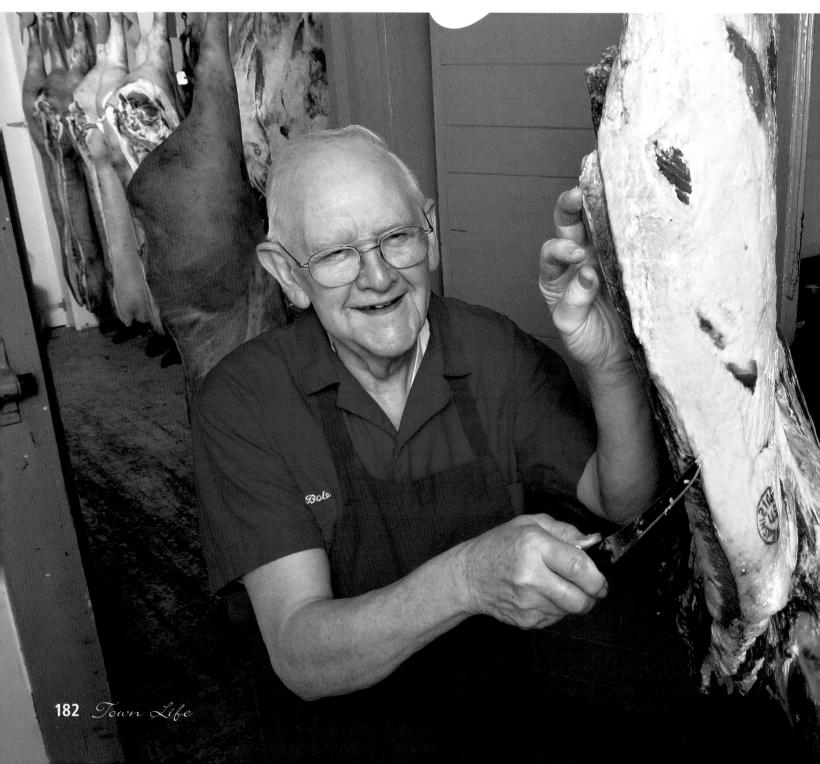

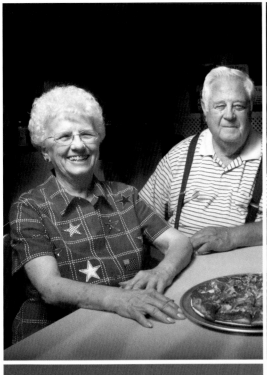

There's an advantage to the smaller places, for in them tradition sometimes hangs on. The best serve as repositories for custom service, personal relationships, and the occasional afternoon when time seems to pass at a speed somewhere *under* the speed of light.

At left, Bob Eutsler (and his fifty years of meat-cutting experience) with Larry Barrera at Barrera's Community Meat Market in Port William. Above is Charlie's Pizza in Sabina with Wanda and Charles Everman and grandson Justin Bernard. At right is Clarksville fireman Chuck Muchmore, and below, Brenda Mays and her brother Chuck Gaskins of Gaskins Printing in Sabina.

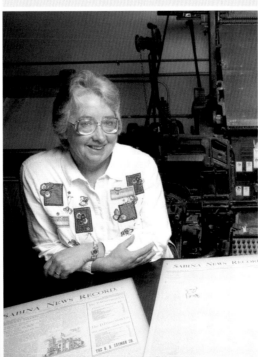

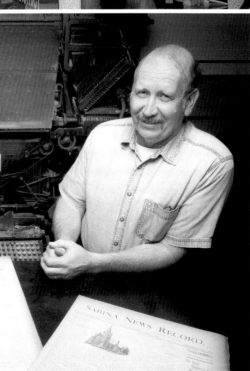

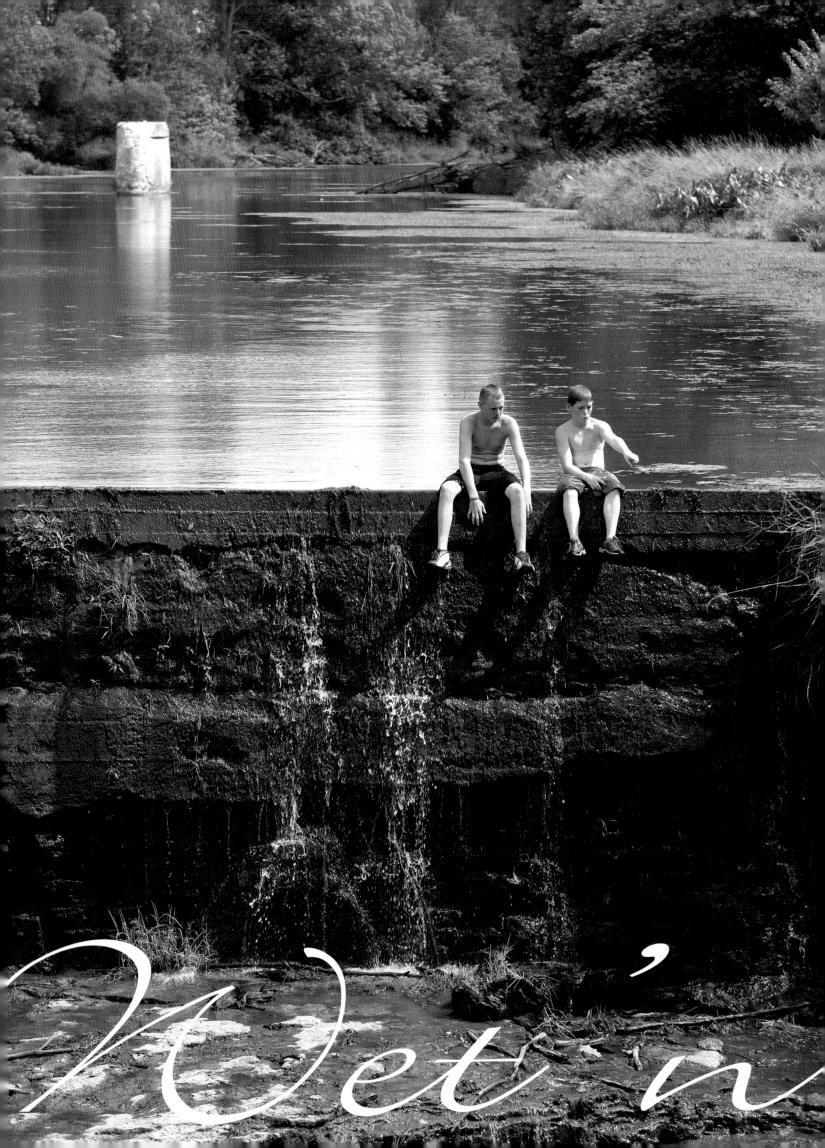

Wet 'n

One of the county's favorite parties is Port William's Dam Days. They occur in late summer when folks like the Clinton County Squares (below) dance on Main Street, and Jacob Davis (left) and James Cashmore sluff off the afternoon sitting on the dam.

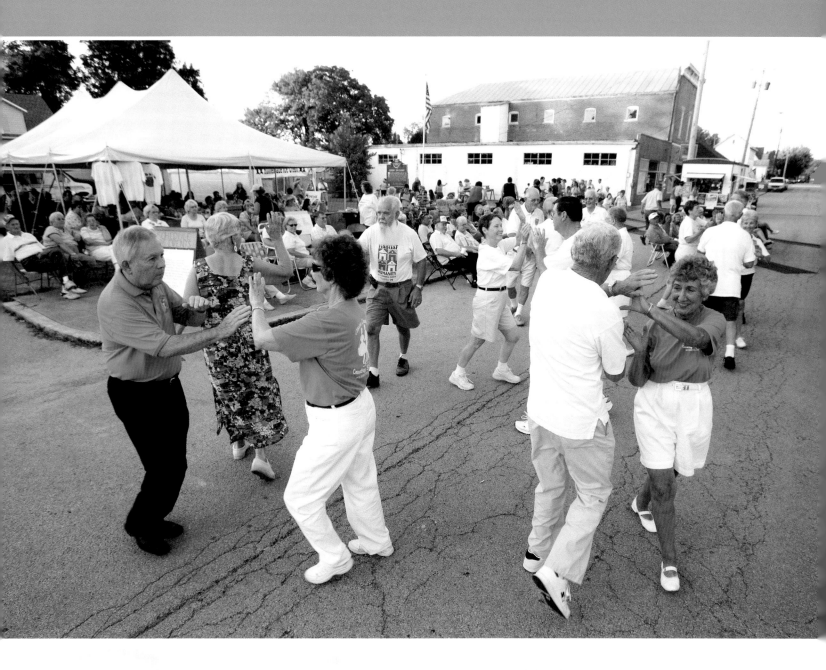

PORT WILLIAM

The last census reported there's 258 people in Port William, but the folks here say that in 2004, someone new moved in and now the population's up .4 percent. Well, things just never stand still for long.

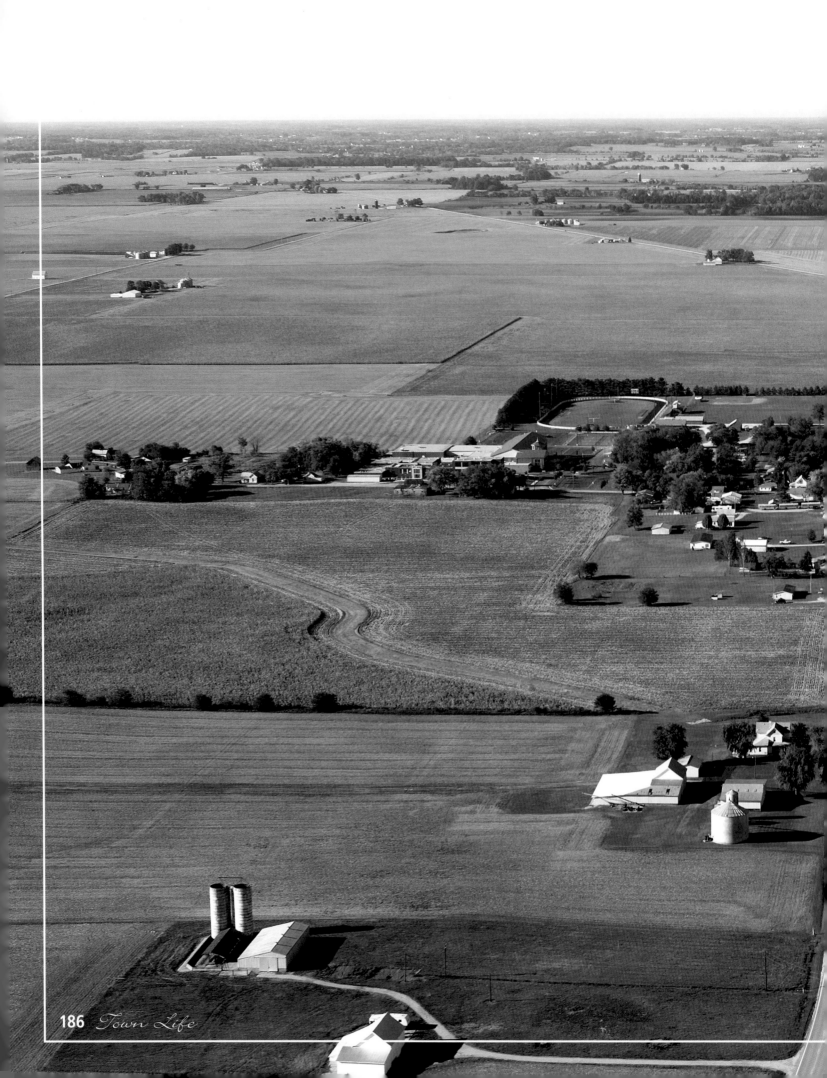

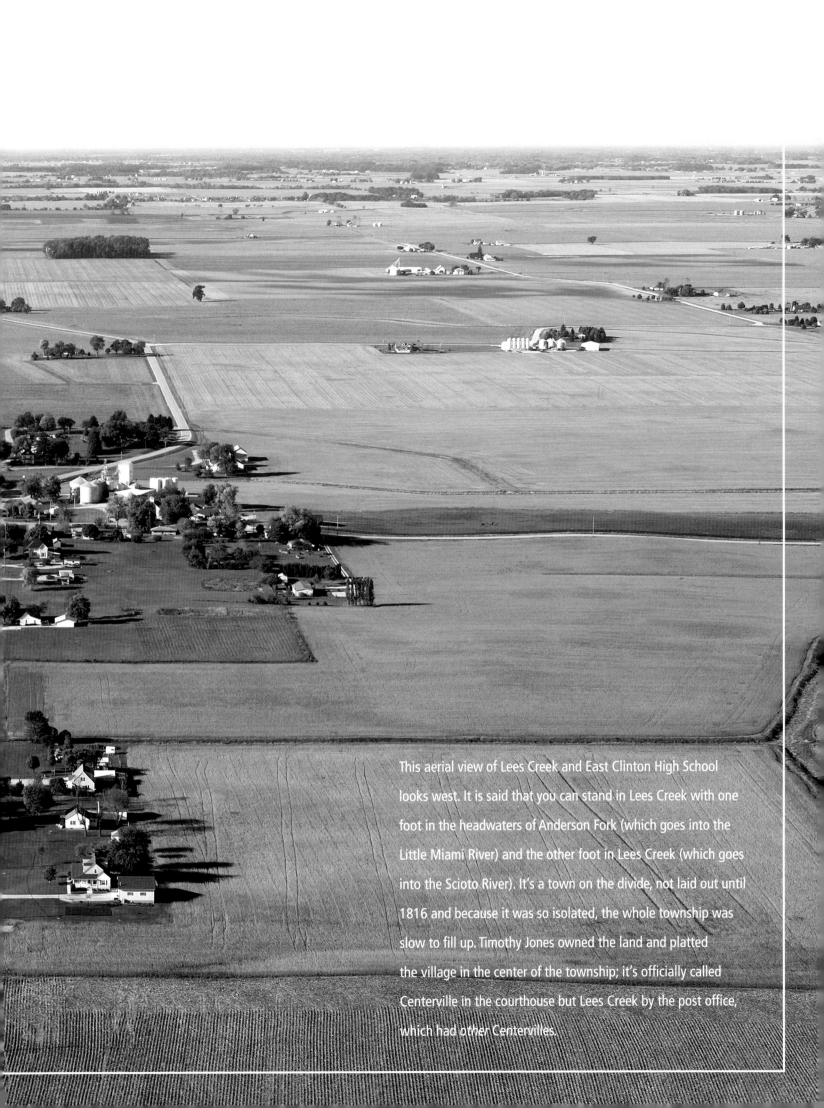

This aerial view of Lees Creek and East Clinton High School looks west. It is said that you can stand in Lees Creek with one foot in the headwaters of Anderson Fork (which goes into the Little Miami River) and the other foot in Lees Creek (which goes into the Scioto River). It's a town on the divide, not laid out until 1816 and because it was so isolated, the whole township was slow to fill up. Timothy Jones owned the land and platted the village in the center of the township; it's officially called Centerville in the courthouse but Lees Creek by the post office, which had other Centervilles.

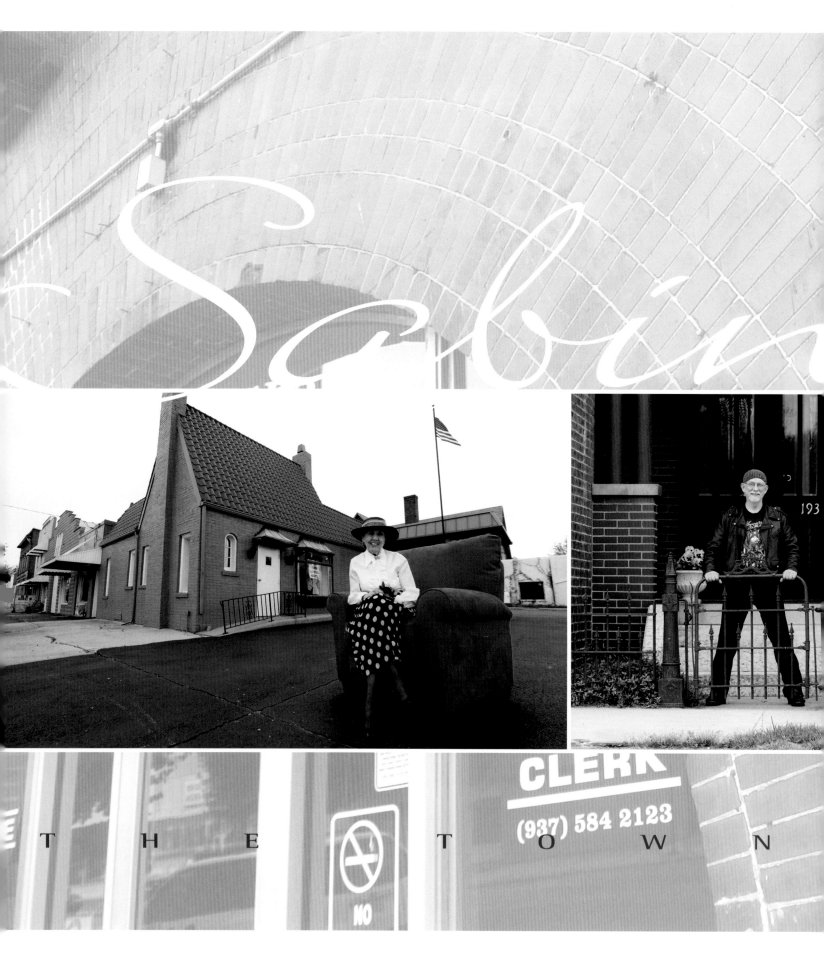

Warren Sabin platted his "Sabina" in 1830—a high place in the swamp—after buying 500 acres at a sheriff's sale. He put his imprimatur upon it by building a tavern and, in time, his town became known as "The Eden of Ohio." Even if that sobriquet *was* a remarkable example of local press agentry, it's a photogenic little town. And these folks prove it: From left, Joy Shoemaker, president of the Sabina Historical Society, in front of the society building; Rick Kendall, at his home on Howard Street (he's a master gardener and fluent in Japanese), and one of life's auspicious moments, the first haircut. That's Ethan Campbell, the son of Tim and Lindsay, in the capable hands of local artisan Kim Knauff at her Sabina Barber Shop.

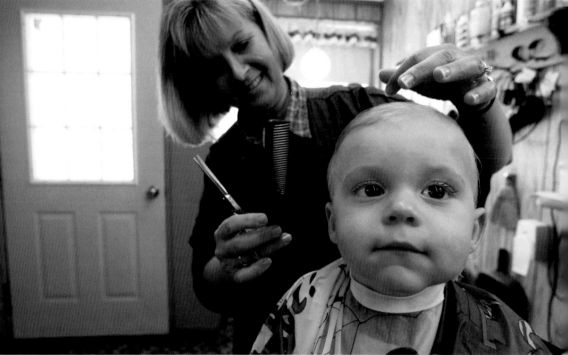

O F S A B I N A

The Sabina City Hall was built in 1894, originally an opera house, the last of seven in the county, and by far the best. Music and drama first, police and civic affairs later. When the wooden truss roof collapsed in 1941—and almost brought the whole building down—the balcony and top floor were removed, along with the old trusses and most of the aesthetics.

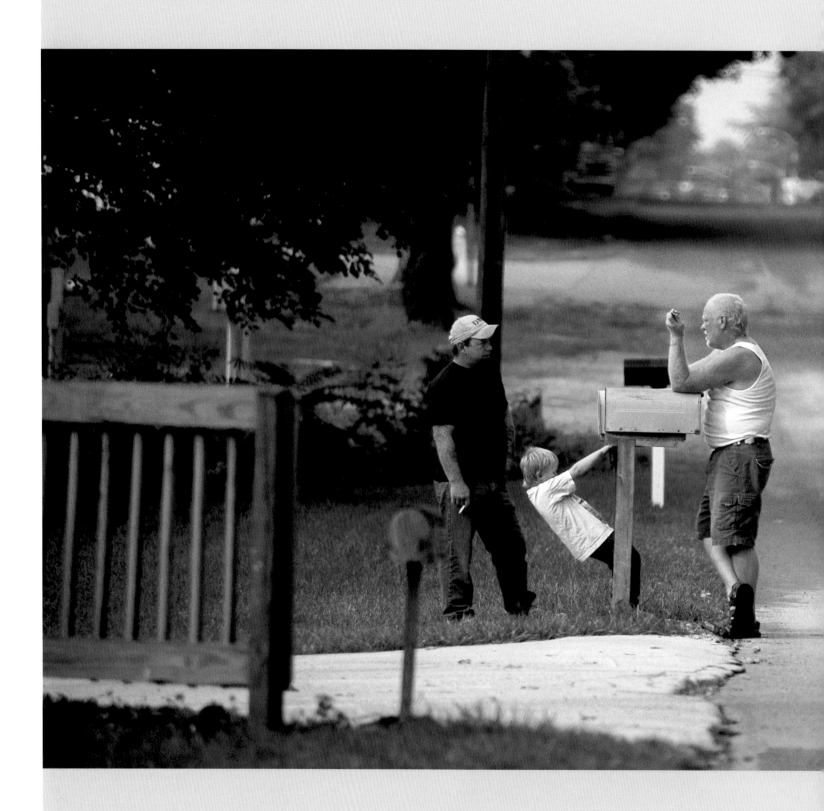

hese peaceful scenes are of New Vienna, where Doug Huston (at left) and Tom Nichols (in white shirt) indulge in the time-honored tradition of beating the mailbox to the news. The odds here are high that whatever news arrives, Doug and Tom already know it. That's young Keith Huston with them.

The picture above is the old section of downtown. New Vienna is one of the older county settlements and became a town in 1827 when it was known by the colorful appellation, "Buzzard's Glory." It was named after a tanner who became "financially embarrassed" and his hides, hung on poles, attracted a bevy of buzzards.

T H E D I N E R

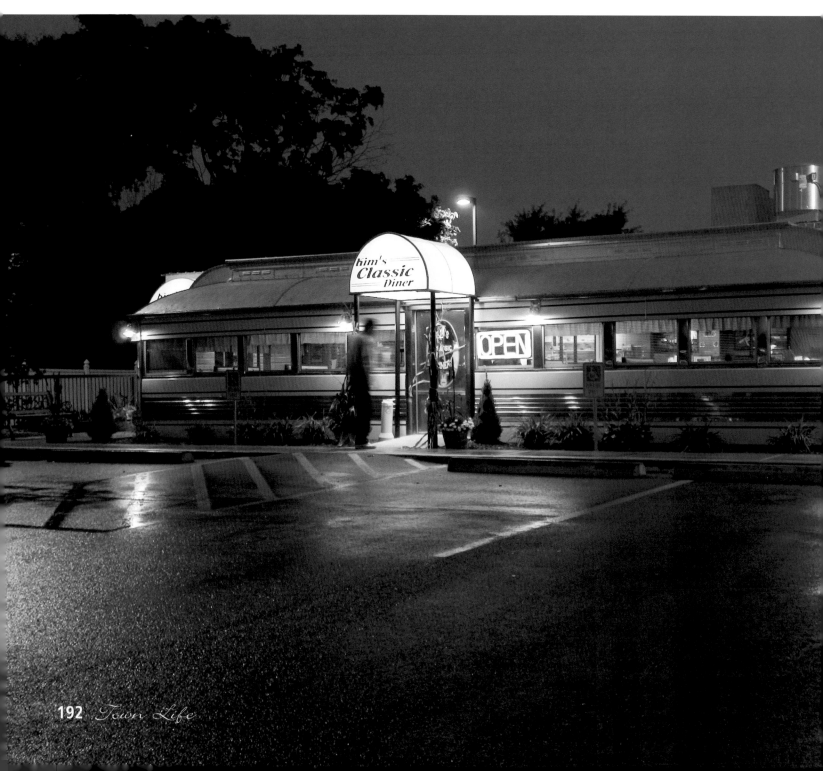

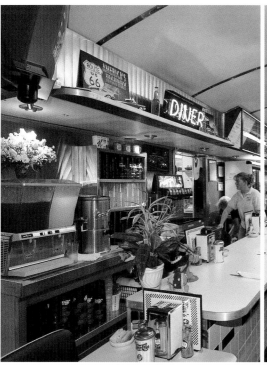

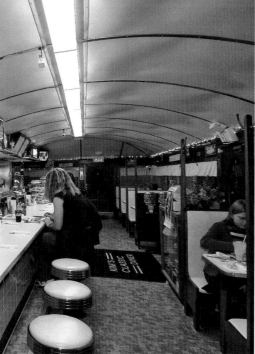

That's Amber Starr and John West at the counter of Kim's Classic Diner and server Casey Watson behind (in yellow shirt). Behind Casey is owner Kim Starr, who researched diners for 14 years before taking the plunge and buying this steel-framed 1946 Silk City Diner.

It's a remnant of America's roadside architecture, before we were overwhelmed by golden arches. This one went into use in New York's Hudson Valley, then was moved to Michigan where Kim salvaged it from a field in 2002 and brought it to Sabina, where it looks like it has always been.

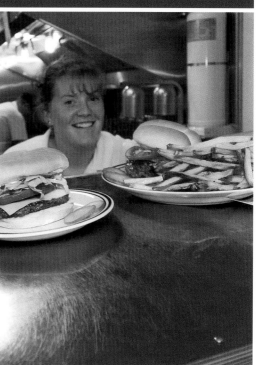

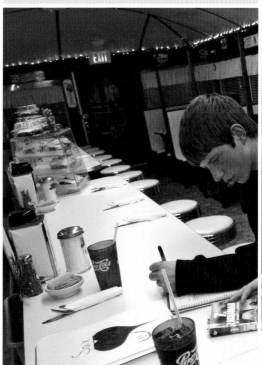

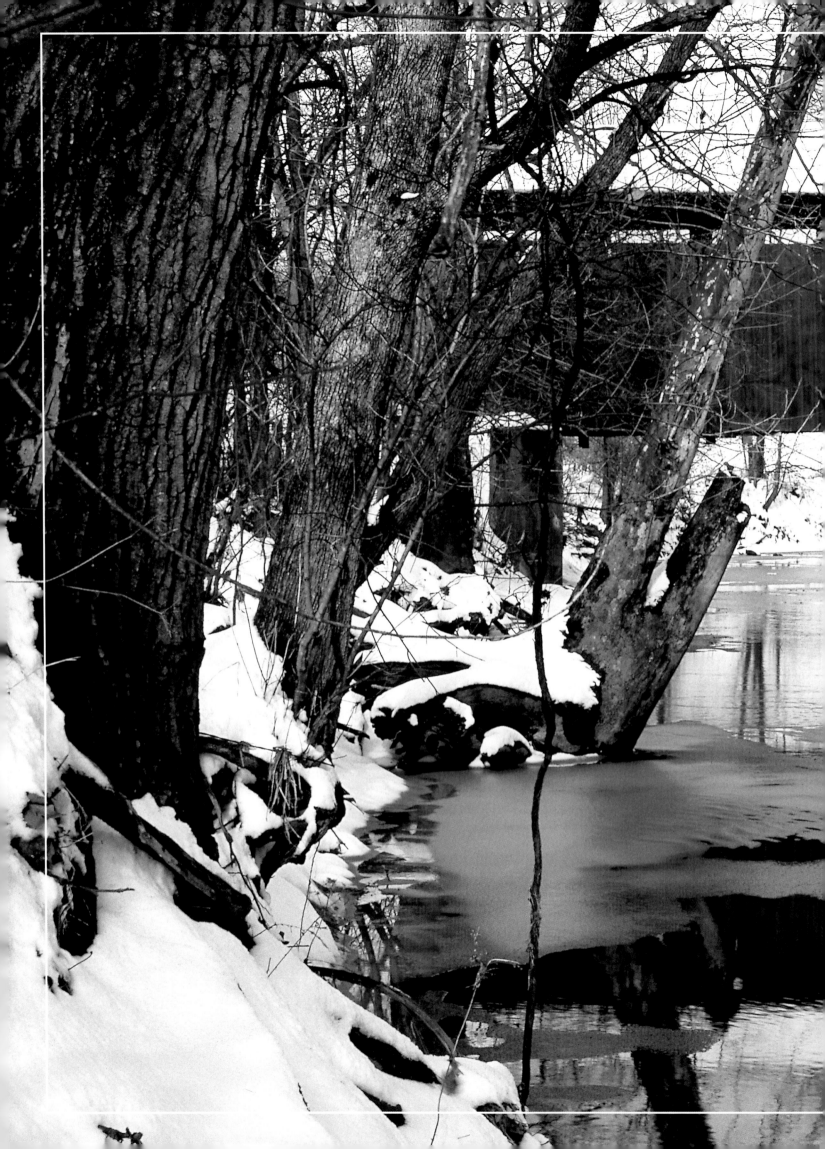

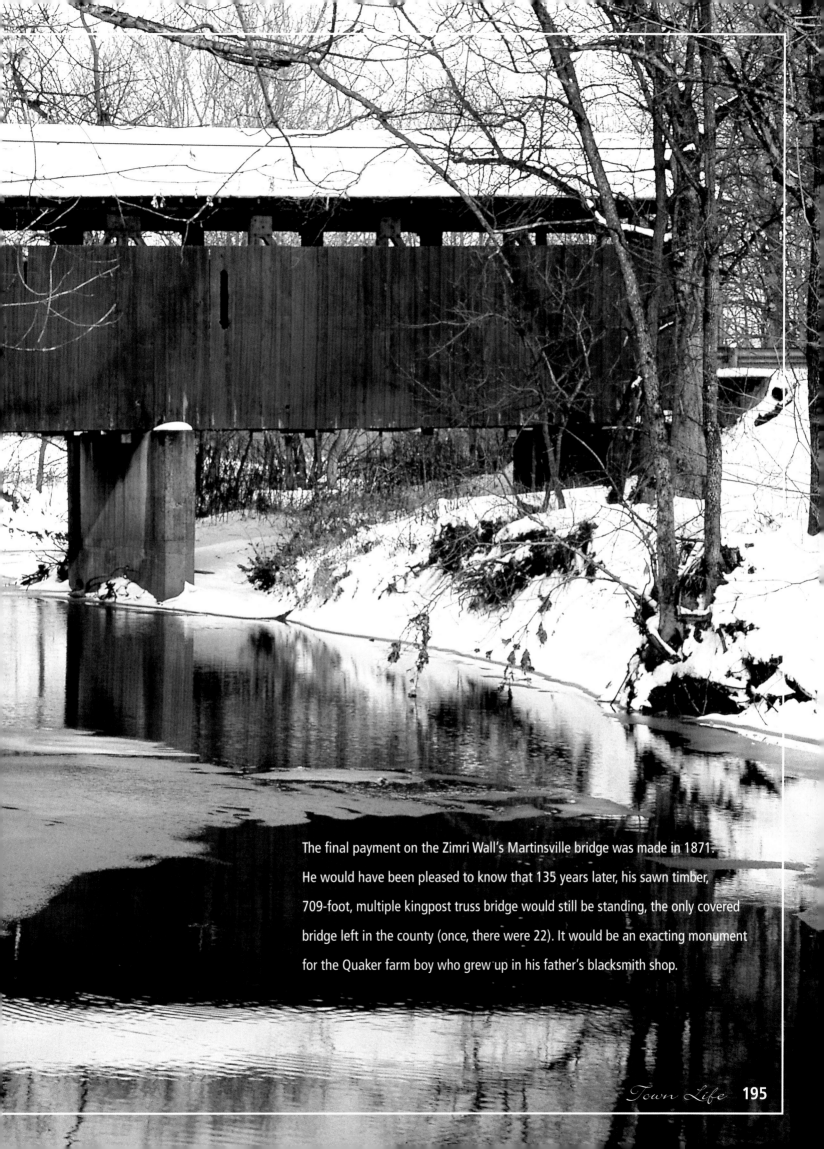

The final payment on the Zimri Wall's Martinsville bridge was made in 1871. He would have been pleased to know that 135 years later, his sawn timber, 709-foot, multiple kingpost truss bridge would still be standing, the only covered bridge left in the county (once, there were 22). It would be an exacting monument for the Quaker farm boy who grew up in his father's blacksmith shop.

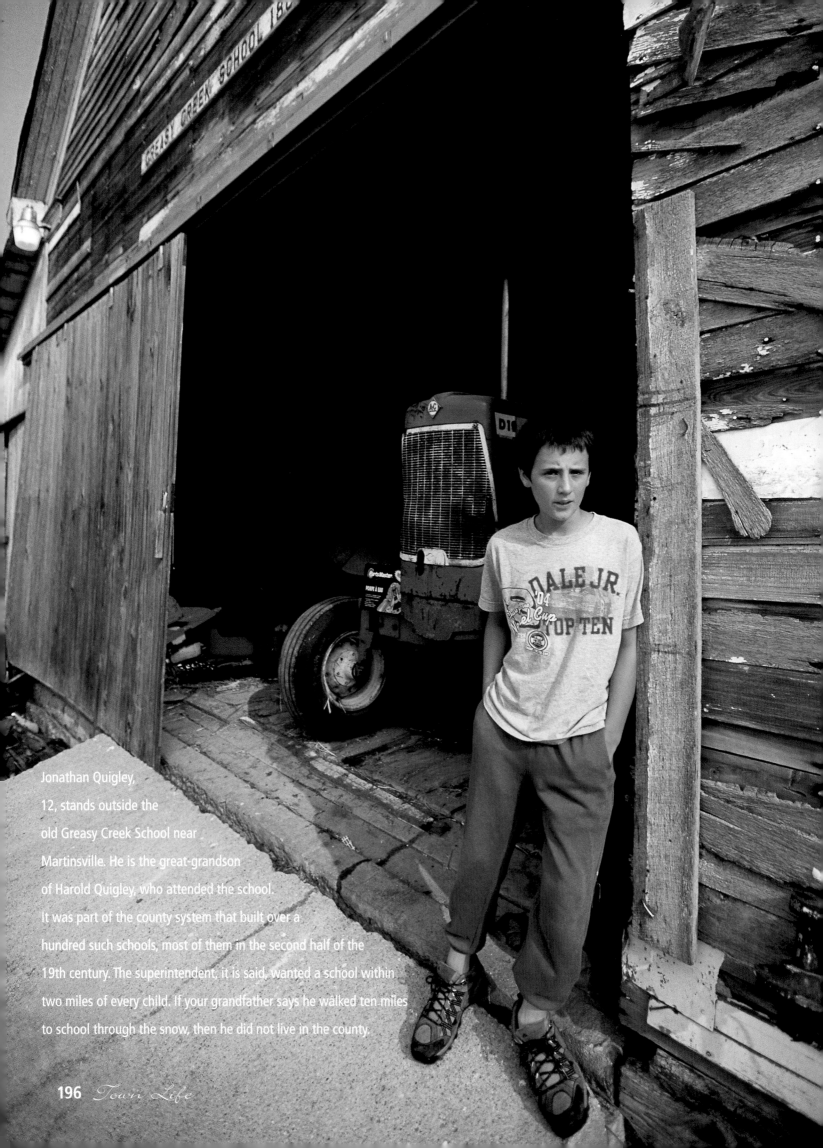

Jonathan Quigley,
12, stands outside the
old Greasy Creek School near
Martinsville. He is the great-grandson
of Harold Quigley, who attended the school.
It was part of the county system that built over a
hundred such schools, most of them in the second half of the
19th century. The superintendent, it is said, wanted a school within
two miles of every child. If your grandfather says he walked ten miles
to school through the snow, then he did not live in the county.

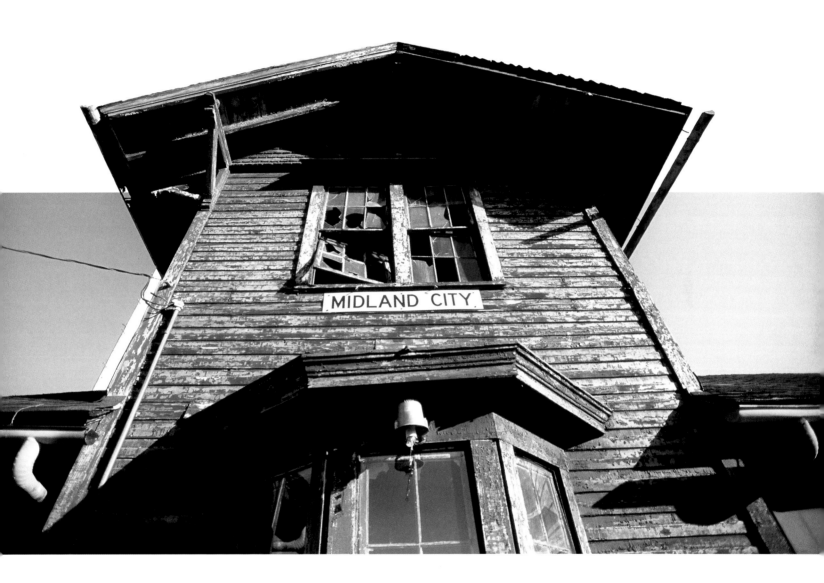

The old Midland train station was the first in the county—
1852, a year before Wilmington's, which disappeared long ago.
Midland was first called Clinton Valley but there was a Clinton
Station east of Wilmington, and, anyway—or so it was said—
the station was midway between Wilmington and Hillsboro.
The area was forested, and Midland was known for its good
straight logs, sent into Cincinnati along with the normal
complement of hay for city liveries, hogs for German sausage,
and corn for Irish whiskey.

GREASY CREEK SCHOOL 1893

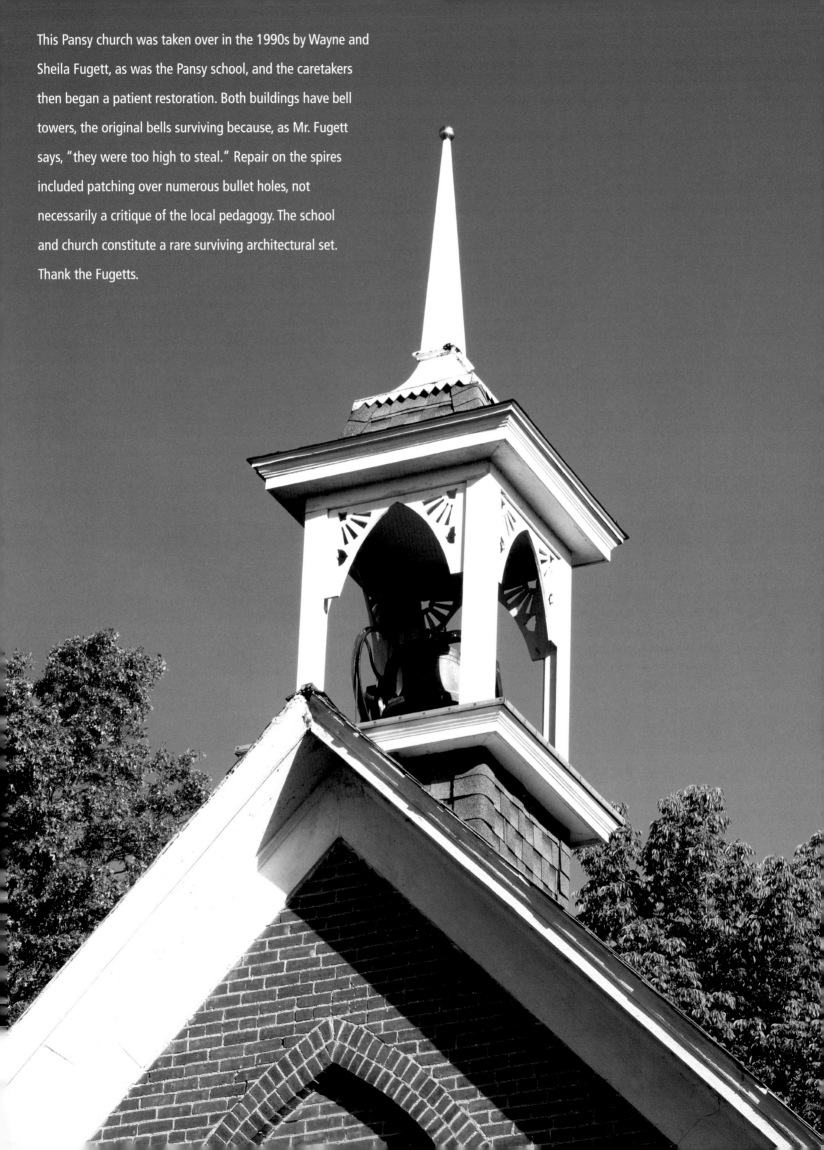

This Pansy church was taken over in the 1990s by Wayne and Sheila Fugett, as was the Pansy school, and the caretakers then began a patient restoration. Both buildings have bell towers, the original bells surviving because, as Mr. Fugett says, "they were too high to steal." Repair on the spires included patching over numerous bullet holes, not necessarily a critique of the local pedagogy. The school and church constitute a rare surviving architectural set. Thank the Fugetts.

Blanchester

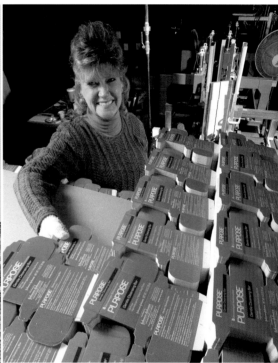

Margaret Freeman of East Main Street displays a three-pound tomato, the splendid fruit linking her with Blanchester's Everett Ertel, the one-time tomato monarch of the county. Mr. Ertel survived his 94th winter by walking a mile each day (inside his house), memorized the square mileage of each state, and planned his tomato production, which was prodigious. Next, that's *the* Blanchester landmark, the cupola on the old bank building. If you're new in town and get turned about, it will tell you where you are. Then, there's Charlotte Helton, who started at Curless Printing as a custodian and worked her way into operating the automatic box pasting machine.

ew Burlington was laid out in 1830 by a man named Alexander Jay, who never suspected he was founding the archetypal Midwest farming village. Never more than 400 people, New Burlington produced at least one fine carpenter, more than one splendid farmer, and one notable chicken thief. It expired quietly in the early 1970s when the Army Corps of Engineers built Caesar Creek Lake. It was revived, but only somewhat, by the book, *New Burlington, The Life and Death of an American Village,* which was called "one of the most unique and beautiful histories ever written about rural America."

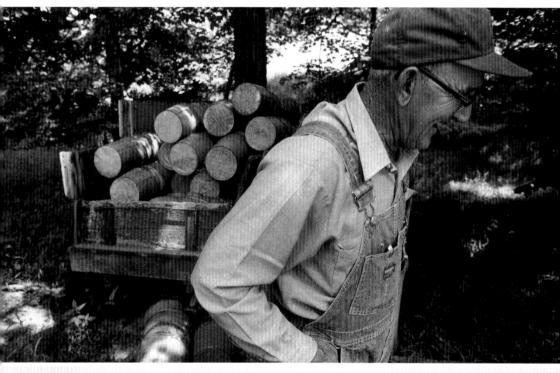

THE VILLAGE OF

It became a Harvard text as well as a play, but, as its author noted in his preface to a new edition, "Most of the pleasure-seekers would have been only mildly surprised if someone had told them they were water-skiing over a town." From left, that's Lee Ames at his sugar camp; Elmer Lemar, the construction foreman on the General Denver Hotel; Merle McIntire and granddaughter Cherie; and Mary Robinson.

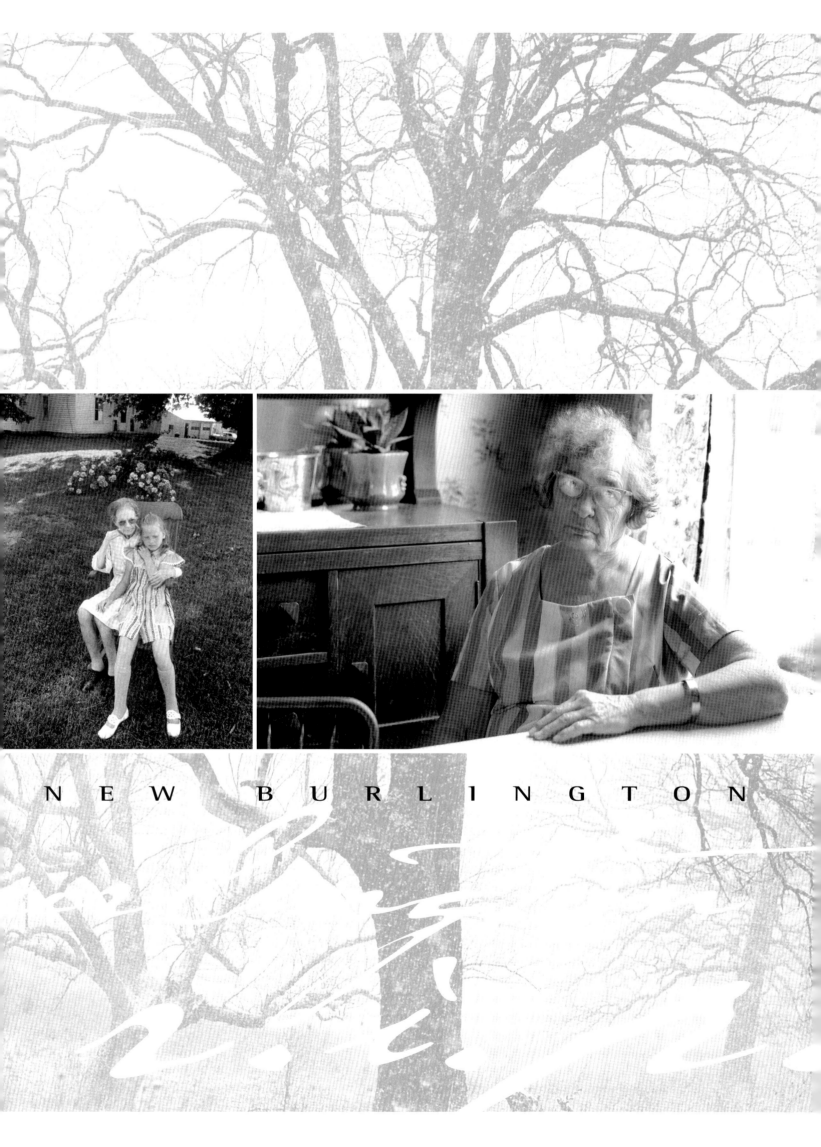

NEW BURLINGTON

HANGING OUT @ THE FAIR

The fair—nearly 175 years old—is one of the county's most venerable events, if not by age then by livestock and produce, attesting to impossible work and good blood. The fair is, finally, a distillation of hope, the kind that permits a farmer to plant his fields in the spring following a drought year. The fair and its cornrowcopia of all things rural is the essential picture of where we've been—and still are. *(See page 260.)*

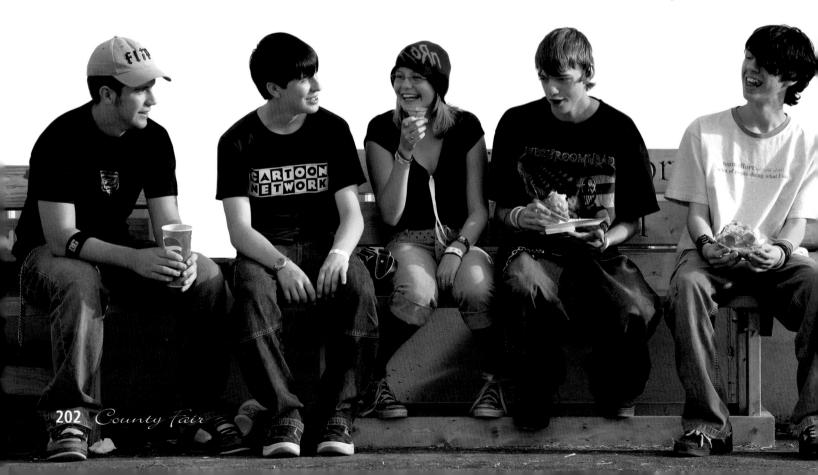

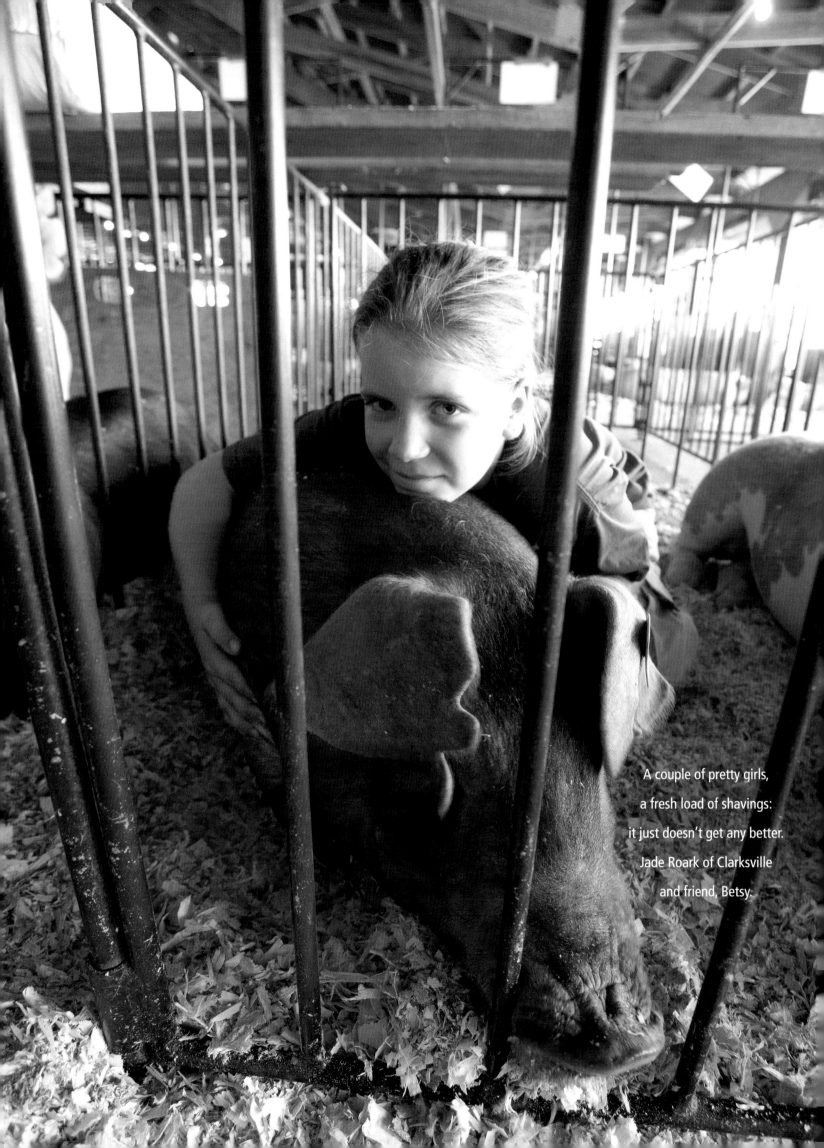

A couple of pretty girls,
a fresh load of shavings:
it just doesn't get any better.
Jade Roark of Clarksville
and friend, Betsy.

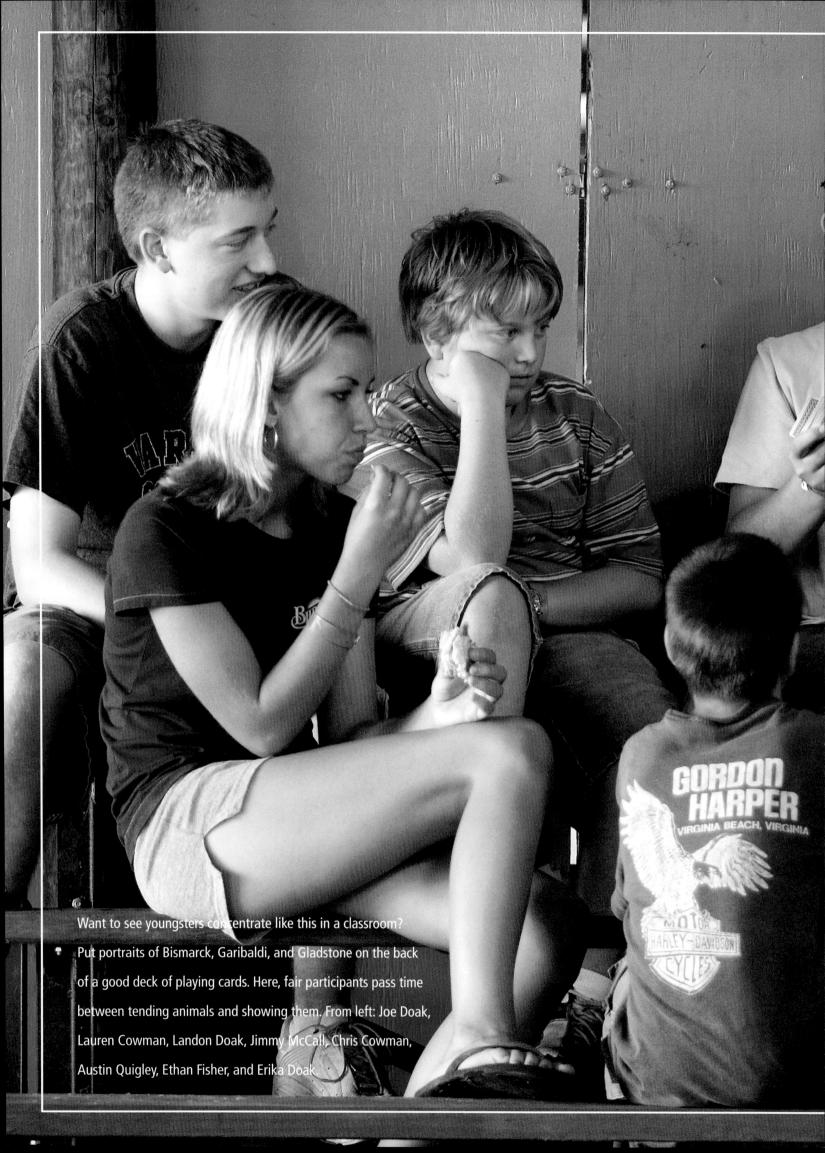

Want to see youngsters concentrate like this in a classroom?
Put portraits of Bismarck, Garibaldi, and Gladstone on the back
of a good deck of playing cards. Here, fair participants pass time
between tending animals and showing them. From left: Joe Doak,
Lauren Cowman, Landon Doak, Jimmy McCall, Chris Cowman,
Austin Quigley, Ethan Fisher, and Erika Doak.

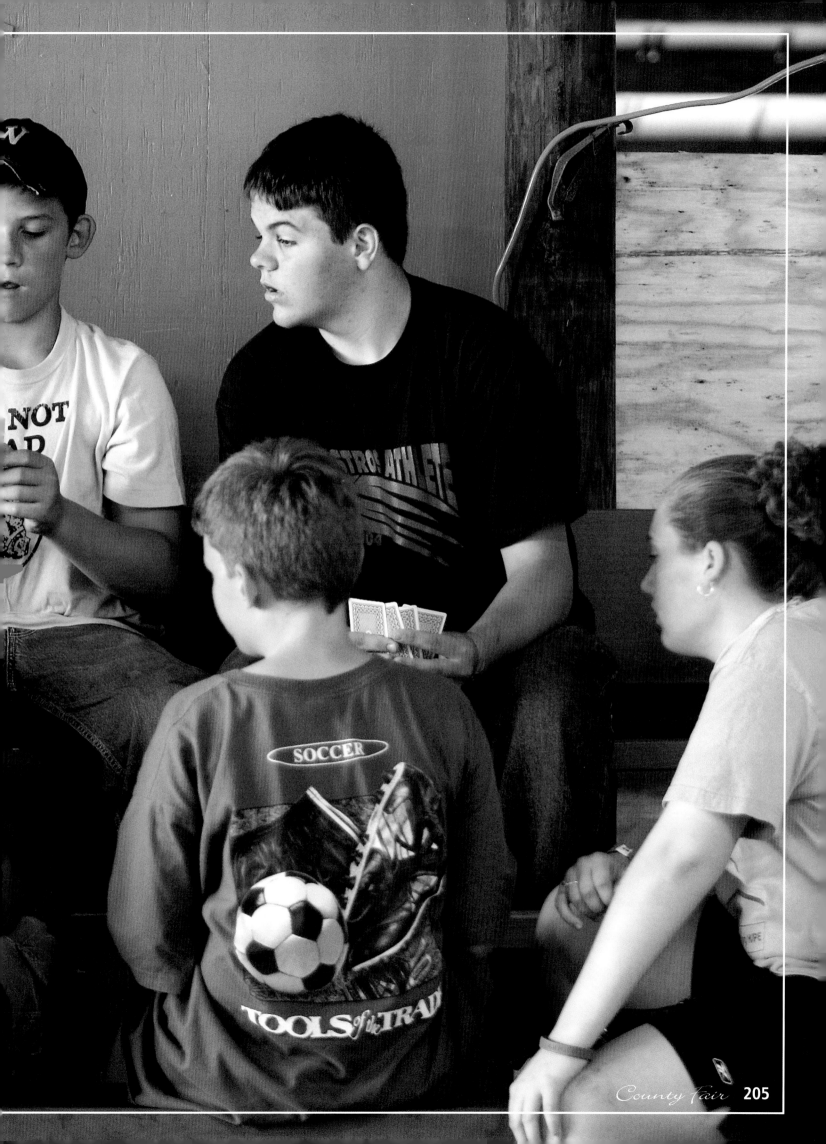

Joshua Wiget and his sister, Jessica, recline on their small but elegant herd of Holsteins, who have turned in after being carefully washed and dried. Indolent in the straw of their circumstances are, from left, Buddy, Sonny, Bugs, and Ziggy.

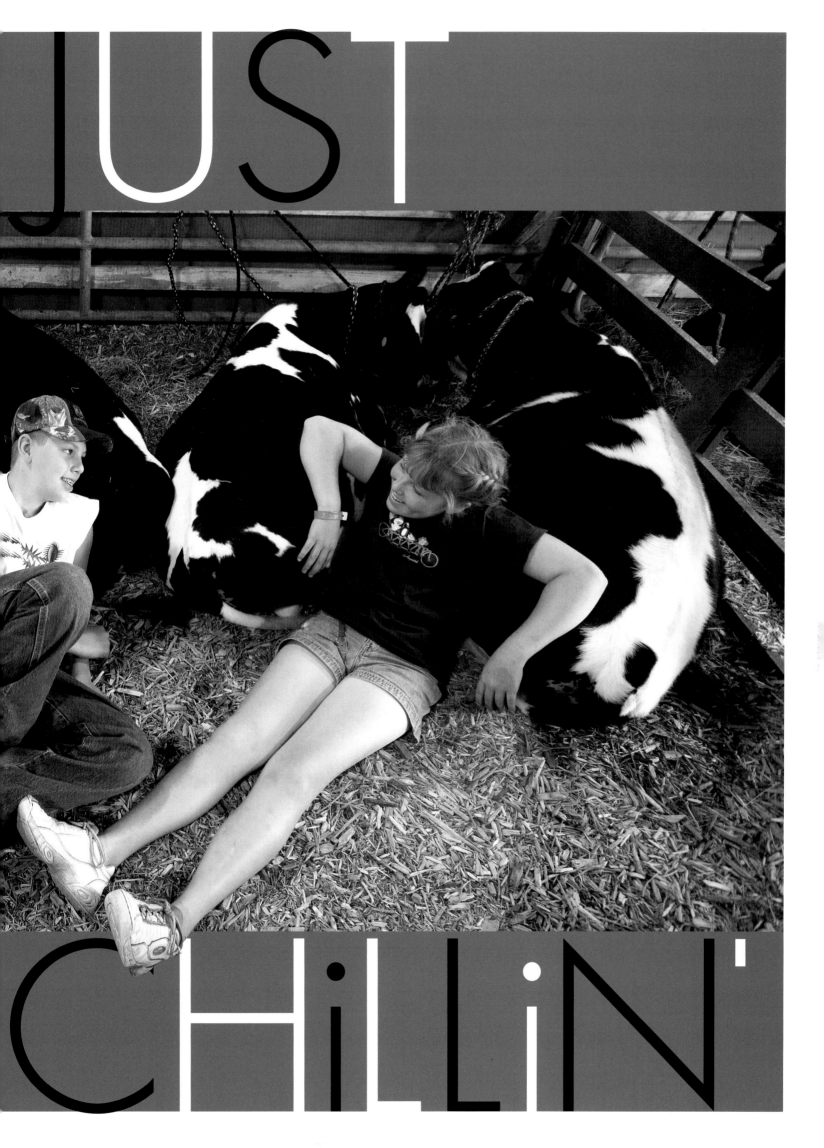

JUST

CHiLLiN'

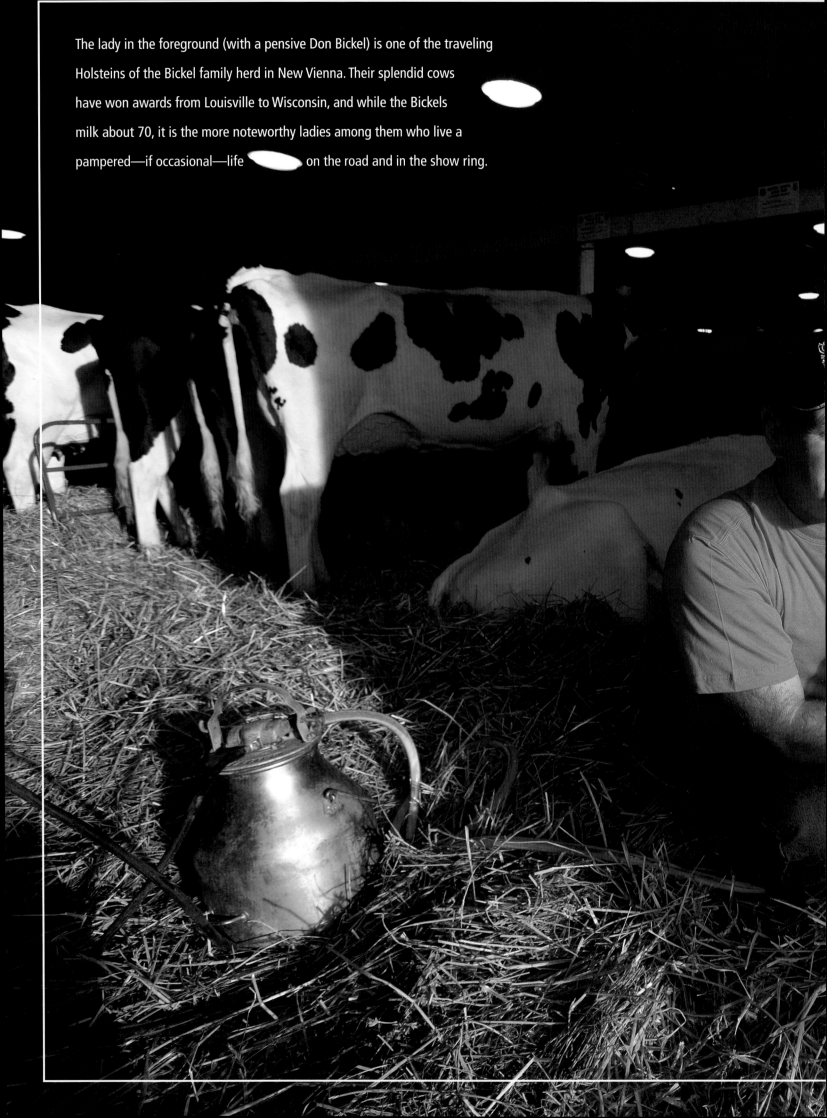

The lady in the foreground (with a pensive Don Bickel) is one of the traveling Holsteins of the Bickel family herd in New Vienna. Their splendid cows have won awards from Louisville to Wisconsin, and while the Bickels milk about 70, it is the more noteworthy ladies among them who live a pampered—if occasional—life on the road and in the show ring.

make me pretty

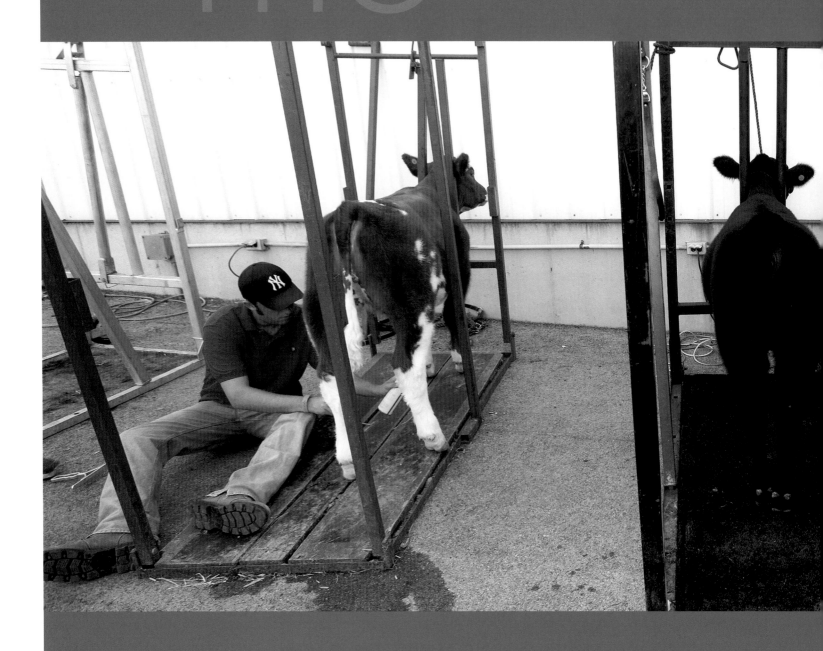

The word from such experts as Keri Bickel suggest that young ladies are young ladies the world over, even when they may be from another species. Make what you will of this, but heifers like to be pampered. Keri, who has shown all over Ohio, and other states as

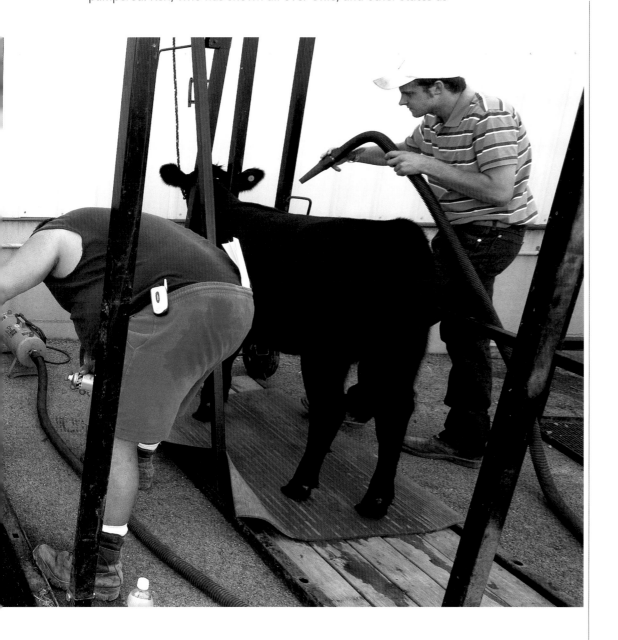

well, says the girls like to travel. "They get washed and fed several times a day, and their hair cut. When it's hot, they get their own fans. Who *wouldn't* like it?" The heifers here are feeder heifers, and attending them are (from left) Jake Figgins, Doug Holland, and Jay Holland.

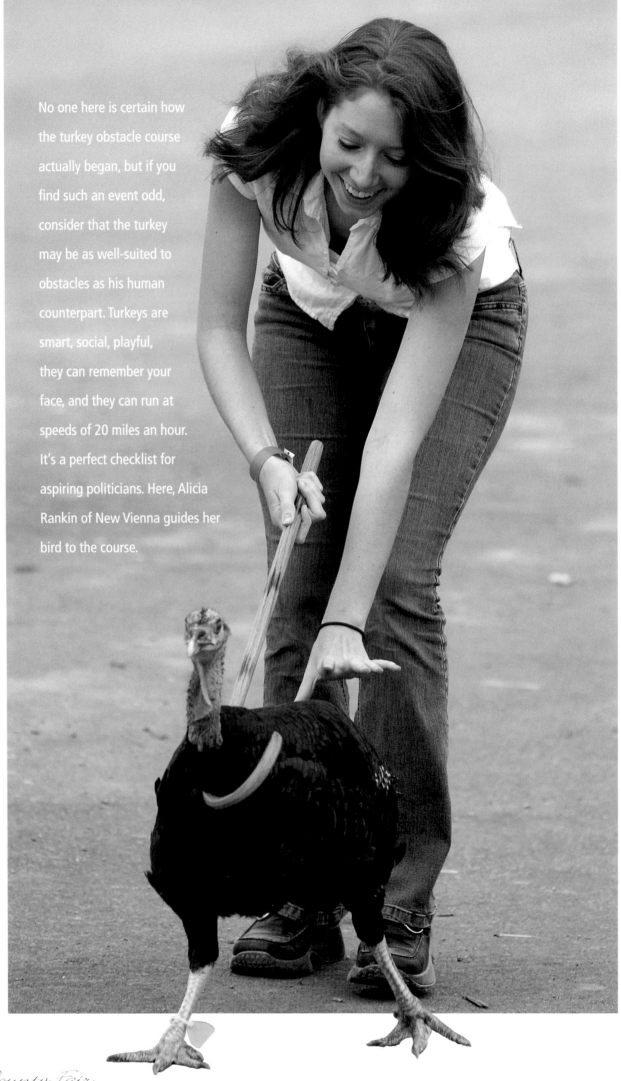

No one here is certain how the turkey obstacle course actually began, but if you find such an event odd, consider that the turkey may be as well-suited to obstacles as his human counterpart. Turkeys are smart, social, playful, they can remember your face, and they can run at speeds of 20 miles an hour. It's a perfect checklist for aspiring politicians. Here, Alicia Rankin of New Vienna guides her bird to the course.

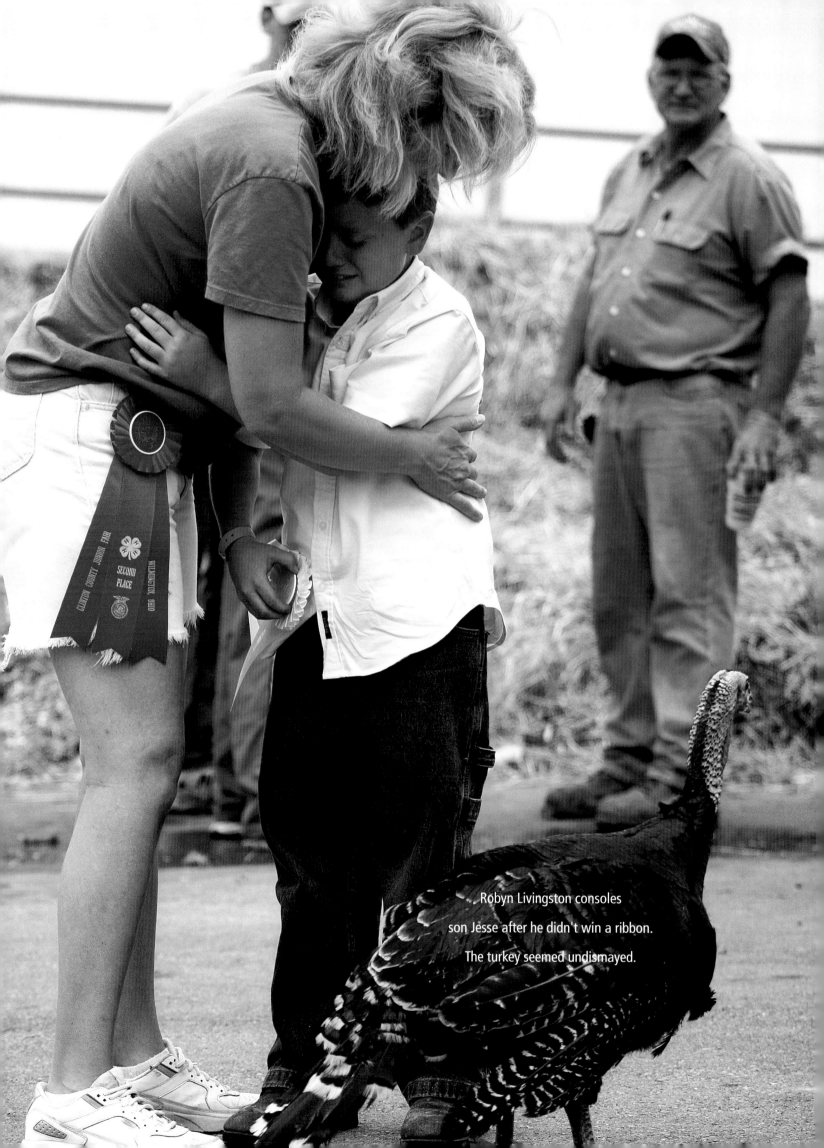

Robyn Livingston consoles
son Jesse after he didn't win a ribbon.
The turkey seemed undismayed.

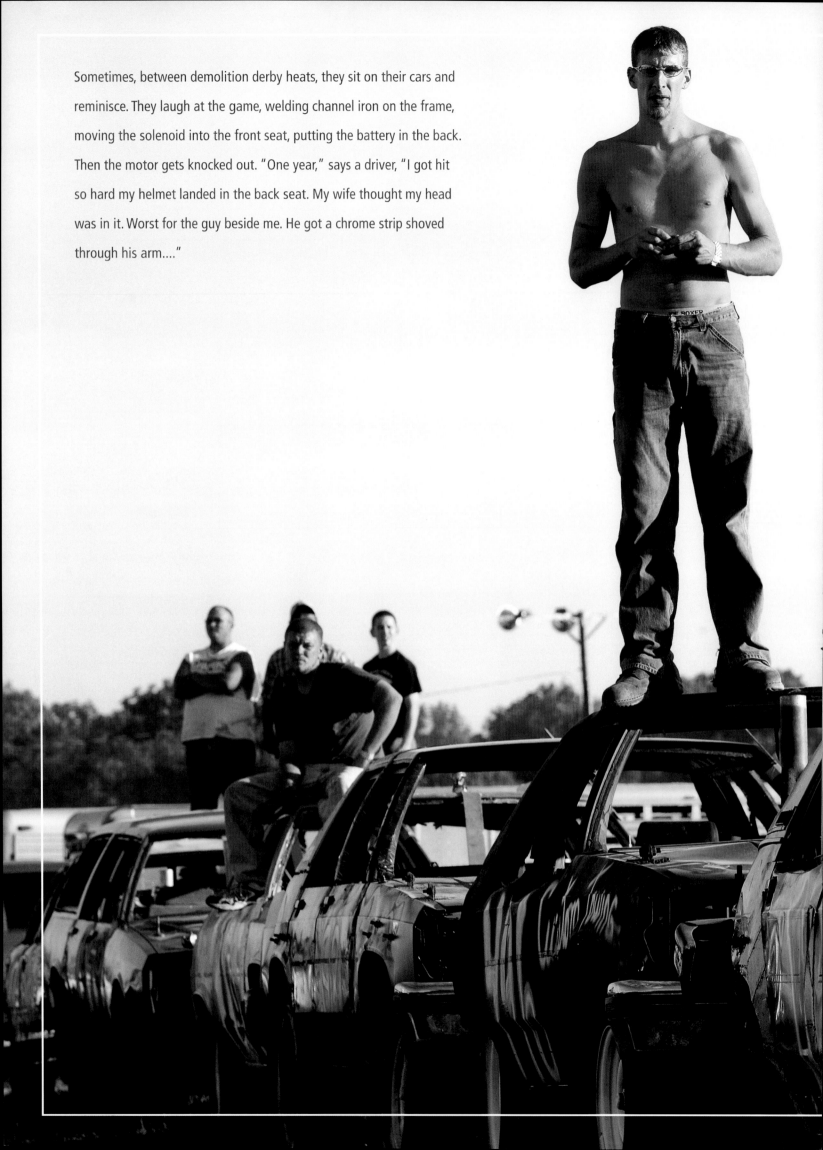

Sometimes, between demolition derby heats, they sit on their cars and reminisce. They laugh at the game, welding channel iron on the frame, moving the solenoid into the front seat, putting the battery in the back. Then the motor gets knocked out. "One year," says a driver, "I got hit so hard my helmet landed in the back seat. My wife thought my head was in it. Worst for the guy beside me. He got a chrome strip shoved through his arm...."

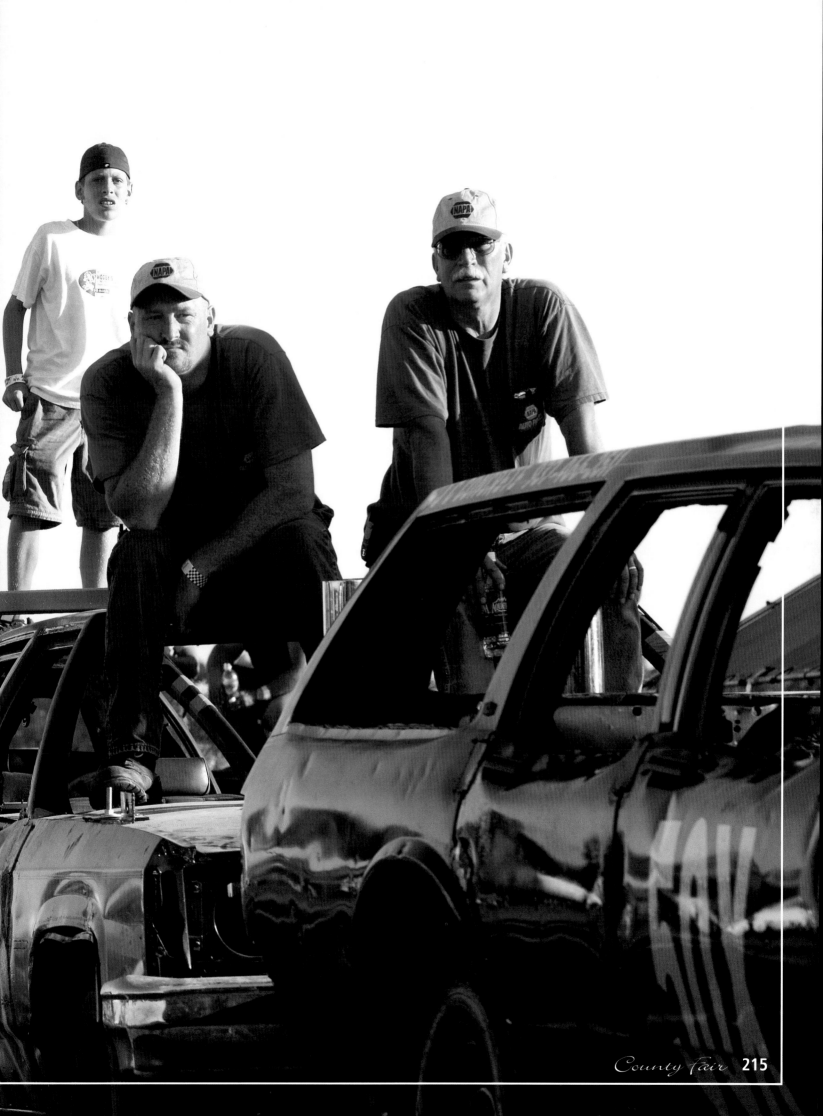

The fair's midway is a place for young people, or those young at heart, anyway. It has a foreign air, the nearest place many county kids will ever come to visiting another country, where the air is filled with rich scents—the cow barn competing with popcorn and fried pork—and the next impromptu conversation may begin undying love. In truth, being heartstruck is less likely than heartburn. But on just the right summer night, there's no other place to be.

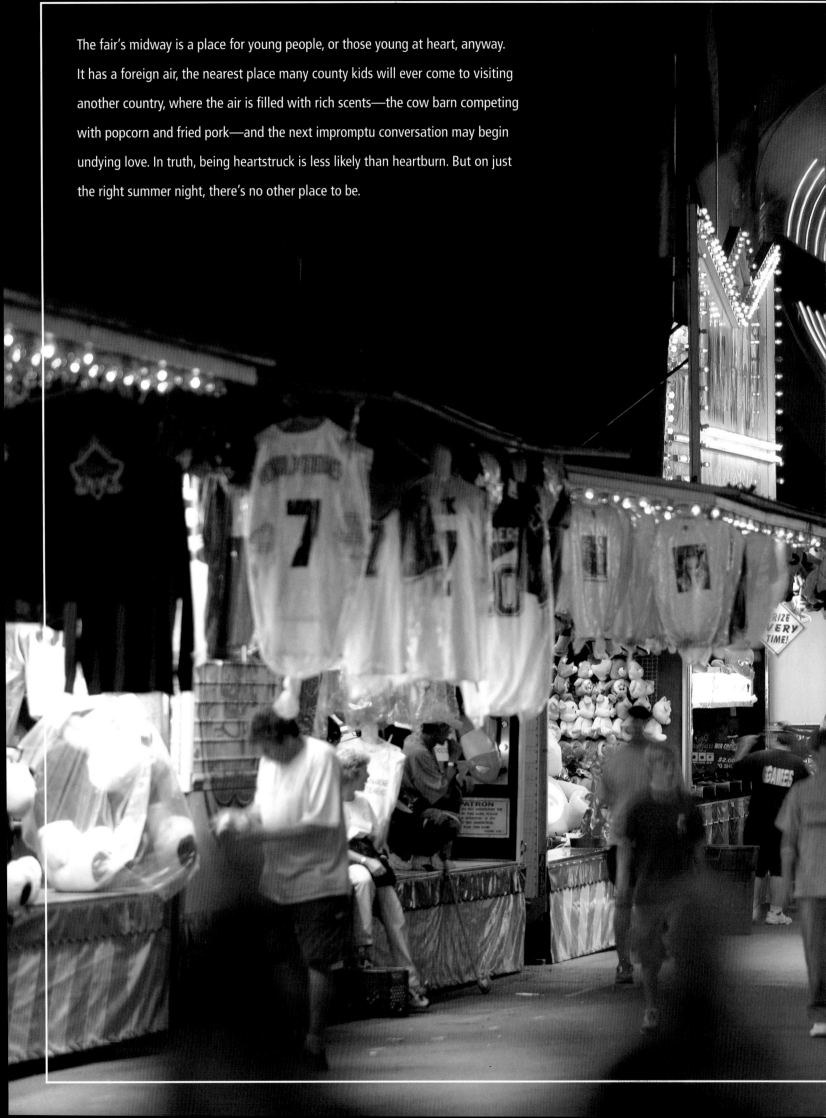

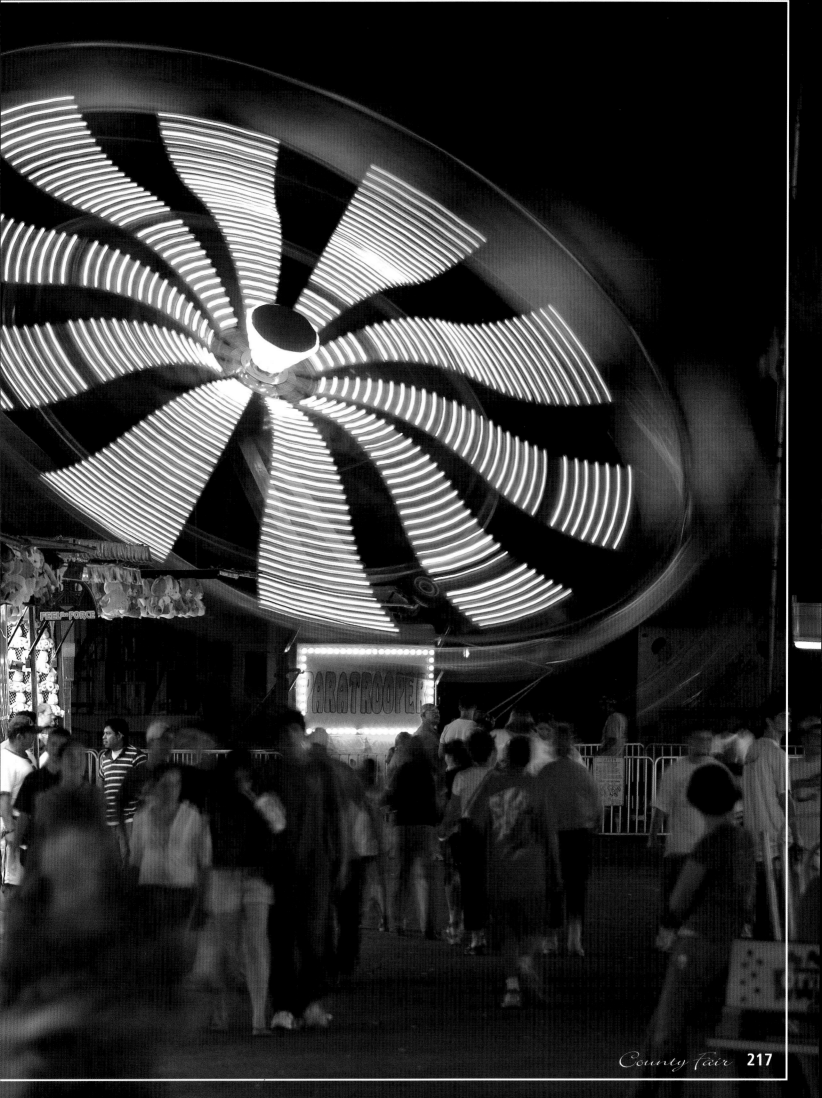

Under Blue Skies...

...A CORN-UTOPIA OF DELIGHT

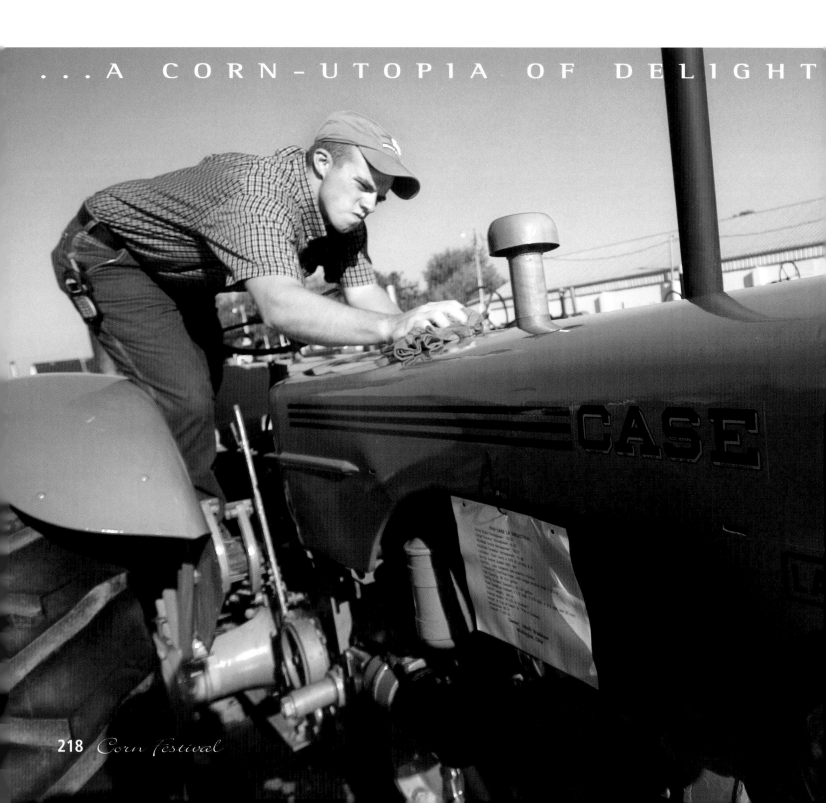

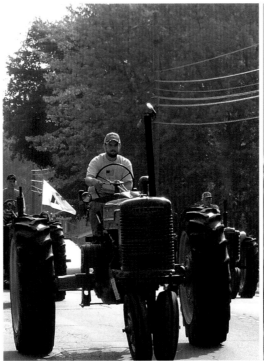

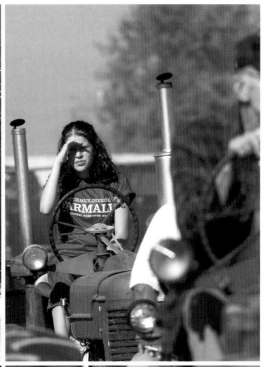

The Corn Festival is a parade as well as a reunion, where old boys, many retired, get together to show off their toys, also retired. Thus old models—men and machines alike—make way for new models, but at the fairgrounds, for a weekend at least, history holds sway.

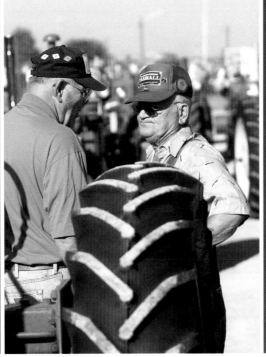

At far left, an intent young man gets on his own Case. At top, the parade of machinery, flexing its horsepower in full view of an appreciative audience, heads out Locust Street to the fairground. That's Shawnee Hawkins (top, right), and James Knowles chatting up Glenn Murphy (immediate left).

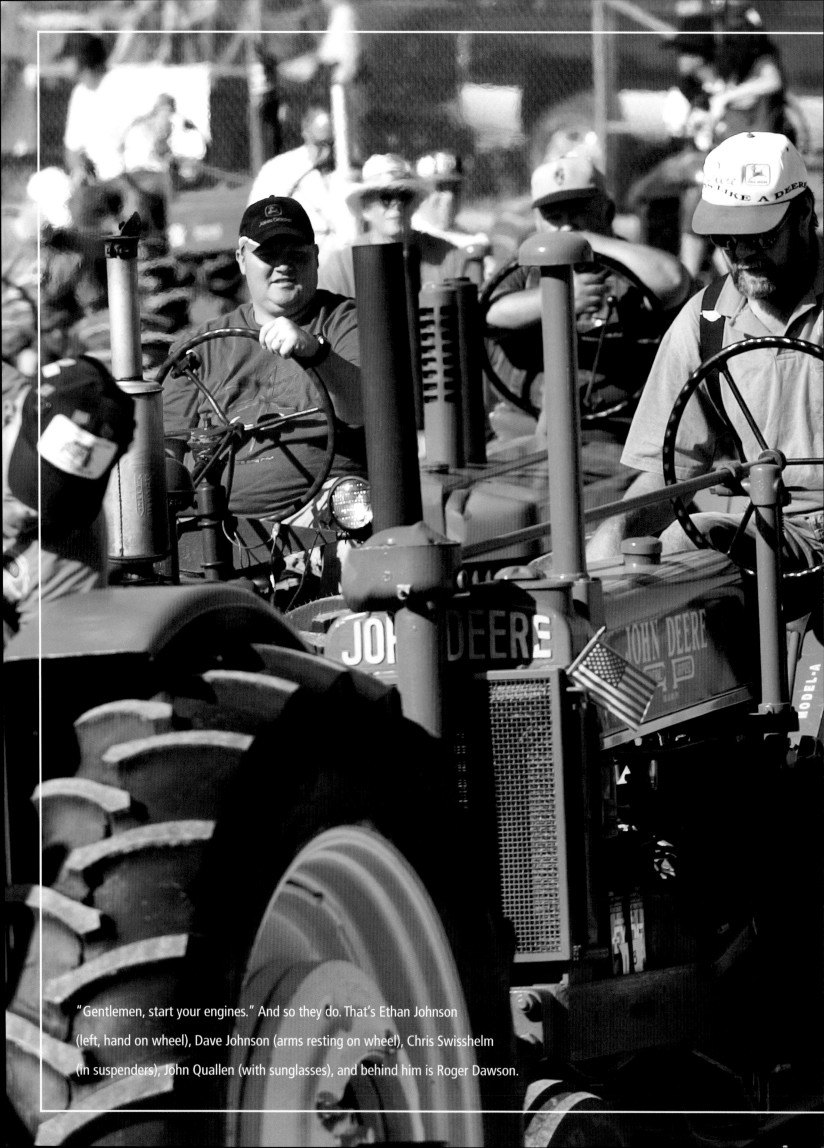

"Gentlemen, start your engines." And so they do. That's Ethan Johnson (left, hand on wheel), Dave Johnson (arms resting on wheel), Chris Swisshelm (in suspenders), John Quallen (with sunglasses), and behind him is Roger Dawson.

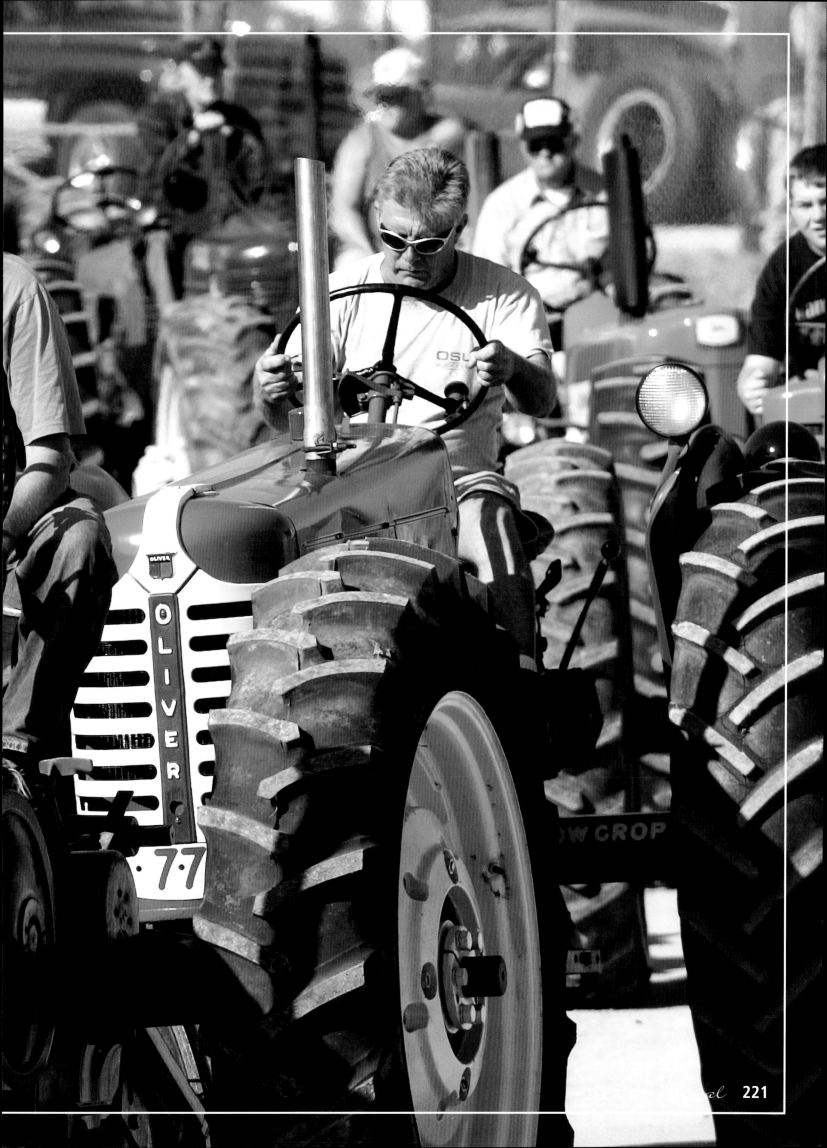

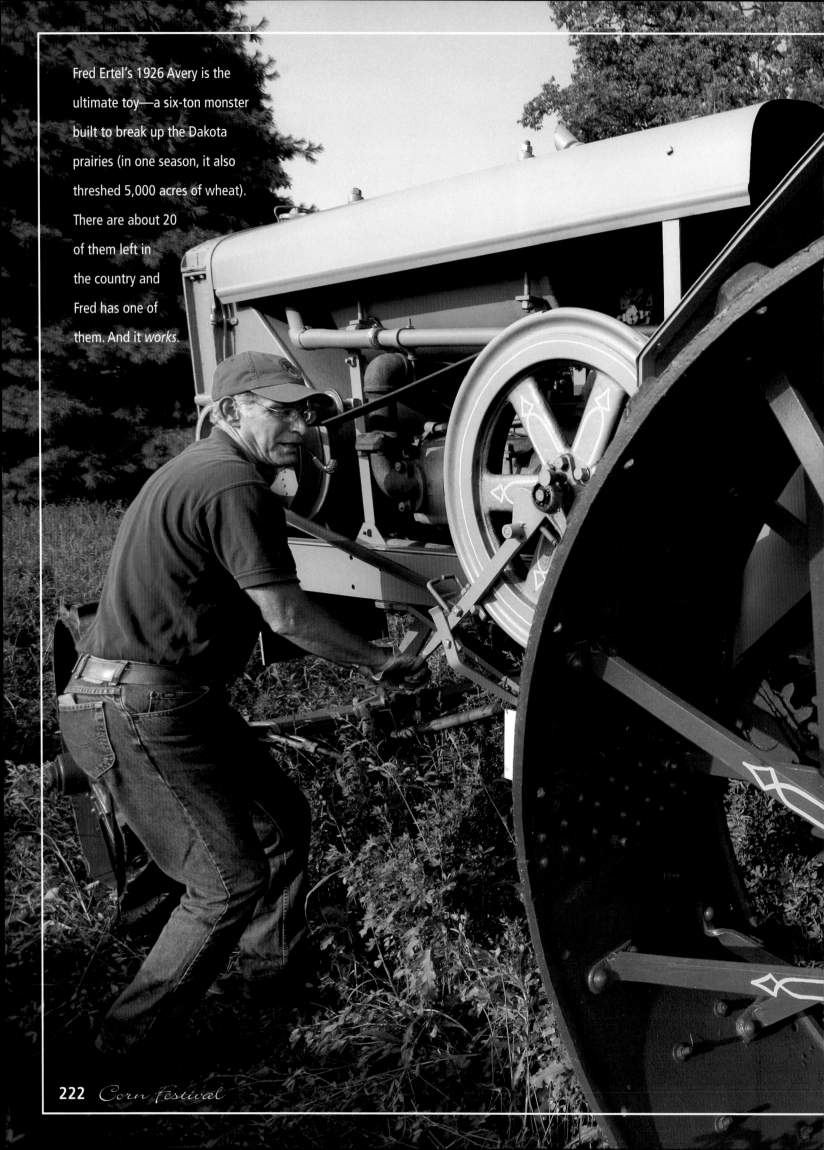

Fred Ertel's 1926 Avery is the ultimate toy—a six-ton monster built to break up the Dakota prairies (in one season, it also threshed 5,000 acres of wheat). There are about 20 of them left in the country and Fred has one of them. And it *works*.

For smaller folks, there are smaller antiques and besides, it's the caps and overalls that *really* make the driver.

More onlookers: Cub Scout Pack 909 and YMCA gymnasts—Coach Aimee Blakeman's girls. *(See page 260.)*

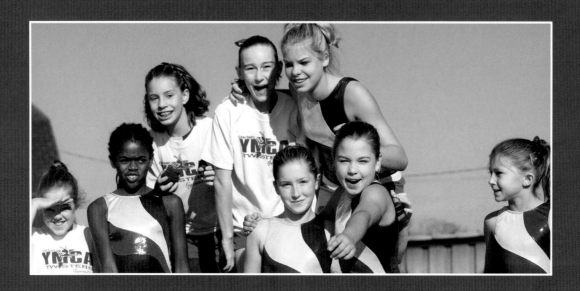

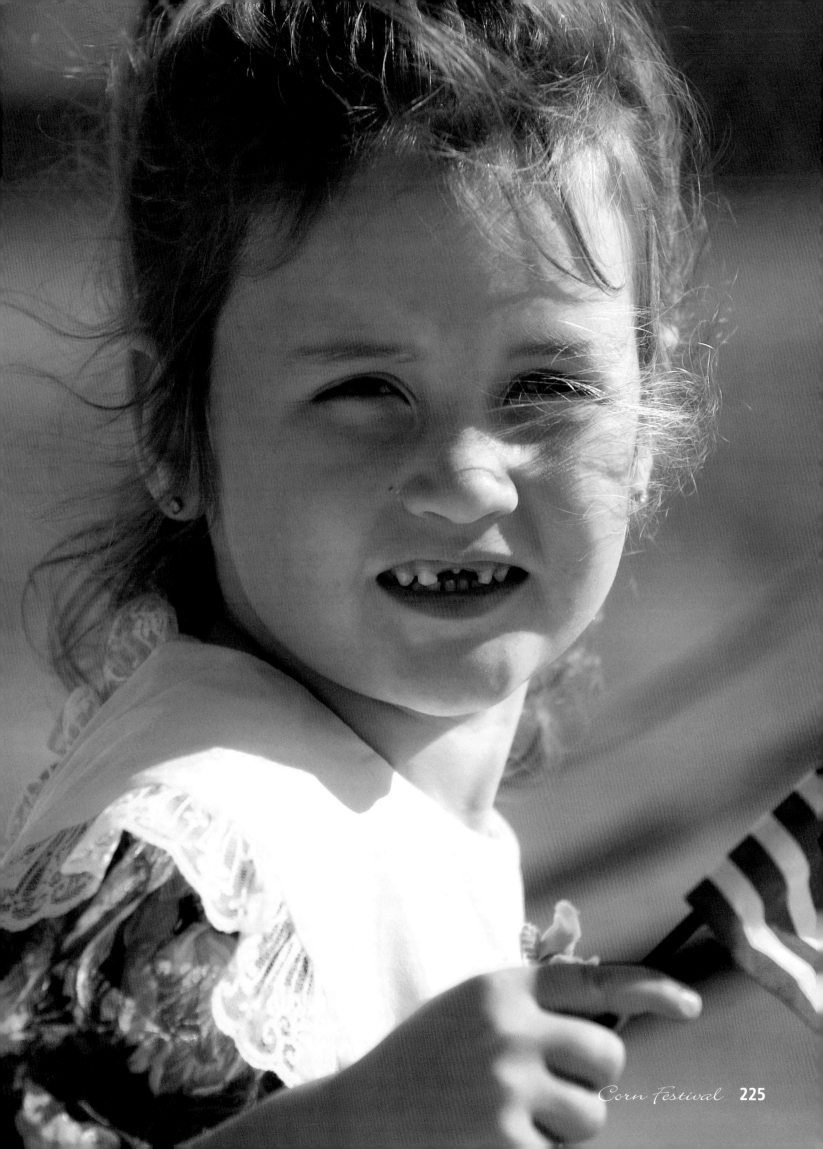

Harold Nelson is a
man of such presence
that we are not certain
if his immense pleasure
comes from his machine
or his impeccable suspenders.

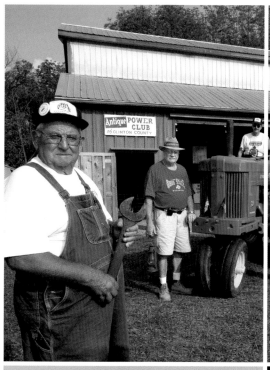

The top festival cog is the Antique Power Club (left), begun in 1972 by a group of folks, mostly farmers. The major club rule is that members must own machinery, a foregone conclusion to the founders. The festival is one of the few places where steam traction can still be seen *in use*. *(See page 260.)*

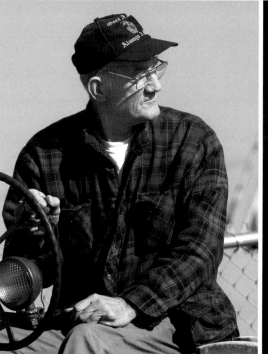

While Maynard Storer (left) lends the Corn Festival a traditional plaid and khaki look (it matches his tractor), the forces of modernization do creep up: Scarlet and Gray color schemes have evolved—seen even on the tractors—and some have tried the new steam-powered cell phones.

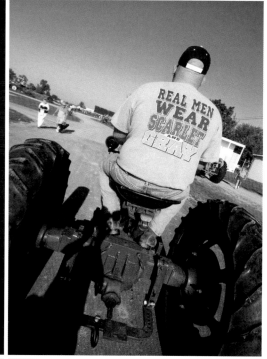

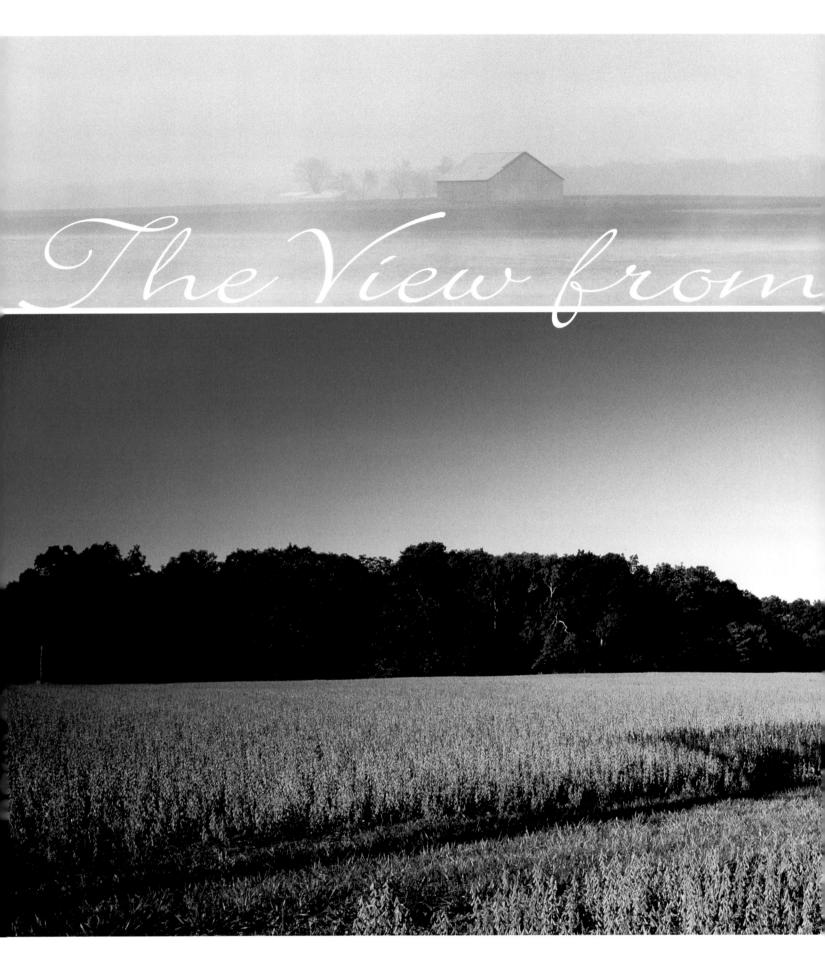

The View from

The enduring fields — postcards of the county

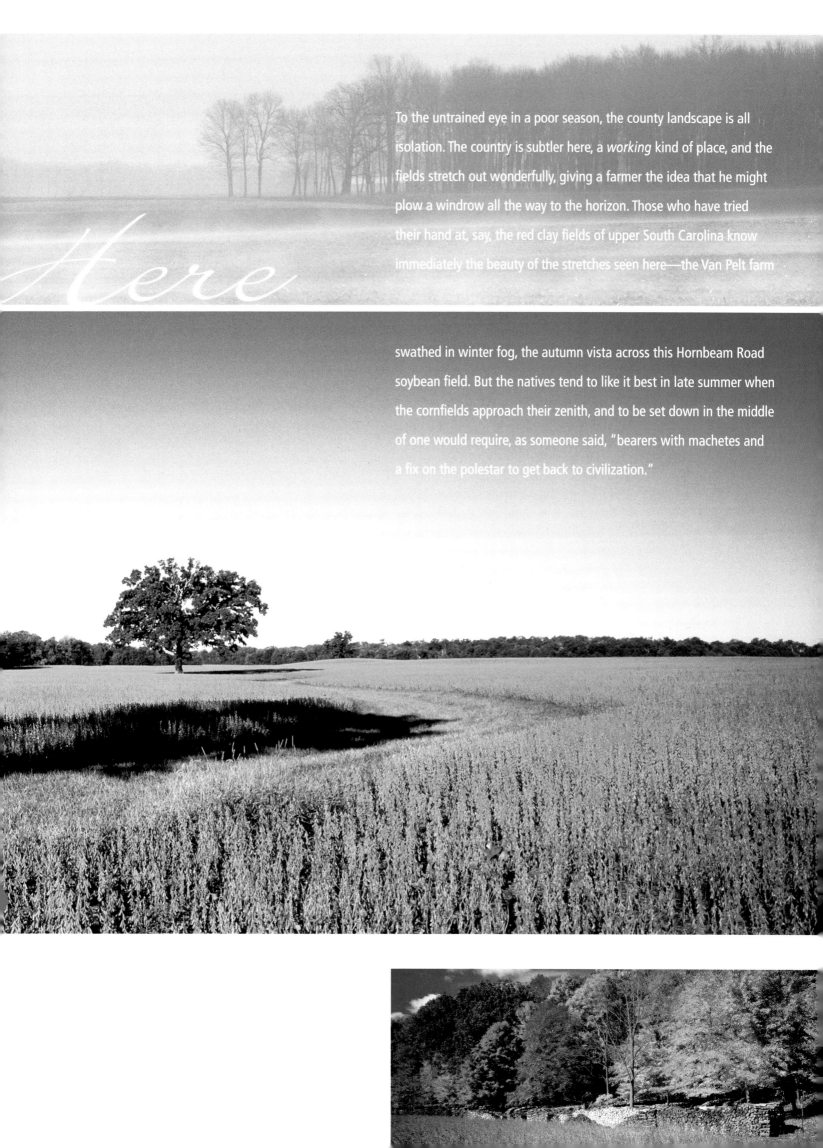

Here

To the untrained eye in a poor season, the county landscape is all isolation. The country is subtler here, a *working* kind of place, and the fields stretch out wonderfully, giving a farmer the idea that he might plow a windrow all the way to the horizon. Those who have tried their hand at, say, the red clay fields of upper South Carolina know immediately the beauty of the stretches seen here—the Van Pelt farm

swathed in winter fog, the autumn vista across this Hornbeam Road soybean field. But the natives tend to like it best in late summer when the cornfields approach their zenith, and to be set down in the middle of one would require, as someone said, "bearers with machetes and a fix on the polestar to get back to civilization."

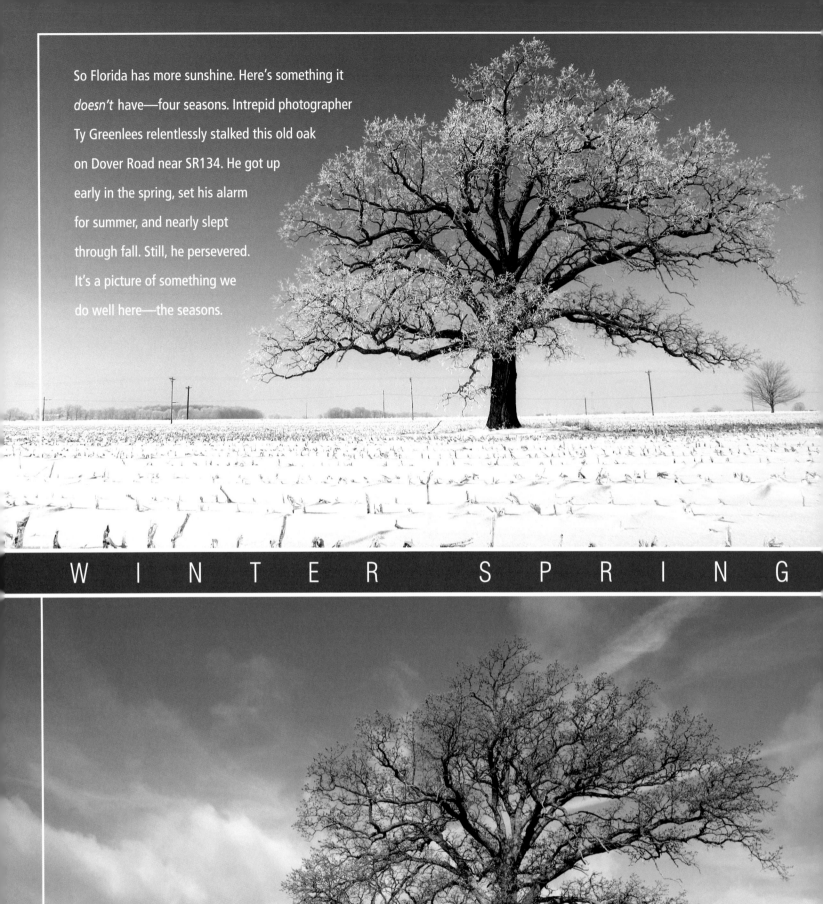

So Florida has more sunshine. Here's something it *doesn't* have—four seasons. Intrepid photographer Ty Greenlees relentlessly stalked this old oak on Dover Road near SR134. He got up early in the spring, set his alarm for summer, and nearly slept through fall. Still, he persevered. It's a picture of something we do well here—the seasons.

W I N T E R S P R I N G

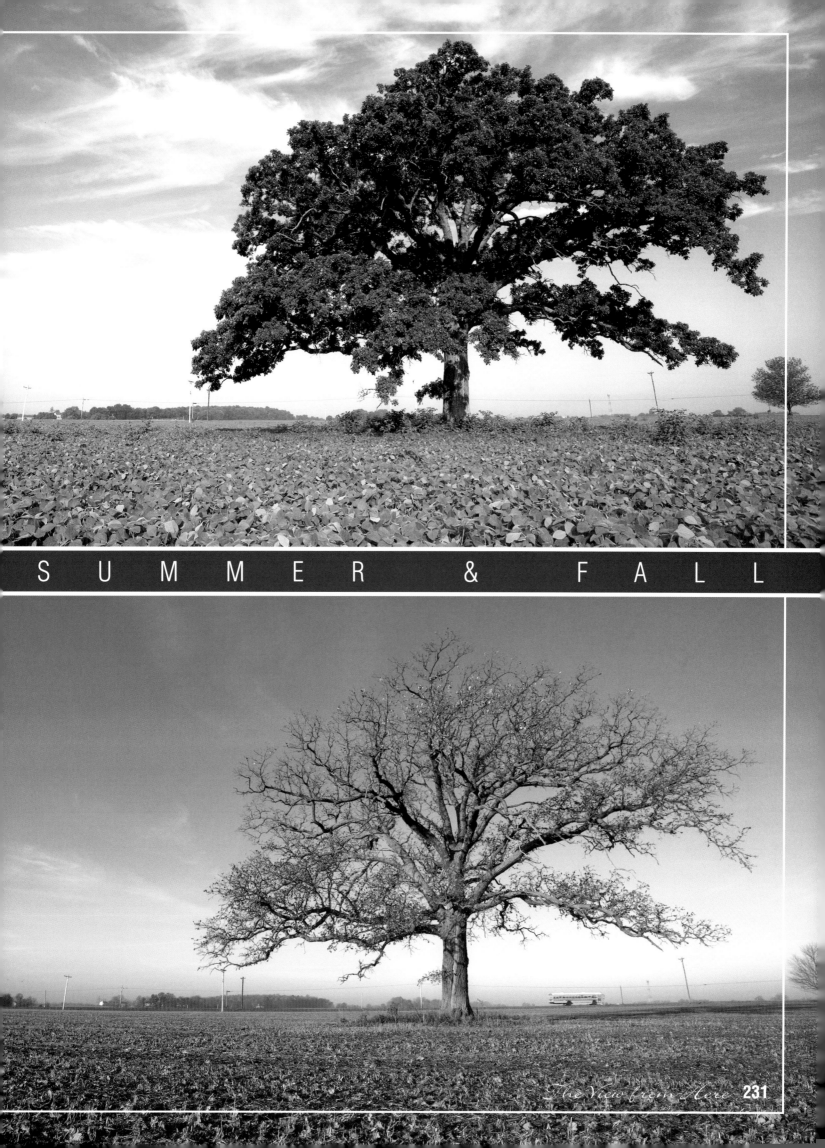

SUMMER & FALL

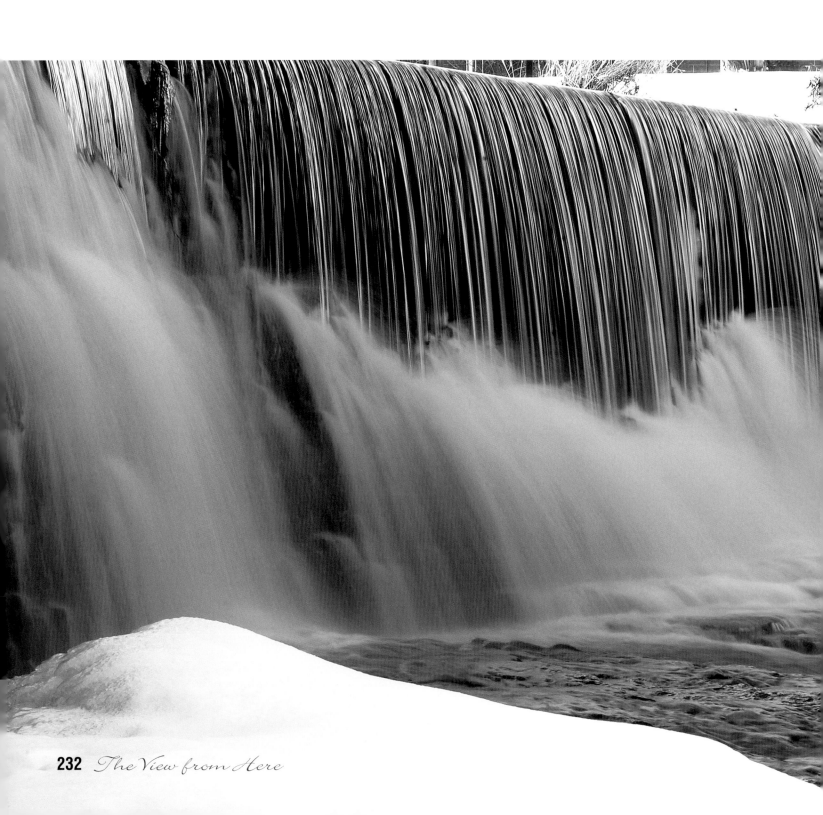

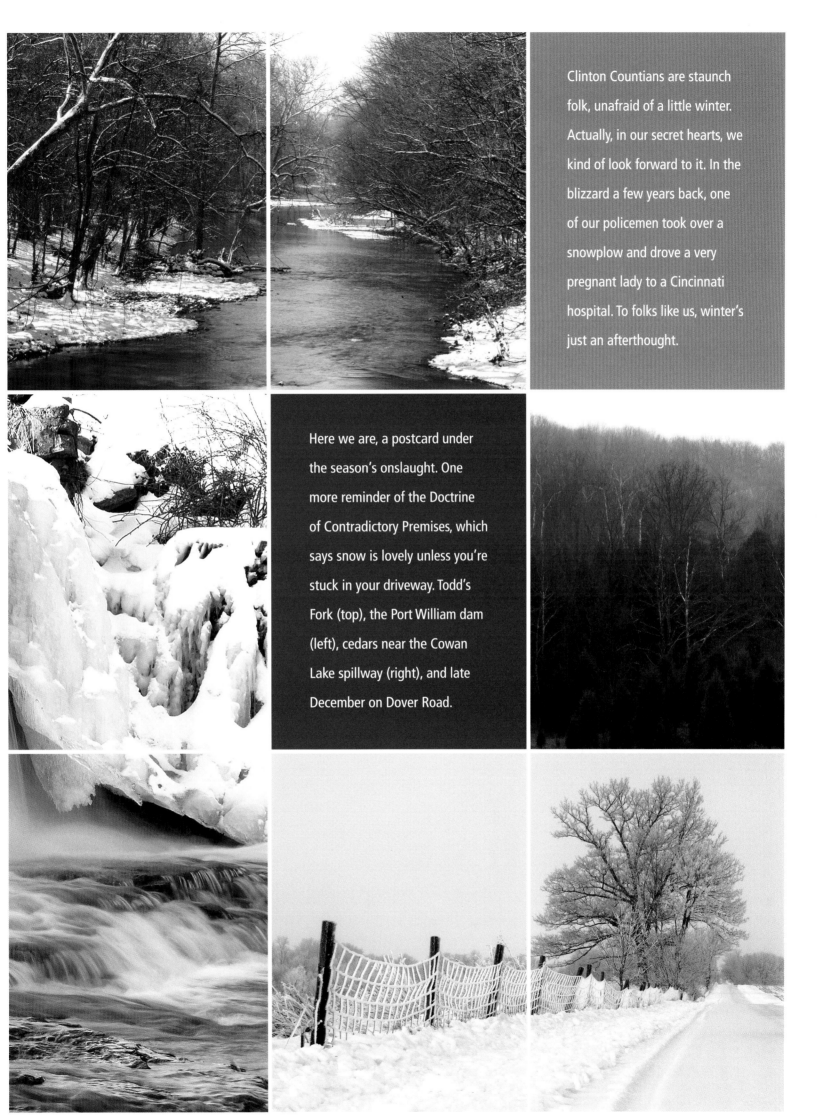

Clinton Countians are staunch folk, unafraid of a little winter. Actually, in our secret hearts, we kind of look forward to it. In the blizzard a few years back, one of our policemen took over a snowplow and drove a very pregnant lady to a Cincinnati hospital. To folks like us, winter's just an afterthought.

Here we are, a postcard under the season's onslaught. One more reminder of the Doctrine of Contradictory Premises, which says snow is lovely unless you're stuck in your driveway. Todd's Fork (top), the Port William dam (left), cedars near the Cowan Lake spillway (right), and late December on Dover Road.

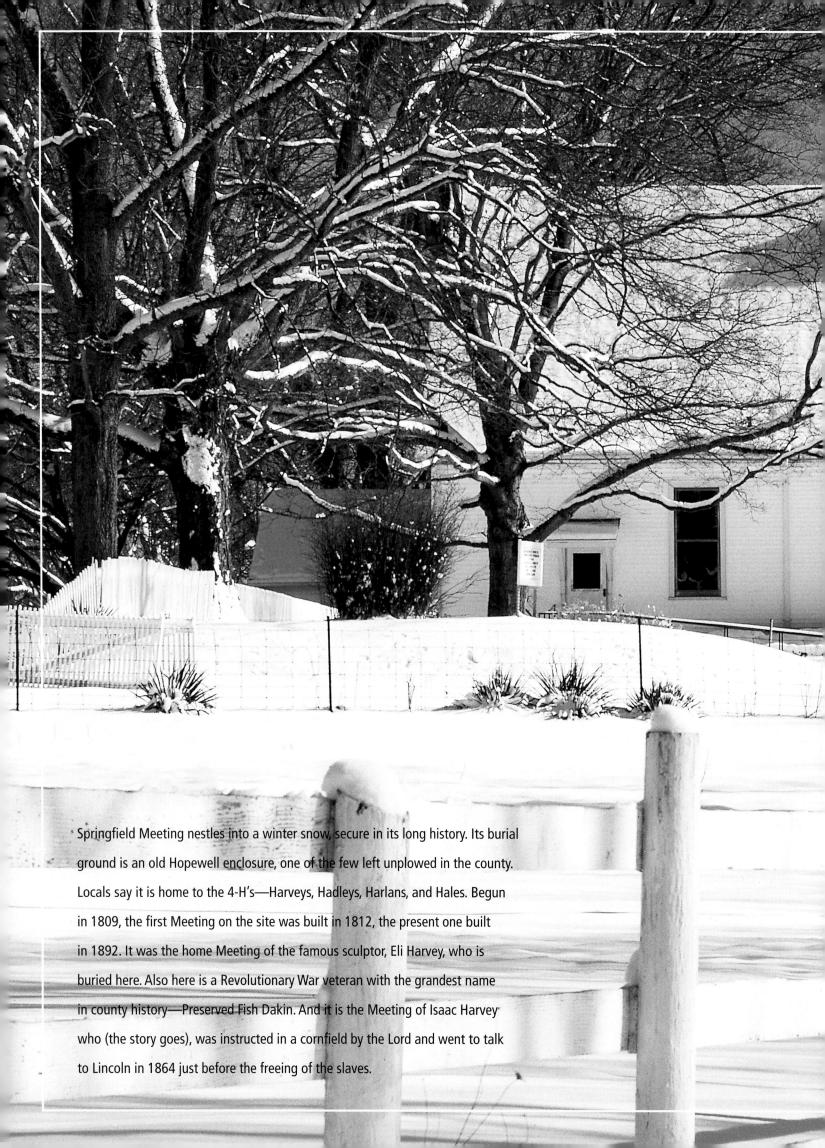

Springfield Meeting nestles into a winter snow, secure in its long history. Its burial ground is an old Hopewell enclosure, one of the few left unplowed in the county. Locals say it is home to the 4-H's—Harveys, Hadleys, Harlans, and Hales. Begun in 1809, the first Meeting on the site was built in 1812, the present one built in 1892. It was the home Meeting of the famous sculptor, Eli Harvey, who is buried here. Also here is a Revolutionary War veteran with the grandest name in county history—Preserved Fish Dakin. And it is the Meeting of Isaac Harvey who (the story goes), was instructed in a cornfield by the Lord and went to talk to Lincoln in 1864 just before the freeing of the slaves.

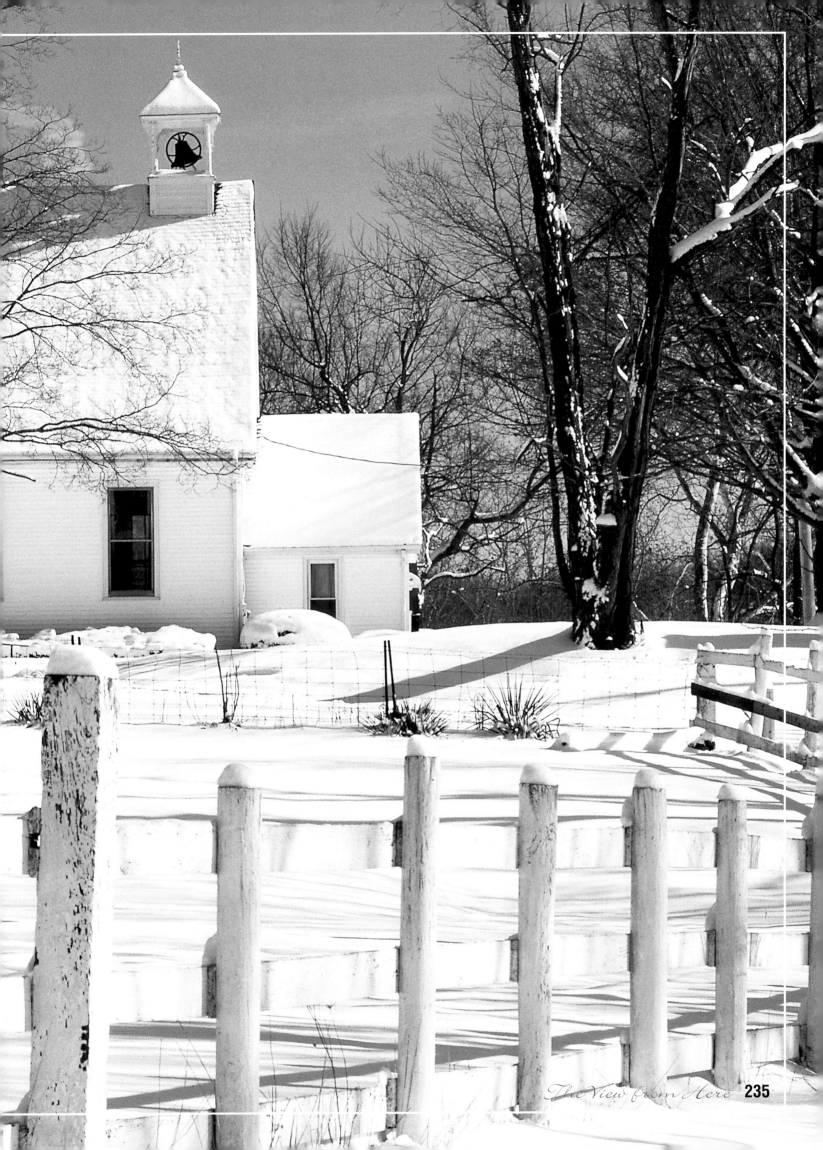

Sunri

Daybreak in the county—it all begins here

J.R. Williams, the Squire of Williams Road, was known as a sunset man for some years. Then as he got older, he said he had gone over to daybreak. The sun was punctual, he said, held up well, and was fairly successful at resisting government regulation, although there *was* Daylight Savings Time, which he saw as a dangerous trend. The Squire's friend, Frank Irelan, said the time change threw off his milk cows.

A bluegrass singer who worked in the county said she had seen daybreak once or twice and was impressed with it. "I saw some Angus browsing across a pasture and the sun coming up behind them. I felt at one with nature. Or with the Angus. I've forgotten which, but I took some note of it at the time." She said that it seemed that the real early kind of daylight was thinnest. "I've also noticed it's thinner depending on how thick the night was," she said. She thought daylight towards the first of the week tended to be a bit thinner, too.

Sunset

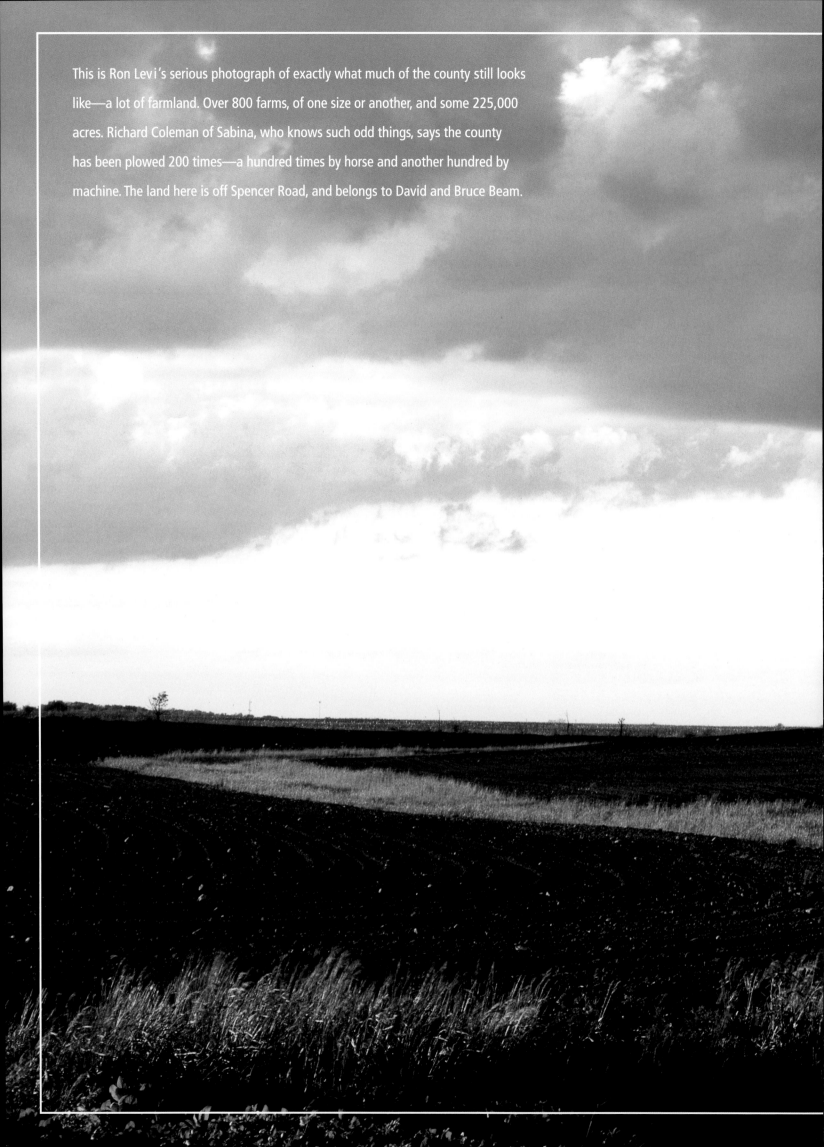

This is Ron Levi's serious photograph of exactly what much of the county still looks like—a lot of farmland. Over 800 farms, of one size or another, and some 225,000 acres. Richard Coleman of Sabina, who knows such odd things, says the county has been plowed 200 times—a hundred times by horse and another hundred by machine. The land here is off Spencer Road, and belongs to David and Bruce Beam.

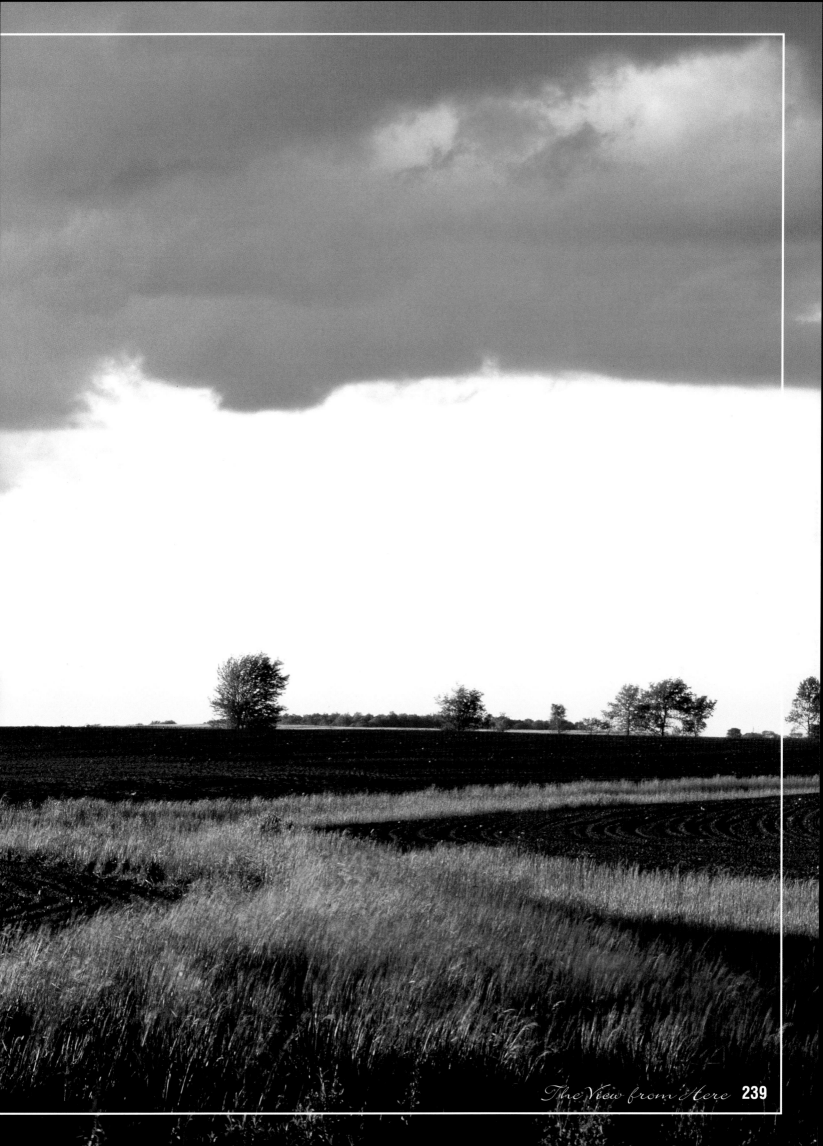

There's something about a lightning strike that is a bracing reminder of the inescapable power of nature. It also means—because you're seeing it—that it missed you. So it's both symbol and verdict. It's a fierce display, and the insurance folks say Clinton County may get hit as many as 2,000 times a year, although—thankfully—we don't see most of it. This photograph was taken in a spring storm near Port William.

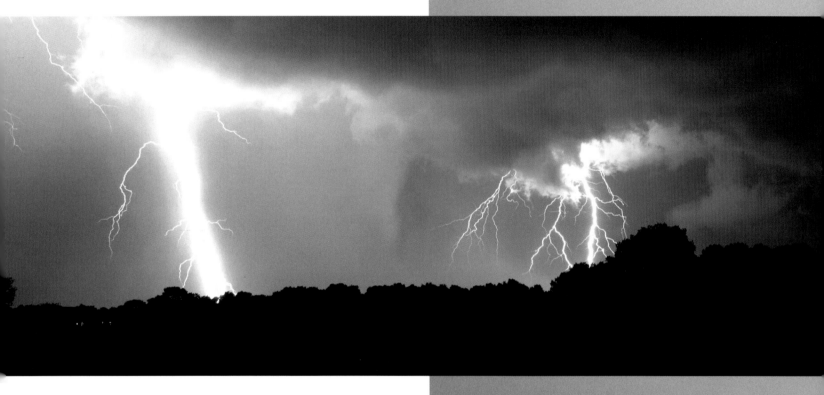

Photographer Ron Levi spotted the rainbow, then found himself frantically looking for the perfect background. A good nature photographer understands that a rainbow is nature's warranty—it says that Clinton County won't be destroyed by a flood again (especially after the Caesar Creek dam was built)—but it does not arrive with a warranty, disappearing as quickly as it comes. Levy ran this one to ground on the Dennis Ling farm on SR380.

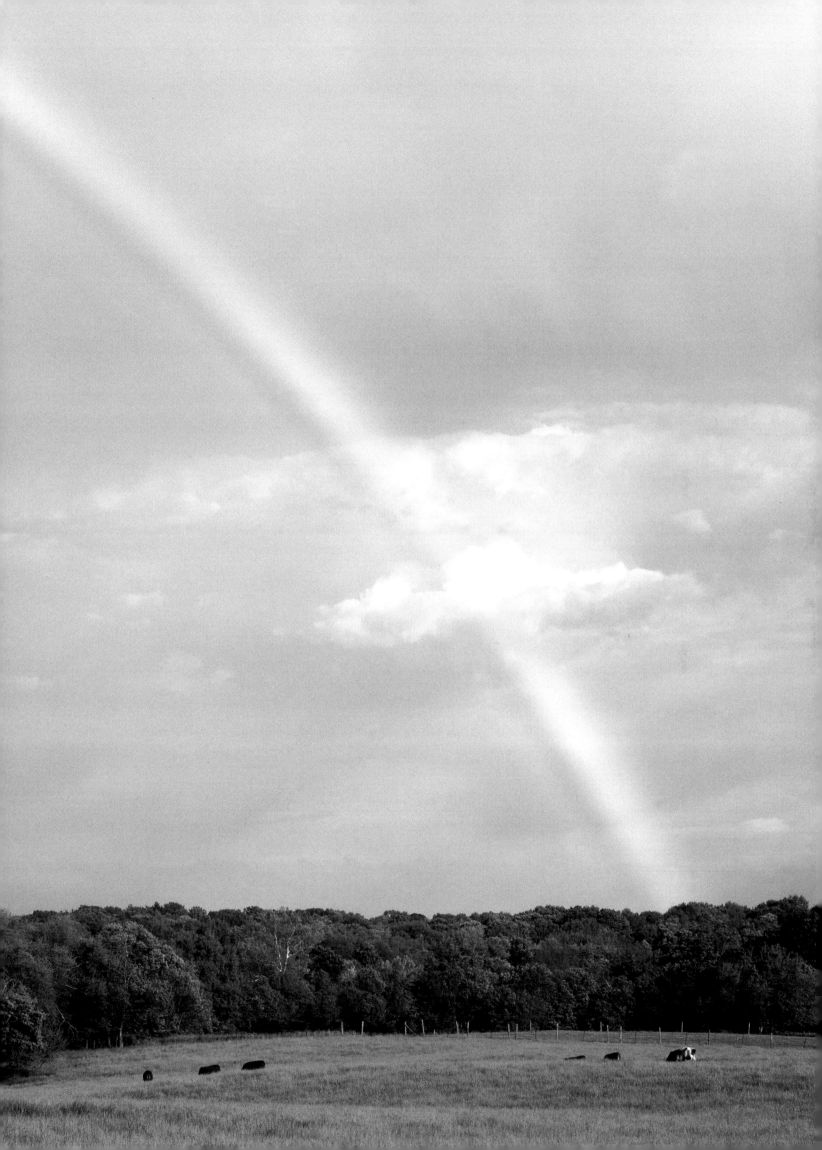

There have always been sheepmen in Clinton County, as this splendid hillside farm at the corner of Farmers Road and SR 134, owned by Roger and Janet Achor, reminds us. As a notable county sheepman once wrote in his journal: "Sheep lend to the pasture a peculiar charm. The landscape would lose some of its quality without the patient decoration of sheep, and without them, the landscape would lack the charm of completeness. Their habits are as fixed and dependable as the planets, and it is a joy to work with such known quantities."

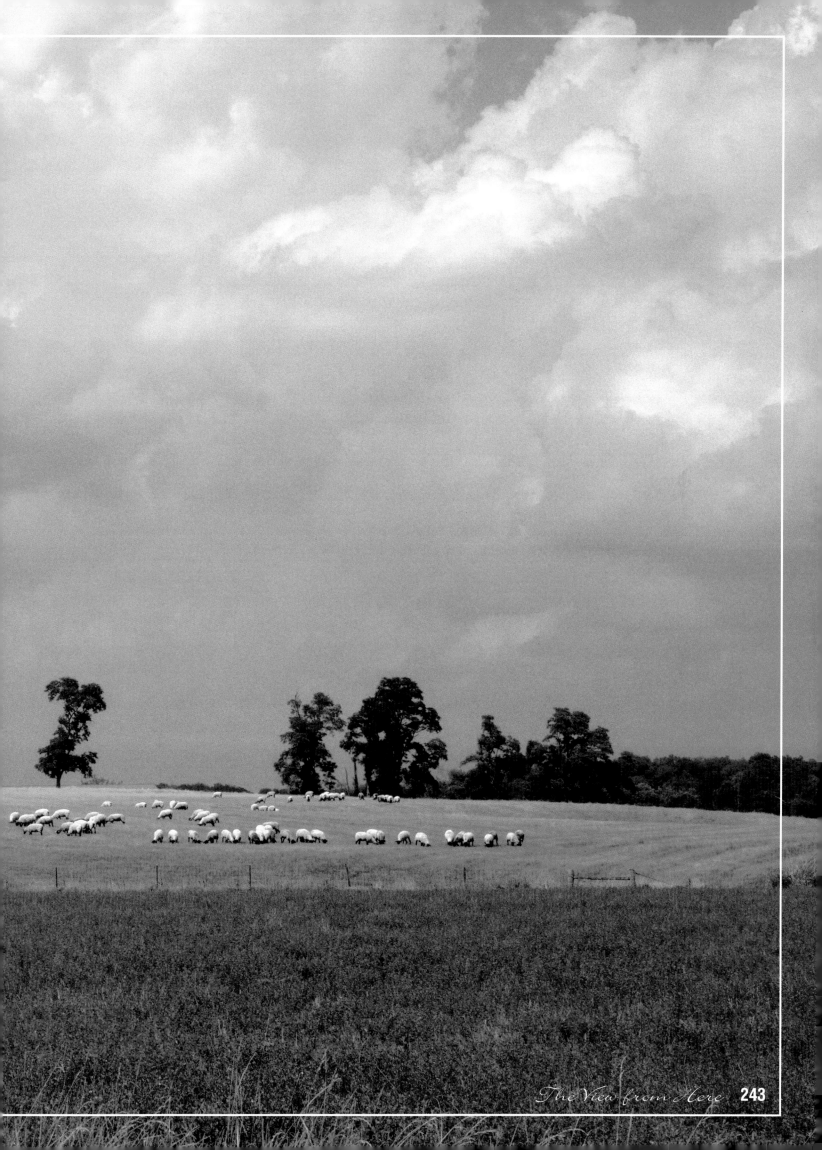

Cowan Lake

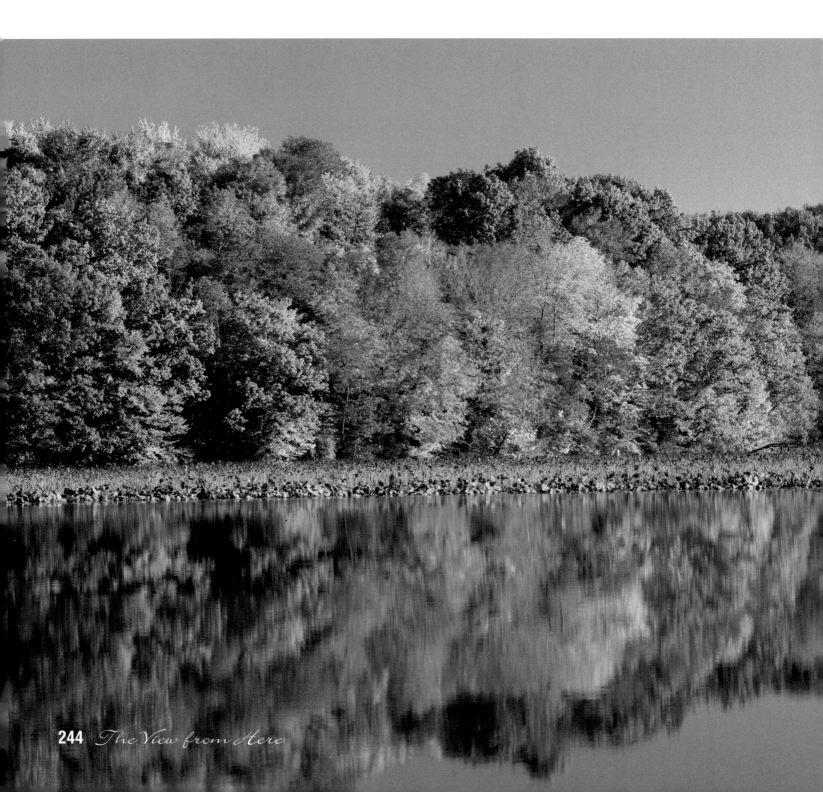

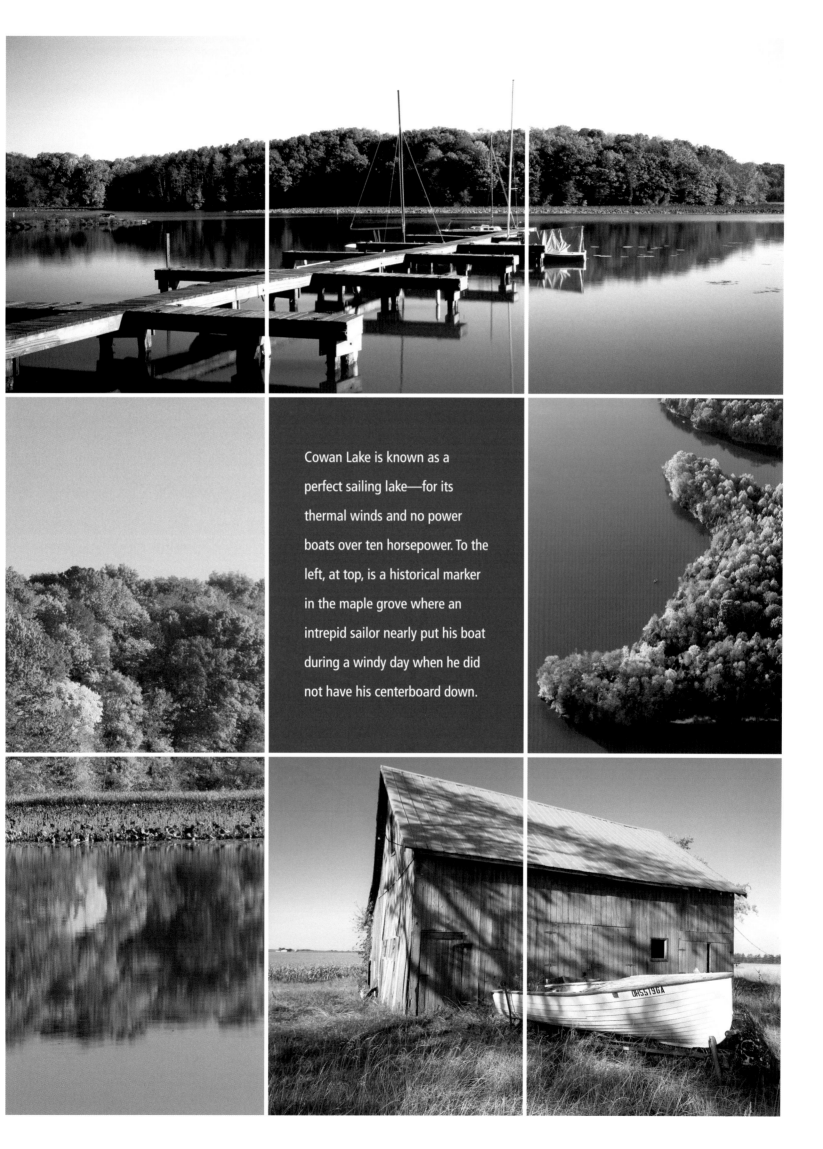

Cowan Lake is known as a perfect sailing lake—for its thermal winds and no power boats over ten horsepower. To the left, at top, is a historical marker in the maple grove where an intrepid sailor nearly put his boat during a windy day when he did not have his centerboard down.

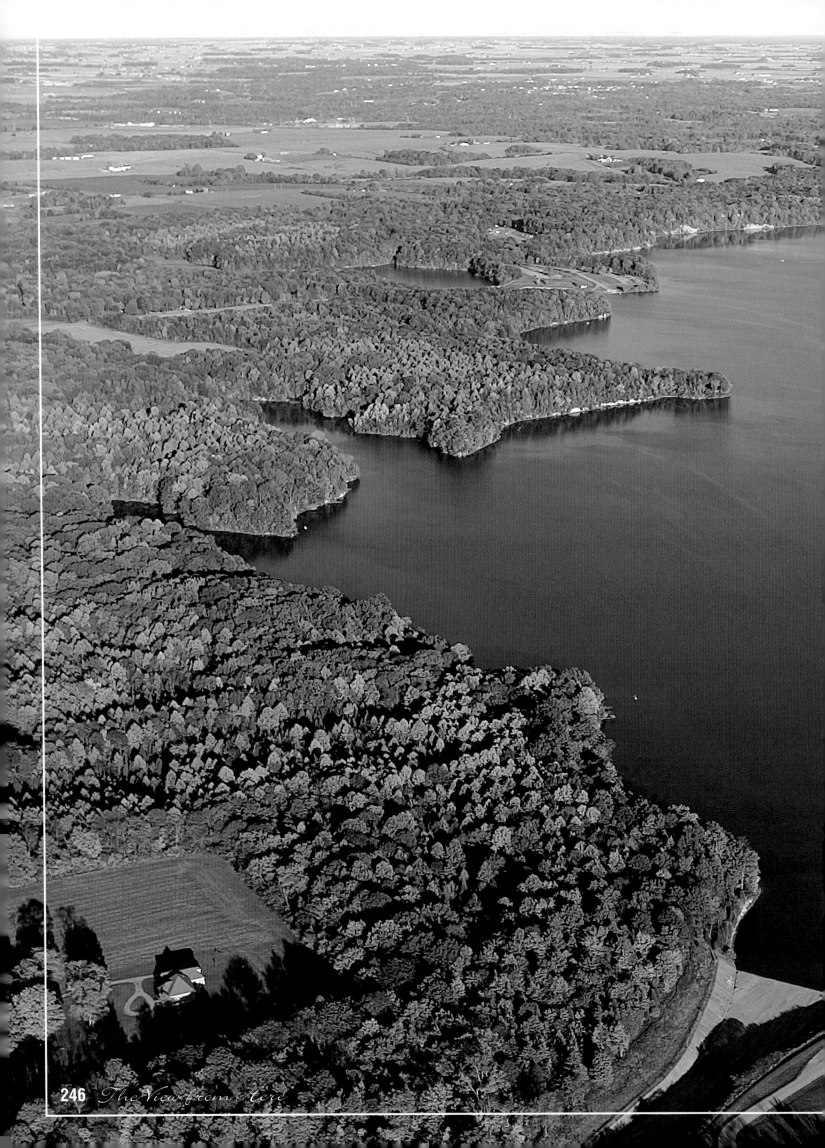

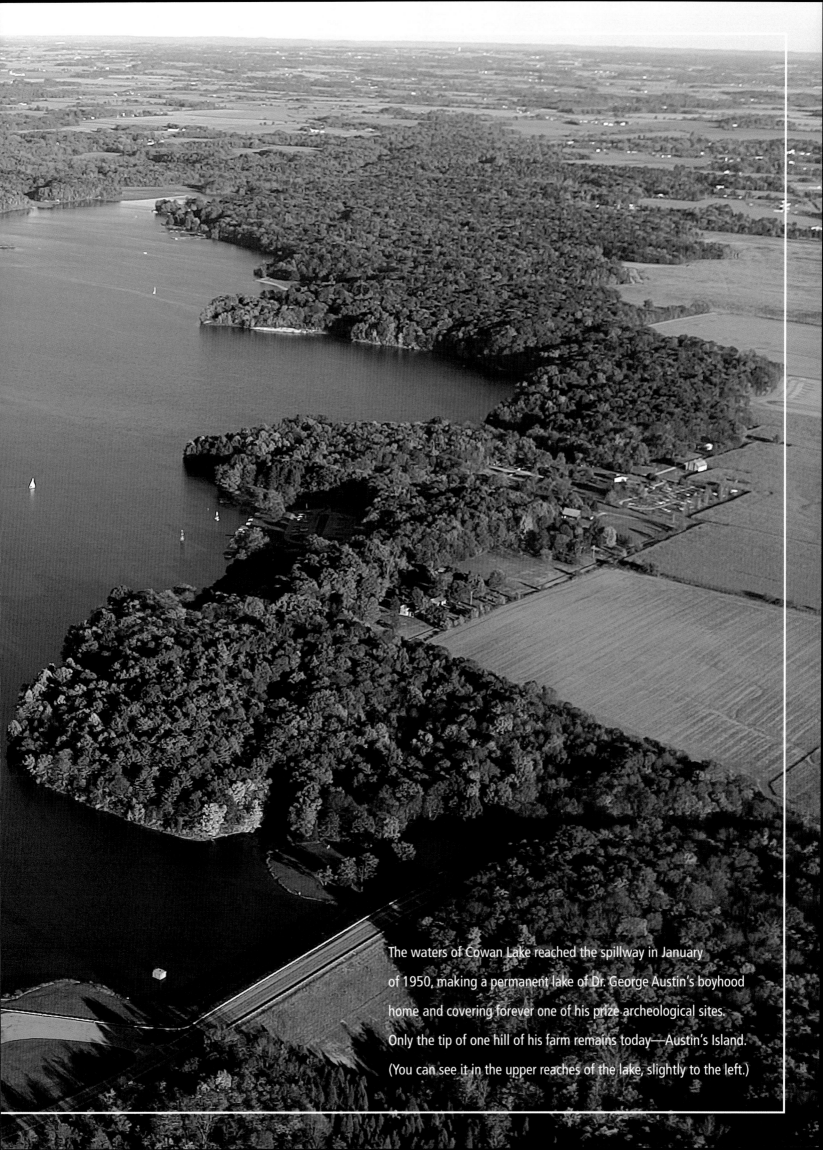

The waters of Cowan Lake reached the spillway in January of 1950, making a permanent lake of Dr. George Austin's boyhood home and covering forever one of his prize archeological sites. Only the tip of one hill of his farm remains today—Austin's Island. (You can see it in the upper reaches of the lake, slightly to the left.)

The waning of the season occurs here on Inwood Road, one of the county's great little arteries that remind nostalgic oldtimers in the northwestern reaches of the county of a time before the Hummer (which always reminds them of baseball) and the SUV. The energetic music of early autumn shifts to something slow and impending.

And Inwood is the perfect place from which to observe it all. Is it actually paved? No matter. Except for that, it could have been here forever. There should be a historic designation: roads we once had. Except there it is, full of twists and surprises. A road for all seasons, not just fall.

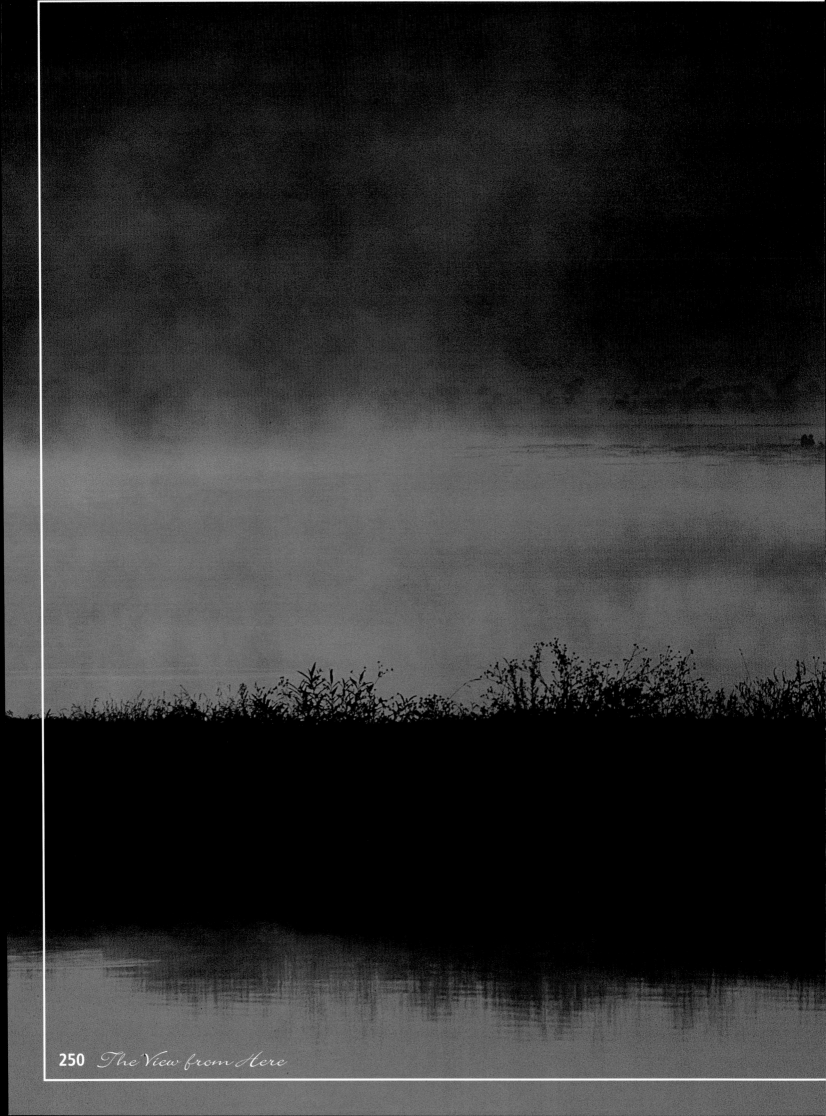

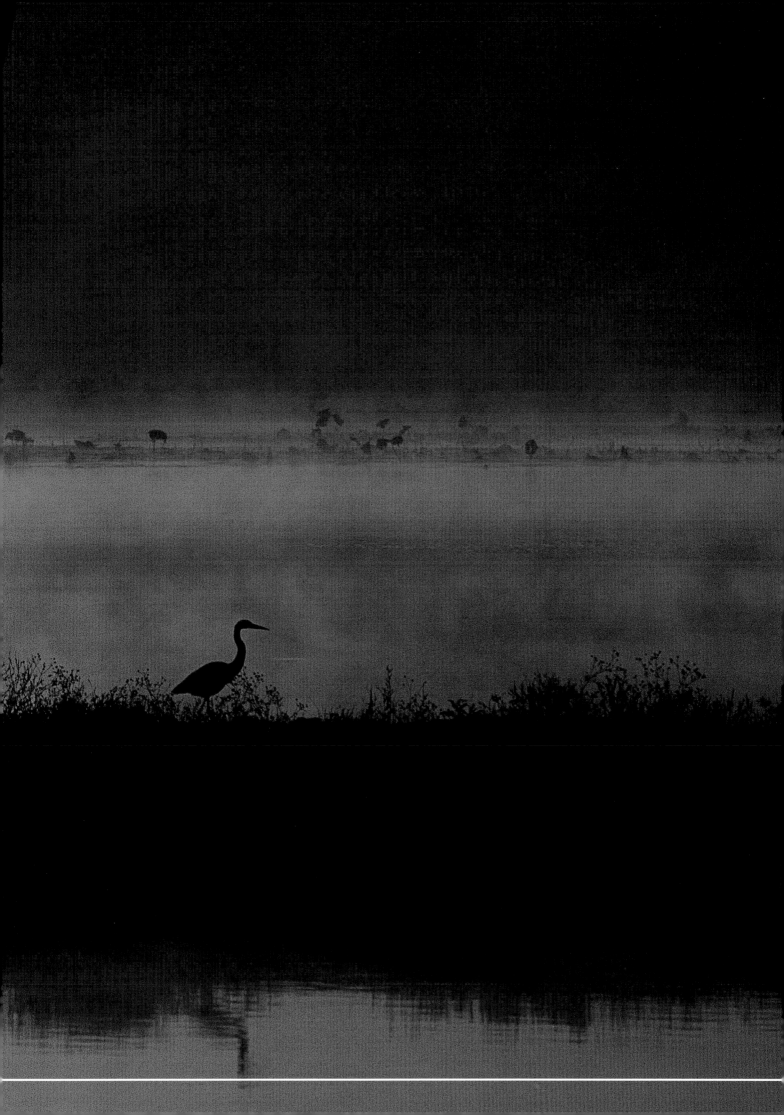

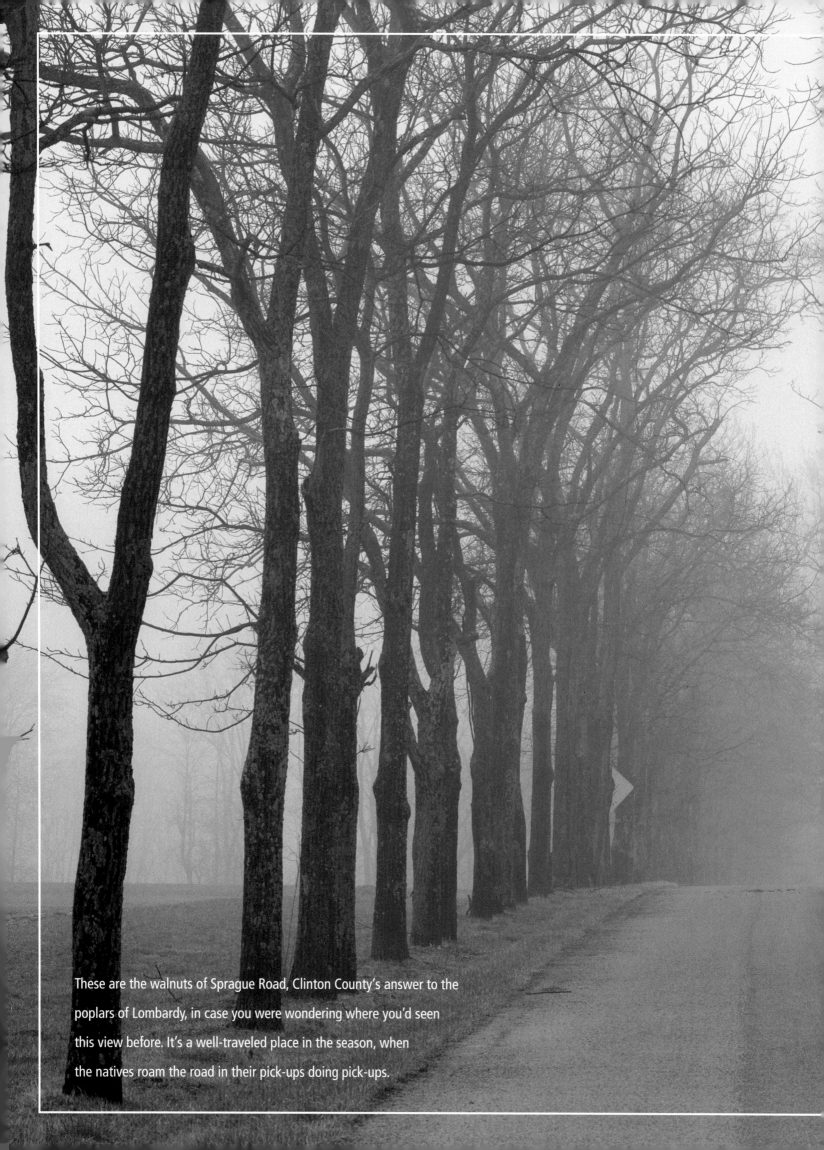

These are the walnuts of Sprague Road, Clinton County's answer to the poplars of Lombardy, in case you were wondering where you'd seen this view before. It's a well-traveled place in the season, when the natives roam the road in their pick-ups doing pick-ups.

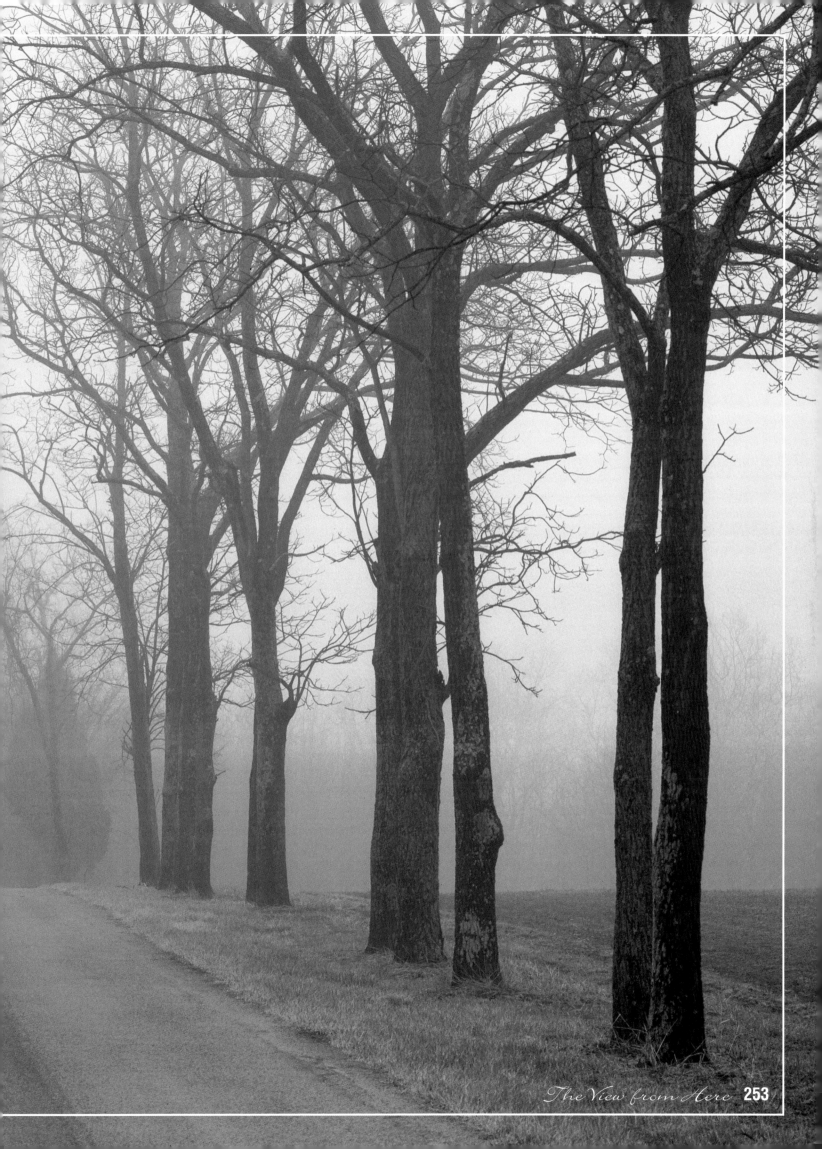

From page 46:
Outstanding Women.

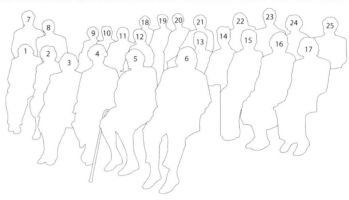

(1) Shirley Colvin, (2) Rosemary Ehlerding, (3) Rev. Mary Cochran, (4) Beulah Hill, (5) Aline Taylor, (6) Dr. Mary Boyd, (7) Joann Chamberlin, (8) Georgiana Thomas, (9) Helen Storer, (10) Karen Haley, (11) Susanne Kenney, (12) Lois Boyer, (13) Barbara Bayless, (14) Jo Miller, (15) Betty Rice, (16) Madalyn Loftin, (17) Margaret Hollon, (18) Jane Telfair, (19) Darleen Myers, (20) Linda Eichelberger, (21) Eleanor Harris, (22) Pat King, (23) Judith Briggs, (24) Judy Gano, and (25) Virgene Peterson. Absent—Kathryn Hale. The 2006 recipients (named after photograph was taken)—Sara Conti, Polly Countryman, Dr. Maxine Hamilton, Pastor Elizabeth Looney, Maxine Miller, and Lori Williams. Deceased recipients—Mary Curry, Ellenetta Gibbons, Dessa Hale, Esther Janes, Garnett McKee, Helen McCoy, Lucy Olds, Elizabeth Sharkey, Virginia Smith, Elizabeth Shrieves, Elizabeth Williams, and Esther Williams.

From page 47:
The county book clubs.
Book Clubs represented—Wednesday Book Club, Six and Twenty, Conversation Club, La Petite Book Club, all of Wilmington. Bayview Reading Club of Sabina.

Twentieth Century Club and Book Lovers Club of Blanchester.

From rear of photograph, top of library steps down)—Debbie Crawford, Donna Holmes, Judy Sargent, Terri Thobaben, Kay McMillan, Dr. Mary Boyd, Mary Lou Larick, Pat Schultz, Sue Miars, Ann Kuehn, Rachel Boyd, Carolyn Matthews, Jane Dunlap, Karin Dahl-Rice, Karen Buckley, Pam Thompson, Julie Shrubb, Theresa Rembert, Marsha Wagstaff, Marge McMullen, Jane Telfair, Ruth Ann Faris, Beverly Sanders, Jama Hayes, Susan Douglass, Kathleen Blake, Chris Burns-DiBiasio, Sarah Barker, Phyllis Carey, Donna Thorp, Dorothy Kirk, Hei Ran Kim, Dr. Maxine Hamilton, Dr. Ruth Hayes, Lena Mae Gara, Ann Moore, Ann Lynch, Charlotte Bean, Ruth Mandrell, Barbara Briggs, Mary Kay Howard, Cynthia Saylor, Joann Chamberlin (in red, at bend) Judy Brumbaugh, Beth West, Georgia Peck, Marlene Rhude, Tawney Pierce, Susan Ertel, Jeanette Gerritz, Kim Vandervort, Pat King, Sara Conti, Mary Alexander, Marcy Hawley, Beatrice Warren, Phyllis Newton, Kathryn Moore, Robin Prewitt, Carole Haines, Barbara Derrick, Mary Kathryn Hilberg, Shirley Katter, Hilda Brandehoff, Rowen Monroe (Ann Kuehn's granddaughter).

From page 50-51:
Hot Hoops in the park.
At left—Eleanor Harris with Langdon and Cheyann McKee.
Foreground group—Ricky Smith, Kayla Conner, Ariana Goins, Art Brooks, Elexis Murdock, Bill Peelle, and (kneeling) Anna Gray.
Rear, from left: Nehemiah and his parents, Vanessa and Bruce McKee; daughter Angelica (against post); Karin Harris; Eric Greene; Paul Hodges; and Markie Jones (leaning against

railing); Marque Jones, Michael Graham.
Group at right—three at rear are Brooke Atsalis, Antonia Gilbert, and Monica Howard.
In front—Gini Harris, Cherese Johns, Leah Howard, Phyllis Greene, and Seth Murdock.
At top, extreme left—Lorenzo Harris. Far right, Ciara Murdock.

From page 54-55:
Last Supper.
From left, seated—Ed Conrad, Ellen Newman, Chris Evans, Allen Willoughby, Mark Piatt, Tony Nye, Dillon and Jolene Piatt. Standing, from left—Burt Kemp, Ann Johnson, Josephine Harner, Debbie Huddleson, Sabrina Hunt, and Diane Hein.

From page 58:
Peterson Place.
Front row (the children), from left—Abbey Judd, Courtney Kirkendall, Corwyn Kirkendall, Caleb Kirkendall.
Front row, sitting, from left—Katie Simonds, Dorothy Kirk
Last row, from left—Barbara Hazard, Edith Tucker, Sara Kirkendall, Darleen Myers, Charles Kirkendall, Phyllis Sweet, Catherine and Ed Ostendorf, Tripp Gleason, Sandy Mongold, Jama Hayes, Danny Mongold, Tom and Cathy Hanover.

From page 59:
Nathan's bridge.

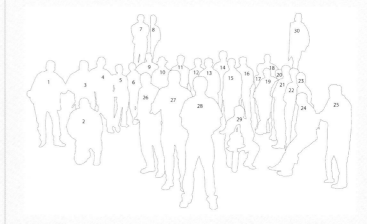

From left—(1) Jan Claibourne, (2) Mike Mahaffey (kneeling), (3) Ron Mahaffey (behind Mike), (4) Greg Schultz, (5) Sue Hanna, (6) Joan McCarren, (7) Fadi Al-Ghawi (standing on bridge), (8) Jerry Huber (standing next to Fadi on Bridge), (9) Buddy Kienle (back row), (10) Phil Hale, (11) Rich Conti, (12) Don Troike, (13) Jim Ranz, (14) Rhett Clifton, (15) Chuck Watts, (16) Frank Shaw, (17) Lori Williams, (18) Greg Hart, (19) Becky Haines, (20) Tom Matrka, (21) Steve Hein, (22) Diane Hein, (23) Micah Hein, (24) Mac McKibben, (25) Fred Anliot, (26) Bruce Saunders (with bike), (27) Rick Stanforth (with shovel over shoulder), (28) Jonah Hein, (29) Faye Mahaffey (with chain saw), and (30) Jeff Linkous (on bridge, right hand side).

From page 60-61:
Lower Eastern Ohio Mekoce Shawnee
tribal leaders.
Standing, rear—Mark Blue Heron Singer Burden, drum keeper.
Second row, standing, from left—Carrie Lodgewoman Sharp, medicine bundle keeper; Paulette Konah M'Kwa Wood, village chief of the West Virginia band; Margaret Stands True Wilson, tribal mother; Ronnie Red Snapping Turtle Stombaugh, elder.
Front row, seated, from left—Logan Sharp, war chief; Fred Stone Eagle Moeller, council elder; Frank Standing Storm Wilson, principal chief.

From page 64:
Wilmington College fraternity.
Back row—Adam Holbrook, Edeal Velez, Cole Weddle, Kris Berry, Scott Custis, Jared Piar, Mike Williams.
Middle row—Levi Tkach, Wil Goldman, Grant Spencer, Greg Temming, Mark Kinsel, Dale Hodapp,

Jesse Apperson.
Front row—Ricky Fairrow, Kyle Anderson, high school student Eric Nock, Trey Pauley, and Michael Cooper.

From page 65:
The Cape May Red Hatters and the Happy
Hatters of Wilmington at the Sara Rose
Gallagher House, Sabina, Ohio.
From left, behind rail—Frankie Baker, Thelma Settlemyre, Ann Evans, Dorothy Robinson, Helen Schilling.
Sitting on steps—Jane Cook, Susan Henry, Margaret Briggs, Marge Carey.
Upstairs—Carole Nichols, Eleanor Faye Harris, Sharon Breckel.
On Porch, Behind rail—Grace Nichols, Joan Burge, Daphne Blackburn, Cleo Bales, Helen Wilkin, Helen Rannells, Phyllis Borror.

From page 70-71:
Midland Daycare and the Habitat
for Humanity volunteers.
On roof, five at top—Dan Dallmer, Fadi Al-Ghawi, Ben Burns, Jerry Huber, and Shane Dobbs.
Lower roof—Dick Neff, Julia Saylor, Jack Lewis—and at far right—Wendell Compton and Frank Shaw on scaffolding.
Foreground—Jim and Cecilia Krusling, with Kim Smith (in front, holding rake), mysterious man in plaid, Barry Michaelson, Don Derrick, Angela Smith, and Shawna Burns.

From page 78:
Bill Finkle (top left)
From high atop his downtown atelier on South Street, artist Bill Finkle has surrounded himself with books, pottery, and a museum's worth of his

own artwork. A cheerful man of parts, Bill may often be found holding forth in the coffee bar at Jen's Deli.

Harriet Shrieves (top right)

Harriet Shrieves was the grande dame of Columbus Street, and one of the last of the town socialites, a tender woman who poured herself a juice glass of beer each afternoon, loved children (though having none of her own), and refused to go to funerals (except her own, which was mandatory, and attended by her many, many friends).

Hiatt Family (bottom left)

The Hiatt family was forever on Wood Street, all of the 20th century, anyway (and a bit of two other centuries as well). Here is the curmudgeon himself, Richard—biologist, teacher, farmer—and wife Muriel, activist. "There she goes," Richard would say, watching Muriel head out. "Off to do the Lord's work." Indeed she was. And a good part of it was the maintenance of Richard.

Dick Bath (bottom right)

Dick Bath was the town physician who put himself through college as a Denver Hotel bellhop, a job he got because he was the same size as the other bellhop (they could share the uniform). Here he is in his old classroom at Main School. The Bathhouse Five—his jazz band—and the piano playing came later.

From page 79:
Jim Carey (top left)

The county was always a working place, typified by such places as the old Carey Foundry at the west end of town, and by the captain of the place, Jim Carey himself.

Esther Janes (top right)

Esther Janes was the county's quintessential woman of service: 8,000 hours to the 4-H Club, 50 years in the church choir, and a Girl Scout from age 10. In her full uniform young girls thought she had been beamed down from scouting's universal headquarters. When she died, she was buried in her uniform, even the hat. Said her daughter, Sandy, "We knew she'd be comfortable."

Melvin Ballein (bottom left)

Melvin Ballein poses at the old Master Mix logo, a classic portrait of what has always been a county strength, its working men. Melvin, who has always worked in area mills, since moved over to Buckley's where he now helps make custom horse feed.

Luther Warren (bottom right)

In 1915, Luther Warren won $5 at the county fair with his vegetables and bought a suit for his first teaching job. He was a teacher of science and loved to take his students outdoors and show them animals and plants and the wonder of it all. Luther heard William Jennings Bryan speak in Wilmington, was teaching in Tennessee during the famed Scopes trial and watched him again as prosecutor of young John Scopes (Luther was, of course, on Scopes' side), and remarried when he was well into his 90s. The bike trail between Mulberry and Nelson—the Luther Warren Peace Path—is named after him.

The Body Politic

From page 80-81:
The people of the courthouse.
Top Floor, from left—Judy Gano, Barbara Wells,

Cindy Bailey, Mike Sutton, Robert Ross, Fred
Moeller, Jackie Souder, Robert Wisecup, Dorothy
Vanscoy, Judy Laycock, Linda Custis, David Reeder,
Helen Waln, Lorain Davis, Brenda Hoffer, Shirley
Tagg, Julianne Mason, Vickie Cordy, Lori Luttrell,
Dianne Fugate, Carolyn Alexander, Jackie Stevens,
Peggy Watters, Barb Baker, Gwen Inlow, Mary
Taylor,Kay Collins, Lois Allen, and Bobbie Thatcher.
Coming down steps, from left—Priscilla Vaughan,
Gary Browning, Regina Goodman, Steven Ambrose,
Mickey Keller, Deanna Whalen, Karen O'Rourke,
Kim Stratemeyer, Kelly Shoemaker, Rachel VanPelt,
Pam Myers, Colleen Fear, Georgia Carr, Patrick
Denier, David Henry, Randy Riley, Jerry Bryant,
Darleen Myers, William Peelle, Mike Curry,
Chad Randolph, Tom Dusseau, Joann Chamberlin,
Leesa Cox, Lynn King, Chris Poe, Roger Bennett,
Billy Stephens, Cheryl Reinsmith, Glenda Parker,
Brenda Woods, Sharon Ackerman, Kathy Macke,
Andrea Regan, Sue Barr, and Susan Kocher.
Sitting in front—Magistrate Mary H. McElwee,
Judge G. Allen Gano, Judge John W. Rudduck,
Magistrate Roger Bowling, and Magistrate
Helen Rowlands.

From page 82-83:
Participants in the Southern Ohio Fire and
EMS School.
From left—Jason Pollitt, Matt Dyer, Steve Rutherford
(in tire), Renee Estep, and Jason Knauff.

From page 83:
Old jail with the county sheriff and deputies.
From left—Lt. Ed Fizer; chief deputy Brian Prickett;
Sheriff Ralph Fizer Jr.; chief detective
Brian Edwards (jacket).
Back—Lt. Pete Smith; Major Brett Prickett; sitting,
Lt. Justin Drake.

From page 86-87:
Firefighters from Martinsville, Clinton South
and Wilmington.
Back row, from left—Chris Lewis (Martinsville FD),
Joe Haygood (Clinton South FD), Terry Hatfield
(Martinsville FD), Keith Carpenter (Martinsville FD),
Chief Andy Mason (Wilmington FD), JR Conberger
(Martinsville FD), Jeff Nichols (Martinsville FD),
Chief Mike Jones (Martinsville FD).
Front row, from left—Jason Highlander (Clinton
South FD), Darrell Inlow (Clinton South FD),
Ermon Mobley (Clinton South FD), Asst. Chief
Mark Wiswell (Wilmington FD), Dave Quigley
(Martinsville FD), Jerry Quigley (Martinsville FD).

A Senese of Place

From page 116-117:
Southern State Community College's Truck
Driving Academy.
Southern State Truck Driving Academy students
and instructors gathered around the big rigs at the
college. From left, on ground—Mary Jane Shakro;
Latasha Medley; Bill Lankford; Steve Sheeley;
Ed Mullins, the assistant director of training
(out front); then Bryan Cline; Dwain Black;
John Helton; Doug Edwards, the Academy director
(on truck cab); Nancy Wisecup; Gayle Mackay;
and Paul Schwab. On top of trailers, from left
to right—George Murarescu, Steve Skidmore,
Chuck Morris, and Rick Shrubb, dean of General
Education and Director of the North Campus.

From page 125:
Wilmington College Theater production
of Anything Goes in Wilmington College's
new performing arts center.

From left—Steven Haines, Lois A. Hock,
Timothy Larrick, Tricia Heys, Becky Haines.
J. Wynn Alexander in chair.
Hugh G. Heiland on stairs.
On set, from left—Erin Haas-Hatten, Gina Beck,
Tonja Ruther, Emily Moroney, Allyssa Benson,
Jessica Finnegan, and Mary Staggs.

Fields of Play

From page 149:
Clinton-Massie, Cider Barrel game of 2004.
Front, from left—Mason Sutton, Jake McSurley,
Justin Steckenfinger, J. D. Brooks, Eric Johnson,
and Larry Bailey.
Middle, from left—Nick Fairchild, Billy Atchley,
Tim Schanda, Roger McKay, Matt Isaacs,
Cole Ross and Ridge Sams, and Josh Smith.
Back, from left—Ron Pinkerton, Jesse Gilliam,
Andrew Heyob, Trent Daugherty, Drew Frey,
Josh Weaver, and Tyler Sargent.

From page 154:
WHS football team, 2005.

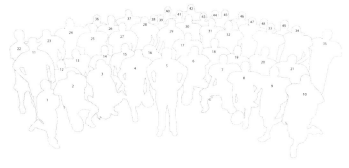

(1) Keith Morris, (2) Eric Harden, (3) Ben Carter,
(4) Dustin Jacoby, (5) former coach Dean "Oakie"
Waddell, (6) James Baldwin, (7) Tyce Rupert,
(8) Darren Day, (9) Marcus Stewart, (10) Bryce
Martin, (11) Coach Rob Vida, (12) Willie Murphy,
(13) Evan Stull, (14) Drew Hertlein, (15) Jimmy

Kelly, (16) Donald Kinney, (17) Matt Tucker,
(18) Scott Gregory-Tims, (19) Logan Sams,
(20) Aaron Seyfried, (21) Tyler Woollet, (22) Ryan
Johnson, (23) Grant McDermott, (24) Jeremiah
Webb, (25) Spenser Smith, (26) Michael Walker,
(27) Zach Pennington, (28) Christian Bare,
(29) Tyler Waller, (30) Cody Arnett, (31) Luke
Green, (32) Josh Martin, (33) TJ McNair,
(34) Davey Allen, (35) Jansen Hagen, (36) Derrick
Jones, (37) Ben Webb, (38) Jake Smith, (39) Caleb
Hollingsworth, (40) Matt Sexton, (41) Wilstan Cline,
(42) Derek Rice, (43) Dennis Nance, (44) Jason Law,
(45) Chad Fields, (46) Jake Viars, (47) Luke Harris,
(48) Eric Wooddell, and (49) Jeff Deaton.

From page 155:
WHS 2004 girls basketball team.
Clockwise from (24) Julie Earley are (21) Sarah
Achtermann, (22) Samantha Hinton, (13) Molly
Hinton, (23) Monica Howard, (25) Erica
Richardson, (11) Krystin Miller, (4) Ashley Howard,
and (5) Leah Hollingsworth.

A Piece of Work

From page 166:
KD and Steele Cabinetry.
Left on sideboard—Brian Young, Eric Pratt and
seated, Joel Coup.
Standing behind counter, from left—Rick
Somboretz, Don Derrick, Blain Hammons,
John Chaney, Rodney Hampton.
kneeling, Joe Steele.
Foreground—Kimball Derrick (in suit);
Phillip Anderson (holding blade); Andrea Acuff
(seated); and Joe Steele (kneeling).

From page 166:
McCarty Landscaping.
Foreground—Owners Tim and Mike McCarty.
First row—Timothy Larrick, Stephanie Seaman,
and Mary Ann Roddy.
Five in back—Kim Cordrey, Janet Blessing, Gwen
Maher, Jane Vandervort, and Gary Hollon.

From page 167:
Wilmington Iron & Metal Company, Inc.
Back row, from left—Todd Vanscoy, Mark Keplinger,
Frank Crowe, Jacob McKeever, Ed Harrison,
Bob Strauthers, Joe Quigley, Jim Greiner.
Front row, from left—Fred Ertel, Josh Brunck,
John Cohmer, Charlie Norvell, Greg McGuire.

From page 167:
Curliss Printing Company.
Back row, from left—James Breezley, Alan Davis,
Brian Roll, Greg Richardson, Mike Brooker,
Ed Zinsmeister, and Jon Cochran.
Middle row, from left—Tammy Cochran, Robert
Bleska (in black shirt), Charlotte Helton, Darrell
Culberson, Jan Wilson, Bev Skinner, Wayne Nelson
(arms crossed), Ralph Achor, and Thomas Allen.
Foreground—Jeff Campbell, Kip Zech, and Libby
Williams (at far right).

County Fair

From page 202:
Kids eating their way through the fair.
From left to right—Polton Goodman,
Josh Speelman, Kristy Swisshelm, Jason Ewing,
and Bobby Renshaw.

Corn Festival

From page 224:
*Cub Scout Pack 909, Wilmington Church
of Christ.*
Brian Hoggatt, Ryan Macella, Zachary Macella,
Brent Hoggatt

From page 224:
YMCA Twisters, Coach Aimee Blakeman.
Back row (from left)—Mary Ellen Hardin,
Maria Cosler, and Leah Donahue.
Front row (from left)—Christine Inlow,
Amina Affini, Becky Powell, Kara Sikorski,
and Alex Luttrell. Coach: Aimee Blakeman.

From page 227:
Antique Power Club of Clinton County.
From left—Alfred Kendall, Miles Barrere,
Mark Rembis and Jim Brown (behind tractor),
Charlie Ledford (in front, with wrench),
Jim Campbell (chin in hand), Raymond Smith,
and Bret Ledford.

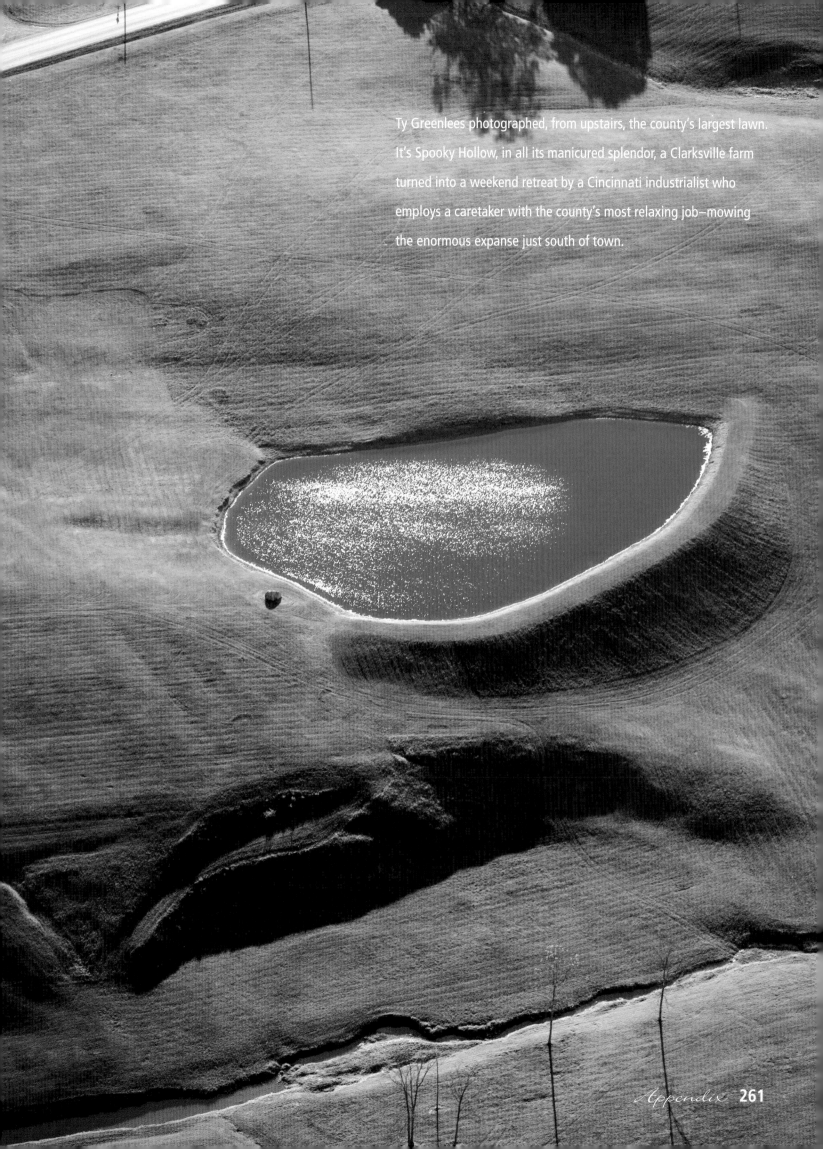

Ty Greenlees photographed, from upstairs, the county's largest lawn. It's Spooky Hollow, in all its manicured splendor, a Clarksville farm turned into a weekend retreat by a Cincinnati industrialist who employs a caretaker with the county's most relaxing job—mowing the enormous expanse just south of town.

Photography Credits

Upfront—viii, watchdog, Ty Greenlees; *x*,
Port William Mill, Ron Levi; *xii–xiv*, the Fair,
July 4th, and Walter and Grace, all by
Ty Greenlees; *xv*, Cape May, Thomas Schiff.

Native Land—2–5, plowing, Ty Greenlees; 6–7,
the McMichaels, Roman Sapecki; 8–11, haying and
the Stokes farm by Ty Greenlees; 12–15, auction,
Ty Greenlees; 16–19, farmscapes, Ron Levi;
20–27, Ali and her hogs, lambing, Dr. Bob and
the tractor wash by Ty Greenlees; 28–32, harvest,
Ty Greenlees; 33 (at top), Landmark conveyor,
Ty Greenlees; Clarksville elevator (two at bottom),
Joe Simon; 34, Sabina elevator, Chris Smith; 35,
Craig Davis portrait, Joe Simon; 36–38, Wyke's
woodpile and sugar camp by Ron Levi; 39,
the Wicals making syrup, Ty Greenlees.

The Human Condition—40–41, summer scenes,
all by Ty Greenlees except family in park, at left,
by Robert Flischel; 42–43, sledding, Ty Greenlees;
44, Elizabeth in park, Thomas Witte; 45–46, dance
studio and Outstanding Women by Robert Flischel;
47, book clubs, Roman Sapecki; 48, Jen's, Thomas
Witte; 49, George Horton, Chris Smith; 50–51, Hot
Hoops in park, Robert Flischel; 52–53, veterans
at the Air Force Museum, Dan Patterson; 53,
Wightman mural, Joe Saville; 54–55, Last Supper,
Robert Flischel; 56–57, Putnam Elementary Wax
Museum, Ty Greenlees; 58, Peterson Place, Roman
Sapecki; 59, Nathan's bridge, Ty Greenlees; 60–62,
Native Americans and Joe Saville by Robert
Flischel; 63, Rod & Rod, Roman Sapecki; 64–65,
frat guys and the Red Hat Ladies by Thomas Witte;
66, John & Bailey by Marcy Hawley; 66–69, the
farm pond and the Joe Nuxhall Street Fair by Ty

Greenlees; 70–73, Midland Daycare, Habitat
for Humanity and the Williams' summer barn by
Ty Greenlees (barn dismantling pictures courtesy
the Williams' family); 74–75, gardeners and old
Pumpkin Butt by Robert Flischel; 76, first baby,
Thomas Witte; 77, our centenarian, Ty Greenlees;
78–79, black & white portraits of old Wilmington,
Jay Paris.

The Body Politic—80–81, courthouse, Thomas
Witte; 82, EMS School, Ty Greenlees; 83, mayors,
Robert Flischel; jail cell and deputies by Thomas
Witte; 84–87, The Chief and the practice burn by
Ty Greenlees; 88–89, Chris and the maintenance
crew by Thomas Witte; 90, Cuba postmaster,
Robert Flischel; 91, Reesville postmaster, Thomas
Witte; 92, Lees Creek postmaster (and inset of
Martinsville on 93), Chris Smith; 93, Gladys,
Roman Sapecki; 94–96, president at ABX hangar
and Cuba voting by Ty Greenlees; 97, Democrats
at their headquarters, Nelson Thompson; 97,
election night at the courthouse, Alan Haines;
98–99, Bush in Wilmington, Ty Greenlees.

A Sense of Place—100–107, first day of school,
Banana Split Festival and the Murphy by Ty
Greenlees; 108–109, panoramas of the Murphy,
Thomas Schiff; 109–111, small inset of Murphy &
the drive-in by Chris Smith; 112, surgeons,
Thomas Witte; 113, hospital portraits, Todd
Joyce; 114–115, CMH's Cath Lab, Thomas Witte;
116–117, town panorama, Thomas Schiff;
116–117, Truckdriving Academy, Ty Greenlees; 118,
Nathan & Main School, Jerry Socha; 119, Historical
Society, Robert Flischel; 120–121, Cardboard City,
Ty Greenlees; 122, hip hop kids, Robert Flischel;
123–124, chemistry lab and college theatre by
Thomas Witte; 125, *Anything Goes* cast and crew,

Ty Greenlees; 125, Cat in Hat, Randy Sarvis; 126–129, Wilmington College, Ty Greenlees; 130–131, Panoramas, Thomas Schiff; 132–133, insets one and three, Thomas Witte, two and four by Ty Greenlees; 134–135, balloon launch, Thomas Witte.

Fields of Play—136, equine program, Ty Greenlees; 137, basketball champions, John Schwartzel; 138–139, Wilmington College football, Ty Greenlees; 140–143, the basketball guys and the YMCA swimmers by Thomas Witte; 144, The Haleys, Robert Flischel; 145, Gayle's bike, Roman Sapecki; 146, Special Olympics, Ty Greenlees; 148–154, football in the county, Ty Greenlees (except 150-151, Blanchester, by Sarah Clark); 155, taking the field and the lady basketballers by Linda Rinehart; 156–157, bowling, Ty Greenlees; 158, Kay's Wee Warriors, Thomas Witte; 159, soccer, Ty Greenlees.

A Piece of Work—160, Sabin Wholesale, Roman Sapecki; 161 (clockwise), Orange Frazer Press, Chris Smith; Delmar Ferguson at Champion Bridge, Ty Greenlees; the town barbers, Roman Sapecki; and the Dullea Family at the General Denver by Thomas Witte; 162–163, grain elevators and the Melvin quarry by Ty Greenlees; 164, Walt of Wilmingtoons, Roman Sapecki; 165, Buckley Brothers, Ty Greenlees; 166–167, K.D. and Steele and Curless Printing by Ty Greenlees; Wilmington Iron and Metal and McCarty Gardens by Thomas Witte; 168–169, Tim Smith and National Bank by Robert Flischel; 170–171, International Dial and Dr. Vieson's office by Ty Greenlees; Ferno–Washington, Jerry Socha; and the dialysis service, Thomas Witte; 172–173, Champion Bridge, Ty Greenlees; 174–175, Danny Vaughn by Thomas Witte, Doug Roberson and Jim Compton

by Roman Sapecki;176–177, R+L Carriers, Robert Flischel; 178–181, DHL/ABX, Ty Greenlees.

Town Life—182, market in Port William, Ty Greenlees; 183, Charlie's Pizza and Gaskins Printing by Thomas Witte; fireman Chuck Muchmore, Joe Simon; 184–187, Dam Days and Lees Creek aerial by Ty Greenlees; 188–189, Sabina by Thomas Witte (except the city hall, Chris Smith); 190, New Vienna at the mailbox, Robert Flischel; 191, New Vienna architecture, Ty Greenlees; 192–193, Kim's Classic Diner, Chris Smith; 194–195, Martinsville covered bridge, Ron Levi;196–197, Greasy Creek and Midland by Robert Flischel; 198, Pansy church, Ron Levi; 199, Blanchester's Margaret Freeman by Robert Flischel, and cupola and Charlotte Helton by Ty Greenlees; 200–201, Lee Ames, Elmer Lemar and the McIntires by Ken Steinhoff, and Mary Robinson (and the background scene) by Dan Patterson.

County Fair—all photographs are by Ty Greenlees.

Corn Festival—all photographs are by Chris Smith except the Corn Festival parade on 219 by John Porter; and Fred Ertel on 222–223 and the Antique Power Club on 227, both by Ty Greenlees.

The View from Here—all landscape photography is by Ron Levi, with the exception of the four seasons, 230–231, the snowy road at bottom of 233, the smaller picture of Cowan Lake on 245, 246–247, and 250-251 by Ty Greenlees; and the boathouse on 245 by Chris Smith.

Appendix—254, Harry Potter festival, Joe Simon; 264–265, Martinsville Friends Church, Chris Smith; 268, county road, Robert Flischel; and 269, Leaving Clinton, Thomas Witte.

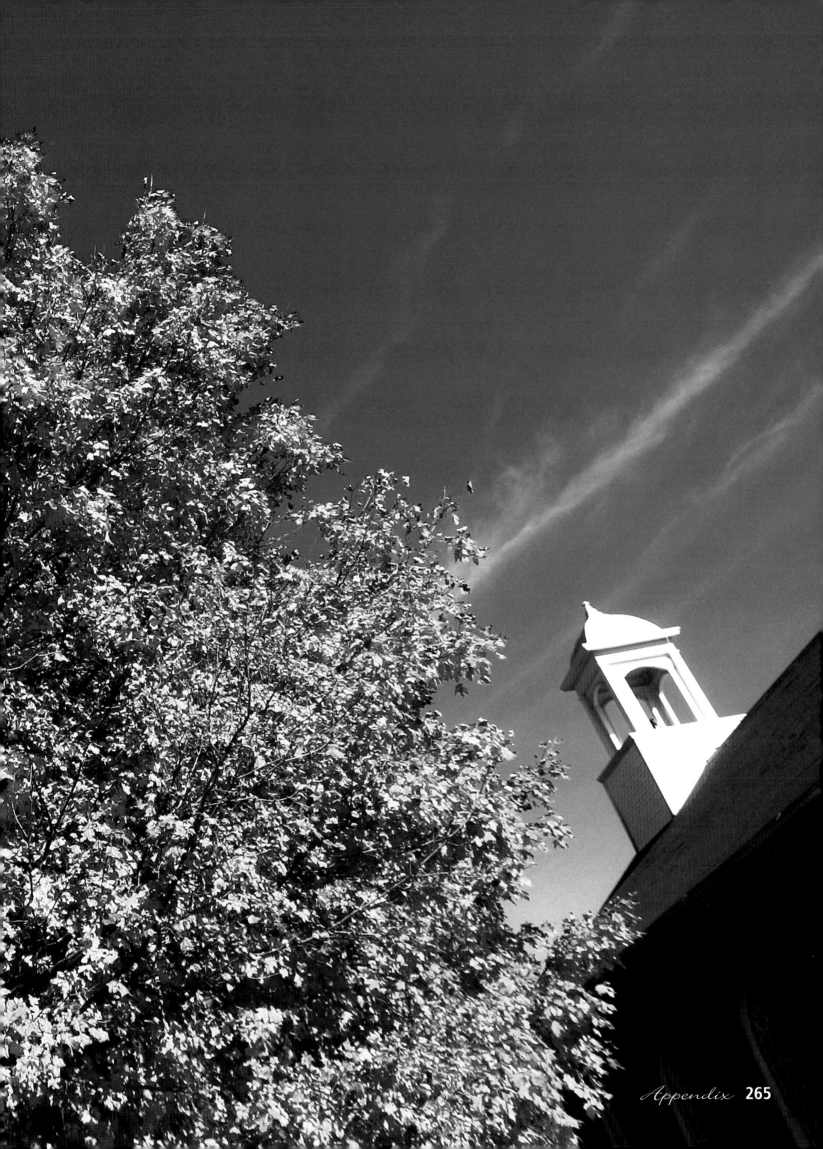

Ty Greenlees received an instamatic camera on his 7th birthday, a transforming moment that resulted, some years later, in a job as high school yearbook photographer. He has been a staff photographer with the *Dayton Daily News* since 1984, and is a licensed airplane and helicopter pilot. In 1997, he flew across the country photographing aviation for a series called "Spirit of Flight," which won the Max Karant Award for aviation journalism. The

lead photographer for the Clinton County project, Ty, wife Amy, Avery and Claire live on a small farm near Lumberton.

Ron Levi is a landscape/nature photographer living in Maineville, Ohio, specializing in natural and scenic photography. His images have appeared in *Audubon*, BrownTrout, Downeast Books, and many other publications. His fine art prints are in museums, public buildings and many private collections throughout the United States and Canada. An amateur naturalist, he is interested in helping people appreciate and understand the importance of

preserving the fragile natural world for future generations.

Thomas E. Witte, after being laid off after six months on his first job on a Pennsylvania newspaper, returned to the tri-state to begin working for himself. In the five years since, his images have appeared in over 50 countries and seven continents, his regular clients ranging from *Sports Illustrated* and *ESPN the Magazine* to *Business Week* and *Getty Images*. While primarily a sports photojournalist working with the NFL and NHL, he has begun to segue towards environmental portraits and experimental lighting techniques. He is a graduate of the Ohio University School of Visual Communications.

Robert Flischel graduated from Xavier University in 1971 where he studied photography under Kazik Pazovski, crediting his direct style to Pazovski's influence. Flischel's books include *Cincinnati Illuminated, a Photographic Journey; An Expression of Community: Cincinnati Public School's Legacy of Art and Architecture; New Bremen, 2000;* and *Then and Now.* In addition, he has been a contributor to *Life, Smithsonian, Newsweek, Business Week, Audubon, National Geographic Traveler,* and his corporate clients include Fifth Third Bankcorp, the Procter & Gamble Company, the Jay Leno Show, and Walt Disney, Inc. Flischel has taught photography at Northern Kentucky University and lectures on historic preservation.

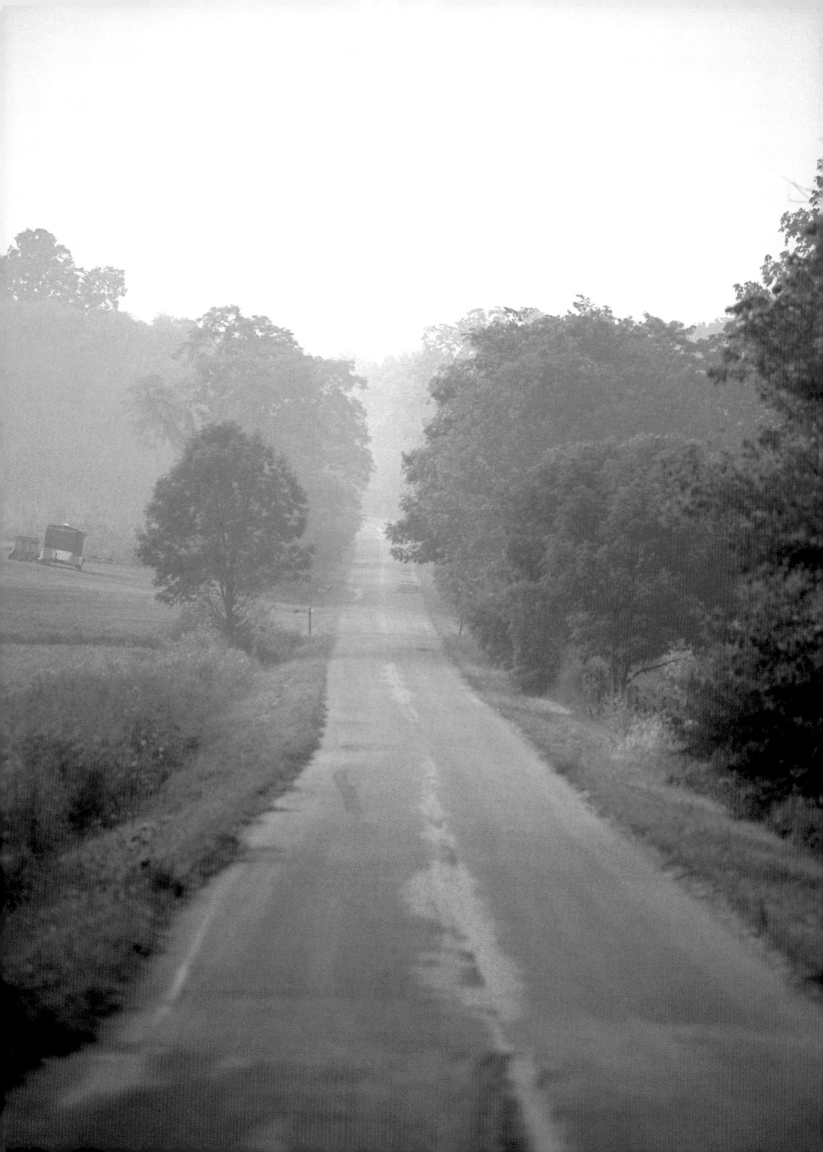

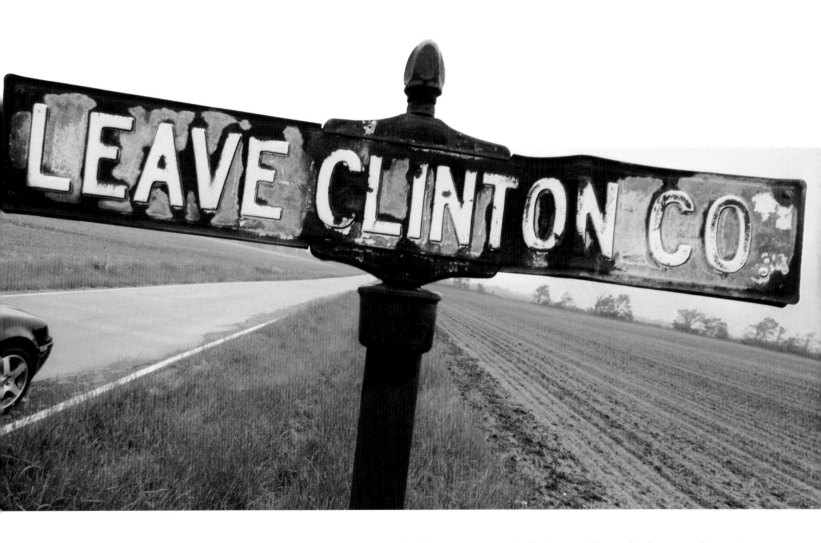

The first written record of what would one day become Clinton County was left in March of 1751 by Christopher Gist. Commissioned by the Ohio Company, an English real estate firm, Mr. Gist pronounced the prairie land splendid. "Very fertile land with beautiful meadows, streams full of fishes, wild turkeys, and hardly a bush in sight," he wrote in his detailed diary. The forest grew up when the last of the buffalo left at the end of the 18th century. The farmers edged their way into the forest and, well, you know the rest....

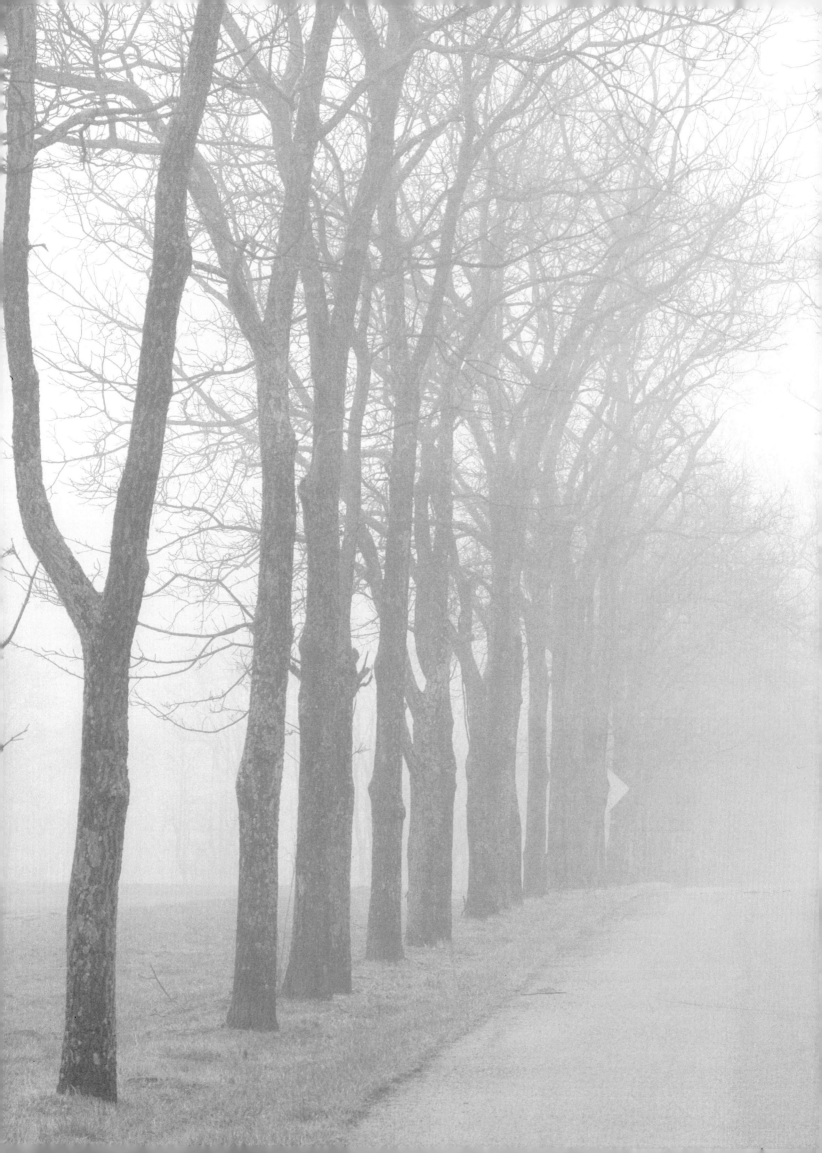